■ A F T E R T H E L A W

A book series edited by John Brigham and Christine B. Harrington

C O N T E S T E D S T A T E S

■ *AFTER THE LAW*
A book series edited by John Brigham and Christine B. Harrington

Also published in the series:

Gigs: Jazz and the Cabaret Laws in New York City
by Paul Chevigny

A Theory of Liberty: The Constitution and Minorities
by H.N. Hirsch

Inside the State: The Bracero Program, Immigration, and the I.N.S.
by Kitty Calavita

*Explorations in Law and Society: Toward a Constitutive
Theory of Law*
by Alan Hunt

*Virtuous Citizens, Disruptive Subjects: Order and Complaint in a New
England Court*
by Barbara Yngvesson

Contested States

LAW, HEGEMONY AND RESISTANCE

■ EDITED BY MINDIE LAZARUS-BLACK
AND SUSAN F. HIRSCH

Foreword by John L. Comaroff

■ ROUTLEDGE NEW YORK ■ LONDON

Published in 1994 by

Routledge
29 West 35th Street
New York, NY 10001

Published in Great Britain by

Routledge
11 New Fetter Lane
London EC4P 4EE

Library of Congress Cataloging-in-Publication Data

Lazarus-Black, Mindie.
 Contested states : law, hegemony, and resistance / Mindie Lazarus
-Black and Susan F. Hirsch (eds.).
 p. cm. — (After the law)
 Includes bibliographical references.
 ISBN 0-415-90779-9 (HB) — ISBN 0-415-90780-2 (PB)
 1. Sociological jurisprudence. 2. Ethnological jurisprudence.
3. Customary law. I. Hirsch, Susan. II. Title. III. Series.
K376.L393 1994
340'.115—dc20 93-47569
 CIP

British Library Cataloguing-in-Publication Data also available.

CONTENTS

THE PARADOXES OF LEGAL PRACTICE

ACKNOWLEDGMENTS

In *Contested States* we seek to demonstrate that new scholarship in legal history and the anthropology of law contributes to theoretical understanding of power, hegemony, and resistance. We began with this goal, and it is the thread that binds together eleven papers written from different perspectives about diverse parts of the world and moments separated in time.

Like flags in the wind, the ideas in the volume have shifted, changed, and unfurled through our separate ruminations, conversations, and contestations with each other, our contributors, and other colleagues. We developed this collection in several intellectual forums. Our interest in the project first emerged in conversations we had at the American Bar Foundation in Chicago, a place that brought us together and provided each of us with intellectual stimulation, new colleagues, and personal friendships. We invited our contributors to a panel at the joint meetings of the Law and Society Association and the research Committee on the Sociology of Law of the International Sociology Association held in Amsterdam, the Netherlands, June 26–28, 1991. Excited by the obvious connections between the issues we were investigating in different times and places, most of us met again at the American Anthropological Association Annual Meeting in Chicago in November of the same year. Michael Musheno and Dirk Hartog commented astutely on the papers in Amsterdam and we benefited from Don Brenneis's insights and support in Chicago. Our thanks to them.

As *Contested States* began to take shape, we talked at great length on the telephone and by fax, and twice camped out in each other's homes. We would like to thank our separate institutions, Wesleyan University and the University of Illinois at Chicago, for support. We are also grateful to colleagues and students who listened to us and stimulated our thinking through their questions and comments. We want to acknowledge the family members and close friends who have

supported us in this project, for all the things that sometimes get taken for granted and for respecting our time together.

Christine Harrington and John Brigham introduced us to Routledge and asked us to be part of their exciting series. They worked with us to further enhance the manuscript for publication, and we have appreciated their support, editorial advice, and early assurances that this collection deserved publication. Cecelia Cancellero and her staff at Routledge were helpful and efficient throughout the publication process. We especially thank John Comaroff for writing the foreword and for comments on a prior version of the introduction.

Early in this project we learned that collaboration can be an invaluable and very special experience. We found the quality of our thinking enhanced through the creative exercise of talking and writing together. We are grateful to each other for working hard and in good faith and for all that we have learned together through this process. We want our readers to know that we flipped a coin to determine whose name should be placed first on the title page, agreeing beforehand that the other would then be named first author of the introductory chapter.

We owe a special debt of gratitude to our contributors whose scholarship inspired us to take on the project. We want them to know that when we began this manuscript we were warned that editing a long volume with many authors would be hard work—it was—and that it might turn into an unpleasant ordeal—it didn't. Ours was an apparently unusual editing experience; each author responded to our letters and telephone queries, suggestions for revisions, and requests for advice with intelligence, good will, and prompt attention. Thank you all for your scholarly contributions to this volume, your comments on our introduction, and your support and professionalism. We value deeply what we have learned with and from you.

Susan F. Hirsch and Mindie Lazarus-Black

FOREWORD

John L. Comaroff

You are better off not knowing how sausages and laws are made.
 Chinese Fortune Cookie
 Amherst, Massachusetts; September 9, 1993

Every god, it seems, has its day. In the academy, our current deity du jour is unquestionably Janus. It is almost impossible to read anything at present on, say, nationalism without being told, after Hugh Seton-Watson, that the beast is "Janus-faced." It is said to have both a light and a dark side, to prompt people both to heroic freedom struggles and to horrific ethnocidal excesses.

As with nationalism, so with many other things in our imploding, explosive world. The body. The self. Social identity. Modernity. Power. Language. Time. Technology. Travel. Representation. Reality. Space. Virtual reality. Almost everything which engages our attention is held, by someone or another, to have a double visage, to produce a double consciousness in us, to constrain and enable, to promise freedom and potentiate bondage. Janus turns out not just to be the god-of-two-faces, but also the god of paradox and contradiction.

And now The Law. In this excellent collection of essays, we are taken on an intriguing tour through the labyrinthine ways of legality, power and hegemony, contestation and resistance. And through the conceptual minefields that enclose them. Much recent writing—especially on colonialism and the political sociology of race, class, and gender—has emphasized the dark side of the law. From this vantage, legal institutions and processes appear as tools of domination and disempowerment; blunt instruments wielded by states, ruling classes, reigning regimes. By contrast, liberal theory, always long on optimism, has it that law holds the key, actual or potential, to liberation and

empowerment, to civil rights and equality of opportunity. *Contested States* succeeds splendidly in showing that each of these representations captures, or rather caricatures, just one face of the beast. And it does so by interrogating legal processes, precepts, and practices precisely where they should be interrogated: in historically constituted, socially situated fields of power and resistance; the force fields within which human beings live out their lives—however ordinary, however epic.

Lazarus-Black and Hirsch, along with their contributors, demonstrate how the law may serve those who contest authority as well as those who wield it; that legal structures and sensibilities are everywhere polymorphous, everywhere politicized; how efforts intended to subvert the state by recourse to illegalities may reinforce the received state of the world; that the mysterious workings of power may implicate the law quite unpredictably in its means and ends. But they also do more. They show us *how* and *why* legality enters into the making of modern history—past and present, at home and abroad—in inherently ambivalent, contradictory ways. In so doing, they compel us to rethink both the scope and the substance of the anthropology (taken in its most general sense) of law in culture and society.

I am reminded, in saying this, of three things, three texts that, although far removed from each other, together underscore the lessons to be learned from this book. And speak for its importance.

One is the remarkable opening sentence of Montesquieu's *The Spirit of the Laws*: "Laws, in their most general significance," it says, "are the necessary relations arising from the nature of things." A less acute, more mechanistic mind—of the kind, for example that later gave us sociological functionalism—might have written instead that "laws are necessary things that arise from the nature of relations." However, in his more compelling formulation, Montesquieu anticipated the first principle, the founding syllogism, of a postfunctionalist, poststructuralist, post-Marxist, postcolonial legal anthropology: that, inasmuch as relations always entail multiple representations, multiple subjectivities, multiple realities, they are, by their very nature, the perpetual object of construction and contention; and inasmuch as "laws . . . are . . . relations," it follows that they, too, are perennial sites of struggle— as are the social institutions, the economic practices, the cultural forms that rest upon them. Such processes of construction and contestation may be strident or silent. They may move with dramatic speed or seem hardly to be moving at all. But they are always there, always happening. As Hirsch and Lazarus-Black insist, the contestation and (re)construction of relations, by means legal or illegal, do not occur only when history takes a detour from its expected pathways. Or only when

something ruptures the accepted order of things. They *are* the means by which histories are made, both histories of the momentous and histories of the mundane: the means, that is, by which states—nation-states and states of everyday being in the world—are formed, informed, deformed, transformed. Here, then, is the first lesson to be learned from *Contested States*.

The second comes from a memorable moment in Carlos Fuentes's recent novel *The Campaign*, a narrative of the liberation struggle in nineteenth-century South America. One of its recurring themes is a discourse on the role of lawyers and legalities in building a new, unfettered society. From the frontier, the irrepressible Rousseauian revolutionary Baltasar Bustos writes a letter to his friends. In it he asks, "Isn't law reality itself?" The answer—here as everywhere, at all times—is no. Of course not. What is significant, though, is not the answer. It is the fact that the question was thinkable; the fact that, in Baltasar's world at the edges of a European empire in the early eighteen hundreds, law might plausibly *appear* to be reality itself. For it bespeaks a dawning awareness of the centrality of a culture of legality in the scaffolding of the modernist nation-state; of the significance, in its architecture, of the right-bearing subject, of constitutionality and citizenship, of private property and an imagined social contract. Baltasar's practical lessons in elementary Eurocivics bring to the surfaces of our analytic consciousness many things which we often take for granted: among them, the unspoken axioms, ideologies, and aesthetics on which rests not merely the idea of "civil(ized)" society, but the anatomy of our (ever more global) political world.

So, too, do the essays in *Contested States*. And, as they do, they force us to confront the most basic questions of all: What, exactly, *are* the invisible components of the cultures of legality that underpin modernist political sensibilities in the West and elsewhere? How exactly are they constructed and connected to one another? How and when do they come to be taken for granted? When and why do they become objects of struggle? A great deal, patently, rests on our answers to these Big Questions. In insisting that we address them, Lazarus-Black and Hirsch read us a profound lesson about the present and future of legal anthropology. If we are to elucidate the place of law in the making of economy and society, itself an exercise in perpetual motion, we have always to situate (even) our (most local) analyses in larger-scale processes. In the large-scale processes, that is, which give cultures of legality their specific historical character.

But Baltasar was to learn another lesson, one which colonized peoples all over the world—in South America, South Africa, South Asia,

the south side of some American cities—have also had to learn. It is that power, too, is less a thing than a relation; that it lies in the relative capacity—of human beings and habitual processes, of social institutions and cultural practices—to construct reality, to shape lived worlds, to give form to perceptions and conceptions, to beat out the polyrhythms of everyday life. Here is where my third text becomes salient. It is from the South African interior in the second half of the nineteenth century, the ground on which Tswana "tribes" encountered European colonizers.

Frontiers—the spaces in which people of different cultures seek to make sense of, and encompass, the world of others—are always fascinating. And revealing. This case is no exception. Black South Africans at the height of the imperial epoch, wrote the missionary John Mackenzie, were alike engrossed and affrighted by the British obsession with legal papers, processes, contracts, and courts. Such, said one of his "native" interlocutors, were "the English mode of warfare," the mysterious means by which Tswana autonomy was brought to an end, their land expropriated, and their labor extracted. All without a sword drawn or a drop of blood shed. Colonial law, it seemed to these colonized people, was a nonviolent means of committing great violence. And this in spite of the curious fact that the language of legality was also the lingua franca most widely spoken (if not as widely understood) on the terrain where Europeans and Africans met to speak of peace and to negotiate the terms of their relations.

Like Baltasar, in short, the Tswana came to see law as an enchanted key to the altogether disenchanting realities of colonial politics. This, then, is the point, and the final lesson of *Contested States*. If power lies in the relative capacity to construct reality, and law appears as "reality itself," it is obvious why the connection between the two, between law and power, should feature so prominently and problematically in the historical consciousness of those who feel disempowered; of those who would alter the existing order of things, be it in the name of constitutional rights, private self-interest, or identity politics. To the degree that law *appears* to be imbricated in the empowered construction of reality, it also presents itself as the ground on which to unravel the workings of power, to disable and reconstruct received realities. Which is why, when they begin to find a voice, people who see themselves as disadvantaged often do so either by speaking back in the language of the law or by disrupting its means and ends. The crucial challenge we face—and it is raised by *Contested States* with particular acuity—is to establish when and why some seek legal remedies for their sense of dispossession and disempowerment; when and

why others resort to illegalities, to techniques of silent subversion or to carnivals of violence.

In a memorable essay on Hallam's *Constitutional History of England* in the *Edinburgh Review* of 1828, Lord Macaulay differentiates the cartographer's map from the painter's landscape. Each is likened to a form of history—which, he says, should be "a compound of poetry and philosophy" that "impresses general truths by a vivid representation of particular characters and incidents." To this Renaissance realist, the map was meant to serve as a reliable guide, a means of accurately establishing our bearings. The landscape, on the other hand, was meant to serve the imagination by challenging our senses to see beneath the surfaces of the scenic. In teaching us its lessons, *Contested States* is at once map and landscape. Hirsch and Lazarus-Black and their co-contributors achieve the difficult objective of mapping a conceptual landscape sufficient to the task of elucidating the place of law in the making of history. And they do so with real imagination. Before you, to be sure, lies the future of legal anthropology.

INTRODUCTION

PERFORMANCE AND PARADOX: EXPLORING LAW'S ROLE IN HEGEMONY AND RESISTANCE

Susan F. Hirsch and Mindie Lazarus-Black

This volume investigates law as a struggle revealing contested states of governance, mind, and being. The dual meaning of "state" as "institutionalized political order" and "condition of being" (cf. Comaroff and Comaroff 1991:5) encourages new ways of thinking about law and power. We argue that theories of law and power identifying states as institutionalized polities must also consider the strategies through which people reshape oppressive states of being. As the case studies in this volume demonstrate, people who are otherwise politically marginal go to court regularly to resist domination. From Philadelphia to Tonga, they skillfully manipulate legal rhetoric in courts and in a variety of other sites of oppositional practice. Their contestations in and around law shape, and are shaped by, hierarchies of gender, class, race, ethnicity, religion, age, and caste. The volume's examples illustrate that, although governments wield tremendous power to encode and enforce law, a crucial part of the power of law is its very contestability.

The volume shares and extends a growing concern with law, power, and social process in anthropology, history, and legal studies.[1] These works describe law as manifesting power of various sorts, including the authority to legitimate certain visions of the social order, to determine relations between persons and groups, and to manipulate cultural understandings and discourses. In *Contested States*, analyses of law and power begin with a conceptualization of power as fluid and dynamic, constitutive of social interactions, and embedded materially and sym-

bolically in legal processes. Accordingly, we include studies of slaves invoking law to charge masters with illegal behavior, women asking courts to help them defy or escape their husbands, colonized peoples preserving cultural practices in legal contexts, and one homeless American using law to get himself a shower and a shave.

The naturalizing, noncoercive, and mostly invisible power that Gramsci termed hegemony and the methods and means that constitute resistance are of central concern in this volume. Recent scholarship on hegemony and resistance captures how power frames, shapes, and pervades social processes in subtle and "everyday" ways (see, e.g., Abu-Lughod 1990; Comaroff and Comaroff 1991; Scott 1985, 1990). Our specific interest in law leads us to explore how the political, social, and economic mandates of states operate in courts and other law-related arenas. We analyze how people respond to and reinterpret these directives. For example, what does it mean to be a Hawaiian man compelled by a white judge from the mainland to attend a school for rehabilitating wife beaters (Merry this volume)? As they protect Central American refugees from the "deporting gaze" of the INS, do U.S. sanctuary workers subject refugees to other gazes that are sympathetic though intrusive (Coutin this volume)? In failing to attend to what Muslim women do in courts, how did traditional scholarship on sixteenth-century Islamic communities contribute to stereotypes of Muslim women as lacking political acumen (Seng this volume)? The chapters in this volume examine how these and other behaviors address simultaneously legal and other hierarchical structures.

We begin this introduction with a brief review of recent developments in scholarship on law and power. We then introduce the concepts of hegemony and resistance, and explore their dynamic relationship. The third section applies the analysis of hegemony and resistance to a range of legalities and across diverse contexts. Introducing the chapters in the fourth section, we focus on two themes that reveal the character of legal power: the contested performances and the paradoxes that characterize law and legal practice. Other themes emerge as we discuss the scholarly projects in each chapter, including discourse and law, gender and identity, and legal continuity and change.

POWER AND LAW

The past two decades of intellectual development in social theory have changed radically how scholars think about the concept of power, and how power is understood in relation to law. The current explosion of

ideas about power has roots in Gramsci's exploration of how civil institutions, such as the church, the media, and schools, are implicated in domination. Gramsci's work encouraged scholars to rethink the long-standing assumption that power is primarily exercised through the force of the state in concert with the ruling classes. More recently, Foucault has been a prominent proponent of radical redefinitions of power (see, e.g., Lukes 1974; Wrong 1979). At one level, Foucault's "analytics of power" entails simple inversions of commonplace assumptions: power is exercised, not possessed; power is productive, not primarily repressive; power should be analyzed from the bottom up, not the top down (Sawicki 1991:21). These concise reframings are Foucault's basis for examining power's role in the production and circulation of knowledge. As he has shown, power operates through disciplinary practices that constitute the specific categories and procedures regulating social life in sometimes determinative and often intimate ways (see also Bourdieu 1977; de Certeau 1984). In this view power is central to the formation of discourses—both dominant and subjugated—which set the parameters of what can be said, thought, challenged, struggled over, and achieved in a given historical moment.[2]

Asserting that "the personal is political," feminists have also reconceptualized power to show how power dynamics play out in the home and the bedroom, the factory line and the lunchroom, the legislature and the courtroom (see, e.g., Hartsock 1983; Janeway 1980; Segal 1990). Through the analysis of power in different local contexts, feminists developed significant understandings of how power operates at the microlevel of interaction to construct gender roles and hierarchies. This work also illuminates the discursive constitution of gendered subjectivity in and through the body, clothing, and language. Bordo (1988), for example, analyzes anorexia nervosa as the "crystallization" of pathological discourses about gender, consumption, and success in contemporary Western society. Anorexics are ". . . surely the most startling and stark illustration of how cavalier power relations are with respect to the motivations and goals of individuals, yet how deeply they are etched on our bodies, and how well our bodies serve them" (109). Although, like Bordo, many feminists draw on Foucauldian approaches to discourse and the microlevel of power dynamics, most also offer the critique that theorizing power primarily in multiple local contexts tends to elide more systematic domination, particularly the oppressive effects of patriarchal institutions on women (see, e.g., Diamond and Quinby 1988; Hartsock 1990; McNay 1992; Sawicki 1991). Accordingly, these scholars emphasize that power operates discursively *and* materially in many contexts, *including* state institu-

tions, an innovation that puts the bite back into new concepts of power (see also Hall 1983; Hunt 1992).

These theoretical shifts are particularly relevant to understanding law as discourse, process, practice, and system of domination and resistance. It is important to note that rethinking power coincided with, and helped shape, new directions in social history, legal anthropology, and cultural analyses of law. Social historians, for example, began reassessing the power of law in the 1970s (e.g., Chambliss 1973; Genovese 1972; Hay 1975; Thompson 1975), and their work remains highly influential. They challenged positivistic views that equated law with coercion, as well as Marxist readings that reduced law to a tool serving class (elite) interests. Hay, for example, drew attention to the "authority," "majesty," and "mercy" of English law, a body of law that was certainly repressive but that also commanded great loyalty (1975). Mindful of the ability of "haves" to manipulate law in their own interests,[3] Thompson (1975) also wrote with critical insight about the character and power of law as ideology and social practice. He identified two features of British law that are relevant cross-culturally and that appear in this volume: (1) law governs through paradoxical forms and practices which curb certain injustices as they create others; and (2) ideologies and practices in and around legal arenas reproduce hierarchies even as they constitute new social groups and categories that, in turn, transform law's meaning and application.

Historians and historically minded anthropologists investigated law and power in the 1980s less by emphasizing legal institutions per se and more by attending to the details of how states function in different times and places (e.g., Blok 1989; Cohn and Dirks 1988; Moore 1986; Stoler 1989). In addition, several studies demonstrated that "tradition" and "customary law" could be and frequently were "invented" (see, e.g., Asad 1973; Chanock 1985; Cohn 1959; Hobsbawm and Ranger 1983; Moore 1986, 1992; Snyder 1981b). With respect to law in African contexts, it became clear that colonization, including British "indirect rule," altered directly and momentously the lives of indigenous peoples, as did the "imposition of law" (see, e.g., Burman and Harrell-Bond 1979; Hay and Wright 1984; Merry 1988; Merry 1991) and the advance of capital (Snyder 1981a; Vincent 1989). Feminist historians have illuminated how political states buttress patriarchy, sometimes through law, in studies of prostitution (Walkowitz 1980), domestic violence (Gordon 1976), and abortion (Petchesky 1984).

Anthropology has long been an important arena for the investigation of law and power.[4] Attention to the meaning and activity of disputing illuminated cross-cultural variation in the micropolitics of legal pro-

cesses and, more generally, offered numerous examples of law's role in shaping social life and power relations in local contexts (see, e.g., Nader 1969; Nader and Todd 1978; Starr and Yngvesson 1974).[5] In the context of framing "new directions in legal anthropology," Starr and Collier summarize several important characteristics of law in relation to power (1989:6–9). They argue, among other things, that law is never "neutral," that states and certain classes rely on law to uphold particular arrangements of power, that conflict is endemic to all societies, that lawmakers fashion a "reality" to which the governed must and do acquiesce, and that legal change marks change in the way that power and privilege are distributed in a society. Asserting that in both ancient and modern states power has been distributed unevenly, their volume includes case studies of law's role in forging, maintaining, and sometimes challenging such relations (see also Nader 1990; Starr 1992; Vincent 1990).

That law is "not only practice and process, but also discourse, code, and communication" (Lazarus-Black 1989:11) emerges clearly in the writings of Geertz (1983), Greenhouse (1986, 1989), and Rosen (1984, 1989a, 1989b), among other anthropologists, who focus on the relation between law and culture. Greenhouse, for example, explores the meaning of conflict among Baptists in a Southern community, locating law within a range of ways to contend with dissidence. For working-class New Englanders, differences in how people think about and use law mark subtle gradations of class, while legal processes are themselves important means of displaying and manipulating class differences (Merry 1990; Yngvesson 1993). These studies pay close attention to the discourses about law that touch people's lives and shape their expectations.

Sensing the tension in recent works in legal anthropology, Just (1992) finds the field moving in two different directions. On the one hand, scholars are "urged to connect palpably 'legal' institutions and practices to broader historical processes creating and maintaining hierarchies and inequalities." On the other hand, they "are drawn to ever-subtler examinations of the ontological and epistemological categories of meaning on which the discourse of law is based" (375–76). Just suspects, and we concur, that this dichotomy will prove misleading (ibid.:376). Scholars will increasingly be called upon to attend to both history and local meaning. And we would add they will also need to be mindful of law as a place of contest and struggle and of law's critical constitutive capacity to alter meaning and hierarchy.

As scholars turn to the study of law's contestability, they have begun to develop new approaches to power and law, ones that emphasize

cultural complexity and discursive practices. Recent ethnographic studies of law, for example, direct attention to the discursive fields that constitute legal identities and legal relationships (see, e.g., Coombe 1991; Coutin 1993b; Hirsch 1992; Lazarus-Black 1992; Merry 1990; Yngvesson 1993). Cultural studies as developed in Britain (see, e.g., Hall and Jefferson 1976; Hebdige 1979) encourages attention to law's role in the production of popular culture, a control vehicle for deposing power in complex societies (Bumiller 1991; Coombe forthcoming; Hirsch 1994; Silbey 1992; Young 1990). In addition, the legal cultures of institutions and social movements are critical to how power shapes, defines, and transforms new subjectivities—such as immigrants, people with AIDS, victims, and sex workers (Brigham 1992; Bumiller 1991; Calavita 1992; Musheno et al. 1992). The overlapping fields of critical race theory, Critical Legal Studies, and feminist jurisprudence explore legal texts, institutions, pedagogy, and scholarship as well as statutes, cases, and legal processes to expose multiple layers of law's power (see, e.g., Bell 1992; Fineman and Thomadsen 1991; Kairys 1982; P. Williams 1991).

Finally, as Smart (1989) argues, law is important in women's lives not only because it constructs their subordinate subjectivity and enforces the terms of patriarchy but also because, as feminist legal scholarship has demonstrated, it offers possibilities for their liberation (Eisenstein 1988; Fineman and Thomadsen 1991; MacKinnon 1987; Smart 1989; P. Williams 1991). These approaches, and those of the contributors to this volume situate power at the center of their considerations of law. Moreover, they develop rich understandings of how power and law transform and are themselves transformed by culture, discourse, and practice.

Duncan Kennedy once remarked, "Law is an aspect of the social totality, not just the tail of the dog" (1982:49). He was right, of course. Like that animal, however, law nuzzles as well as barks and bites. Reconceptualizing law in relation to power means coming closer to understanding when and why the dog sometimes nuzzles, sometimes barks, and sometimes bites. Unravelling law's awesome potential in the transformation of power requires a theoretical framework that can link law and power to the making of hegemony and the practices of resistance.

THE DYNAMICS OF HEGEMONY
AND RESISTANCE

Gramsci coined the term hegemony to refer to power that maintains certain structures of domination but that is ordinarily invisible.[6] The

Socratic method, common to many law schools, illustrates the concept of a hegemonic practice. In this form of instruction, a law professor directs a series of questions to one student who must rapidly respond with the facts, issues, and laws relevant to the case under discussion. What ensues is a performance that teaches about the power of law, imparts professional authority, and trains students to become lawyers. As Mertz writes,

> This method requires students to remain in conversation with the professor students are often forced to assume the new style; they are not generally permitted to "give up" In one sense, the power imposed in the law school classroom is more authoritarian [than in a traditional classroom]; and yet, it is empowering also, in the sense that students are not permitted to go off and "practice"; they must remain in and master the dialogue. The law school professor is thus at once giving students no choice and telling them that they are capable of performing this genre. (Mertz 1994)

Law students know when they give the wrong answer because they are either blatantly embarrassed, passed over, or questioned until they "tumble" on to the correct answer. That they willingly pay high tuition to participate in their own coercion—and the reconstruction of their thought that it entails—and that they rarely challenge the Socratic method is an example of hegemony.[7]

A remarkable amount of writing has been devoted to hegemony's meaning, pervasiveness, significance, and relation to ideology and resistance. Williams's rendering of hegemony is frequently cited:

> What I have in mind is the central, effective and dominant system of meanings and values, which are not merely abstract but which are organized and lived. That is why hegemony is not to be understood at the level of mere opinion or mere manipulation. It is a whole body of practices and expectations; our assignments of energy, our ordinary understanding of the nature of man and of his world. It is a set of meanings and values which as they are experienced as practices appear as reciprocally affirming. (Williams 1973:9)

Hegemony refers to power that "naturalizes" a social order, an institution, or even an everyday practice so that "how things are" seems inevitable and not the consequence of particular historical actors, classes, and events. It tends to sustain the interests of a society's dominant groups, while generally obscuring these interests in the eyes of subordinates.[8] Hegemony functions in talk, silences, activities, and inaction. In other words, it is "that order of signs and practices, relations and distinctions, images and epistemologies—drawn from a his-

torically situated cultural field—that come to be taken-for-granted as the natural and received shape of the world and everything that inhabits it. . . . In a quite literal sense, hegemony is habit forming" (Comaroff and Comaroff 1991:23). Hegemony operates in institutions that educate and socialize such as schools, the press, and churches. Furthermore, as Gramsci argued and this volume makes clear, the educative function of law operates within and around legal arenas to perpetuate hegemony but also to test its limits (Cain 1983:101–3, see also Hunt 1993).[9]

Recent conceptualizations of hegemony emphasize its role in the active negotiation of power (see, e.g., Comaroff and Comaroff 1991; Hall 1988; Hunt 1992; Lagos 1993). In one approach, hegemony can be understood in dynamic tension with ideology, the two concepts positioned as poles of a heuristic continuum (Comaroff and Comaroff 1991:24–28). Situated at one end of the continuum is ideology, a system of beliefs, meanings, and values articulated by a social group. A society's reigning ideology is that of the dominant group, which is likely to protect and enforce it. Subordinate groups possess other ideologies with which they express and assert themselves. At the other end of the continuum is hegemony, that part of the dominant worldview that has been so naturalized as to no longer appear as ideology. The more successful the dominating group, "the more of their ideology will disappear into the domain of the hegemonic" (ibid.:26). Thus, ideologies are subject to open contestation while hegemony operates unnoticed much of the time. Movement along the continuum between ideology and hegemony is marked by varying degrees of consciousness.

The continuum model is provocative because it depicts hegemony as subject to continual negotiation and transformation.[10] Resistance plays a key role in this process. "Everyday resistances," such as work slowdowns and covert mockings of authority, are evidence that subordinate people are capable of thinking themselves out of hegemony and wielding a diverse range of oppositional tactics (Scott 1985,1990).[11] Forms of resistance—from subtle, "everyday" opposition to organized rebellion—constitute a second heuristic continuum. Through oppositional ideologies, behaviors, and representations, subordinate people confront dominant worldviews with varying degrees of organization, intention, and effectivity.[12] As Glassman (1991:282) reminds us, "the consciousness of most exploited populations is turbulent, fluctuating, incoherent; in Gramsci's phrase, it is 'contradictory.' "

In real life, of course, most struggles against domination take place in the "murky" areas of each continuum where neither the ends of

resistance nor the terms of hegemony are clearly articulated (Comaroff and Comaroff 1991:29, 31). These struggles remake relations of power in critical ways: they expose some of the terms of hegemony and promote oppositional visions of society, and, by contrast, through these struggles the contradictions in ruling ideologies might be papered over and some aspects of domination transformed into unspoken "truths."

Struggles involving hegemony and resistance transform the terms of dominations that are themselves multiple and interrelated (see, e.g., Keesing 1992; Ong 1987). Studies inspired by Willis's (1977) analysis of working-class resistance to schooling stimulated concern for how gender, race, and ethnicity, as well as class, are all critical factors in power struggles.[13] Practices of resistance in colonial situations are particularly revealing of the fact that "webs of domination" encompass those who resist (see, e.g., Abu-Lughod 1990; Comaroff and Comaroff 1991; Feierman 1990; Stoler 1989). Opposition from within these webs frequently leads to contradictory results as "resisting at one level may catch people up at other levels" (Abu-Lughod 1990:52).[14]

As hegemonic processes and oppositional practices mutually constitute and reconfigure each other, they effect elaborate discursive realignments. Hegemony and resistance sometimes appropriate each other's terms and redeploy them to transform and transgress the existing social order (see, e.g., Comaroff 1985; Feierman 1990; Mouffe 1979). The challenge is to "describe how discourses are produced, enacted, and reproduced" and to "notice the opportunities for resistance in the same processes that also contribute to structural reproduction" (Silbey 1992:41–42). Understanding hegemony and resistance as mutually constitutive helps explain why most law students willingly participate in the reconstruction of their thought through the Socratic method and why some are silenced or drop out.

LAW, HEGEMONY, AND RESISTANCE

The rich scholarship on power, hegemony, and resistance informs the point that law is simultaneously a maker of hegemony and a means of resistance. But how, we ask, is this accomplished? How do hegemony and resistance operate in legal contexts and practices? To answer these questions, we consider next some of the manners, places, and times when hegemony and resistance operate in tandem within and around legal arenas. In addition, we focus on the people involved in struggles over power and law, asking how hegemony and resistance shape who they are and what their lives can be.

Encoding and advancing the terms of hegemony, law and legal practices set markers to which those who resist must attend. As Scott suggests, many resisters act like "prudent opposition newspaper editors under strict censorship, . . . setting a course at the very perimeter of what the authorities are obliged to permit or unable to prevent" (1990:139). But resisting state domination (or domination of other sorts) often entails seeking inclusion in legal institutions. Protest and resistance are thus sometimes framed as efforts to participate in dominant society by gaining access to its institutions (Glassman 1991; Lazarus-Black 1994; Moore 1992; P. Williams 1991). Historically and cross-culturally there are many examples of subordinate peoples struggling for the inclusion afforded by voting rights, political representation, equal opportunities for education, and entitlements to resources.

Although some people actively seek inclusion in legal processes for specific ends, others "get included" in the law quite implicitly through the legalities that hegemonically organize their lives. In both cases, people regularly appropriate the terms, constructs, and procedures of law in formulating opposition. For example, colonial subjects protested their subordination through documents which incorporated, often inaccurately, the language of colonial law. These imitative oppositional discourses reproduce the legally enshrined relation between colonizers and the colonized by adopting the *logic of opposition* that underpins colonial claims to power. Nevertheless, negations of this logic are also possible: by appropriating colonial discourses and logics, subordinate people engage in transforming them, sometimes in radical ways (Keesing 1992:238).[15]

Legal procedures contribute to the making of hegemony. For many litigants, witnesses, and spectators, the court is a daunting site where positioning, language, and timing are regulated in ways that contrast with the norms of interaction in other places (Conley and O'Barr 1990; O'Barr 1982).[16] Sometimes participants rebel against these rules, as did the defendants at the Chicago Seven trial who used silence and shouting to resist the state's efforts to contain them (Coutin 1993a; Dee 1981). Although a witness's silence can signal the antagonistic refusal to answer an inappropriate question, neither silence nor any other linguistic feature always indicates resistance (O'Barr 1982). Murphy's (1993) study of disputes over insults in Sierra Leone demonstrates that linguistic conventions for resisting are specific to language and culture. Court speech, oppositional or not, is often transcribed "for the record" and what is captured and what is not reflect the power

of certain persons and the subordination of others (Berk-Seligson 1992; Moore 1992).

Symbols of the law are important vehicles in the making of hegemony and in the display of resistance. In the United States, the state uses symbols of the law's power—scales of justice, judges' robes, uniformed police and bailiffs, the American eagle, the courthouse facade—to index its own power and authority. But these symbols are multivocal; interpreted and deployed to serve diverse ends. Observing the trial in which Mashpee Indians sued for tribal status, Clifford (1988) describes his ironic realization that the eagle depicted on the courtroom wall was a Native American cultural symbol appropriated by a hegemonic state. Yet, subordinate people bring their own symbols to court. In a dispute over whether Mrs. G., a poor black woman, used state assistance to buy "life necessities" for her daughters, "Sunday shoes" emerged as a contentious symbol. For Mrs. G., purchasing "Sunday shoes" represented values that she was proud to acknowledge even though the state considered those shoes an unauthorized extravagance (White 1991).

Litigants not only deploy legal symbols as oppositional resources, they also inventively manipulate context. Legal institutions are important sites for public performances of resistance by individuals and groups. Telling one's story in court, particularly a story of oppression, can be an important act of resistance. Legal contexts sometimes provide the arena for narrating a group's history of resistance, as in cultural defense cases brought by the Amish and Native Americans in which they emphasize their long-standing opposition to dominant culture. But telling the story of resistance can be a perverse rather than liberatory act if, as in treason trials, the narration of oppositional acts is compelled by the state in its own interest (Hirsch 1993). Sometimes oppositional practice is undertaken away from official or legal contexts, but it is "about" the search for justice, as in slaves' illegal participation in obeah rites to resolve crimes (Lazarus-Black 1994).

Time and timing are essential considerations when one investigates resistance and hegemony in relation to law. Acts of resistance that use or challenge law—marching, picketing, taking cases to court, and sitting at lunch counters—depend on daytime exposure. By contrast, certain kinds of resistance to law are best concealed under the cover of night. Sometimes resistance is momentary: the political and illegal art of the graffiti painter, for example, succeeds only until the wall is whitewashed. Winning independence from a European power, however, takes years of struggle in courts and other contexts. Moreover,

notions of timing vary cross-culturally and within different legal cultures, and these calibrate the dymanics of hegemony and resistance. Moore points out, for example, that "British law has its own cultural constructions of time" and shows how these clashed with African ideas about when to stake a claim and when to give one up (1992:34; see also Cohn 1959; Moore 1986). Time is critical, too, in the transformation of disputes (see, e.g., Felstiner, Abel, and Sarat 1980; Mather and Yngvesson 1980). Allowing time to pass is sometimes a way to oppress and at others the expression of deep defiance.

In this volume, Joan Vincent directs attention to another way of thinking about time in relation to law, hegemony, and resistance: the hegemonic moment. Vincent looks for such moments "before the law," that is, before the terms of hegemony (e.g., hierarchical social classifications) are established through legal statutes. The identification of hegemonic moments, however, does not imply a direct and unproblematic trajectory of hegemony over time, from the subtle to the public. Rather, the process of encoding hegemonic constructions in law is frequently interrupted, transmuted, and sometimes reversed. Similarly, several authors caution against reading local acts of resistance as the groundwork to moments of more overt or more effective political action (Handler 1992; Hunt 1992; Keesing 1992; Scott 1990).

Contrary to assumptions that women pursue resistance out of public view, primarily in "domestic spheres," studies of women's use of courts suggest that they turn to the state to contest gender hierarchy (Collier 1973; Fineman and Thomadsen 1991; Hirsch 1990; Lazarus-Black 1991, 1994; Merry 1990; Starr 1989; Taub and Schneider 1982). Recent scholarship on women's responses to subordination demonstrates that resistance is mounted in and through legal institutions, in and through hegemonic legal identities. Women's resistances can involve demanding the rights, privileges, and protections associated with their legal status or calling on the courts to enforce a "justice" not inscribed in patriarchal law. Yet women seeking equal protection and other remedies have found that, by turning to the law, they risk cementing their status in ways that provoke other forms of discrimination. As Hirsch argues in this volume, "Given [. . .] that women are situated in positions of multiple subordination, their oppositional practices might differ from those of men, might be directed against men, or, if pursued in concert with men (e.g., against the state), might have gender-specific outcomes."

The subject position from which one enters the legal process, or is "entered" involuntarily, influences the success or failure of the struggle. And law's relation to subjectivity is much more extensive:

> Legal processes . . . do more than merely reflect and reproduce domi-
> nant cultural conceptions of self, personhood, and identity in Western
> societies. They are, instead, constitutive of subjectivities. By defining
> and legitimating *particular* representations of how those in different
> subject positions or social groups experience their selfhood, adjudica-
> tive and legislative processes serve to maintain, reproduce and some-
> times transform relations of power. (Coombe 1991:5)

Given the law's role in constituting subjectivities, contesting the terms
of identity is a significant act of resistance in legal arenas. Dominguez
(1986) describes cases involving "Creoles" in Louisiana suing to
change their racial classification from black to white. As Minow (1991)
argues, however, legal rules, procedures, and practitioners rarely ap-
preciate the "kaleidoscopic nature" of identity (see also Clifford 1988).
The productivity of the law—mobilized by the state and by individual
actors—yields new subjectivities and thereby refigures relations of
power.

The making of subjectivity through law is a particularly intimate
locus for the operation of hegemony and resistance. Contestations over
the "states of being" of individuals also implicate social struggles
involving political "states." In transforming people and polities, hege-
monic processes and oppositional practices—and the contested states
that they produce—are inextricably linked to law. As described below,
the chapters in this volume explore struggles in and around legal
arenas, revealing the many ways that law is critical to the negotiation
of power.

COMPLEMENTARY APPROACHES AND EMERGENT THEMES

The chapters of *Contested States* examine the active role of law, legal
agents, and institutions in fashioning forms of domination. Each author
pays careful attention to the myriad ways in which people reconfigure
hierarchical coercive structures. We ask how legal identities like wife,
slave, undocumented alien, delinquent, and colonial subject—catego-
ries imbued with "naturalized" notions about race, gender, class, and
citizenship—structure the practice and consciousness of those who
embody and encounter them. We do not assume that subordinated
people come to courts only as victims or supplicants; we focus instead
on how power and law are transformed by their words and actions.

Part 1, "Performance and Protest," addresses the role of law in
hegemony and resistance by attending to the theatrical display of law's

power and its vulnerability in legal and extralegal contexts. In assessing the use of law by wives, colonized people, and other subordinate persons, the authors question whether the oppositional use of legal institutions and processes intensifies hegemony or undermines it. This section's emphasis on performance and protest develops important theoretical insights by scholars who investigate courts as "theaters," illuminating their political, ideological, and educational functions in earlier times (see, e.g., Hay 1975; Thompson 1975). The dramaturgical metaphor applied to courts leads contributors to ask: What stories do people tell in court? Which litigants are silenced? Are the audiences for these performances disgruntled villagers, the press, or court clerks and judges? Who directs the performance?

In some respects, though, the metaphor "courts as theater" is too limiting. Thinking about law and power in terms of "performance and protest" rather than "theater" encourages us to pay analytic attention to audiences as well as actors, to silences within and between dialogues, to nakedness as well as costume, to scene designers and stage tools as well as sets and props. The focus on performance illuminates instances when legal struggles crystallize in infamous trials and also captures how routine encounters with law shape social processes less dramatically but more pervasively.

Part 1 begins with Sally Engle Merry's analysis of courts as sites for the performance of hegemony and resistance. In locales marked by cultural diversity and unequal power, one group's rules are imposed on another through court performances that expand the hegemony of law. She argues: "These performances demonstrate the procedures of the dominant order, demand compliance with it, and illustrate, through both the imposition of laws and their enactment in the daily life of subordinate peoples, the ways it applies to everyday life." In mediating domestic conflicts in a working-class, ethnically diverse population, lower court judges in Hawaii find themselves caught between the laws and norms of the dominant social and legal elite and those of an underclass who regularly participate in unruly and illegal behaviors. Merry demonstrates that litigants are taught through the court's performances to distinguish between acceptable and unacceptable behaviors. In Hawaii, legal cases are performances of hegemony and resistance that actively reshape legal consciousness under conditions of postcolonial legal pluralism.

The colonial legacy operates quite differently in Tonga. Susan Philips finds that Tongans' performances in court exhibit and encourage distinctly Tongan values and relationships, many of which were incorporated into the legal system during the colonial and postcolonial periods.

When magistrates rely on indigenous ideologies in criminal cases involving drunkenness, hitting, and theft, they effectively appropriate the moral authority of traditional Tongan understandings of gender and kinship. For example, because Tongan *tapu* (taboo) dictates that opposite sex siblings should not be co-present when insults are uttered, even as evidence, women remain in the background in these criminal trials. Women's constrained speech and circumscribed presence in court reproduces Tongan gender hierarchy and reflects hegemonic ideologies about public order, respect, and the traditional primacy of brother-sister relations. As a result, these courts protect sisters while doing little to address the victimization of wives in intrafamilial conflicts. Yet, in addition to illuminating the distinctly Tongan nature of the postcolonial legal system, Philips insists on that system's ideological diversity: "what law is and does is quite varied in Tonga, and the genderedness of the Tongan state in the legal realm is not an implicit, seamless web, but consists as well of flashes, of displays of explicit stances on gender that themselves are not necessarily coherent."

The Tongan example also illustrates the critical power of words in shaping power dynamics in legal contexts. Language, inherently mutable and manipulable, offers an important resource for resisting and transforming hegemonic legal constructions. Oppositional linguistic practices include reinterpreting legal language, refusing to speak at the law's command, and drawing on legal discourse in nonlegal contexts. Some people learn new rhetorical strategies through their encounters with legal institutions. Most, however, learn the language of law by hearing and speaking about legal processes. To return to the theatrical metaphor, tales told in intermissions and interpretations offered by critics partially define the meanings of a performance.

Control over legal discourse and the silences of litigants are central in Erin Moore's chapter about disputing in rural Rajasthan, India. Moore investigates men's hegemonic control of public disputing forums through the tale of one woman's stubborn attempt to subvert that control. Honey, a Muslim woman who refuses to conform to religious and gender norms, actively pursues her legal rights in village councils and state courts. Honey's oppositional performances highlight the patriarchal nature of law in India and illustrate how lawmakers invoke custom, religious ideology, and formal statutes to communicate and enforce the social and legal consequences of marriage. The juxtaposition of village councils and state courts means that Muslim women "find themselves in positions of multiple subordinations and at the same time in conflicting alliances—with and against the state, with and against the local Muslim caste, with and against the religious

leaders who have the voice to fight the state" For some readers, Honey's saga raises a perplexing question: If her claims fall on deaf ears, why does she persist in using the courts? The example reminds us that the decision to seek justice in court cannot be reduced to a simplistic calculation of whether or not one might "win." Rather, Honey's performance confronts the limits of hegemony.

Joan Vincent examines a very different "dramaturgy of power": an agricultural show in colonial Uganda. Her analysis of the making of hegemony through the performance of state ritual offers provocative commentary on the role of consciousness in processes of domination: "All three cultural constituencies within the colonial state—European and Asian merchants, Baganda subimperialists, and other African ethnic groups encapsulated in the new modern Uganda—were thus all subject to this moment of hegemony. In the performance they concurred unwittingly, as it were, in the making of their future statuses in colonial law." As noted earlier, Vincent develops the concept of the "hegemonic moment" to draw attention to those events or periods in which the content and means of domination coalesce, especially as they remain beneath conscious elaboration. Her example shows that power relations evolve through performances seemingly unrelated to law and emphasizes the importance of "decentering" legal contexts in capturing law's contribution to hegemony.

Barbara Yngvesson's chapter draws part 1 to a close with a performance that illustrates succinctly how hegemony and resistance operate in tandem in the United States. Through court appearances, working-class people "restructure the social contours of their lives" creatively and oppositionally. Yngvesson argues that "court hearings become sites of momentary insurrection as complainants who are caught up in the power of law deploy the law in unconventional ways." Her profile of Charlie, a homeless man who repeatedly disrupts local court, displays the capacity of people without social resources to manipulate the law. Charlie's fate, however, suggests the tenuous nature of such control, and of resistance, in legal contexts. Yngvesson's work makes clear that sometimes performance, like power itself, is "double-edged," moving us deftly from the issue of performance to the problem of paradox.

The chapters in part 2, "The Paradoxes of Legal Practice," explore law as contested practice, contributing to the making of hegemony through its capacity to categorize and coerce. At the same time, legal categories, processes, and discourses encourage and enable multiple forms of resistance. These chapters highlight paradoxes within and between legal and extralegal arenas. Each author finds that legal pro-

cesses themselves generate forms of domination and resistance. Paradox is a critical component of the legal treatment of women: law subordinates women categorically and yet is an important resource for their empowerment. Shifting attention to the paradoxes of law enables us to understand better the relation between individual experience and the structures, processes, and institutions that constitute social life in complex societies.

This part of the book begins in a mid-nineteenth-century Philadelphia courtroom which has become "an arena of conflict, . . . [a] public [site] for contests over the meaning and application of law." Through his focus on the struggle between Ellen and Paul d'Hauteville for custody of their young son, Michael Grossberg investigates transformations in American family law at a time when law and lawyers were assuming hegemonic authority. Widely discussed in the press and the local community, the d'Hauteville custody case provided a public context for negotiating shifts in the meaning of "motherhood," "fatherhood," and "child welfare" as well as mapping new roles for law in family life. Grossberg's analysis reveals "why and when within a hegemonic legal order certain ideologies and distributions of power became privileged while others were rendered oppositional or ignored." Grossberg demonstrates how courts empowered one woman in her struggle against patriarchal authority, while strengthening the power of law over domestic relations.

What does it mean to read the legal record for paradox? In her analysis of rare legal records from sixteenth-century Üsküdar, Istanbul, Yvonne Seng challenges long-standing assumptions about Turkish women which held that they were confined to the home and subject to male authority without legal redress. The Üsküdar record reveals instead that women were actively involved in a wide range of cases involving property and family law. Case records and estate inventories indicate that workmen participated to a surprising degree in local business and economic ventures. Seng explores how women empowered themselves in relation to law, devising subterfuges to escape the strictures of Muslim inheritance laws and appearing in court in defiance of community norms. The variety and number of legal cases confirm that the women in these legal records were not exceptional; thus, "we must begin to think of their actions as strategies for the everyday." Seng's chapter finds paradox at two levels: in the legal practices of sixteenth-century Turkey and in the scholarly treatment of Turkish women.

Merry, Philips, Moore, Grossberg, and Seng all offer examples of women's use of the legal system for resistance, highlighting the paradox

of gender hierarchy and legal patriarchy. Susan Hirsch argues that understanding law's treatment of women also requires attention to struggles involving class, ethnicity, religion and politics. Her chapter analyzes how Kenyan Islamic courts (Kadhi's Courts) have emerged in the postcolonial period as a critical arena for Swahili Muslim women to contest male authority in the family. Yet the Kadhi's Courts play another role: they symbolize the religious commitment and community solidarity of all Swahili Muslims, a religious minority living in a secular state. Paradoxical alliances and divisions result from the positioning of Islamic courts as "complex sites of resistance" with multiple purposes and meanings. For example, the success that Swahili women find in court depends on the secular state's intervention in Kadhi's court procedures. However, these same women unite with Muslim men across class and ethnic divisions to protest the Kenyan state's hegemonic attempt to change inheritance law, another kind of secular state intervention. In analyzing the example, Hirsch proposes that "the points of interconnection among resistant acts are quite telling, capable of revealing that some struggles over power facilitate or preclude others."

The chapters by Moore, Seng, and Hirsch contribute to an emerging literature that moves beyond stereotypical depictions of Muslim law as hegemonically ensuring women's oppression. This literature explores the local character of oppression in the name of Islam, legal reform in Muslim countries, and Islam's expression in contexts of legal pluralism (see, e.g., Beck and Keddie 1978; Dwyer 1990; Kandiyot 1991). That individual women are positioned differently from one another, even when they are positioned under Muslim law, is demonstrated through these chapters. The contrasts among Indian, Turkish, and Kenyan courts in the treatment of Muslim women's claims suggests that understanding the legal position of Muslim women requires attention to customary practices, ethnic and national politics, legal pluralism, and global discourses about "women's rights."

June Starr also recasts previous understandings about the hegemony of Muslim law by exposing a paradox: Why did the nineteenth-century Muslim Turkish state adopt a secular code of law for trade rather than Islamic law? As background for her discussion, she describes the role of Islam in the Ottoman Empire and the growth of trade within the empire and with Europe. Her account, centered on the Ottoman port of Izmir, highlights growing European influence in the reorganization of agrarian production, market practices, and the adjudication of commercial disputes. Starr examines the creative role of middlemen merchants in challenging hegemony and creating new legal codes. Legal

change in this instance is not the result of one hegemonic system replacing another, but rather that these transformations evolved over many years through the deals, exchanges, and sheer volume of trade in the region. Legal culture, as practiced in an intense market "nexus," came to be recognized by reformists and, eventually, reflected in the legal code.

Mindie Lazarus-Black challenges a persistent argument in Caribbean studies which holds that issues of law and justice remained within the province of West Indian colonists and that the few legal rights accorded slaves had little influence in their lives. She argues instead that courts, cases, and legal consciousness were critical to the politics of slave resistance. Lazarus-Black documents that between 1736 and 1834 slaves in the English-speaking Caribbean used at least three alternative legal forums to protest the behavior of their masters and that of other slaves. Her chapter examines when and why slaves invoked formal law, investigating how they altered the meaning and practice of bringing cases before the courts. She finds that slaves practiced resistance at court even as they participated in the making of hegemony. Her description offers a portrait of the range of slaves' oppositional practices, noting the pursuit in tandem of legal and illegal strategies. West Indian hegemony was "forged around slave huts and cooking pots as well as in courts of law."

Attention to the dynamics of hegemony and resistance in relation to law alters our perspective on the intersection of historical and legal change. Sally Falk Moore has suggested that we need to investigate further the "secular moralizing, practical admonition, and redefinition of reality that accompanied the legal and administrative apparatus of the colonial period" (1992:43). Starr's account of the fate of Islamic commercial law in Turkey takes up Moore's suggestion in a noncolonial but culturally diverse context. Grossberg's study illuminates an infamous case interesting in its own right but also important because it indexes cultural and social transformation. In investigating law's role in social transformation, contributors to this volume approach both historical and legal records with a healthy skepticism shared by some of our colleagues.[17] Asking what constitutes a legal record, who keeps them, for what purposes, and which legal archives are "mined" while others are ignored, provides us with fresh insights about how hegemony is shaped and to what extent resistance is possible. We find it telling, for example, that sixteenth-century documents revealing Turkish women's use of courts remained untranslated until recently and that slaves' use of courts was "unseen" by many Caribbeanists.

The problem of documentation or lack thereof is a central theme

in the volume's final chapter. Susan Coutin examines practices of the United States sanctuary movement developed in the 1980s to assist undocumented Central Americans. To define the undocumented as refugees, movement workers pursued a strategy of "civil initiative," authorizing private citizens to reinterpret American immigration laws and to challenge the exclusivity of the government's right to confer legal statuses. They instituted procedures to screen potential refugees and to offer them sanctuary in local communities. However, by drawing on a power-laden discourse grounded in law, the sanctuary movement reinforced rather than subverted hierarchical immigration categories and practices. As Coutin explains, the movement's reliance on confessional "testimonies" of torture from Central Americans to establish their claims for refugee status is a particularly poignant replication of hierarchy which documents "the difficulty of drawing on the law's potential for resistance without simultaneously invoking its capacity to oppress."

CONCLUSION

The contributors to *Contested States* approach and analyze law, hegemony, and resistance in myriad ways. We welcome this diversity as intellectually challenging and appropriate, suggesting that in different sociocultural orders and at different times these concepts operate and are expressed in historically and culturally specific ways. Yet common themes link these chapters. They demonstrate that law and legal practices are constitutive of a variety of powers—political, economic, symbolic—and that, cross-culturally, the power of law is at once hegemonic and oppositional. The authors share a concern for the way in which law contributes to the making of everyday consciousness and practice, and they also attend to how it shapes and is shaped by oppositional practices.

What is most striking methodologically about *Contested States* is that each author breaks hegemonic disciplinary boundaries. The impact of feminist theory and social history is obvious in many of the chapters. Philips, Moore, Seng, and Hirsch extend feminist analysis to encompass several languages, diverse courts, and different forms of knowledge held by men and women. In these works, "contested states" alludes not just to gender or government, but to feminist theory and method, as authors endeavor to develop theoretical constructs like power, hegemony, and resistance and at the same time remain especially sensitive to women's experiences. Many of us captured women's cynical critique of law in our field notes, even as we watched women

use courts in strategies of resistance and to gain power. Ironically, women may comprehend the paradoxes of law so clearly because they live under conditions of multiple subordination in which law makes rules for relationships but also offers opportunities to reconstruct power and gender hierarchy.

The influence of history and historical anthropology continues in studies of law and power. In this volume, Starr and Vincent exemplify the rapprochement of these fields; their chapters reassess historical events and processes with great sensitivity to the forms and forces that shape cultural categories and usher in their transformation. Working with historical legal documents from the Caribbean, Lazarus-Black learned it was impossible to understand why slaves used colonial tribunals until she relinquished the hegemonic notion that West Indian slave masters alone controlled the meaning of going to court. In contrast, historian Grossberg's "extended case" analysis uses a method familiar to legal anthropologists to prove law's power to redefine American families. And, finally, Yngvesson, Merry, and Coutin expand ethnography's capacity to uncover fundamental meanings and struggles in and around legal arenas in the contemporary United States.

In presenting these essays, we are encouraged that cross-cultural comparison offers a rich and fruitful strategy for building scholarly knowledge about law and society. Contrasts and congruences among the theoretical approaches and illustrative examples presented in the chapters expand our understanding of the role of law in hegemony and resistance. Investigating law cross-culturally, and in relation to hegemony and resistance, we have come to a new appreciation for law as discourse, process, power, and subversive activity.

Notes

1. See, e.g., Comaroff and Roberts 1981; Coutin 1983b; Foucault 1979; Glassman 1991; Grossberg 1985; Hall et. al. 1979; Hirsch 1990; Lazarus-Black 1992; Merry 1990; Moore 1985; Moore 1978; 1986; Starr 1992; Starr and Collier 1989; Vincent 1990; Yngvesson 1993; and note 4 below.

2. Foucault's concepts of power and discourse are addressed in several of his major works (Foucault 1978, 1979, 1980, 1983). Interpreting Foucault, Shapiro explains that discursive practices in society "delimit the range of objects that can be identified, define the perspective that one can legitimately regard as knowledge, and constitute certain kinds of persons developing conceptualizations that are used to understand the phenomena which emerge as a result of the discursive delimitation" (1981:130).

3. Thompson (1975) demonstrated that in eighteenth-century England there was money to be made from men who illegally hunted deer in state

forests. "Crime" was reconstituted as a category to protect property, while peasants' customary use rights in the forests became felonies.

4. Legal anthropologists often trace the beginning of their subdiscipline to the work of Sir Henry Maine, an evolutionary theorist who argued that "primitive law" manifested a concern with "status," while "civilized law" dealt with issues of "contract." Slightly later, Emile Durkheim elaborated the distinction between "primitive" and "civilized" legal sanctions. In the mid-twentieth century, anthropologists of law debated the universality of law, collected legal cases, and described systematically how other people's legal systems functioned (see, e.g., Bohannan 1957; Collier 1973; Colson 1974; Fallers 1969; Gluckman 1955; Gulliver 1969; Llewellyn and Hoebel 1941; Nader 1969; Pospisil 1971; Roberts 1979; Schapera 1937). These studies demonstrated the importance of law in social life and illuminated its cross-cultural variations. Customs were codified, but, ironically, researchers ignored the impact of colonialism on indigenous legal institutions and practices. Moreover, they continued to assume two things about power in relation to law; namely, that it was the province of the state and its supporting institutions and that it operated through force.

5. By the early 1980s, Comaroff and Roberts had identified two approaches in the anthropological study of law. To summarize these briefly, the "rule-centered" paradigm directed attention to order, judges, and judgments, while the "processual" paradigm led scholars to focus on conflict, legal processes, and litigants. For further discussion of the history of legal anthropology, see Comaroff and Roberts (1981); Nader (1969); Nader and Yngvesson (1973); Roberts (1979); Starr and Collier (1989).

6. As is well known, Gramsci (1971) did not explicitly define hegemony; the concept evolves in his *Prison Notebooks*. Important discussions of hegemony appear in Comaroff and Comaroff (1991), Femia (1981), Forgacs (1988), Laclau and Mouffe (1985), B. Williams (1991), and others.

7. In recent years a number of authors have explored hegemonic practices characterizing legal institutions, particularly law schools. See, e.g., Kennedy (1982); P. Williams (1991).

8. We do not mean to suggest that elites always act in ways that further their interests (Foucault 1980:187) or even as a united front (Vincent 1989). Vincent argues in reference to colonial law in Africa: "While lawmaking in the hands of members of the ruling class serves their interests, the particular form that the law takes and the impetus that projects it into the societal arena derive from events in the course of their struggles against one another and the compromises finally reached" (1989:156).

9. Cain is unusual in reading Gramsci "to achieve a better understanding of law" (1983:96). As she points out, Gramsci emphasized law's educative function and its role as a generator of social norms. He understood that law's advantage was that it could be used both coercively and persuasively, but law did not achieve a specific place in his political strategy or theory (ibid.:101–2). We argue that law's coercive and productive capacities render it an especially critical place to deduce how hegemony is manufactured and when it is undermined by oppositional practices.

10. Thus, we find, as Hunt does, that a focus on the end result of hegemony as secured or lost is too narrow a use of the concept. Hunt (1992:33) directs attention instead to "the processes through which different discursive elements

are put together in constituting hegemony." We note that Hunt, like others, uses the concept of counterhegemonic practices to describe some types of resistance. The continuum model outlined in this introduction is less restrictive than the concept counterhegemony.

11. The peasants Scott studied imagined both the reversal and the negation of their domination, and, more important, "they have acted on these values in desperation and on those rare occasions when the circumstances allowed" (Scott 1990:81). The fact that peasants rebel brings Scott close to rejecting the concept of hegemony entirely. He does, however, suggest two conditions under which subordinate groups may come to accept or legitimize the arrangements that justify their subordination: (1) there is a good chance that many of the subordinates will eventually occupy positions of power (as in age grades); (2) the subordinates are under conditions of extreme isolation (ibid.:82).

12. Comaroff and Comaroff (1991:31) summarize the controversy over the meaning of resistance as "the problem of consciousness and motivation." In a nutshell, some scholars prefer to limit resistance to conscious behaviors; others allow acts motivated by less explicit levels of awareness to qualify as resistance. We agree that, "just as technologies of control run the gamut from overt coercion to implicit persuasion, so modes of resistance may extend across similarly wide spectrum" (ibid.:31). Conceptualizing resistance has been a challenge as scholars debate, among other issues, whether oppositional acts must be conscious, collective, organized, or effective to be called resistance. For discussions of these debates see, e.g., Comaroff (1985); Giroux (1983); Keesing (1992); Ong (1987); Sholle (1990); B. Williams (1991).

13. Educational institutions have provided a rich context for the development of theories about resistance and identity. Willis's (1977) study of working-class "lads" in a British school demonstrated that class is often remade through resistant practices. McRobbie (1981), Holland and Eisenhart (1990), and Hall (1993) demonstrate that the forms of resistance to schooling, and their consequences, are shaped by gender and race. Foley (1990) makes the critical point that, in many schools, ethnicity is a key factor in determining how students resist and whether the institution is altered through their efforts.

14. Keesing raises a related methodological challenge by suggesting that scholars of resistance must unravel the "tangled skeins of personal motivation, hidden schemes, private ambitions, as well as conceptions of collective struggle" (Keesing 1992:6) that stimulate and shape opposition.

15. An example of this strategy is a "legalistic" letter written by Kwaio people to insist that the colonial state reroute airplanes in their region so that Kwaio men could avoid being positioned underneath menstruating women and thus avoid "pollution." Their remarkable letter constituted a demand for recognition of custom made through the terms of law (Keesing 1992:233).

16. Early scholarship on the language of law emphasized its hegemonic role, highlighting, among other linguistic features, the mystifying syntax of legal documents and the peculiar conventions of courtroom speech (see, e.g., Atkinson and Drew 1979; Brenneis 1988; Charrow et al. 1982; Levi and Walker 1990; O'Barr 1982). More recently, several authors have demonstrated that courts and legal documents embrace multiple discursive practices, including those of ordinary, even powerless, speakers (see, e.g., Conley and O'Barr 1990; Hirsch 1994; Merry 1990; Mertz 1988; Philips 1984; White 1991).

17. For sources on method, see, e.g., Clifford 1988; Cohn 1959; Geertz

1983; Greenhouse 1986; Moore 1986; Rosen 1984; Sahlins 1981; Starr and Collier 1989.

References

Abu-Lughod, Lila. 1990. "The Romance of Resistance: Tracing Transformations of Power through Bedouin Women." *American Ethnologist* 17(1):41–55.

Asad, Talal. 1973. *Anthropology and the Colonial Encounter*. London: Ithaca Press.

Atkinson, J. Maxwell, and Paul Drew. 1979. *Order in Court: The Organization of Verbal Interaction in Judicial Settings*. Atlantic Highlands: Humanities Press.

Beck, Lois, and Nikki Keddie, eds. 1978. *Women in the Muslim World*. Cambridge: Harvard University Press.

Bell, Derrick. 1992. *Faces at the Bottom of the Well: The Permanence of Racism*. New York: Basic Books.

Berk-Seligson, Susan. 1992. *The Bilingual Courtroom: Court Interpreters in the Judicial Process*. Chicago: University of Chicago Press.

Blok, Anton. 1989. "The Symbolic Vocabulary of Public Executions." In *History and Power in the Study of Law: New Directions in Legal Anthropology*. June Starr and Jane Collier, eds. Ithaca: Cornell University Press. 31–54.

Bohannan, Paul. 1957. *Justice and Judgment among the Tiv*. London: Oxford University Press.

Bordo, Susan. 1988. "Anorexia Nervosa: Psychopathology as the Crystallization of Culture." In *Feminism and Foucault: Reflections on Resistance*. Irene Diamond and Lee Quinby, eds. Boston: Northeastern University Press. 87–117.

Bourdieu, Pierre. 1977. *Outline of a Theory of Practice*. Cambridge: Cambridge University Press.

Brenneis, Donald. 1988. "Language and Disputing." *Annual Review of Anthropology* 17:221–37.

Brigham, John. 1992. "Sexual Entitlement: The Baths and AIDS in California, 1983–1986." Paper presented at the 1992 Law and Society Annual Meeting, Philadelphia.

Bumiller, Kristin. 1991. "Fallen Angels: The Representation of Violence against Women in Legal Culture." In *At the Boundaries of Law: Feminism and Legal Theory*. M. Fireman and N. Thomadsen, eds. New York: Routledge. 95–112.

Burman, Sandra, and Barbara Harrell-Bond, eds. 1979. *The Imposition of Law*. New York: Academic Press.

Cain, Maureen. 1983. "Gramsci, The State, and the Place of Law." In *Legality, Ideology, and the State*. David Sugarman, ed. New York: Academic Press. 95–117.

Calavita, Kitty. 1992. *Inside the State: The Bracero Program, Immigration, and the I.N.S.* New York: Routledge.

Chambliss, William Jones, ed. 1973. *Sociological Readings in the Conflict Perspective.* Reading: Addison-Wesley.

Chanock, Martin. 1985. *Law, Custom, and Social Order: The Colonial Experience in Malawi and Zambia.* Cambridge: Cambridge University Press.

Charrow, V. R., J. A. Crandall, and R. P. Charrow. 1982. "Characteristics and Functions of Legal Language." In *Sublanguage: Studies of Language in Restricted Semantic Domains.* R. Kittredge and J. Lehrberger, eds. Berlin: Walter de Gruyter. 175–90.

Clifford, James. 1988. *The Predicament of Culture: Twentieth-Century Ethnography, Literature, and Art.* Cambridge: Harvard University Press.

Cohn, Bernard. 1959. "Some Notes on Law and Change in North India." *Economic Development and Cultural Change* 8:79–93.

Cohn, Bernard, S. and Nicholas B. Dirks. 1988. "Beyond the Fringe: The Nation State, Colonialism, and The Technologies of Power." *Journal of Historical Sociology* 1(2): 224–229.

Collier, Jane. 1973. *Law and Social Change in Zinacantan.* Stanford: Stanford University Press.

Colson, Elizabeth. 1974. *Tradition and Contract: The Problem of Order.* Chicago: Aldine.

Comaroff, Jean. 1985. *Body of Power, Spirit of Resistance: The Culture and History of a South African People.* Chicago: University of Chicago Press.

Comaroff, Jean, and John Comaroff. 1991. *Of Revelation and Revolution: Christianity, Colonialism, and Consciousness in South Africa.* Chicago: University of Chicago Press.

Comaroff, John, and Simon Roberts. 1981. *Rules and Processes: The Cultural Logic of Disputes in an African Context.* Chicago: University of Chicago Press.

Conley, John, and William M. O'Barr. 1990. *Rules versus Relationships: The Ethnography of Legal Discourse.* Chicago: University of Chicago Press.

Coombe, Rosemary. Forthcoming. *Cultural Appropriations: Intellectual Property, Colonialism, and Contemporary Politics.* New York: Routledge.

———. 1991. "Contesting the Self: Negotiating Subjectivities in Nineteenth-Century Ontario Defamation Trials." In *Studies in Law, Politics, and Society.* Greenwich: JAI Press. 11:3–40.

Coutin, Susan. 1993a. "The Chicago Seven and the Sanctuary Eleven: Conspiracy and Spectacle in U.S. Courts." Paper presented at the Law and Society Association Annual Meeting, Chicago, May.

———. 1993b. *The Culture of Protest: Religious Activism and the U.S. Sanctuary Movement.* Denver: Westview Press.

de Certeau, Michel. 1984. *The Practice of Everyday Life.* Berkeley: University of California Press.

Dee, Juliet. 1981. "Constraints on Persuasion in the Chicago Seven Trial." In *Popular Trials: Rhetoric, Mass Media, and the Law.* Robert Hariman, ed. Tuscaloosa: University of Alabama Press. 86–113.

Diamond, Irene, and Lee Quinby, eds. 1988. *Feminism and Foucault: Reflections on Resistance.* Boston: Northeastern University Press.

Dominguez, Virginia. 1986. *White by Definition: Social Classification in Creole Louisiana.* New Brunswick: Rutgers University Press.

Dwyer, Daisy Hilse, ed. 1990. *Law and Islam in the Middle East.* New York: Bergin and Garvey.

Eisenstein, Zillah. 1988. *The Female Body and the Law.* Berkeley: University of California Press.

Fallers, Lloyd. 1969. *Law without Precedent: Legal Ideas in Action in the Courts of Colonial Busoga.* Chicago: Aldine.

Feierman, Steven. 1990. *Peasant Intellectuals: Anthropology and History in Tanzania.* Madison: University of Wisconsin Press.

Felstiner, William, Richard Abel, and Austin Sarat. 1980. "The Emergence and Transformation of Disputes: Naming, Blaming, Claiming." *Law and Society Review* 15(3): 631–54.

Femia, Joseph. 1981. *Gramsci's Political Thought: Hegemony, Consciousness, and the Revolutionary Process.* Oxford: Clarendon Press.

Fineman, Martha, and Nancy Thomadsen, eds. 1991. *At the Boundaries of Law: Feminism and Legal Theory.* New York: Routledge.

Foley, Douglas. 1990. *Learning Capitalist Culture: Deep in the Heart of Tejas.* Philadelphia: University of Pennsylvania Press.

Forgacs, David, ed. 1988. *An Antonio Gramsci Reader: Selected Writings, 1916–1935.* New York: Schocken Books.

Foucault, Michel. 1978. *The History of Sexuality, Volume 1: An Introduction.* Robert Hurley, trans. New York: Random House.

———. 1979. *Discipline and Punish: The Birth of the Prison.* Alan Sheridan, trans. New York: Vintage Books.

———. 1980. *Power/Knowledge: Selected Interviews and Other Writings, 1972–1977.* Colin Gordon, ed. Colin Gordon, Leo Marshall, John Mepham, Kate Soper, trans. New York: Pantheon Books.

———. 1983. "The Subject and Power." In *Michel Foucault: Beyond Structuralism and Hermeneutics.* Hubert Dreyfus and Paul Rabinow, eds. Chicago: University of Chicago Press. 208–226.

Geertz, Clifford. 1983. *Local Knowledge: Further Essays in Interpretive Anthropology.* New York: Basic Books.

Genovese, Eugene D. 1972. *Roll, Jordan, Roll: The World the Slaves Made.* New York: Pantheon Books.

Giroux, Paul. 1983. "Theories of Reproduction and Resistance in the New Sociology of Education: A Critical Analysis." *Harvard Education Review* 55(3): 257–95.

Glassman, Jonathon. 1991. "The Bondsman's New Clothes: The Contradictory Consciousness of Slave Resistance on the Swahili Coast." *Journal of African History* 32: 277–312.

Gluckman, Max.1955. *Judicial Process among the Barotse of Northern Rhodesia.* Manchester: Manchester University Press.

Goldman, Laurence. 1983. *Talk Never Dies: The Language of Huli Disputes.* London: Tavistock.

Gordon, Linda. 1976. *Woman's Body, Woman's Right: A Social History of Birth Control in America.* New York: Grossman.

Gramsci, Antonio. 1971. *Selections from the Prison Notebooks.* London: Lawrence and Wishart.

Greenhouse, Carol. 1986. *Praying for Justice: Faith, Order, and Community in an American Town.* Ithaca: Cornell University Press.

———. 1989. "Interpreting American Litigiousness." In *History and Power*

in the Study of Law: New Directions in Legal Anthropology. June Starr and Jane Collier, eds. Ithaca: Cornell University Press. 252–276.

Grossberg, Michael. 1985. *Governing the Hearth: Law and the Family in Nineteenth-Century America.* Chapel Hill: University of North Carolina.

Gulliver, Philip. 1969. "Case Studies of Law in Non-Western Societies." In *Law in Culture and Society.* Laura Nader, ed. Chicago: Aldine. 11–23.

Hall, Kathleen. 1993. *Becoming British Sikhs: The Politics of Identity and Difference in England.* Ph.D. dissertation, University of Chicago.

Hall, Stuart. 1983. "The Problem of Ideology—Marxism without Guarantees." In *Marx 100 Years On.* B. Matthews, ed. London: Lawrence and Wishart. 57–86.

———. 1988. "The Toad in the Garden: Thatcherism among the Theorists." In *Marxism and the Interpretation of Culture.* Cary Nelson and Lawrence Grossberg, eds. Urbana and Chicago: University of Illinois Press. 35–73.

Hall, Stuart, and Tony Jefferson. 1976. *Resistance through Rituals: Youth Subcultures in Post-War Britain.* London: Hutchinson.

Hall, Stuart, Chas Critcher, Tony Jefferson, John Clarke, and Brian Roberts, eds. 1979. *Policing the Crisis: Mugging, the State, and Law and Order.* London: Macmillan.

Handler, Joel F. 1992. "Postmodernism, Protest, and the New Social Movements." *Law and Society Review* 26(4): 697–732.

Hartsock, Nancy. 1983. *Money, Sex, and Power: Toward a Feminist Historical Materialism.* New York: Longman.

———. 1990. "Foucault on Power: A Theory for Women?" In *Feminism/Postmodernism.* Linda Nicholson, ed. New York: Routledge. 157–75.

Hay, Douglas. 1975. "Property, Authority, and the Criminal Law." In *Albion's Fatal Tree: Crime and Society in Eighteenth-Century England.* Douglas Hay et al., eds. New York: Pantheon Books. 17–63.

Hay, Jean, and Marcia Wright, eds. 1984. *African Women and the Law: Historical Perspectives.* Boston: Boston University Press.

Hebdige, Dick. 1979. *Subculture: The Meaning of Style.* New York: Methuen.

Hirsch, Susan F. 1990. *Gender and Disputing: Insurgent Voices in Coastal Kenyan Muslim Courts.* Ph.D. dissertation, Duke University.

———. 1992. "Language, Gender, and Linguistic Ideologies in Coastal Kenyan Muslim Courts." *Working Papers on Language, Gender, and Sexism* 2(1): 39–58.

———. 1993. "Challenging Power through Discourse: Cases of Seditious Speech from Kenya." Paper presented at the Law and Society Association Annual Meeting, Chicago, May.

———. 1994. "Interpreting Media Representations of a 'Night of Madness': Law and Culture in the Construction of Rape Identities." *Law and Social Inquiry* 19(4).

Hobsbawm, Erik and Terrence Ranger. 1983. *The Invention of Tradition.* Cambridge: Cambridge University Press.

Holland, Dorothy, and Margaret Eisenhart. 1990. *Educated in Romance: College Culture and Achievement.* Chicago: University of Chicago Press.

Hunt, Alan. 1992. "Foucault's Expulsion of Law: Toward a Retrieval." *Law and Social Inquiry* 17(1): 1–38.

———. 1993. *Explorations in Law and Society: Toward a Constitutive Theory of Law.* New York: Routledge.

Janeway, Elizabeth. 1980. *Powers of the Weak.* New York: Knopf.

Just, Peter. 1992. "History, Power, Ideology, and Culture: Current Directions in the Anthropology of Law." *Law and Society Review* 26(2): 373–412.

Kairys, David. 1982. *The Politics of Law: A Progressive Critique.* New York: Pantheon Books.

Kandiyot, Deniz, ed. 1991. *Women, Islam, and the State.* Philadelphia: Temple University Press.

Keesing, Roger. 1992. *Custom and Confrontation: The Kwaio Struggle for Cultural Autonomy.* Chicago: University of Chicago Press.

Kennedy, Duncan. 1982. "Legal Education as Training for Hierarchy." In *The Politics of Law: A Progressive Critique.* David Kairys, ed. New York: Pantheon Books. 40–61.

Laclau, Ernesto, and Chantal Mouffe. 1985. *Hegemony and Socialist Strategy: Towards a Radical Democratic Politics.* London: Verso.

Lagos, Maria. 1993. "We Have to Learn to Ask: Hegemony, Diverse Experiences, and Antagonistic Meanings in Bolivia." *American Ethnologist* 20(1): 52–71.

Lazarus-Black, Mindie. 1989. "Review of History and Power in the Study of Law." June Starr and Jane F. Collier, eds. *APLA Newsletter* 12(2): 8–12.

———. 1991. "Why Women Take Men to Magistrate's Court: Caribbean Kinship Ideology and Law." *Ethnology* 30(2): 119–33.

———. 1992. "Bastardy, Gender Hierarchy, and the State: The Politics of Family Law Reform in Antigua and Barbuda." *Law and Society Review* 26(4): 863–901.

———. 1994. *Legitimate Acts and Illegal Encounters: Law and Society in Antigua and Barbuda.* Washington, D.C.: Smithsonian Institution Press.

Levi, Judith, and Anne Grafam Walker. 1990. *Language in the Judicial Process.* New York: Plenum Press.

Llewellyn, Kal, and E. Adamson Hoebel. 1941. *The Cheyenne Way: Conflict and Case Law in Primitive Jurisprudence.* Norman: University of Oklahoma Press.

Lukes, Steven. 1974. *Power: A Radical View.* London: Macmillan.

MacKinnon, Catherine. 1987. *Feminism Unmodified: Discourses on Life and Law.* Cambridge: Harvard University Press.

Mather, Lynn, and Barbara Yngvesson. 1980. "Language, Audience, and the Transformation of Disputes." *Law and Society Review* 15(3): 775–821.

McNay, Lois. 1992. *Foucault and Feminism: Power, Gender, and the Self.* Boston: Northeastern University Press.

McRobbie, Angela. 1981. "Settling Accounts with Subcultures: A Feminist Critique." In *Culture, Ideology, and Social Process: A Reader.* T. G. Martin Bennett, C. Mercer, and J. Woollacott, eds. London: Batsford Academic and Education Ltd. 66–80.

Merry, Sally Engle. 1988. "Legal Pluralism." *Law and Society Review* 22(5): 869–96.

———. 1990. *Getting Justice and Getting Even: Legal Consciousness among Working-Class Americans.* Chicago: University of Chicago Press.

———. 1991. "Law and Colonialism." *Law and Society Review* 25(4): 889–922.

Mertz, Elizabeth. 1988. "The Uses of History: Language, Ideology, and Law in the United States and South Africa." *Law and Society Review* 22(4): 661–85.

———. 1994. "Reconceptualization as Socialization: Text and Pragmatics in the Law School Classroom." In *Natural Histories of Discourse.* Michael Silverstein and Greg Urban, eds.

Minow, Martha. 1991. "Identities." *Yale Journal of Law and the Humanities* 3:97–133.

Moore, Barrington. 1966. *Social Origins of Dictatorship and Democracy: Lord and Peasant in the Making of the Modern World.* Boston: Beacon Press.

Moore, Erin. 1985. *Conflict and Compromise: Justice in an Indian Village.* Lanham: University Press of America.

Moore, Sally Falk. 1978. *Law as Process: An Anthropological Approach.* London: Routledge and Kegan Paul.

———. 1986. *Social Facts and Fabrications: "Customary" Law on Kilimanjaro, 1880–1980.* Cambridge: Cambridge University Press.

———. 1992. "Treating Law as Knowledge: Telling Colonial Officers What to Say to Africans about Running Their Own Native Courts." *Law and Society Review* 26(1): 11–46.

Mouffe, Chantal. 1979. "Hegemony and Ideology in Gramsci," In *Gramsci and Marxist Theory.* Chantal Mouffe, ed. London: Routledge and Kegan Paul. 168–204.

Murphy, William. 1993. Paper presented at the 1993 Law and Society Association Annual Meeting, Chicago, May.

Musheno, Michael, Julie Verill, and Michael Hallett. 1992. "AIDS and Law: Reshaping Identities amidst Crisis." Paper presented at the 1992 American Anthropological Association Annual Meeting, Chicago, November.

Nader, Laura. 1969. *Law in Culture and Society.* Chicago: Aldine.

———. 1990. *Harmony Ideology: Justice and Control in a Zapotec Mountain Village.* Stanford: Stanford University Press.

Nader, Laura, and Barbara Yngvesson. 1973. "On Studying the Ethnography of Law and Its Consequences." In *Handbook of Social and Cultural Anthropology.* John Honigman, ed. Chicago: Rand McNally. 883–921.

Nader, Laura, and Harry F. Todd, eds. 1978. *The Disputing Process: Law in Ten Societies.* New York: Columbia University Press.

O'Barr, William M. 1982. *Linguistic Evidence: Language, Power, and Strategy in the Courtroom.* New York: Academic Press.

Ong, Aihwa. 1987. *Spirits of Resistance and Capitalist Discipline: Factory Women in Malaysia.* Albany: SUNY Press.

Petchesky, Rosalind. 1984. *Abortion and Woman's Choice: The State, Sexuality, and Reproductive Freedom.* Boston: Northeastern University Press.

Philips, Susan. 1984. "The Social Organization of Questions and Answers in

Courtroom Discourse: A Study of Changes of Plea in an Arizona Court." *TEXT* 4(1): 225–48.

Pospisil, Leopold. 1971. *Anthropology of Law: A Comparative Perspective.* New York: Harper and Row.

Roberts, Simon. 1979. *Order and Dispute: An Introduction to Legal Anthropology.* Harmondsworth: Penguin.

Rosen, Lawrence. 1984. *Bargaining for Reality: The Construction of Social Relations in a Muslim Community.* Chicago: University of Chicago Press.

———. 1989a. *The Anthropology of Justice: Law as Culture in Islam.* Cambridge: Cambridge University Press.

———. 1989b "Islamic 'Case Law' and the Logic of Consequence." In *History and Power in the Study of Law: New Directions in Legal Anthropology.* June Starr and Jane F. Collier, eds. Ithaca: Cornell University Press. 302–19.

Sahlins, Marshall. 1981. *Historical Metaphors and Mythical Realities: Structure in the Early History of the Sandwich Islands Kingdom.* Ann Arbor: University of Michigan Press.

Sawicki, Jana. 1991. *Disciplining Foucault: Feminism, Power, and the Body.* New York: Routledge.

Schapera, Isaac. 1937. *Handbook of Tswana Law and Custom.* London: Oxford University Press.

Scott, James. 1985. *Weapons of the Weak: Everyday Forms of Peasant Resistance.* New Haven: Yale University Press.

———. 1990. *Domination and the Arts of Resistance: Hidden Transcripts.* New Haven: Yale University Press.

Segal, Lynne. 1990. *Slow Motion: Changing Masculinities, Changing Men.* New Brunswick: Rutgers University Press.

Shapiro, Michael J. 1981. *Language and Political Understanding.* New Haven: Yale University Press.

Sholle, David. 1990. "Resistance: Pinning Down a Wandering Concept in Cultural Studies Discourse." *Journal of Urban and Cultural Studies* 1(1): 87–105.

Silbey, Susan. 1992. "Making a Place for Cultural Analyses of Law." *Law and Social Inquiry* 17(1): 39–48.

Smart, Carol. 1989. *Feminism and the Power of Law.* New York: Routledge.

Snyder, Francis. 1981a. *Capitalism and Legal Change: An African Transformation.* New York: Academic Press.

———. 1981b. "Colonialism and Legal Form: The Creation of Customary Law in Senegal." *Journal of Legal Pluralism and Unofficial Law* 9:49–90.

Starr, June. 1989. "The Role of Turkish Secular Law in Changing the Lives of Rural Muslim Women, 1950–1970." *Law and Society Review* 23(3): 497–523.

———. 1992. *Law as Metaphor: From Islamic Courts to the Palace of Justice.* Albany: SUNY Press.

Starr, June, and Barbara Yngvesson. 1974. "Zeroing In on Compromise Decisions." *American Ethnologist* 2:553–66.

Starr, June, and Jane F. Collier, eds. 1989. *History and Power in the Study*

of Law: New Directions in Legal Anthropology. Ithaca: Cornell University Press.

Stoler, Ann. 1989. "Making Empire Respectable: The Politics of Race and Sexual Morality in 20th-Century Colonial Cultures." *American Ethnologist* 16(4):634–60.

Taub, Nadine, and Elizabeth Schneider. 1982. "Women's Subordination and the Role of Law." In *The Politics of Law: A Progressive Critique*. David Kairys, ed. New York: Pantheon Books. 151–76.

Thompson, E. P. 1975. *Whigs and Hunters: The Origin of the Black Act*. New York: Pantheon Books.

Vincent, Joan. 1989. "Contours of Change: Agrarian Law in Colonial Uganda, 1895–1962." In *History and Power in the Study of Law: New Directions in Legal Anthropology*. June Starr and Jane F. Collier, eds. Ithaca: Cornell University Press. 153–67.

———. 1990. *Anthropology and Politics: Visions, Traditions, and Trends*. Tucson: University of Arizona Press.

Walkowitz, Judith R. 1980. *Prostitution and Victorian Society: Women, Class, and the State*. Cambridge: Cambridge University Press.

White, Lucie. 1991. "Subordination, Rhetorical Survival Skills, and Sunday Shoes: Notes on the Hearing of Mrs. G." In *At the Boundaries of the Law: Feminism and Legal Theory*. Martha Fineman and Nancy Thomadsen, eds. New York: Routledge. 40–58.

Williams, Brackette. 1991. *Stains on My Name, War in My Veins: Guyana and the Politics of Cultural Struggle*. Durham: Duke University Press.

Williams, Patricia J. 1991. *The Alchemy of Race and Rights: Diary of a Law Professor*. Cambridge: Harvard University Press.

Williams, Raymond. 1973. "Base and Superstructure in Marxist Cultural Theory." *New Left Review* 82: 3–16.

Willis, Paul. 1977. *Learning to Labor: How Working-Class Kids Get Working Class Jobs*. New York: Columbia University Press.

Wrong, Dennis. 1979. *Power: Its Forms, Bases, and Uses*. New York: Harper and Row.

Yngvesson, Barbara. 1993. *Virtuous Citizens, Disruptive Subjects: Order and Complaint in a New England Court*. New York: Routledge.

Young, Alison. 1990. *Femininity in Dissent*. London and New York: Routledge.

PERFORMANCE AND PROTEST

CHAPTER I

COURTS AS PERFORMANCES: DOMESTIC VIOLENCE HEARINGS IN A HAWAI'I FAMILY COURT[1]

Sally Engle Merry

"But she deserved to be hit," argued the man wearing sandals and a faded T-shirt. "You should see the way she takes care of our children."

"There is no excuse for violence. I don't care what she does," replied the judge, a middle-aged white man wearing a black robe sitting behind a large desk. "That is the law of Hawaii. You may not hit your wife. That is all there is to it." After a little more argument, the judge imposed a temporary restraining order on him, enjoining him from seeing the woman. At the same time he required the husband to participate in a six-month reeducation program for men who batter women. If the husband violates this order, he will face serious criminal penalties.

In a single morning, this judge heard eight other requests for restraining orders from women and men in the Family Court of Hilo, Hawai'i. Hilo is a small town of about 35,000, the center of an old sugar plantation industry and the county seat of the island of Hawai'i. The people seeking help from the court come from diverse ethnic backgrounds, including white, Filipino, Hawaiian, Portuguese, Japanese, and Puerto Rican. Several of the batterers argued that their violence was appropriate punishment for the women. The judge's stance was the same in every case: battering is never deserved. His position parallels the view advocated by the local battered women's shelter and its program for retraining men who batter, called Alternatives to Violence. The judge has served on the board of directors of

the shelter and shares the feminist politics of its founders. He comes to the bench after a long period as a legal services attorney.

This paper argues that court hearings serve as critical sites for the creation and imposition of cultural meanings. Lower courts address day-to-day social problems and conflicts, rendering interpretations of them in terms of a particular "legal sensibility" enshrined in the judicial forum (Geertz 1983). Lower criminal and family courts produce cultural meanings by interpreting the experiences of the people who bring their problems there. As these problems are named, discussed, and settled, new cultural meanings are imposed on them. Moreover, courts signal how seriously they regard an offense by deciding whether or not to impose a penalty and, if so, how severe a penalty. For example, courts can present new definitions of wife battering and male entitlement to violence against women. Ultimately these new ways of framing violent incidents contribute to redefining cultural notions of masculinity and femininity.

Court hearings are highly ritualized events. Consequently, the interpretations they provide gain saliency from the authority and legitimacy the court is able to convey. The procedures, personnel, and organization of the court itself enact a drama which conveys messages about social hierarchy, authority, and order (Arno 1985). Features of class, gender, and race add in subtle but significant ways to the authority of the judge and court personnel. If judges belong to the dominant racial group and speak with the accent of educated people, as they do in my example, these features of social hierarchy contribute to the authority of their pronouncements.

In the public performances provided by the courts, rules are bent, folded, and applied to the quotidian realm of social life. Events are redefined in legal terms; relationships are measured against the rules for such persons, and violence is threatened or imposed. These performances reinterpret daily social life and at the same time, generally include normative statements by authoritatively endowed actors, such as judges and clerks, which specify appropriate behavior. They have a quality of theater for the audiences—a theater of the state endowed with coercive power. The audiences for these performances are the parties themselves and their social networks, those who watch court proceedings, and the wider public to whom the deliberations and outcomes are reported. The audience also includes the judges, attorneys, and other court officials themselves. In the domestic violence hearings I observed, the audience includes participants and advocates from the battered women's shelter and Alternatives to Violence program, a closely knit group of women's advocates which clearly shares

information about what happens in court. Such performances, over time, may reshape legal consciousness and redefine social rules and norms.[2] Of course, audiences respond with differing levels of awe and respect to this ritual (Merry 1990).

Court performances rely on specialized costumes (robes, suits and ties), demarcation of space (public space, lawyer's space, judge's raised bench), specialized language, and the presence of gatekeepers, in the form of bailiffs or court officers, who move the uninitiated and uninformed around the complex, socially demarcated spaces of the courtroom, telling them where to sit, where to stand, how to behave, and whether or not they are permitted to speak or to read a newspaper. The shape of this ritual demarcation of space, costume, and language suggests an affinity more to religion than to a play. Although the ritualized role of courts has long been noted, I am less interested in how ritual enhances the power of the court than in how the ritualized decision-making events of the court and the penalties they impose change the way people understand themselves and their rights and obligations.

Of course, the interpretations of events and persons constructed in legal definitions have consequences (see Silbey and Sarat 1987). The interpretations they provide can lead to imprisonment, fines, restriction of activities, or payments of debts, among many other consequences. Law is a discourse which interprets and conveys meaning, but it is a discourse with force behind it. Its impact is not only in the realm of meaning.

The cultural messages being produced in any particular court reflect the practices and perspectives of the court officials. What is being produced is not simply the dominant ideology of the legal system, but a particular interpretation and enactment of that ideology. The cultural message bears some relationship to the ideology, but a filtered, derivative one. The central government typically passes laws and establishes legal institutions to promote a particular vision of the social order. In that sense, the courts impose the dominant ideology embodied in the law. On the other hand, local working groups develop their own ways of managing problems and imposing rules which are not necessarily congruent with the ideology of the center. Consequently, looking at courts in terms of cultural production leads to asking questions about processes of domination and resistance in the social field of the court, about the effect of court processes on larger communities, and about the hegemonic functions of law and the processes which limit it.[3] As Thompson comments, courts do not simply express the interests of the ruling classes but also enact the practices and conceptions of the

people who staff them and decide whom to finger and arrest, whom to prosecute, and whom to let go (1975).

Local practices for handling problems are influenced by the law but also by local conditions. Courts consist of people who decide whether or not to do anything about a problem, what to call the problem, and what kind of people the plaintiff and the defendants are. They make judgments about who is a troublemaker, who is a good person who has made a forgivable slip, which kinds of events are serious and which are trivial, and what principles of justice are most important. Yngvesson, for example, compares various court clerks in two Massachusetts towns showing how they differ in their modes of case interpretation and case handling (1993). She shows that clerks differ significantly in how they handle cases depending on their background, training, and standing in the community. Local court officials decide how to weigh conflicting stories, how far to allow a case to progress, and when to eject it from the court. In the United States, as is common elsewhere, these officials are political people, aware that the larger community is watching them and paying their salaries (see also Merry 1990). Many are appointed by political leaders and keep their jobs only on the sufferance of these leaders.

The dramatic nature of criminal court trials has long been recognized and discussed, although rarely in terms of the way it contributes to changes in legal consciousness or in definitions of relationships. Anthropologists of law have in the past considered conflict situations as opportunities to identify underlying normative codes. In his analysis of Trobriand law, for example, Malinowski provides vivid illustrations of public moments of confrontation which reveal conflicts among laws. The dramatic story of a nighttime shouting match which leads to the exile of a chief's favored son illustrates the conflict between principles of matrilineal descent and paternal affection (1972:100–105). Working in a similar tradition, Llewellyn and Hoebel develop the concept of the "trouble case"—the dramatic moment in which a concrete problem is subjected to the law—to reveal the content of Cheyenne law (1941). Victor Turner named the moment in which contradictory social principles erupt into conflict the social drama, similarly viewing this moment as one in which social norms are laid bare (1957). Gluckman used the analysis of a conflict and its surrounding social relationships, the extended case method, to reveal social structures (1955).

Thurman Arnold, commenting on American government in the early twentieth century, also emphasizes the dramatic role of criminal courts, but he used this analysis to make a somewhat different point (1935).

He focuses on the way these dramatic events convey cultural messages about the values of the government, about the dignity of the state as enforcer of law, and about the dignity of the individual despite his background as a criminal or opponent of the state (1935:130). Criminal courts are public ceremonial enactments of dearly held values concerning the right of all people to a fair trial and the power of the state to enforce laws. Yet, because there are so many conflicting laws and ways of guaranteeing fair trials, courts are places of contest between contradictory principles.

More recently, scholars have examined the relationship between criminal trials as dramatic events and their role in maintaining or challenging the power of particular social classes. As E. P. Thompson and his collaborators demonstrate in their examination of eighteenth-century British legal history, courts clearly worked to support the power of the dominant classes and to quash, often harshly, challenges to their power and property mounted by their inferiors (1975; Hay 1975). In one account of trials in this period, Douglas Hay argues that the courts maintained their legitimacy through dramatic performances in which they displayed not only their majesty but also their mercy, sternly sentencing then magnanimously pardoning convicted felons at the last moment (1975). Yet these courts did, from time to time, convict the privileged and protect the weak. Indeed, both Thompson and Hay note that the power of the courts to buttress the authority of elites depended on their appearance of fairness and justice and their willingness to apply the same rules to the powerful. Thus, these historians recognize the dramatic nature of trials but, instead of seeing them only as contributing to the maintenance of the power of dominant groups, they see trials as ways in which the ruling class casts an aura of legitimacy and fairness on its sometimes capricious and harsh rule.

None of these scholars addresses the question of how this ritualized processing of problems changes the way people think about their problems or about themselves. The analysis of dispute transformation developed by Lynn Mather and Barbara Yngvesson is valuable here; it highlights the way meanings are created in judicial hearings (1980/81; see also Yngvesson 1988, 1993). Disputing, they argue, can be viewed as a bargaining process "in which the object of the dispute and the normative framework to be applied are negotiated as the dispute proceeds" (1980/81:818). Thus, the meanings of conflict are not fixed but negotiated between disputants and judicial third parties. Disputes are typically "rephrased," reformulated into some kind of a public discourse (ibid.:777). The most common rephrasing is narrowing the dispute into conventional categories of action and event,

but disputes may also be expanded in terms of a new framework outside existing categories for events and relationships (ibid.:778).

Third parties such as judges and court clerks play a crucial role in this rephrasing, although they may do so subtly rather than by announcing their power to decide. For example, they may construe the facts so that the outcome follows logically from their description of the situation. Mather and Yngvesson emphasize the importance of audiences such as judicial third parties in rephrasing disputes: those endowed with legitimacy by the state have particular power to rephrase disputes (ibid.).

COURT PERFORMANCES IN CONTEXTS OF LEGAL PLURALISM

In legally plural environments, the role of courts in creating systems of meaning takes on particular significance. Under these conditions, local courts are one mechanism for introducing a new cultural system to a community with distinctive values and rules. When one legal system is that of a politically dominant power superimposed over a second legal system of politically subordinate peoples, as is the case in colonial situations or the incorporation of indigenous peoples into a nation-state, the local courts take on a critical role in both social control and cultural transformation. Court performances introduce the cultural practices of the dominant group to the subordinate group as they impose new regulations and conceptions of social relationships. In their public ritual performances, courts operating in situations of cultural diversity and unequal power tend to apply the rules of one group to other groups. These performances demonstrate the procedures of the dominant order, demand compliance with it, and illustrate through both the imposition of laws and their enactment in the daily life of subordinate peoples, the ways it applies to everyday life. Thus, court performances are one way of expanding the hegemony of the law. Not only are ideas articulated but they are superimposed on everyday life in front of an audience of relatives, neighbors, and friends.

Yet members of subordinate groups frequently mobilize aspects of the introduced legal system to challenge both old and new hierarchies of power (see, e.g., Thompson 1975: Chanock 1985; Matsuda 1988). Moreover, local judges and court officers occupy an intermediate position in the structure of power, linked both to the subordinate group and to the dominant group. In understanding what kinds of cultural messages courts provide in situations of legal pluralism when the legal

spheres are of sharply different power, it is critical to examine the performances of local court judges, persons whom, as Mather and Yngvesson point out, have a uniquely powerful role to play in transforming the meaning of disputes. They represent an intermediate locus of power, imposing the legal system of the dominant group yet responsive to the political pressures and cultural systems of the subordinate groups. Examining the culturally productive role of courts in legally plural situations highlights the role of local officials who interpret and impose the law created by the state.

The impact of a culturally distinct and dominant legal system is particularly powerful at the moment in which a problem or situation is subjected to the legal gaze and a decision rendered (see Yngvesson 1988). Part of this procedure includes some discussion of the problem. The problem is often reformulated into the terms of a new legal ideology, with new conceptions of relationships and persons (see Merry 1990). Insofar as this translation takes place in public arenas, such as courts, it serves a broader educative role, showing people how their problems can be interpreted in the new legal code and, at the same time, demonstrating that these interpretations lead to decisions with coercive consequences: to fines, prison terms, probation, supervision, and mandatory treatment programs.

Recognizing the capacity of local judicial forums to educate the public and to change behavior, political movements seeking to transform local social relationships often create new local courts. For example, the Cuban revolutionary government formed people's tribunals for public discussion of the new morality (see, e.g., Salas 1983). The European colonization of Africa similarly employed local courts as settings in which to articulate and impose a new conceptual world.[4]

The distinct sets of laws of each group in a situation of legal pluralism incorporate differing conceptions about kinds of persons, about relationships, and about duties and responsibilities embedded in particular cultural systems. Each defines, for example, the responsibilities of women, the nature of the family, the obligations between masters and servants, and the terms of marriage and divorce. For example, Hawaiian laws passed in 1840 under the influence of New England missionaries specified that the business of women was to be at home and to tend their children. Hawaiian women, particularly chiefly women, had occupied a relatively autonomous and occasionally powerful position in the precontact period. Under the influence of the New England missionaries, who arrived in Hawaii beginning in 1820, women were redefined as more subordinate to men and excluded from participation in public life. At the same time, rape law changed from

a small payment of compensation to the victim to a substantial fine and period of imprisonment for the culprit (Nelligan 1983). The victim received no compensation.[5] Thus, in this legally plural situation, the laws began the work of redefining the nature of woman, in part through the way rapes were handled and the penalties imposed.

In fact, courts characteristically work within implicit categories of race and gender, categories which they may reproduce or challenge. As courts handle cases concerning assault, violence, neighborly behavior, family life, work, and leisure activities, they base their actions on persons raced and gendered, reproducing assumptions about people of different racial and gender identities. Mindie Lazarus-Black (1992, and this volume) provides an important analysis of the ways in which Antiguan laws during both the slavery era and the more recent period construct images of personhood and of kin ties. During the slavery period, laws about marriage helped to define distinct categories of persons: free, indentured, and slave, by establishing different marriage regulations (Lazarus-Black 1992). Laws about the collective responsibility of kin for the poor contributed to forming a kinship system relatively little connected with formal marriage but extensively involved in kin networks. The recent decision to eliminate bastardy as a distinct (and disabling) legal category in Antiqua, a change produced by the rise to power of groups previously excluded from lawmaking, promises to work further changes in the kinship system and in the meaning of gender.

RECONSTITUTING GENDER IDENTITIES IN DOMESTIC VIOLENCE HEARINGS

Hearings about cases of wife battering provide one instance of the cultural production of the courts. Over the last decade, the courts in Hilo have developed an increasingly activist, feminist approach to spousal violence, encouraged by an energetic group of women who founded a shelter, developed a reeducation program for men who batter, and formed a support group for women (Rodriguez 1988). Many convicted batterers and men subject to restraining orders are mandated by the court to attend the anger management program.

Over the last ten years, there has been a sharp increase in the number of cases concerning domestic violence brought to the Family Court by victims seeking protective orders and to the criminal court by police and by victims for criminal prosecution. The former increase reflects changes in the willingness of victims (usually but not always women)

to turn to the court for help while the latter increase indicates that police are more energetic in making arrests, as are prosecutors in pressing charges. There has also been a significant strengthening of the laws concerning domestic violence, including increases in the penalties for spousal violence.

Although cases of domestic violence appear in the court record in Hilo from time to time during the nineteenth and early twentieth centuries as assault charges, in most instances it appears that such cases were brought to trial only when the violence was frequent and the injuries severe. The court has typically failed to prosecute these cases or has imposed a fine far less than that for adultery or selling liquor without a license. By the mid-1970s, one observes the beginnings of a change. The first law specifically addressed to domestic violence was passed in 1973 in Hawaii, but based on caseload figures and interviews, it had little effect.[6] It was gradually strengthened during the 1980s.[7]

Thus, the legal response to domestic violence has shifted from an approach common in the 1970s of separating the parties and allowing them to cool off without further intervention to an increasingly severe penalty for the offender, both incarceration and mandatory treatment programs, and more extensive record keeping which isolates and identifies this problem in particular and labels the offender. This bureaucratic change signals not only that the problem is viewed as more serious, but also that it is separated out from the larger stream of assault cases and marked as different. Such record-keeping shifts, as the Oahu Task Force notes, increase the visibility of the action and shape consciousness about the offense and its frequency (Oahu Spouse Abuse Task Force [1986], quoted in Hawaii Island Spouse Abuse Task Force 1989:Appendix C—5).[8]

On the island of Hawai'i, the mobilization for a stronger legal approach occurred in the late 1970s as the newly established women's center confronted a surprisingly large demand for a shelter for battered women. A shelter was established in the early 1980s by a charismatic and effective woman who mobilized public awareness, fought resistance from those who declared the shelter hostile to men, and gathered significant support from private charities to continue its operation. She came originally from New York City and has been working on women's issues in Hilo for fifteen years. Many of the leaders of this program are white working-class women. The founder continued to press the legislature, at the time a liberal, Democratic body, for further protection for women. A new, autonomous Family Court was established in 1989 under a judge who had many years of experience as a

legal aid attorney seeking to get protection for battered women. This judge had worked closely with the shelter for many years and had served on its board.[9] Since 1986 the courts have supported Alternatives to Violence, a training program for men who abuse their partners which focuses on learning to manage anger and on reshaping beliefs. The courts routinely require a significant proportion of the men accused of domestic violence to participate in this program and encourage their partners to attend a women's support group. Alternatives to Violence (ATV) is part of the shelter and comes out of the same political movement dedicated to protecting women. Leaders of the program say that their main concern is with women's safety, and that the training program for men is one way of increasing women's safety.

There are two distinct routes, one criminal and one civil, by which a case of domestic violence comes to the attention of the courts. A batterer can be arrested and charged with abuse of a household member in criminal court, an offense with a mandatory forty-eight-hour prison sentence. Civilly, a victim can file for a temporary protective order, generally called a temporary restraining order or TRO, from the Family Court.[10] A person can apply for a TRO against any family member, whether or not he or she is living in the same household.[11] The victim goes to the probation office or a shelter and fills out an affidavit which is reviewed and signed by the judge. There must be a hearing within fifteen days. Since this is a civil action, the law does not provide an attorney for the person accused.

At the hearing, the Family Court judge reads the written account provided by the victim, asks the accused if he or she acknowledges the charge, and takes testimony if the accused denies all violence. If the accused accepts the charge or the evidence is persuasive, the judge issues a temporary restraining order for a period of months with a series of conditions. If there are no children and a desire on the part of both parties to separate, they are told to stay away from each other and have no further contact. If they have children but the victim wishes no contact, the judge will arrange visitation or custody for the children and specify no contact between the adults. If they wish to continue the relationship and to live together or to have contact, the judge will often send them to ATV, requiring either the accused or both parties to participate in the program and permit them contact on the condition that there is no violence. Any violation of the conditions of the protective order is a misdemeanor, punishable by a jail sentence of up to one year and/or a fine of two thousand dollars. The judge frequently schedules a review hearing in a month or two to monitor the situation, particularly for the contact restraining orders.

Table 1
Number of Temporary Restraining Order (TRO)
Cases in Family Court by Years*

1985	250
1986	327
1987	355
1988	277
1989	289
1990	338
1991	359

*Counts based on circuit court case files of miscellaneous family court cases; these numbers were produced by going through the files of miscellaneous cases looking for those concerning domestic violence. After 1990, domestic violence cases were catalogued separately.

The victims typically fill out the request for a TRO in the shelter or at ATV where workers are paid by the court to help them. Victims are almost always accompanied by a woman advocate from ATV. The man appears alone. Although there is always a man from the men's side of the ATV program present in the waiting area of the court and willing to talk to the men, the men are rarely interested in talking at that time. The ATV representative does not regularly talk to them at all until the judge tells them they must go to ATV and that they must talk to him. Thus, access to this process requires the initiative of the victim and her willingness to summon the accused to court.

The number of requests for TROs has increased dramatically since the early 1970s. Between 1971 and 1978, there were seven TROs issued in Hilo for domestic violence situations. By 1985, however, the year the new spouse abuse law went into effect, the numbers were much larger, as Table 1 indicates. These figures are only for cases from Hilo. I was unable to locate figures for the period from 1979, when the regulation providing for these protective orders in domestic situations came into effect, to 1985.

In sum, during the 1980s, victims of violence in the home were increasingly turning to the court for protection through temporary restraining orders. The number of batterers arrested and prosecuted in the criminal court has grown even faster. As the changing caseloads and the historical material suggest, people who are battered (mostly but not entirely women) are going to court for behavior which, twenty years ago, was taken for granted as a part of male authority.

My research assistant and I observed the domestic violence calendar

in the Hilo family court, which was held once a week, for nineteen weeks during the period from July 1991 to August 1992. This period gave rise to approximately 105 requests for a TRO. In most cases, the defendants were men and the victims were women. The women who bring these cases to the court are primarily young, in their twenties and thirties, and nonprofessional workers or nonworkers. Their ethnic identities are widely varied and reflective of the local population, including white, Portuguese, Filipino, Japanese, Hawaiian, Hawaiian/Chinese, and Puerto Rican individuals. Because of the high rate of intermarriage among these groups, the majority have multiple ethnicities. Most fall into the group labeled "local," a quasi-ethnic identity premised on birth and rearing on the island and marked most significantly by mastery of pidgin, a dialect of English which combines features of Hawaiian, Japanese, Filipino, and other local languages in vocabulary and syntax. A significant minority are people from the mainland following a wide variety of alternative lifestyles from born-again Christians to pioneer-survivalists and people aspiring to live off the land. A few support themselves by cultivating marijuana. Many of these men and women bring varying ideas about the acceptability and legitimacy of violence against women to the court hearing. Most of the people have low incomes, and the men often are not working. According to the judge, about forty percent of the women want to separate from the men and about sixty percent want to stay together without the violence.

Hearings are temporarily held in an office building near the courthouse for lack of space, but the ritual dimensions of a court are nevertheless reproduced. Parties wait outside in an open lobby area and are ushered into the courtroom by the bailiff when their case is called. Although they are scheduled for a particular time and the judge generally keeps to the schedule, sometimes they must wait. The judge sits behind a large desk wearing a black robe, flanked by a court clerk and assisted by his bailiff. The parties are assigned seats at two tables, one for the plaintiff and one for the defendant, and told by the bailiff where to sit. Children or other relatives accompanying the parties sit behind the parties. Lawyers are rarely present. Since this is a civil matter, there is no attorney appointed for the defendant. If the defendant wishes to hire one at his own expense, however, he is allowed to postpone the hearing until he can do so. When defendants hear that they have to pay for the lawyer themselves, most decide to forgo legal representation. Women plaintiffs are typically accompanied by women workers at the local shelter who have helped them to fill out the form and encouraged them to file for a temporary restraining order.

Although the hearings are private, the advocates from the community women's group are an important audience. Thus, despite the informality of the setting, the ritual fundamentals of costume and space are reproduced.

The Family Court judge's concerns are twofold: first, to stop the violence and, second, to protect the children involved. He endeavors to convey a clear message that violence is against the law and that it is bad for children. He defines his task as preventing the parties from killing each other rather than finding out what the underlying issues are. There is not enough time to handle the cases that way, and his objective is to prevent violence and threats and to protect any children in the family. He knows drugs and alcohol are involved but sees dealing with these problems as beyond his capacity for intervention. Any indication of violence or abuse against children elicits an immediate referral to Children's Protective Services.

The judge generally resists the efforts the aggressor makes to reframe the problem as one of mutual fault or responsibility. If the aggressor (usually, but not always, a man) attempts to justify his blows on the basis of the misbehavior of the other person, whether because the person has had an affair with someone else or failed to take care of the house or children well, the judge will hear him out but not excuse the violence. If both parties have filed complaints against each other, the judge refuses to issue both, only issuing an order against the primary aggressor, usually the man. When men start complaining that their women drink, take care of the children poorly, have affairs with other men, or get angry and hit them, he cuts them off. He asks if that is why they are here, and when the man meekly answers, "No," the judge reiterates that they are here because the man has hit the woman and that it is wrong and against the law. As one man put it, "You just make me the bad guy. It's her too." The judge's response is that the men need to learn to control their anger for the sake of the children and for the example they provide their children. If the man insists that his wife needs counseling too, the judge may agree, but he reiterates that the reason they are there is that the man has abused her and that that is against the law and is bad for the children.

The following case illustrates the active role the judge plays in framing the problem and resisting the effort of the man to place blame upon the woman.

Both parties in this case are of Filipino ancestry and in their twenties. They are not married, but they have a baby. They speak the local pidgin version of English. The man is working. The woman was brought to the court by the shelter workers. The following account is based on

my notes, since I did not tape-record the session. It is not a verbatim dialogue, and it does not reflect "local" speech.

> Judge: Can you understand English? Do you want a lawyer?
>
> Man: I can't afford a lawyer.
>
> Judge: Is what she says in this paper true?
>
> Man: (*silence*)
>
> (*The judge has both parties sworn as witnesses.*)
>
> Judge: What happened?
>
> Judge (*to plaintiff, reading from the application*): You say you came home from work, he was jealous, started hitting you, dragging you around by the hair. You are pregnant.
>
> Woman: Yes. I'm not fooling around.
>
> Judge (*to man*): You have read this statement. Did you do what she says?
>
> Man: I did hit her. But I came home, I saw her panties on the floor with sperm in them. The doctor said I'm not fertile. So how come she's pregnant? So I hit her.
>
> Judge: Whether or not she is fooling around, you have no right to hit her, drag her by the hair, especially when she is pregnant. Are we in court because you think she is fooling around?
>
> Man: No.
>
> Judge: If you are upset about her fooling around, you need to talk to someone, or to seek counseling. (*To plaintiff*) What kind of restraining order do you want? Do you want to see him or not?
>
> Woman: I want to have contact with him but to live away from him. I want him to go to the counseling program for violence.
>
> Man: I want a family that lives together.
>
> Judge: This is not the right way to do it. You have to learn not to hit when you get angry and frustrated. I am going to send you to a counseling program to learn how to handle your violence. Do you agree?
>
> Man: I guess so.
>
> (*The judge discusses and arranges visitation for the child.*)
>
> Judge: This is the order of the court: Do not hit her or pull her hair. I don't care what she does. It is not right and it is against the law. I want you to go to the counseling program, to pay for the program, and to finish it. If you don't go, the case will go to the prosecutor and you will be prosecuted for contempt of court.

The man replies that he doesn't know if he can go to the program. The judge responds that he should work out the details with the

program staff, and if he violates this order, he will get up to one year in jail, a fine of two thousand dollars, or both.

Thus, the judge actively reframes the problem; what had seemed to be a question of mutual responsibility and fault becomes an illegal and unacceptable form of behavior which is never warranted. This is his typical approach to this kind of case. He is, I think, unusual in his commitment to handling domestic violence firmly.[12]

The judge believes that the major impact of his rulings falls on the women rather than the men. It is, of course, unrealistic to expect that this new stance from the court will quickly change cultural biases concerning male entitlement to violence. There are some indications, however, that, through the social networks surrounding these court appearances, women are hearing a new message about their obligation to accept violence. The following case was heard in the district court (the lower criminal court) in a proceeding and courtroom which are much more formal than those of the Family Court and are open to the general public. It demonstrates the way women who have heard the new message about violence mobilize that message in court contexts. The wife/witness expresses her position in language reminiscent of that of the Family Court judge and the women's shelter. She has had contact with both in the past. She received a restraining order in Family Court in June 1991, which was extended to March 1992. (The hearing took place in January 1992.) Her friend and neighbor who testified for her worked with the shelter and was a member of the ATV women's support group. It is likely that the wife was able to resist the defense effort to blame her for the violence she suffered because of these experiences. It is, of course, impossible to separate the impact of the messages communicated by the court from the roles of the shelter and ATV program in changing people's consciousness. But the court's pronouncements have the added weight of the legitimacy of the state and the force of penalties behind them.

A man is charged with abuse of a family or household member, burglary, and assault in the third degree. This is a preliminary hearing on the burglary charge, which is a felony. His wife, who no longer lives with him, is the principal witness against him. The defendant is from Tonga, the wife a "local" person in accent, although she is white. The case is handled by a prosecutor and a public defender. Both are whites without local accents, as is the judge. Aside from these people and other court clerks and bailiffs, I am the only person in the audience. The neighbor testifying on the wife's behalf waits outside. Since I was unable to tape-record, the following dialogue is based on my notes,

as was the previous one. It again fails to reproduce the local speech. The names are pseudonyms.

Jane Marinpa, the wife, is the first witness. She is a large woman wearing a loose house dress and appears to be of middle age. She says she is married to the defendant, Louri, and had lived with him, but that they have been separated for a year. She is a tenant in an apartment house where she pays rent and has lived for five years. She describes the incident as follows:

> Witness: It was 9:00 AM and I was laying on the futon, waiting for my son to come back from Kalapana. I waited to see if he would use the key to unlock the door. Then I looked through the peephole and I saw the defendant. I thought it was best to call up on the restraining order. Then the door flew open and my husband was standing there. He said he was here for the kids. He punched my nose, then my face, and he threw me on the floor, my head was aching. He hit me with a closed fist. He ripped off my shirt and underwear. (*She cries.*) I ran out the door to my sister's apartment downstairs. I called the police and went to the hospital in an ambulance. My neighbor had already called the police, and they came within three minutes after I left to go to my sister's.
>
> Public Defender: How long were you married?
> Witness: Three years this past October. I lived in an apartment for five years, then we moved to a bigger apartment and he moved in and was added onto the lease with me. He lives somewhere else now.
> Public Defender: You are not formally divorced?
> Witness: He was going to try to control his anger, but he has a lot of affairs; he made no effort. Plus, I wanted to wait for the birth of our second child.
> (*She has two children, aged 2 1/2 and 9 months, who are living with her but Louri is the father. She indicates clearly her ambivalence about leaving the man who is the father of her children and who not so long ago was the man she loved and married. She expresses a commonly felt desire not to give up on the man.*)
> Public Defender: You've had marital problems?
> Witness: No. Abuse problems, physical and psychological.
> Public Defender: He's had affairs?
> Witness: Yes, I saw it with my own eyes. And I've had to leave my job to take care of my children.

Questions to both parties establish that she had called her husband and asked him to come take care of the children for the evening,

expecting to be back by 2:00 AM. When she failed to return by early morning, he called her sister to come up and take care of the children while he left. She came home somewhat later and was lying down when he returned at 9:00 AM. When the public defender asks if she had gone out the night before, she responds angrily, "Don't I have a right to go out for my thirty-third birthday? He attacked me. It was unprovoked. I don't see what my going out has to do with it."

The public defender points out that the restraining order forbids Louri from abusing or threatening his wife, but it does not require him to stay away from her. Both the friend/neighbor and the police officer who arrived at the scene testify that there was hitting and discuss the severity of the injuries. The public defender explores with Jane the extent of her injuries—she says she had a concussion—and asks about her alcohol consumption the night before the incident.

The story from the defense side is somewhat different. Louri is from Tonga and has an interpreter because his English is limited, although Jane does not speak Tongan and the court personnel tell me his English is adequate. No one translated the testimony of his wife to him. He says he is twenty-six years old. He came to take care of the children because she called him, but when she didn't return by 5:00 AM he called her sister to come take care of the kids and left. He returned at 7:30 AM to check on the children, he says, and finding only the sister there, left again. At 9:00 AM he returned again to check on the children. The translator interprets his description of his actions as follows:

> Translator: He knock ten minutes, heard kids crying, not sure anyone there, so he broke into the house. When he opened the door, she was lying on the floor, passed out. He said he was going to take the babies, then she pushed him and told him to get out of the house. She said she had a restraining order, was going to call the police. Then he punched her. He was worrying about the babies.
> Prosecutor: Was she passed out?
> Louri: She sat up when I kicked open the door.

In summing up the case, the prosecutor says that it is clear that this is a burglary, and that the evidence of injury is sufficient to charge the defendant with abuse of a household member. The public defender argues that Louri entered the apartment with force but only to see if the children were all right, because he heard crying babies. He acknowledges that there was abuse of a household member, but argues

that this would be better handled without the burglary charge in the first degree.

The judge concludes that, based on inferences from the testimony and the means of access used by Mr. Marinpa, that there is probable cause for burglary in the first degree and he will bind him over for further proceedings. He will also bind him over on the abuse charge and the assault charge for a hearing in circuit court.

The interesting feature of the case was the fierce resistance mounted by Mrs. Marinpa to defense insinuations that she was responsible for the assault because she went out, stayed out late, and did some drinking. She says very clearly that it doesn't matter what she does or where she goes because an assault on her is never justified. The defense attorney is clearly trying to construe the situation in such a way that breaking down the door was reasonable paternal concern for crying children who were poorly cared for by their mother who was passed out drunk. This argument is used to justify the assault on the door, if not the assault on the woman. It is interesting to me that Jane Marinpa repeats the argument used by the Family Court judge to defend herself in this hearing. The defense strategy, on the other hand, relies on older conceptions of justifiable violence, an idea which, at least in this case, in front of the court personnel and me, did not carry the day. I find in the testimony delivered by the wife clear indications of a new understanding of women's right not to be hit, phrased in a way reflective of the philosophy of ATV and the women's shelter. Here, this language is reinforced by the court, while the alternative view—that men are justified in engaging in violence when women misbehave—loses out.

Although the audience was small, several others testified and were aware of the outcome: a police officer, the neighbor, (who will carry news of the decision back to her friends at ATV), and a friend of the husband. Although no one from the general public was present, the audience of friends and neighbors who will hear about this case is substantial. It seems highly probable that this legal event will have an impact on the way women and men in this community think about their right to exercise violence against each other.

Buttressing this message is the class composition of the court. The judge and the attorneys are all Caucasians who speak standard English. The court clerks are all Japanese Americans, as is the police officer. The parties are locals, speaking pidgin English. Thus, the court performance is strengthened by the power accorded class, education, and race. Court performances join the effect of the statements made by the judge, the class power of the judge and the attorneys, the ritualized expression of state power in the courtroom, and the coercive power

of the outcome in constructing an event which conveys messages about personhood and violence, messages which, from time to time, may reshape the way people think about themselves. Although the courts have placed priority on the maintenance of marriage and patriarchal authority in the past, the current understanding privileges protection of the female body at the expense of marriage and patriarchal authority.

CONCLUSION: COURT PERFORMANCES AND THE PROBLEM OF HEGEMONY

Given the perspective developed in this paper, the question of the hegemony of law becomes an intriguing one. If law is part of the cultural world, if it shapes consciousness, and if its form is reflective of the interests of those who have the means to shape statutes, render decisions, and determine which rules to enforce—then it must contribute to this group's power. Law, here, has the ability to transform class-based edicts and principles into common sense. But, subjugated peoples have themselves seized the law, in a variety of ways, to advance their own interests. In this example, an activist group of women, and a supportive judge, have introduced new laws and constructed a judicial performance which enacts ideas about violence and gender that differ sharply from the previous norm. Although some forms of male violence against women have always been condemned, there has clearly been an assumption in the past that misbehavior on the part of women justifies violence which is interpreted as discipline. Women have taken the law and used it to combat patriarchal authority.

Moreover, the capacity of the law to impose hegemonic categories of meaning is circumscribed by the role of intermediaries who stand between the law as conceived and administered at the top and ordinary people. Judges, attorneys, clerks, bailiffs, and police are critical cultural agents, reinterpreting this law in the light of local circumstances and local categories of personhood. These people filter and interpret the law and serve as core actors in imposing it. Thus, the law can serve as a mode of cultural transformation, but its capacity to do so depends on the ways it can mobilize local support and the implicit categories of race, class, and gender through which people and events are interpreted.

Yet, the fundamental categories of the law—property, the individual, the family, the obligations of contract—remain unchallenged. Women go to court to assert their right not to be hit, a right which belongs to them as individuals. While the right not to be hit no matter

what a woman does is a powerful and transformative idea, it does not encompass the totality of the relationship a woman has with a man whom she may love when he is not violent, on whom she often depends for support, and who is frequently the father of at least some of her children. Despite the complex emotional and economic connections a woman has with the man who abuses her, in court the relationship is viewed simply in terms of her right to protection. She is a legal individual, even though she is a socially connected person. And this individualism does not come under question. Courts can serve as a mode of resistance to social practices such as domestic violence, but such resistance must be framed in the terms of the law itself, allowing protest only within the hegemonic categories of the law.

Where does this leave the concept of hegemony? Is there, as Scott suggests, an authentic peasant who sees through the hegemony of the system imposed on him or her (1985)? I do not think there is any possible stance outside the system from which one can gain a "true" picture of the relations of domination and of the participation of the legal system in that domination. Nor is there a single hegemony. Instead of an overarching hegemony, there are hegemonies: parts of law that are more fundamental and unquestioned, parts which are becoming challenged, parts which authorize the dominant culture, parts which offer liberation to the subordinate. Law cannot be viewed as either hegemonic or not as a whole, but instead as incorporating contradictory discourses about equality, justice, persons. Some areas of social life are opening up to question, such as ideas about men's right to hit women, while others, such as the systems of gender and class inequality which create the totality of the situation confronting a poor woman with children whose main means of support is a man who batters her, are not.

Notes

1. My research was generously supported by a grant from the National Science Foundation, Anthropology Program and Law and Social Sciences Program, #SES 90–23397. I am grateful to Judge Ben Gaddis for allowing me to visit his court, for insightful conversations, and for thoughtful advice on this paper. Marilyn Brown provided valuable research assistance for the project. Susan Hirsch and Mindie Lazarus-Black provided helpful advice and suggestions for the paper. For the final shape of the paper, however, I alone am responsible.

2. In his recent book on Islamic law, Lawrence Rosen advocates a similar approach to the cultural analysis of law, but without attention to relations of power. He advocates looking at courts as locations for the reproduction of

culture and as shaped by their cultural context, in other words, "tacking back and forth between law and culture" (1989). He argues that courts serve to reproduce the cultural practices and categories of the surrounding society, but does not analyze them as locations for the production of culture in situations of cultural diversity and unequal power. He does not look at the relative power relations of the producers of the law and the consumer, nor at the relationship between the qadi in his local court and the higher levels of the legal system which provide some supervision and appeal from his decisions. Nevertheless, his emphasis on the cultural role of local courts is valuable in suggesting a revived anthropological focus on courts which can be extended to considering the role of local courts in situations of cultural domination.

3. As Joan Vincent's recent historical account of the development of political and legal anthropology indicates, legal anthropologists have not in the past taken this approach to understanding legal systems (1990). Originally, of course, legal anthropologists studied societies without courts, in which the central concern was "custom" or other informal, nonstate forms of social control. Much of the early work focused on "trouble cases," under Llewellyn and Hoebel's leadership, and was theoretically informed by the legal realism of the early twentieth century: by questions about the abstract principles within the law as well as the social causes of judges' decisions and the social effects of those decisions (Vincent 1990:242–52). Legal realists, she argues, located legal actions within a wider social world which changed in response to its actions. Legal realists such as Cardozo argued that judges were concerned not only with legal rules but also with assessing the social consequences of their decisions, an idea picked up by Llewellyn and introduced into the anthropology of law via his collaboration with Hoebel (Vincent 1990:244).

4. Chanock argues, in his study of colonization in Central Africa, that: "The law was the cutting edge of colonialism, an instrument of the power of an alien state and part of the process of coercion. And it also came to be a new way of conceptualizing relationships and powers and a weapon within African communities which were undergoing basic economic changes, many of which were interpreted and fought over by those involved in moral terms" (1985:4).

5. Peter Nelligan describes this transformation in his excellent work on the changing meanings of rape in Hawaii (1983). According to laws passed in 1835 and 1840, the victim of rape received thirty-five dollars and the judge fifteen dollars. When an internationally famous case in 1844 revealed the paltry punishment for rape under Hawaiian law, the government was embarrassed into passing more stringent legislation. In 1850, the penalty for rape was increased to a maximum fine of one thousand dollars and up to five years imprisonment, with no compensation provided to the victim (1983:91–93). Thus, as rape became redefined as a more serious offense under the influence of New England conceptions of the family (the 1850 legislation was based on a proposed code for Massachusetts), the status of women was simultaneously redefined as more subordinate and dependent on men. Rape became a damage to the woman's marriageability and, consequently, a more serious offense.

6. In Oahu, the major urban area of the state, of 103 spouse abuse cases between 1973 and 1979, only three resulted in conviction (Oahu Spouse Abuse Task Force [1986], quoted in Hawaii Island Spouse Abuse Task Force 1989: Appendix C–8). In 1984/85, in contrast, there were forty-five convictions

for spouse abuse on Oahu and forty-one criminal contempt convictions for violation of spouse abuse protective orders (ibid.).

7. In 1985 the spouse abuse law was amended to provide a mandatory forty-eight-hour sentence for people convicted of abuse of a household member with a possible jail sentence of up to one year. The cooling-off period was increased from three hours to twelve (Act 143, Session Laws 1985:253). In 1986, the statute was amended to require the police to issue a written citation to abusive persons required to leave the premises for a cooling-off period (H.R.S. 1991 Commentary:66). The law in effect in 1991 allowed the police officer to require the person to leave the premises for a twenty-four-hour cooling-off period, to give a written warning citation, and to arrest a person who refuses to leave. An arrested person must post bail of $250 for pretrial release. In addition to the forty-eight-hour jail sentence, convicted persons are "required to undergo any available domestic violence treatment and counseling program as ordered by the court," a provision in effect since 1985 (H.R.S. 1991:709–906 [4]). The law applies to household or family members: "spouses or former spouses, parents, children and persons jointly residing or formerly residing in the same dwelling unit" (H.R.S. 1985:709–906 [1]).

8. Susan Silbey has emphasized the importance of record-keeping procedures in understanding the processes by which law is enacted (1980/81).

9. The concern with domestic violence is a latecomer to the family court agenda, however. A report describing major conferences in 1972 and 1973 in which the family court idea was developed and promoted talks only about the needs of children and juveniles. Violence against women is never mentioned (1974).

10. A law providing for ex-parte temporary restraining orders for victims of domestic violence was passed in 1979 (Oahu Spouse Abuse Task Force [1986], quoted in Hawaii Island Spouse Abuse Task Force 1989:Appendix C–5).

11. The statute for domestic violence is in Chapter 586 of the Civil Family Law. Harm or threat of harm is sufficient reason for a temporary restraining order. Violation of a protective order is covered under Penal Code 709–906. Violation of the protective order means a mandatory minimum two days in jail for the convicted person.

12. I heard only one other judge in this calendar, who was much less stern about the unacceptability of violence in intimate relationships.

References

Arno, Andrew. 1985. "Structural Communication and Control Communication: An Interactionist Perspective on Legal and Customary Procedures for Conflict Management." *American Anthropologist* 87:40–55.

Arnold, Thurman W. 1935. *Symbols of Government*. New Haven: Yale University Press.

Chanock, Martin. 1985. *Law, Custom, and Social Order: The Colonial Experience in Malawi and Zambia*. Cambridge: Cambridge University Press.

The Family Court: Its Goals and Role. A Summary Report of the Project: Community and Family Courts in Program Goal Planning. 1974. An LEAA Funded Project.

Geertz, Clifford. 1983. *Local Knowledge: Further Essays in Interpretive Anthropology.* New York: Basic Books.

Gluckman, Max. 1955. *The Judicial Process among the Barotse of Northern Rhodesia.* Manchester: Manchester University Press.

Hawaii Island Spouse Abuse Task Force. 1989. *A Report on Spouse Abuse in Hawaii County and Recommendations for Change.* Sponsored by Hawaii County Committee on the Status of Women. Typescript.

Hay, Douglas. 1975. "Property, Authority, and the Criminal Law." In *Albion's Fatal Tree: Crime and Society in Eighteenth-Century England,* by Douglas Hay, Peter Linebaugh, John G. Rule, E. P. Thompson, and Cal Winslow. New York: Pantheon. 17–63.

Lam, Maivan. 1985. "The Imposition of Anglo-American Land Tenure Law on Hawaiians." *Journal of Legal Pluralism* 23:103–29.

Lazarus-Black, Mindie. 1992. "Bastardy, Gender Hierarchy, and the State: The Politics of Family Law Reform in Antigua and Barbuda." *Law and Society Review* 26(4): 863–901.

Llewellyn, Karl, and E. Adamson Hoebel. 1941. *The Cheyenne Way.* Norman, Okla.: Oklahoma University Press.

Malinowski, Bronislaw. 1972 [1926]. *Crime and Custom in Savage Society.* Totowa, N.J.: Littlefield, Adams.

Mather, Lynn, and Barbara Yngvesson. 1980/81. "Language, Audience, and the Transformation of Disputes." *Law and Society Review* 15:775–822.

Matsuda, Mari J. 1988. "Law and Culture in the District Court of Honolulu, 1844–1845: A Case Study of the Rise of Legal Consciousness." *American Journal of Legal History* 32:16–41.

Merry, Sally Engle. 1988. "Legal Pluralism: Review Essay." *Law and Society Review* 22(5): 869–96.

———. 1990. *Getting Justice and Getting Even: Legal Consciousness among Working-Class Americans.* Chicago: University of Chicago Press.

Meschievitz, Catherine S., and Marc Galanter. 1982. "In Search of Nyaya Panchayats: The Politics of a Moribund Institution." In *The Politics of Informal Justice.* Richard L. Abel, ed. New York: Academic Press. 2:47–81.

Nelligan, Peter James. 1983. *Social Change and Rape Law in Hawaii.* Ph.D. dissertation, Dept. of Sociology, University of Hawaii.

Rodriguez, Noelie Maria. 1988. "A Successful Feminist Shelter: A Case Study of the Family Crisis Shelter in Hawaii." *Journal of Applied Behavioral Science* 24:235–50.

Rosen, Lawrence. 1989. *The Anthropology of Justice: Law as Culture in Islamic Society.* Cambridge: Cambridge University Press.

Salas, Louis. 1983. "The Emergence and Decline of the Cuban Popular Tribunals." *Law and Society Review* 17:587–613.

Scott, James. 1985. *Weapons of the Weak: Everyday Forms of Peasant Resistance.* New Haven: Yale University Press.

Silbey, Susan S. 1980/81. "Case Processing: Consumer Protection in an Attorney General's Office." *Law and Society Review* 15:849–83.

Silbey, Susan, and Austin Sarat.1987. "Critical Traditions in Law and Society Research." *Law and Society Review* 21:165–74.

Starr, June. 1989. "The Role of Turkish Secular Law in Changing the Lives of

Rural Muslim Women, 1950–1970." *Law and Society Review* 23:497–523.

Thompson, E. P. 1975. *Whigs and Hunters*. New York: Pantheon.

Tiruchelvam, Neelan. 1984. *The Ideology of Popular Justice in Sri Lanka: A Socio-Legal Inquiry*. New Delhi: Vikas Publishing House.

Turner, Victor. 1957. *Schism and Continuity in an African Society*. Manchester: Manchester University Press.

Vincent, Joan. 1990. *Anthropology and Politics: Visions, Traditions, and Trends*. Tucson: University of Arizona Press.

Yngvesson, Barbara. 1985. "Legal Ideology and Community Justice in the Clerk's Office." *Legal Studies Forum* 9:71–89.

———. 1988. "Making Law at the Doorway: The Clerk, the Court, and the Construction of Community in a New England Town." *Law and Society Review* 22:409–48.

———. 1993. *Virtuous Citizens, Disruptive Subjects: Conflict and Order in a New England Court*. New York: Routledge.

LOCAL LEGAL HEGEMONY IN THE TONGAN MAGISTRATE'S COURT: HOW SISTERS FARE BETTER THAN WIVES

Susan U. Philips

In Tonga, a tiny independent nation-state of 100,000 people in the South Pacific, magistrates daily accomplish a double legitimation of the Tongan state. Both externally, to other nations, particularly European nations, and internally, to Tongan citizens, they legitimate the existence of the Tongan legal system and of Tonga as an independent nation by inflecting their legal actions in court with a distinct Tonganness that can be recognized by outsiders and insiders alike. Other court personnel and users of the courts join the magistrates to construct a local legal hegemony in courtroom discourse that is quite deliberately Tongan.

This courtroom production of legal hegemony is gendered in a specifically Tongan way through invocation of the brother-sister relationship to justify arrangements between the sexes in the public realm controlled by the state. In this way the state appropriates the moral authority of familiar kinship rhetoric and extends it to the nation as a whole, a common hegemonizing strategy of institutional complexes supporting the state. Yet, when placed in the larger context of the legal system as a whole, both historically and at present, this strategy

suggests that state ideological domination is not sustained solely through the creation of a pervasive and implicit lived reality that cannot be challenged. Rather, hegemony involves both implicit and explicit ideological stances, and considerable ideological diversity as well as homogeneity.

THE ROLE OF LAW IN STATE HEGEMONY

In Marxist analysis, law is widely viewed as a tool of domination when deployed by the modern nation-state (Tigar and Levy 1977; Sumner 1979; Cain 1983). Gramsci conceptualized law as involving both coercion by the state and cultural or ideological hegemony through both state and civil organizational complexes (Gramsci 1971:246–47). For Gramsci, coercion of citizens by the state was associated with the military and the police, while courts were seen as hegemonic because of their negative educating role (as opposed to the positive educating role of schools).

Until quite recently cultural hegemony fostered by the state has predominantly been conceptualized as so totalizing as to be naturalized and part of the taken-for-granted reality of social actors. This is consistent with Foucault's concepts of "discourse" and "will to truth" (Foucault 1972, 1980) and also with Williams's (1977) notion of "lived reality." In spite of the emphasis on practice in the work of Foucault and Williams, these concepts share a great deal with American anthropological concepts of culture as homogeneous worldview.

Foucault shows the professional and bureaucratic discourses that link state and civil societies to involve claims to truth masking ideologies that both rationalize and constitute domination. This work has led to an exciting new awareness of ideology and culture within state bureaucracies that departs radically from traditional concepts of political ideology and reconceptualizes the relationship between state and civil institutions. Increasingly, however, there is an awareness that the concept of hegemony as a kind of naturalized, implicit, coherent, and pervasive ideological framework through which reality is experienced does not adequately capture the way in which ideology is manifest in state domination, including domination through the legal activity of courts that articulates the state with civil society. Most important here, this concept of hegemony has no theoretical place for the very real ideological diversity that is part of relations of domination and subordination.

In *The Great Arch* Corrigan and Sayer (1985) characterize the historical emergence and perpetuation of the English state as involving

a cultural construction of reality over hundreds of years that has been and still is totalizing in its continuous effort to supplant nonstate realities. This effort is individualizing in that people are defined and treated as individual citizens of the state, while other aspects of social identity are nullified. At the same time, individuals are differentiated socially as a result of state-creating activity, particularly into relations of domination and subordination, such as those between propertied and laboring persons. This social differentiation contributes to varying experiences of the state according to one's social identity. Corrigan and Sayer's work, then, both embraces and qualifies the Foucauldian idea of a pervasive discourse through which the world is experienced.

Others, influenced by Williams's (1977) concept of counterhegemony—with a notable and influential example being Willis (1977)—see ideological diversity as deriving primarily from *resistance* to the state. In practice, however, when resistance is discussed, both the dominant ideology and the counterideology that emerges in resistance to it more often than not get represented as themselves coherent—rather than inevitably partial, fragmented—worldviews.

Recently Roseberry (1991) has advocated a more processual view of hegemony as involving constant struggle between dominating and subordinated groups who share a common framework of meaning. This view opens up room for consideration of a range of sources of ideological diversity and is far more consistent with Gramsci's own discussion of state hegemony than many approaches.

What discussions there have been of ideological diversity in the context of state hegemony are typically grounded in social identity or social group categories such as Willis's (1977) distinction between teachers and students and Corrigan and Sayer's (1985) between propertied and laboring classes. This paper, in contrast, draws on sociolinguistic approaches to contextual variation in meaning (see, e.g., Duranti and Goodwin 1992) to address ideological diversity that is activity and domain-based while still giving attention to issues of social identity. There are discussions of state hegemony compatible with this perspective. Althusser (1971) distinguishes among domains of state and civil activity that contribute to state domination by separating repressive state apparatuses from ideological state apparatuses and by conceptualizing education as the ideological state apparatus with the most influential hegemonizing activity because of its reproduction of the state. Legal scholars considering the hegemonizing nature of law (e.g., Sumner 1979; Joerges and Trubek 1989) see ideological differentiation within law, challenging the idea that law represents a single, coherent, pervasive interpretive perspective (see also Philips 1992, 1993). Sumner

in particular directs attention to an ideological diversity within the law that includes attention to social identity categories, and, in the same work, also addresses different activity spheres of the law:

> Law does not, therefore, just contain bourgeois economic ideology. It also reflects the ideologies of fractions of the bourgeoisie and the ideologies of other classes—through the political activities of these classes and class fractions. Moreover, it reflects the ideologies of occupational groups, minority groups and pressure groups. And, in terms of the range of ideologies, law expresses ideologies relating to the family, morality, the environment, political representation, immigration, communication, public association and so on—as well as ideologies relating to the economy. (Sumner 1979:269–70)

In keeping with this line of thought, the discussion to follow will document several different kinds and sources of ideological diversity within Tongan law. It will give more attention than is typical to the contradictory, fragmented, compartmentalized, and partially implicit, partially explicit nature (Giddens 1979) of instantiations of gender ideology in actual legal practice. And it will counter the image of the agents of nation-states as constantly pushing for more coherence and uniformity with an image of state domination that involves the active proliferation of ideological diversity as well. As we will see, what law is and does is quite varied in Tonga, and the genderedness of the Tongan state in the legal realm is not an implicit, seamless web, but consists as well of flashes, of displays of explicit stances on gender that themselves are not necessarily coherent.

An important factor in the persistence of the concept of hegemony as a naturalized "lived reality," in spite of theoretical attention to the constant struggle of any state to sustain hegemony, has been the methodologies associated with studies of actual examples of hegemony or as is more common, of resistance to ideological and practical domination. Where semiotics, or "discourse," in the Foucauldian sense is invoked as the focus of study, it is typically what I will call "discourse at a distance." This is not discourse of the kind typically referred to by linguists and linguistic anthropologists like myself, not speech or tape recordings or transcripts of speech of real people talking to one another. Instead it is discourse from which both researcher and reader are distanced by one or more devices: the context is historical, so the researcher and reader have no direct access to it; the data are written texts, providing no access to the live producers and consumers of those texts and therefore no access to their intentions and interpretations— or, in some cases, the researcher has had direct access to the activity

in which ideology is embedded and to the people who participated in it but must rely primarily on a self-produced record of that activity, such as field notes, that itself is a selective representation of the activity in question.

All of these distance-establishing factors give more interpretive license to the author than she would have with recordings and transcripts of live people speaking to one another and allow the author's urge to coherence to operate unchecked. With such data one cannot really see how a given hegemony is constituted. Particularly, it is not possible to see how hegemony is jointly constructed by co-interactants in relations of domination and subordination.

This paper, however, is based on tape recordings of naturally occurring speech in Tongan courtrooms and on the understandings of that speech by Tongans. My methodology and its development in the earlier mentioned sociolinguistic study of contextual variation in meaning figures critically in the recognition of the partiality, the varying degrees of explicitness, and the relative contributions of dominant and subordinate agents to the gendered legal hegemony of the Tongan state.

LEGAL AGENCY IN COLONIAL AND POSTCOLONIAL STATES

It is necessary to consider carefully what it means to talk about legal hegemony in a postcolonial state such as Tonga, which was a protectorate of Great Britain from 1900 to 1970, because the concept was originally developed to shed light on state domination in Western European nations. Gramsci himself represented the bourgeois state-civil intertwinings and the complexity of civil society as characteristic primarily of Western European societies. He seemed to see their civil complexity as itself dependent on colonialism and imperialism, and to disclaim the relevance of his theories for other kinds of states (see, e.g., Gramsci 1971:242).

During the 1960s and 1970s when many European colonies in Africa, Southeast Asia, and the Pacific were becoming "independent," a good deal was written about how they lacked the class structure of European societies (see, e.g., Fitzpatrick 1980) and so could neither sustain liberal democracies thought to require a substantial bourgeois class nor accomplish a revolution thought to require an industrial proletariat. The analogues to Gramsci's historic blocs, classes, and parties were thus difficult to find. It has also been argued that European

control of colonized populations need not and could not involve cultural hegemony and the consent of the governed, but was, rather, rule by force or coercion, particularly in the early stages. Yet there are many ways in which European domination of non-European indigenous populations and the reproduction of European nation-state political forms around the world have involved processes central to Gramsci's theory of state hegemony.

First, law has been used as a key tool of domination in colonialism to define and legitimate to both Europeans and indigenous peoples the social relationships through which the indigenous peoples have been controlled and exploited. This process has involved the extension of European categories for both *outsiders* (e.g., defining indigenous peoples as citizens of other nations) and *insiders* (e.g., defining indigenous peoples as citizens of the European nation) in historically unique combinations. Second, in all colonial settings, law has been complemented by the introduction of other familiar European institutional complexes of the kind Gramsci saw as linking state and civil society ideologically, most conspicuously Christian churches and schools. And all of these institutional complexes have been linked to the family, as Althusser (1971) has suggested was critical for state hegemony. Third, in general, European colonizing nations have employed what Gramsci referred to as the "bourgeois" strategy of domination (Gramsci 1971:260), that of homogenization through involvement and education in European institutional complexes.

All of these circumstances point to a role for legal hegemony in nation-states colonized in the past century. It is nevertheless undeniable that European, colonial, and postcolonial states have had very different histories with respect to their external and internal relationships. Neither Gramsci nor those influenced by him have had much to say about the way nation-states relate to other nation-states or about how relations between states are in turn part of the dynamic of internal state hegemonies. Yet clearly these external-internal relationships must be attended to in an attempt to understand the historical and contemporary nature of local colonial and postcolonial state legal hegemonies.

The postcolonial state is by definition different from the colonial state by virtue of the way external-internal relationships are organized. The official Euro-American rhetoric holds that the postcolonial state has been transformed by the removal of direct control of its state structures by Europeans and the replacement of the latter by indigenous people. This official rhetoric is countered in the concept of neocolonialism, which refers to the idea that newly independent nations are still in relations of economic dependence and subordination relative to

Western European nations. Neocolonialism also carries with it the idea of a continued political domination resulting from economic domination.

My own view is that newly postcolonial nation-states are still very much subject to the economic clout of their former European colonizers and must often continue to make changes in their legal systems in ways compatible with evolving Euro-American capitalistic practices if they want to engage in trade with Euro-American business enterprises and other forms of international economic activity. However, the internal sovereignty of former colonies may be very much enhanced by independence in many legal areas. What little social-scientific documentation there is of recently independent nations' legal systems (e.g., Fitzpatrick 1980; Gordon and Meggitt 1985; Moore 1986; Lazarus-Black 1991, 1992; Rodman 1993) suggests there is considerable variation in what these nation-states' governments do with and in their legal systems after independence.

In spite of this variation, however, recently independent nation-states do have in common a strong interest in maintaining the institutional structures of police, courts, and jails that afford direct physical, coercive control over their citizens. There is an interest in state control over these structures in part so that those in the government can maintain power by physically coercing anyone who would take their power away. But there are also ideological- or cultural-hegemonic reasons for controlling this institutional complex of police, courts, and jails. If the new state can keep peace within its borders, or maintain what is sometimes called "law and order," then it is able to show that it is performing a useful function. These state institutions, then, are themselves potentially or actually polysemous; they carry with them a state force that can be both heinously oppressive and welcomed with relief, and sometimes both at the same time.[1]

In addition, courts in particular provide the opportunity for representatives of the state to engage in cultural-hegemonic work on its behalf. Public court sessions are points of articulation between the state and civil society. As Merry (1990) has demonstrated so effectively for American courts, they are contexts in which people with very divergent ideological interpretations of justice come together. Court sessions provide the representatives of the state who dominate the proceedings an opportunity to put forth interpretations of their own actions that constitute and justify the state in a way that will be palatable to people bringing complaints against others. Such sessions are in this sense state performances, public transcripts (Scott 1990) in which dominant and subordinate actors collaborate in jointly con-

structing a coherent image of the state as serving the interests of the people. Courts that deal with criminal matters, then, such as those in Tonga considered in this paper, may have a particular hegemonic function not necessarily shared by all law within a legal system.

NATION-STATE FORMATION IN TONGA

Tonga is a constitutional monarchy which received its "independence" from Great Britain in 1970. Tonga, located in the South Pacific with Fiji as its closest neighbor to the west, was visited by European ships on journeys of exploration and trade during the second half of the eighteenth century. But the first and only major institutionally organized form of colonization, Christian missionization by English-speaking Methodists, did not achieve a continuous presence until the late 1820s. Missionaries became involved in local factional politics and actively assisted the local chief Tāufa'āhau, who is credited with having forcibly unified the country between the 1820s and the 1850s, becoming the country's first king, King George Tupou I.[2]

In Tahiti, Hawaii, and Tonga, missionaries established strong bases earlier than in other Pacific societies. During the first half of the nineteenth century in all three of these settings, indigenous leaders of relatively unified and centralized Polynesian societies were urged by missionaries to develop codes of law that, they argued, would legitimate indigenous rule in the eyes of European nation-state leaders and help local peoples fend off threats to their political sovereignty (Scarr 1967; Lātūkefu 1974; Campbell 1989). Codes of law were circulated among these "island kingdoms" through the initiative of missionaries and political functionaries from English-speaking countries. Tāufa'āhau and the missionaries advising him studied both the 1831 Huahine Code developed for the Society Islands (Latukefu 1974:128) and the Hawaiian Constitution of 1852 (Latukefu 1974:214) during the period between 1839 and 1875. During this period, Taufa'ahau promulgated and revised a series of codes of law, culminating in the Tongan Constitution of 1875 (Latukefu 1974, 1975).

Today Hawaii is part of the United States, and Tahiti, or rather the Society Islands, is still a colony of France, while Tonga is an independent nation. At every stage of development of nation-statehood in Hawaii and Tahiti, the process was far more apt to be initiated and controlled by Europeans than in Tonga, and this appears to have been a major factor in the very different fates of these three island kingdoms.

Competition among European states for colonial influence in Tonga was first manifested in the domain of missionary activity when a French

Catholic mission was established in the 1850s, much to the dismay of the English Wesleyan missionaries. But it was not until Germany expressed interest in trade with Tonga in the 1870s that the British began to more actively exert political control over Tonga's external relations in that region of the Pacific (Scarr 1967). In 1876 Tonga negotiated a treaty with Germany that recognized Tonga's independence and the king's sovereignty. In return, Germany was given rights of trade and the use of the major northern island of Vava'u as a naval station (Latukefu 1975:56). The British quickly followed with a similar treaty signed in 1879.

Great Britain did not want Tonga to come under the dominant influence of Germany (Scarr 1967). No European country had ever had a strong economic motivation to control Tonga. The island group was not seen as a place with great potential for a plantation economy and there were no obviously highly desirable raw materials to be extracted. Nor were there many Europeans there: forty some in 1876 (Scarr 1967:89). So only a few settlers clamored to have their interests protected. But Great Britain did have significant economic and social investments in Fiji and so wanted to control Tonga's external relations with other societies to assure the stability of Fiji.[3] In 1899, at the Samoan Convention, Britain agreed to give up its treaty rights to Samoa in favor of Germany, while in return Germany agreed to give up treaty rights in Tonga in favor of Great Britain (Lātūkefu 1975:69).

In 1900 Tonga signed the Treaty of Friendship and Protection with Great Britain through which for the first time Tonga's full independence was legally curtailed. Virtually all of the island groups in the Pacific had been subjected to similar limitations on their sovereignty by this time (Lātūkefu 1975:69). King Tupou II, who succeeded his grandfather in 1893, "bitterly resisted the inclusion of the protectorate clause in the Treaty" (Lātūkefu 1975:70). In fact the treaty did not stipulate that Tonga's foreign relations should be conducted exclusively by Britain; but they were so conducted for the next seventy years, until Tonga became independent in 1970 (Latukefu 1975:70). And although Tonga was supposed to retain internal sovereignty under the treaty, there was endless coercive meddling by the high commissioners of Fiji and by British consuls to Tonga until Queen Salote took the throne in 1918 (Scarr 1967; Latukefu 1975).

Ironically, while the English missionaries had consistently argued for the Westernization of Tonga and apparently convinced Tongan leadership that it was necessary to prevent British intervention in and control over Tonga, the colonial staff associated with the British High Commission in Fiji who proceeded to intervene in Tonga's internal

affairs had considerable contempt for this Westernization (Scarr 1967). Tongans themselves were (and are) very proud of their constitution, celebrating it and analyzing it in traditional oratory and accepting political actions taken in its name (Lātūkefu 1974:216). But representatives of the British High Commission disparaged it as the ill-begotten progeny of too much Westernization too soon (Scarr 1967).

Although the twentieth-century political life of Tonga has attracted little of the historical attention devoted to the creation of Tonga as a nation-state, the consensus among scholars regarding twentieth-century Tonga is that the country has been able to sustain far more independence, autonomy, and continuity in governmental form than the overwhelming majority of other Pacific societies.

Queen Sālote, who succeeded Tupou II, ruling from 1918 to 1963, is given a great deal of the credit for this continuity and for her country's internal as opposed to external sovereignty. She is still today widely loved and revered by the people of Tonga. Queen Sālote made many fundamental contributions to the cultural construction of Tonga as a nation-state. Her ideological framing of the nation-state's links to Tonga's precontact past is particularly relevant to my argument.

During her reign, Queen Sālote was the single most important voice representing Tonga to scholars writing in English, and they reproduced her vision of the relations between Tonga's past and its present.[4] She constructed the state as linked to the family dynasties of all three of the major figures of Tonga's past, rather than to just the Tu'i Kanokupolu line that her forebearer, George Tupou I, had linked himself to. She represented herself as the direct descendant, the embodiment, of all three lines (Gifford 1929; Lātūkefu 1974; Bott 1982; Ellem 1987).

At the same time Queen Sālote used her position, her power, and state funds to create an educational system which promulgated the traditional arts, the high culture of the Tongan chiefly people. In at least some, if not all, of the schools of Tonga, Tongan morality is expressed in the teaching of many subjects, including the traditional arts. This morality is anchored in, among other things, ideas about how members of the family are supposed to treat one another. The brother-sister relationship which I describe in more detail below, figures prominently in these discourses.

In sum, Queen Sālote played a major role in infusing state and civil society with a Tongan past and present as these were understood by an evolving but still traditional elite. Other Tongans working in European-derived institutional complexes, including the legal system, followed her lead in the ongoing Tonganization of the Tongan state.

THE HISTORICAL EMERGENCE OF COURTS IN TONGA

From the beginning of nation-state formation in Tonga up to the present, law has played a central role in legitimating the state for both Europeans and Tongans. It has been and is used both to maintain Tonga's independence and autonomy as a nation-state and to unify citizens within the state.

Courts were an aspect of the role of law from the time of Tonga's inception as a nation-state. In 1839 Tāufa'āhau had not yet even been given the Tu'i Kanokupolu title that legitimated him in traditional Tongan dynastic terms. Yet, that year he promulgated his first written code of laws, the Vava'u Code. Among its features was the creation of a court with four magistrates appointed by Tāufa'āhau. They were to hold court on the island of Vava'u once a month. Latukefu (1974) has argued that the Vava'u Code was a major move by Taufa'ahau to limit the powers of the chiefs in the area and increase and centralize his own power. The court in particular would end the chiefs' exclusive role as arbiters of the disputes of those under them. In setting up this court, Tāufa'āhau followed the pattern I have already argued is characteristic of nation-state governments, that of securing control over "law and order" at the level of people's daily activities, to assure direct physical control over them and win their support by doing something for them.

The Vava'u Code and the court it set up also signaled to the outside world Tāufa'āhau's intention to create a government "by law" in a form respected by Europeans, as the missionaries were arguing was necessary for autonomy.

Thus, there have continuously been courts of the Tongan nation-state hearing disputes presided over by Tongan magistrates for 150 years. Taūfa'āhau, later King George Tupou I, used his courts to impose new laws (many of them urged on him and drafted by missionaries as part of their Westernizing vision), to punish his enemies, and to generate income from the fines imposed.

Powles (1990) has argued that Western law penetrated Tongan life early and deeply, more so than in other Pacific societies, and in ways consistently reflected in court statistics showing high levels of court use throughout this century. While he sees Western criminal law as making little allowance for Tongan custom, both he and Gifford (1929) recognize, as do Tongans today, that the imposition of the new laws bore important similarities to the precontact imposition of negative

tapu (supernaturally sanctioned proscriptions covering a range of activities).

Each new code of laws put forth by Tupou I expanded the authority of the magistrate's court and elaborated the governmental structure, including a legal system of which the early court formed the core. In 1875 for the first time, the constitution called for a differentiation in types or levels of courts, including a land court, and also specified that Tonga would have a chief justice. From 1875 until 1905 that chief justice was a Tongan (Ellem 1990). But in 1905 British intervention in the Tongan government, resulting in a supplement to the Treaty of 1900, entailed the introduction of British Supreme Court justices, and British men have held that position ever since. This is the only position of power in the government of Tonga today that is still regularly occupied by a European.

Thus, while Tongans assumed European forms of government, law, and courts quite early, they completely controlled and inhabited those forms with little European governmental intervention until the first treaty with Great Britain in 1879. Even after that Tongans experienced the direct presence of the British High Commission in Fiji only intermittently until 1905. Subsequently, there was a British Supreme Court judge in the government. There was also a British agent and consul appointed by and responsible to the high commissioner in Fiji with enhanced judicial powers to try cases involving British subjects living in Tonga (Scarr 1967).

King Tupou II (1893–1918) is represented in historical accounts of the Tongan state as using his first British Supreme Court justice to help him fend off the encroachments on his power by the British agent and consul (Scarr 1967; Latukefu 1975). Queen Sālote (1918–1965), however, is represented as accepting and even welcoming consultation with her agent and consul, while sometimes resisting and undercutting encroachments on her legal authority from her Supreme Court justices by hiring her own lawyers and reducing the power of the position of Supreme Court justice (Ellem 1990; Campbell 1992). Thus the rulers of Tonga seem to have both accepted and actively resisted the efforts of British legal agents to continuously transform the Tongan legal system.

Since independence in 1970, King Tupou III (1965–present), whose own law degree reflects the importance Tongans give to law, has left in place the criminal code and the two-tiered distinction between the lower-level magistrate's court and the higher-level Supreme Court, but there is no longer a land court. The king reportedly has made it his policy to keep land litigation, especially noble title succession disputes,

out of the courts entirely (Marcus 1977). This is consistent with the postcolonial pattern, which I earlier suggested is probably widespread, of leaving "law and order" systems of courts, police, and jails from the colonial period intact while significantly transforming other areas of legal activity.

It should be evident from this account that the Supreme court, presided over by a British barrister since 1905, and the magistrate's court, presided over by Tongan magistrates since 1839, have somewhat different histories, and today are in some respects quite different in their legal functions. It is true that semiotically and rhetorically they are one system. The Supreme Court judge has authority over the magistrates. The code revisions Supreme Court justices have supervised over the years undoubtedly ramify downward through the system. And the courts are interdependent jurisdictionally in that the Supreme Court deals with more serious charges, is a court where there is a right to a jury trial, and is a court of appeal for the magistrate's court.

However, both in the past and today, Supreme Court judges have expressed the view that an important part of their job is to Westernize or modernize the Tongan legal system.[5] The Supreme Court is frequently the context in which cases involving Europeans, European institutions, and Tongans working in European-derived organizations are heard. That court continues, then, to play an important role in mediating Tonga's relations with the outside world. And to the extent that the Supreme Court contributes to sustaining Tonga as a nation-state and to maintaining a Tongan state hegemony, it does so significantly through this articulation of Tonga with the rest of the world.

The magistrate's court, in contrast, is overwhelmingly concerned with activity internal to the state, with the disposition of cases primarily between villagers who are part of a rural proletariat (Fitzpatrick 1980) engaged in conflicts that arise out of their daily interactions. To the extent that the activity of this court helps sustain the Tongan state, it is by providing a service to people and in so doing constructing the state as at one ideologically with the people. At both levels, one aspect of constantly constructing Tonga as a nation-state is the projection of Tonga as both culturally distinct and culturally homogeneous, key criteria for sovereignty in European nation-state ideology.

When the nature of legal hegemony is considered, then, it is apparent that the law may be ideologically unified in some respects, and the impression of unity helps perpetuate the state. But this impression of unity directs attention away from functional and ideological diversity, which arguably also help perpetuate the state.

GENDER AND LAW IN TONGA

According to the feminist critique of the state (Enloe 1989; Connell 1990; Peterson 1992), states are gendered and this gendered quality has been ignored in theories of the nature of the state. Worldwide, it is argued, nation-state government practices are embued with implicit and unacknowledged patriarchal assumptions that are manifested in a variety of ways. States are seen in this perspective as ideologically masculinist, and as constituted overwhelmingly by men, with these two features mutually reinforcing one another. At the same time, it is recognized that while all nation-state governments are patriarchal, the realizations of patriarchy are diverse, so that we may speak of different "gender regimes" (Connell 1990). In anthropology, the view that indigenous women have lost power and status where European colonial gender regimes were imposed through law is commonly argued (Gailey 1987; Silberblatt 1987), but also challenged (Linnekin 1990).

In Tonga the state structure is "gendered" implicitly and pervasively by who can or does hold what kinds of positions. In a taken-for-granted way that I have never heard questioned by Tongans, Tongan men hold all of the highest-level positions of authority within the governmental structure. All of the cabinet ministers and all of the elected representatives in the national legislature are men. Only two women have ever been elected to the national legislature. Women hold lower-level government positions, predominantly of a secretarial nature. In some areas of government, both women and men hold similar positions, but their actual job tasks are gendered. The failure to problematize this gendering is highlighted by the fact that whether or not Europeans should hold government positions rather than Tongans has, in contrast, been problematized historically and sometimes is now. It is also well documented that Tongan rulers have made an effort to populate their highest levels of government with traditional hereditary chiefs, so this too is less taken for granted than the gendering of the state.

There is no general, coherent, explicated ideology about the nature of women and men in Tonga that is used to justify male control of the Tongan state. Instead there are points and regions of clarity, specific positions articulated about women and men, not all of which are necessarily consistent with one another or relatable to one another, and not all of which provide a rationale for the gendering of the state.

In Tongan law, these little islands of ideological clarity and explicitness have emerged historically as a result of a dialogue between Europeans and Tongans, so that Tongan law can be thought of as a

"zone of contact," to use Pratt's (1992) term—one among many such zones—between Europeans and the people they contacted in other parts of the world.

Because the majority of published material on the history of Tonga is written by authors of European background, it is easier to be aware of the British contribution to the Tongan legal dialogue about women. It is clear that the missionaries of the 1830s reacted against certain Tongan practices and views relating to women and made an effort, by way of legislation, to get Tongan women and men to behave in relation to one another as the missionaries thought was proper. For example, the missionaries objected to Tongan marital and sexual practices and succeeded in outlawing polygamy and in legislating marriage by the state as the only legitimate basis for inheritance of land-use rights (Gailey 1987).

Yet not all gendered legal encoding can be explained by missionary morality. Notably, the Constitution of 1875 specified that men could inherit land rights. By implication, and in fact, women cannot inherit, with very few narrow exceptions, up to the present. This fundamental gendering of Tongan law radically differentiates women's and men's present-day efforts to enhance their personal economic circumstances. There is no evidence that these laws were motivated by missionary morality; nor is it clear that an indigenous, precontact Tongan cultural logic influenced them. Rather, the laws seem to be the result of a British understanding of Tongan practices, or of British practices of that time.

Marriage law and land law, then, are two areas of law that explicitly address gender. A third island of relative ideological clarity about gender, which itself is internally differentiated and inconsistent, is the Tongan valuing of and attention to the brother-sister relationship. According to Powles (1990:166), this relationship was an early target of legislation. Conventionally, the sister had the right to take things within her brother's purview and that of his children, as we would say "without asking," including the fruits of his gardens. This was first outlawed in the Code in 1862 and continues to be specifically outlawed in the written law in force today. This law is often used to illustrate how English values were encoded in law in ways that undermined Tongan custom (Powles 1990) and weakened the position of women (Gailey 1987). However, as Powles acknowledged, the old Tongan way is still widespread today. Presently some Tongans disparage the custom of sisterly taking while others revere it; their attitudes toward this practice are determined by a variety of factors, including how well-off the brother is and whether he has a loving relationship

with his sister. It is conceivable that this same diversity of opinion existed among Tongans in 1862; thus, missionary agency in the promulgation of this law may be overestimated.

The brother-sister relationship is also viewed by contemporary magistrates as having a bearing on the way in which they carry out their judicial duties (Helu 1988):

> There are social institutions by which one has to defer to one's father and uncles and to one's father's people, but by far the most powerful is the FAHU institution by which one has to defer to one's sisters or female cousins in the same generation and their children, or to a female line of ancestry common to one's paternal line. These relationships are embodied in real dealings between people and they represent real pitfalls for civil servants, including the adjudicators in their work in court. The traditional social ethic is such that it is more becoming to care for one's relatives than for oneself. (Helu 1988:49–50)

Thus far I have shown how the *fahu* relation has been held up in law and legal discussion as something to constrain, but this is a multifaceted relationship; as we will see further on, the brother-sister relationship is held up as a positive model for general social comportment in many criminal cases in the magistrate's court in Tonga.

For both Samoa (Schoeffel 1978; Shore 1981) and Tonga (Gifford 1929; Fanua 1975; Bott 1981) the conventional reason given for the sister's right to make demands on her brother is her higher rank relative to the brother within the family. This higher rank is said to cause the sister to be owed greater respect and deference by the brother than she owes to him. It endows her with a kind of sacredness and even supernatural power (Rogers 1977). Yet the sister has been said to lack the secular power of her brother (Schoeffel 1978; Bott 1981). Even so, women in these Western Polynesian societies are held to have better standing in the brother-sister relationship than in the husband-wife relationship, in which the wife is clearly subordinate to her husband (Schoeffel 1978).

Recently the conventional view that the sister has no secular power in Tonga has been questioned, as well it might be, considering the aforementioned fears of her powers expressed in law. The new idea that brother and sister pairs frequently cooperate as teams in exercising authority within their family (Ellem 1987; Herda 1987) is more consistent with my own experience of contemporary village life in Tonga and with what Tongans say about the brother-sister relationship.

The sister's right to take whatever she wants from her brother is often mentioned by Tongans. An equally often mentioned aspect of

this relationship that is less developed in written publications, but more relevant to the use of the brother-sister relationship as a general model for good relations between the sexes, is that of a mutual respect in demeanor that distinguishes the brother-sister relationship from other cross-gender relationships. It is conventional in the ethnographic literature (see, e.g., Bott 1981) for it to be said that brothers and sisters avoid one another as a way of showing respect. But in actuality they are often copresent, and reasons for avoidance are conventionalized and predictable.

Tongans often refer to the constraints on demeanor in the presence of one's cross-sex sibling as the brother-sister *tapu*. Basically when brothers and sisters are together they are not supposed to talk or joke about sexual or bodily matters, nor should anyone else talk in this way when brothers and sisters are copresent. The lively, energetic joking and sexual innuendo Tongans often enjoy is thus curtailed. Brothers and sisters are also enjoined not to show anger around one another.

When brothers reach their teenage years, they often build a separate house behind the main house on their family's house lot where they sleep. In such houses, but also elsewhere, young men entertain their friends in the evenings by holding *kava* (a narcotic drink) parties. The *kava* party is presided over by a *tou'a*, a young unmarried woman with whom the men flirt and engage in sexual joking. The explicit reason given for young men removing themselves from the house when they do this is to be away from their sisters when they are having this particular kind of good time.

The respect between brother and sister is extended by both to patri-laterally and matrilaterally related cousins up to several times removed, so that from the male point of view, one must be careful where one goes to *kava* parties in a village where one has kin, because there are often many cousins around. In other words, one cannot be sure when classificatory brothers or sisters are present.

Finally, the brother-sister relationship is held by at least some to play a special role in the preservation of public order. Although this idea was less often mentioned to me than those I have already discussed and may be more idealized, I have been told that if a brother were fighting with others on the street and the sister were to come out of the house, the fighting would stop immediately out of respect for the sister.

In the next section, it will become evident how this reciprocal vision of sibling regard is used by representatives of the state as a general model for appropriate conduct in public.

THE BROTHER-SISTER RELATIONSHIP
IN THE MAGISTRATE'S COURT

My discussion of the way in which the magistrate's court and, more specifically, the criminal cases heard there are gendered begins with a consideration of the gender of bureaucrats and clients. All of the magistrates are men. All of the police who appear in court in the functions of callers of cases, witnesses, and police prosecutors are men. Sometimes male police witnesses are reporting on what female victims and witnesses have told them. There are Tongan women on the police force, but they have clerical jobs or direct traffic. All of the clerks who appeared in the magistrate's court during my observations were also men. Again, there are female clerks, but they tend not to appear in court.

Among the users of the courts, the defendants, and those victims and witnesses who testify against them, men predominate. No more than a few female defendants appeared in the two locations of the magistrate's court where I observed and tape-recorded.

There were more female victims of crimes in proportion to male victims than there were female defendants, but here too more men appeared in court to testify as victims than women, even when women as well as men could be considered victims. For example, when a man was charged with the theft of *kava* from a small store where the clerk was a woman, the man who owned the store testified as the victim or person who had been wronged even though he was not in the store when the *kava* was taken.

Women also appeared as witnesses to testify on behalf of victims and defendants. Again, when both women and men can appear as witnesses, men are often used much more extensively; women are brought in simply to affirm what the male witness said or simply to be identified and/or to identify themselves as present and as having witnessed the relevant events. An exception to this general rule occurs when the victim is a woman; then she will often have only female witnesses.

In all of these ways women are relegated to the background in court activities. Several Tongan women have expressed to me the idea that it is considered undesirable for women to be in the courtroom because bad words—swear words, or words having to do with sex—might be spoken and brothers and sisters might be present. The general extension of the brother-sister *tapu* to cousins means that in a public gathering where strangers are present, a cousin could be present without one's knowing it, so that people say, "You never know when a brother and

sister might be present," and this is what Tongans are concerned about when they are uneasy about women being in a courtroom. No one, however, has ever used this as a rationale for keeping men out of the courtroom, only women.

In this way the presence of males is taken as the norm, or the unmarked condition, and the presence of females as the problematic or marked circumstance. The brother-sister *tapu* becomes a reason for preferring men over women in bureaucratic roles in the police and courts. This is an example of a "gendering" of the state that is specific to Tonga. Here the gendering of state roles, which is naturalized for the most part, is given an explicit rationale in a moment of ideological clarity.

The cases I will discuss here were taped in a magistrate's court in the town of Nuku'alofa, the capital of Tonga, and in a magistrate's court in Nukunuku, a large village. Both communities are on the main island of Tongatapu. The taping occurred between October 1987 and March 1989. The cases heard in these courts were generally either violations of auto licensing and safety requirements or criminal misdemeanors charged as violations of criminal law (Chapter 15, Law of Tonga, 1966), including theft and assault, and violations of the section of law called Order in Public Places (Chapter 26, Law of Tonga, 1966), notably for public drunkenness and profane or indecent language spoken in public.

Theft, assault, public drunkenness, and profane or indecent language are the four most common offenses in Tonga by far. Charges under the few statutes they are governed by tap into only a very small portion of the written criminal code in force in Tonga. From this we can see that the active use of codes can be, and in this case is, very selective.

The procedure through which criminal defendants are charged, plead guilty, and are sentenced is similar to such procedures in the United States. The procedure has a predictable sequential structure. First the magistrate states the nature of the charge and cites the written law describing the relevant violation. Then he elicits a plea from the defendant. If the defendant pleads guilty, as he usually does, the police prosecutor then describes the factual acts that constitute the crime and the defendant's record, if he has one. Often at this point the prosecutor will offer a moral evaluation of the act at issue. The magistrate then addresses and interacts with the defendant who has pled guilty. At this point he, too, usually offers a moral evaluation of the situation. Finally the magistrate sentences the defendant.

The first of the four most common charges is public drunkenness

[*Na'a ke konā 'i he feitu'u fakapule'anga*, "You were drunk in a public place"; Chapter 26, Section 3(q) Law of Tonga, vol. I], and often on the "government" road in the middle of town ['*i he hala pule'anga loto kolo*]. In the rural areas, especially on weekend nights, one sees men walking home from *kava* parties along the edge of the road, some staggering and weaving into the road. These people are sometimes picked up by the police under this charge. Overwhelmingly the defendants in these cases are young to middle-aged men.

In the majority of cases of *kōna* the defendants plead guilty, there is little discussion of the factual circumstances involved, and the person is given a low fine as punishment. Where there is moralizing it comes from the magistrate who deplores the youth's lack of education and possible family neglect or, less often, the middle-aged man's failure as a role model, and urges him to do better. Sometimes the rhetoric of brother-sister copresence is invoked. The defendant is told that, because no one knows whether his relatives might be present or whether brothers and sisters might be copresent, he should not get drunk.

The other three charges are considered more serious and are often given more time and attention than the *kōna* cases. The second charge under which far fewer, but still a great number of cases appear in the magistrate's court is hitting, or simple physical assault [*Na'a ke tā*, "You hit"; Chapter 15, section 104(a)]. Usually information about the factual circumstances surrounding "hitting" emerged when the case was presented to a magistrate. Even when the defendant pled guilty, as was generally the case, he would be questioned by the magistrate. Sometimes the victim and witnesses would also appear to testify. Fines for this charge were higher than for cases of *kōna*, "public drunkenness," and people more often went to prison for this offense.

These cases often involved fights between men, although occasionally it was a question of a woman and a man. They also often involved the less serious charge of drunkenness. Sometimes it was apparent that a fight between two men had been preceded by exchanges of "bad language," the last charge to be discussed, suggesting that angry insulting words had contributed to the escalation of a disagreement.

In only two cases brought before the court in my translated and transcribed data base were men charged with having hit their wives (as opposed to women to whom they were unrelated). This is noteworthy because Tongan men do hit their wives and children. In general the overall level of physical punishment of children at home and at school appears to be higher than in the United States (see also Kavapalu 1990). In both these cases a fight had developed between the husband

and the wife in a public place. In both the woman pleaded with the magistrate to drop the charges and he did so.

Over time I developed the understanding from Tongans that it is acceptable that children and wives are hit, but not too much. There are people who don't want any hitting in their homes, but they will not push that standard on others. Kavapalu (1990) argues that Tongans make a distinction between hitting with control to punish so that a child will learn, and hitting in anger entailing a loss of control, which is considered unacceptable.

When a woman is hit too much, she is supposed to be able to count on her father and/or her brothers to intervene on her behalf. This could involve the husband being beaten up. And she can leave her husband and return to her father's home. But Tongans are very strongly committed to the continuation of marriages and to meeting a perceived need children have to be raised by both parents together. So it is commonly said that a woman will be urged by all her relatives to return to her husband and support will not be there for her to leave permanently. Above all hitting within the primary family is viewed as a matter to be dealt with by families and not through the courts. The moral rhetoric surrounding the cases of assault generally focuses explicitly on the anger of the assailant and on the inappropriateness of his actions considering his relationship with the person he hit.

Theft [*Na'a ke kaiha'a*, "You took"; Chapter 15, section 133(a)] is the third criminal charge that appears commonly in Tongan magistrates' courts. I witnessed no cases in which the thief was a woman, although I did tape a more serious case of theft in the Supreme Court in which a woman was charged. As in the *tā*, "hitting," cases, the defendants usually pled guilty, yet there was still discussion of the factual circumstances. Women sometimes appeared as victims and/or witnesses, but less often than men.

The theft of crops is a common charge in court, although quite often when crops are stolen nothing is done about it, particularly if the theft was not observed by a caretaker of the garden. Pig theft is also common. Theft from stores and from people's houses also occurs, but less often.

In the Nukunuku village magistrate's court, two crop-theft cases that were heard involved family members. In other words, a relative of the person raising the crop had taken some of it and been spotted by a caretaker who had that person arrested. Both these cases were dropped by the magistrate upon appeal from the crop owner. One clearly involved a brother-sister connection in which a sister's children

were taking crops from a brother's field. The other case involved grandchildren taking crops from a grandfather. Tongans with whom I discussed these cases felt it was likely that the crop owner was handling the matter as he did to try to stop the crops from being taken without causing the relative to be convicted.

The common moral rhetoric of magistrates in cases involving the theft of crops or pigs is to tell the defendant that, if he is needy, he can ask for food and he will be given it, and this is true. But it is also true that people often feel ashamed to ask. Thieves are also often reproached by the magistrates for not doing something constructive for their people and country, including not cultivating their own gardens.

The fourth and last common criminal charge brought in magistrates' courts is "profanity" or *lea kovi* in public [*Na'a ke lea kovi 'i he feutu'u fakapul'anga*, "You swore in a public place"; Chapter 26, Section 3 (n,o,p)]. This charge is in sharp contrast to the other three in the way in which men and women are involved. While most of the defendants are men, most of the victims and their witnesses are women. Thus, in this type of charge, in contrast to the other three, women are taking men to court.

The police are apparently involved quite immediately and directly in deciding who is drunk and who is engaged in physical assault, and they intervene in the activity that constitutes the criminal act. They may also be asked to intervene by citizens. Theft and bad language both appear to entail less immediate involvement of the police, and more active immediate involvement of witnesses and victims who take the initiative to report the act to the police. Both charges are more likely to have women as victims and witnesses, with by far the highest involvement of women in the "bad language" or *lea kovi* cases.

In *lea kovi* or "bad language" cases, angry words are spoken in public. In the majority of cases a woman is sworn at, threatened, or spoken to in a derogatory way. Anger is a common thread in these situations, the anger of a man directed toward a woman. But the anger itself is not explicitly addressed in these cases nearly as much as it is in the assault cases. Instead, it is made known by the fact that such words are often shouted (*kaila*), by references to threats of hitting, and by reports of the occasional escalation of bad words to physical assault. One gets the impression that these cases are seen as a threat to public order in general. In addition, even though physical assault sometimes follows the use of bad language, Tongans will say that they consider a spoken insult to be worse—more hurtful and more harmful to one's reputation—than physical assault.

The actual *lea kovi* cases I taped revealed quite a range of kinds of

verbal expressions. In one case, two young Mormon missionary women were sworn at by a drunken young man in English on a public road at night. In another case, a young woman was spoken to in a derogatory way by an older male relative outside their homes on his town property in the context of a long-ongoing feud between their two households. In one, a woman was threatened with bodily harm by a man standing outside her house and yelling at the house. In yet another, one man swore at another but was overheard by a group in which brothers and sisters were copresent.

In each court case, the Tongan exercise of evidence law does entail repeating the exact words that constituted *lea kovi* in a quotelike form, often more than once. This is precisely the type of thing that generally makes Tongan men and women uneasy about women being in the courtroom or about men and women being together in public while such speech is uttered. Clearly, however, women are willing to set aside any uneasiness they may feel to pursue the prosecution of men who have spoken *lea kovi* to them. Most of the *lea kovi* cases I observed occurred toward the end of a court session; thus, most of the people who had been there when the case began had left. This scheduling strategy may be a deliberate attempt to reduce the number of people who will be present when the bad words are uttered.

And as in other circumstances where young women have explained to me that others don't want them in the courtroom, here too the police prosecutor and the magistrate invoke the copresence of brothers and sisters as a reason why *lea kovi* should not be uttered. In courtroom samples 1 and 2 below we see first the police prosecutor's moral stance early in a case of *lea kovi* and then the magistrate's moral stance toward the end of the case.

1. Police Prosecutor (12–3–87, tapes 16–18):
 Sea, ko e lea kovi ko éna he po'uli 'o Novema 7, Sea ko e me'a 'oku tokanga ki ai 'a e talatalaaki Sea ko e nofo feuluulufi 'a e fonua. 'Oku ke mea'i pē 'apē Sea ko e fa'ahinga lea kovi ko éni 'oku 'i ai 'a *tuofefine* mo e *tuonga'ane*, faifekau, 'oku 'i ai e kakai lotu, 'oku nau fanongo ki he ngaahi lea kovi ko éni.

 Your Honor, about that use of obscene language on the night of November 7, Your Honor, what the prosecutor is concerned about is the relationship of mutual respect in society. As you are quite well aware, Your Honor, this use of obscene language was [heard] in the presence of brothers and sisters, church ministers, religious people, and they heard those swear words.

2. Magistrate:
 Na'a ke fanongo ki he me'a 'a e talatalaaki. Ko 'uhinga ko e

kakaila [. . .] 'oku kei fai ha kai efiafi ha 'api 'oku feha'ofaki ai
'a e *tuongna'ane* mo e *tuofefine*. Hanga ai 'e he tamaíki 'o tā koe.
Pea 'alu atu ho famili 'o hoko ai ha fu'u moveuveu 'i ho'o ki'i
fo'i fakakaukau pe mo ho ngutu hala ho'o lea 'oku fai 'o he feitu'u
'oku tapu'i 'e he lao. Ko e fa'ahinga hia ko éni, I., he ko ho'o
kape (mou) kia S., kae fanongo ki ai 'a S. fekau 'e lao ki 'alu 'a
S. 'o faka'ilo koe. Feitu'u ia 'oku tauhi ke maau, feitu'u fakapu-
le'anga, hala pule'anga 'a e fale koloa, feitu'u fakataha'anga kakai
'o ai ki he fakamaau'anga ni.

You have heard the case from the prosecution. The charge is
brought against shouting (. . .) while members of a family were
having their evening meal in a house nearby where *brothers* and
sisters were present. Because of this some youths beat you up,
and your relations came to your aid and a big fight resulted, just
because of your whims and your mouth. Your words were wrong
and were spoken in a place in which the law forbids it. I., for
this kind of offense, your swearing at S., S. heard it and the law
told S. to go and bring a charge against you. Such places are to
be kept orderly—public places, public roads, and shops, [and]
the meeting places for people including this court.

In this case, brothers and sisters actually were present, but often
there is invocation of just the possibility of the copresence of a relative,
which usually means people classified as in a brother-sister relationship
to one another:

3. Magistrate (10–15–87, tape 1):
 'Ikai ke 'ilo na'a ko ho mou *kainga*.
 No one knows if it's your *family/relative*.

In some sense the possible as well as actual copresence of brothers
and sisters operates as an icon and a metonym for relations in public
in general. The idea seems to be that, in public, where people often
in fact don't know one another personally, everyone should relate to
everyone else as brothers and sisters relate to one another. When
women take men to court for *lea kovi*, what they do is seen as a
reasonable thing to do. This is in sharp contrast to the treatment of
wife beating, where everything is done to discourage a wife from taking
a husband to court. Both the metonymic use of the brother-sister
relationship and the effort to keep the husband-wife relationship out
of court are consistent with the generally lesser cultural value associated
with wives relative to sisters mentioned earlier and with the much
greater verbally explicit ideological elaboration of the brother-sister
relationship compared with the husband-wife relationship.

Both the prosecutor and the magistrate cited above invoke the brother-sister relationship. But in other ways their moralizing about what the defendant did differs. The prosecutor emphasizes mutual respect and lists social relations and identities where this respect is especially important. He does not, however, say anything about contexts calling for respectful behavior.

The prosecutor's view is closer than the magistrate's to the explanations Tongans gave me of why those who use bad language are taken to court. A woman's reputation and that of her family as respectable people are seen as jeopardized when she is spoken to angrily in public. There is a sexual dimension to the woman's reputation, that is, the use of bad language, when directed at a woman, can suggest that she is being defined as someone who does not stay within the boundaries of propriety in this area. But a woman's reputation and respectability are not exclusively based on her sexual conduct. Men also are insulted when spoken to angrily in public, but it is considered more acceptable for them to respond in other ways, including hitting, even though this in turn may land a man in court. In taking a man to court for *lea kovi*, a woman preserves her own and her family's reputation by asserting that she deserves to be treated respectfully. Going to court in itself and asserting one's right to good treatment also command respect.

When the magistrate in courtroom sample 2 above condemns the defendant's bad language, in contrast to the prosecutor, he relates the bad words not just to certain role relationships and social identities, but to places, actual contexts, that are generally termed public, *feitu'u fakapule'anga*, and stresses the need for order, *maau*, in these places. In making these connections between the brother-sister relationship, absence of bad language, public places, and social order, the magistrate establishes, through his choice of terms, a clear role for the state in the preservation of morality in a way not matched by the prosecutor.

Maau, "to order," is the root of the word for judge, *fakamaau*, and of the word for court, *fakamaau'anga*; so when the magistrate uses these terms and links them together, he is invoking the fundamental definition of his role and the fundamental function of the court, that of preserving, creating, and reestablishing orderliness. And the adjective *fakapule'anga* means not only "public" but also "government," with the result that there is a subtle or not so subtle asserting of government authority over all public and not-so-public gatherings where respectfulness and orderliness are considered appropriate.

In this way, through the sequential structuring of the contributions of, first, the police prosecutor and then the magistrate, the state is represented as upholding the mutual respect and social order symbol-

ized by the brother-sister relationship. In sharp contrast, the state legal system is treated by Tongans as having no role in intrafamily conflicts, and specifically no role in conflicts between husband and wife, unless the marital tie is broken first.

CONCLUSION

I have argued that in the Tongan magistrate's court the brother-sister relationship is invoked in a way that contributes to the construction of a distinctly Tongan state hegemony. Historically, we know that the cultural distinctness of the Tongan brother-sister relationship has been consciously included in the legal dialogue constructed between Europeans and Tongans for over a hundred years, having first been referred to in written law in the 1860s, as noted earlier. Tongans know that this relationship is different for them from what it is for people in other societies, and that difference is something that English-speaking people who come into contact with Tongans are informed of by Tongans early on.

When the brother-sister relationship is explicitly invoked in a Tongan court proceeding, this invocation is just one of many ways in which participants in court proceedings inflect their activity as Tongan. They thus construct the Tongan state as distinctly Tongan, and as different from other states. This differentness provides a continuous justification both in the international community and within Tonga itself for the continued survival of Tonga as a sovereign nation-state. By holding all public interactions to the standard of mutual respectfulness of the brother-sister relationship, prosecutors and magistrates also identify state interests with family interests and morality, projecting a cultural homogeneity across institutional domains for the country as a whole.

As I have argued throughout this paper, however, the state's attempt to hegemonize the brother-sister cultural norm cannot be captured by a concept that defines hegemony solely as a pervasive, unconscious lived reality for two reasons. First, there are both implicit and explicit dimensions to ideological hegemony, as has been shown for the gendering of the Tongan state. Thus the gendering of governmental positions, giving men all of the positions of power, is largely implicit and has a taken-for-granted quality for most Tongans. And yet there are flashes of explicit justification for this gender ordering, such as the idea that women should not be present or hold positions in some government domains because of the brother-sister *tapu*.

Second, great ideological diversity coexists with shared ideology.

There is, of course, the difference between sisters and wives pointed to in the title of this paper, making it clear that all Tongan female gender identities are not viewed in the same way. I have also argued that within the Tongan legal system, the Supreme Court and the magistrate's court address very different concerns and espouse rather different ideologies. Where gender has been problematized historically in the legal system—for example, through the embedding of Western marriage in Tongan culture, in the limiting of landholding to men, and in the law against sisters taking from brothers—the issues are compartmentalized, suggesting an ideologically fragmented rather than a coherent gendering of the legal institutions of the state.

The actual use of the brother-sister relationship within law reinforces the impression of ideological diversity and even contradictoriness. The cross-gender sibling relationship is framed as needing to be constrained where it involves sisters taking from brothers and where it involves *fahu* relationships that may cause magistrates to have their decisions influenced by such relationships. Yet the same relationship is supported to the point that is imposes and is used to impose a constraint on all cross-gender relationships in public/government domains in the magistrate's court's *lea kovi* cases.

In general, then, it is important to recognize that nation-state hegemony involves the promotion of many kinds of ideological diversity as well as the production of totalizing discourses. Further, the kind of ideological diversity that exists cannot be accounted for by reference to nation-internal relations of domination and subordination alone. It involves international social processes as well as nation-internal social processes and the differentiation of activities and domains as well as the differentiation of social identities. Finally, an understanding of state control requires attention to the nature of the manifestations of state-sustaining ideologies in practice as implicit or explicit, fragmented or coherent, and contradictory or consistent.

Notes

This research was supported by a grant from the National Science Foundation, 1987–1990. I would like to acknowledge the helpful discussions of the topics considered here with Shiela Slaughter, Aaron Cicourel, Ana Alonso, Daniel Nugent, and the graduate students in my Colonial and Postcolonial Legal Systems seminar: Helen Robbins, Andrea Smith, Betsy Krause, Brian Fulfrost, Ted Coyle, Kathleen Williamson, Walt Weber, and Scott London. They cannot, of course, be blamed for problems in the paper.

1. Relatedly, it is apparently quite common in newly independent states for the colonial criminal law codes that address sources of disorder which are probably universal, such as theft and assault, similarly to remain intact, as

opposed to being dismantled and completely reconstituted because they are associated with the oppression of a former colonial power.

2. The island groups that today constitute Tonga have often been characterized as making up one of the most centralized Polynesian societies at the time of initial contact between Tongans and Europeans. Indigenous Tongan histories in contemporary public and official spheres (Bott 1982; Lātūkefu 1974; Mahina 1986) represent a Tongan past of family dynasties that replaced one another over time. Soon after early contact in the late 1700s, however, Tonga is represented by Tongans and Europeans alike (Bott 1982; Lātūkefu 1974) as having been in a state of disunity and warfare among chiefdoms.

3. Fiji had been annexed by Britain in the mid-1870s (Scarr 1967).

4. Examples of Queen Sālote's influence on scholars include Gifford (1929), Bott (1982), and Lātūkefu (1974). This influence still resonates in today's historical writings about Tonga (e.g., Herda 1987; Ellem 1987).

5. Loss of internal political autonomy is not today an immediate danger for Tonga, so this is not a direct motivation for modernization as it once was. But Tongans are under pressure from the businesses and government of other countries, particularly industrialized countries with whom they engage in economic activity, to carry out dealings involving foreigners in ways these outsiders are comfortable with and believe in, and this often entails the use of Western legal processes.

References

Althusser, Louis. 1971. "Ideology and Ideological State Apparatuses." In *Lenin and Philosophy and Other Essays*. New York: Monthly Review Press. 127–86.

Bott, Elizabeth. 1981. "Power and Rank in the Kingdom of Tonga." *Journal of the Polynesian Society* 90:7–81.

———. 1982. *Tongan Society at the Time of Captain Cook's Visits: Discussions with Her Majesty Queen Sālote Tupou*. Wellington: Polynesian Society.

Cain, Maureen. 1983. "Gramsci, the State, and the Place of Law." In *Legality, Ideology, and the State*. David Sugarman, ed. New York: Academic Press. 95–117.

Campbell, I. C. 1989. *A History of the Pacific Islands*. Berkeley: University of California Press.

———. 1992. *Island Kingdom: Tonga Ancient and Modern*. Christchurch: Canterbury University Press.

Connell, R. W. 1990. "The State, Gender, and Sexual Politics: Theory and Appraisal." *Theory and Society* 19:507–44.

Corrigan, Philip, and Derek Sayer. 1985. *The Great Arch*. Oxford: Basil Blackwell.

Duranti, Alessandro, and Charles Goodwin, eds. 1992. *Rethinking Context*. Cambridge: Cambridge University Press.

Ellem, Elizabeth. 1987. "Queen Sālote Tupou of Tonga as Tu'i Fefine." *Journal of Pacific History* 22(4): 209–27.

———. 1990. "Chief Justices of Tonga 1905–40." In *Tongan Culture and*

History. Phyllis Herda, Jennifer Terrell, and Niel Gunson, eds. Canberra: Australian National University. 170–86.

Enloe, Cynthia. 1989. *Bananas, Beaches, and Bases: Making Feminist Sense of International Politics*. Berkeley: University of California Press.

Fanua, Tupou. 1975. "The Jealous Brother/Kuku Mokuku." In *Pō Fananga*. Neiafu: Tofua Press. 43–48.

Fitzpatrick, Peter. 1980. *Law and State in Papua New Guinea*. New York: Academic Press.

Foucault, Michel. 1972. "The Discourse on Language." In *The Archaeology of Knowledge*. New York: Pantheon Books. 215–37.

———. 1980. *The History of Sexuality, Volume 1: An Introduction*. New York: Random House.

Gailey, Christine. 1987. *Kinship to Kingship: Gender Hierarchy and State Formation in the Tongan Islands*. Austin: University of Texas Press.

Giddens, Anthony. 1979. "Ideology and Consciousness." In *Central Problems in Social Theory*. Berkeley: University of California Press. 165–97.

Gifford, Edward. 1929. *Tongan Society*. Honolulu: Bishop Museum.

Gordon, Robert J., and Mervyn J. Meggitt. 1985. *Law and Order in the New Guinea Highlands: Encounters with Enga*. Hanover, N.H.: University Press of New England.

Gramsci, Antonio. 1971. "State and Civil Society." In *Selections from the Prison Notebooks*. New York: International Publishers. 206–76.

Helu, Hingano. 1988. "Independence of Adjudicators and Judicial Decision Making in Tonga." In *Pacific Courts and Legal Systems*. Guy Powles and Mere Pulea, eds. Suva, Fiji: University of the South Pacific. 48–52.

Herda, Phyllis. 1987. "Gender, Rank, and Power in 18th-Century Tonga: The Case of Tupoumoheofo." *Journal of Pacific History* 22(4): 195–208.

Joerges, Christian, and David M. Trubek, eds. 1989. *Critical Legal Thought: An American-German Debate*. Baden-Baden: Nomos Verlagsgesellschaft.

Kavapalu, Helen. 1990. "Dealing with the Dark Side in the Ethnography of Childhood." Unpublished.

Latukefu, Sione. 1974. *Church and State in Tonga*. Canberra: Australian National University Press.

———. 1975. *The Tongan Constitution: A Brief History to Celebrate Its Centenary*. Nuku'alofa: Tonga Traditions Committee Publication.

Law of Tonga 1966. London: Eyre and Spottiswoode Limited obtained from London: Sweet Maxwell.

Lazarus-Black, Mindie. 1991. "Why Women Take Men to Magistrate's Court: Caribbean Kinship Ideology and Law." *Ethnology* 30(2): 119–33.

———. 1992. "Bastardy, Gender Hierarchy, and the State: The Politics of Family Law Reform in Antigua and Barbuda." *Law and Society Review* 26(4): 863–901.

Linnekin, Joyce. 1990. *Sacred Queens and Women of Consequence: Rank, Gender, and Colonialism in the Hawaiian Islands*. Ann Arbor: University of Michigan Press.

Mahina, 'Okusitino. 1986. *Religion, Politics, and the Tu'i Tonga Empire*. M. A. thesis, University of Auckland.

Marcus, George. 1977. "Succession Disputes and the Position of the Nobility in Modern Tonga." *Oceania* 47(3): 220–41, (4): 284–99.

Merry, Sally. 1990. *Getting Justice and Getting Even: Legal Consciousness Among Working-Class Americans*. Chicago: University of Chicago Press.

Moore, Sally. 1986. *Social Facts and Fabrications: "Customary" Law on Kilimanjaro, 1880–1980*. Cambridge: Cambridge University Press.

Peterson, V. Spike. 1992. *Gendered States: Feminist (Re)Visions of International Relations Theory*. Boulder, Colo.: Lynne Rienner Publishers.

Philips, Susan U. 1992. "Husband and Wife in Family Unity: A Tongan Magistrate's Court Case of Wife Beating." Paper presented at the 91st Annual Meeting of the American Anthropological Association, San Francisco, December.

———. 1993. "Ideological Diversity in Judges' Use of Language: Judicial Discretion in the American Guilty Plea." Unpublished. (Book ms)

Powles, Guy. 1990. "The Early Accommodation of Traditional and English Law in Tonga." In *Tongan Culture and History*. Phyllis Herda, Jennifer Terrell, and Niel Gunson, eds. Canberra: Australian National University. 145–69.

Pratt, Mary Louise. 1992. *Imperial Eyes: Travel Writing and Transculturation*. London: Routledge.

Rodman, William. 1993. "The Law of the State and the State of the Law in Vanuatu." In *Contemporary Pacific Societies: Studies in Development and Change*. Victoria Lockwood, Thomas Harding, and Ben Wallace, eds. Englewood Cliffs: Prentice Hall. 55–66.

Rogers, Garth. 1977. "The Father's Sister Is Black: A Consideration of Female Rank and Power in Tonga." *Journal of the Polynesian Society* 86:157–82.

Roseberry, William. 1991. "Introduction." In *Golden Ages, Dark Ages*. Jay O'Brien and William Roseberry, eds. Berkeley: University of California Press. 1–18.

Scarr, Deryck. 1967. "The High Commissioner in Polynesian Politics: Tonga, 1876–1914." In *Fragments of Empire*. Canberra: Australian National University Press. 82–114.

Schoeffel, Patricia. 1978. "Gender Status and Power in Samoa." *Canberra Anthropology* 1(2): 69–81.

Scott, James. 1990. *Domination and the Arts of Resistance: Hidden Transcripts*. New Haven: Yale University Press.

Shore, Bradd. 1981. "Sexuality and Gender in Samoa: Conceptions and Missed Conceptions." In *Sexual Meanings*. Sherry Ortner and Harriet Whitehead, eds. New York: Cambridge University Press. 192–215.

Silverblatt, Irene. 1987. *Moon, Sun, and Witches: Gender Ideologies and Class in Inca and Colonial Peru*. Princeton: Princeton University Press.

Sumner, Colin. 1979. *Reading Ideologies: An Investigation into the Marxist Theory of Ideology and Law*. New York: Academic Press.

Tigar, Michael E., and Madeleine R. Levy. 1977. *Law and the Rise of Capitalism*. New York: Monthly Review Press.

Williams, Raymond. 1977. *Marxism and Literature*. Oxford: Oxford University Press.

Willis, Paul. 1977. *Learning to Labor: How Working-Class Kids Get Working-Class Jobs*. New York: Columbia University Press.

LAW'S PATRIARCHY IN INDIA

Erin P. Moore

A Muslim woman covers her face with a head shawl leaving a crack through which she can view the men. She squats on the floor in the corner of the open-air, three-sided men's bungalow shouting and waving her arms. Today there is a gathering of about twenty men who sit on rope-strung cots in the bungalow. The Muslim woman, Honey, is addressing a village council, a panchayat, in her affinal village. Her father, brother, uncle, husband, male in-laws, and important elders are present. It is unusual that she would voice her side of the story instead of only being represented by her father. But this speaks to the crux of the issue: Honey is said to be bold, assertive, and to dominate her husband, Rahiman.

Honey has had an affair with and raised children by Kamir, a powerful village man. It is gossiped that Honey drove Kamir's sterile wife out of the village in order to arrange a liaison between Honey's younger sister and Kamir. Honey and her sister have shared Kamir's affection since that time, 1978. Honey and her father called the current panchayat, ten years later, to discuss the marriages of her prepubescent daughters and to ask for a divorce. Her continuing affair permeates the panchayat discussion.

"The wife of a weak man is everyone's wife," one elder says. Another man, lamenting this arranged marriage, comments, "If the boy that we had found for [Honey] had been very strong, then the girl [Honey] would have been fine. It would be good for the girl. . . . he could *keep her under control.*"

This paper explores Muslim women's multiple subordination and their conflicting allegiances with and against the local Muslim caste, with and against local religious leaders, and with and against the state. My focus is on Muslim women and the law in rural Rajasthan, India,

in a village that I call Nara. Honey exemplifies one Muslim woman's attempt to define her own sexuality, her obligations to her family, and her relationship to her spouse. I examine performances of domination and resistance in the home, the panchayat, and the state courts. Through the vehicle of this one case, I will examine how law legitimizes ideologies and asymmetrical power relations, particularly between genders.

Legal scholars note that "law and legal institutions in a number of cultures (if not all) have played a significant role in maintaining systems that subordinate and oppress female human beings, and law continues to do so" (Henderson 1991:412; see also Eisenstein 1988; Fineman and Thomadsen 1991; and MacKinnon 1984, 1987, 1991). Henderson connects this oppression to patriarchy, which she defines generally as the systematic domination and subordination of females by males (ibid.). In rural north India patriarchal social organization is marked by male supremacy in the family, politics, and economics. Descent is traced through male heirs and inheritance passes from fathers to sons. The constellation of customs surrounding marriage contributes to an overall ideology of women's dependence on men: child marriages, arranged marriages, dowry (money and gifts given by the bride's family to the groom's family at the time of the marriage), and village exogamy accompanied by patrilocal residence. Within this context of patriarchy, law acquires a gendered nature. Law is used to define and control women's social and sexual personae through both village "customary laws" and state personal laws (laws relating to marriage, divorce, maintenance, child custody, inheritance, and adoption). Law is a key vehicle for the spread and enforcement of the ruling ideologies, a vehicle of ideological domination.[1]

For the rural Indian villager there is not one unified ruling class or ideology; there are a variety of separate, yet interacting, authorities— the dominant village caste, the state, and organized religion. These authorities all present different shades of male patriarchal rule with different political-economic origins, ideological groundings, and agendas of control through schools (the state and religion) and distinct dispute-processing institutions. Each is a source of law whether it be state, village-customary, or religious law. Indian villages like Nara are isolated from the centralized government by the lack of police patrol, paved roads, electricity, and telephones. The powerful villagers can parlay the village's remoteness into "home rule." While villagers frequently make trips into the local towns to market or to sell their cash crops, neither the town dwellers nor representatives of the town's political infrastructure ever spend any appreciable time in the villages.

As a result, control over the village is a contested issue. In Nara, the village panchayat, controlled by the wealthy and the well-connected, exercises the most local influence. However, the state arranges occasional elections for a multivillage administrative and judicial committee that is supposed to govern Nara and a group of surrounding villages by statutory law. The state government funnels agricultural subsidies and other development monies to the village through the head of this committee. The committee is co-opted to village concerns through bribes, village favoritism, and strongarm politics (Meschievitz and Galanter 1982; Moore 1985, 1990a, 1990b). Another contestant for village control, the Islamic fundamentalist movement from Delhi, sends wandering preachers and mendicants into the villages, challenging the Muslim majority to conform village tradition to their teachings (see Aggarwal 1971). In sum, the rural Indian villager is the focus of an ideological warfare waged by competing spheres of authority.

Writing on resistance in South Africa, Comaroff and Comaroff distinguish between ideological control and hegemony. They define hegemony as "a product of the dialectic whereby the content of dominant ideologies is distilled into the shared forms that seem to have such historical longevity as to be above history. . . . they do not appear to have any ideological content. They belong to the domain of fact, not value. They are just there ineffably" (1991:30). In their view, what differentiates hegemony from ideology is the "factor of human consciousness," when a notion enters consciousness it becomes ideological rather than hegemonic (ibid. 28–29). Hegemony is then a question of individual consciousness: to what extent am I aware of the forces that influence my thoughts and actions? Individual members of a group may be "snowed" while others remain skeptical. For Nara men, the awareness of competing authorities may shed light on the ideological nature of their discourses. For Nara women, there is little difference in the patriarchal nature of the village, state, and religious authorities. Patriarchal domination may present the best example, from my research, of Comaroff and Comaroff's notion of hegemony, of a habit so engrained as custom that it continues as a "matter of widespread consensus and silent complicity" (1991:27). Still, there are individuals, like Honey, who can see through the patriarchal domination to demand something different. For them, patriarchy is not hegemony but ideology. In the material below, Honey challenges patriarchal ideology through the use of public dispute-processing institutions.

The state courts and the village panchayat are the two main public dispute-processing forums used by the villagers (Moore 1985, 1990b, 1993; see also Moog 1991). They are foils for each other, standing at

philosophical extremes (Cohn 1959, 1965). Starr and Collier (1989:9) emphasize that inherent in multiple legal orders are asymmetrical power relations derived from divergent economic-political origins. "Legal orders should not be treated as closed cultural systems that one group can impose on another, but rather as 'codes,' discourses, and languages in which people pursue their varying and often antagonistic interests" (ibid.). In Rajasthan, a villager may use a variety of forums in the course of any one dispute, and there is a continuing negotiation between dispute-processing systems (Moore 1985, 1990b). For women, however, the pluralistic legal formations can be seen as "fields of overlapping and intersecting forms of subjection" (Abu-Lughod 1990:52).

No dispute-processing forum welcomes women's complaints; their issues are often not recognized as actionable in the legal lexicon of the male forums. The local male culture does not consider it unfair that only a man can, among other privileges, grant a divorce, marry several contemporaneous spouses, inherit land from parents, and travel freely and without fear. The village panchayat consists of powerful community leaders, men whose decisions are framed within the context of social alliances, politics, and personal histories. In a rhetoric of equality in the all-male panchayat it is said that men and women are both panches (members of the panchayat); but no one interprets this as an invitation for women to participate. Women are excluded from attendance at the panchayat unless they are specifically invited for the limited purpose of presenting testimony. This is true even though most panchayat cases deal with domestic conflicts.[2]

Where the creation of discourse is power, to silence is to dominate. Belenky, Clinchy, Goldberger, and Tarule noted that in the United States one historically and culturally ingrained definition of femininity was that "women, like children, should be seen and not heard" (1986:5). In many contexts, Nara women are taught to be *neither* seen nor heard. The message comes from the male elders, religion, and the state. Silencing is found in traditions of veiling, male leadership and governance, "unilateral" Islamic marriage (the bride is not asked to give her consent to marriage in Nara) and divorce (where only the husband can grant the divorce), as well as in the exclusion of women from the mosques, from the government school (by parents), from inheritance, from land ownership, from participation in the panchayat, and so on (Moore 1990b:367–70; Ramanujan 1991).

On occasion, and in the case presented herein, women may turn to the state system to resist male control within the village. But this is rare. In theory, the state invites women to participate with men in the

benefits of an independent, secular society. State laws offer petitioners an avenue to sidestep village politics with a decision made by a trained judge based on a written, secular, statutory authority that is required by the national constitution to guarantee gender equality. This would lead one to believe that women might use the state courts to challenge oppressive, traditional orders. Starr (1978, 1989) found that in Turkey, where an accompanying economic development program supplemented the legal changes in the status of women, Islamic women successfully used the state judicial system (see also Starr and Poole, 1974). In other examples from traditional Islamic societies, when economic development, education, and social services did not go hand in hand with litigation changing the status of women, women were not successful in using the state system and backlashes occurred (for South Central Asia, see Massell 1968, and for Iran under the shah in 1965 and 1969, see Craig 1979). In still another example, Hirsch argues (this volume) that Islamic women in Kenya can access rights through the Islamic court.

For Nara women, there is no Islamic court and there is no local infrastructure to encourage or direct participation in the state system. Instead, local state courts speak the language of money, politics, and male networking, with the result that local judges often return domestic issues to the villages of their origins. On the macro scale, the state also turns a blind eye to mandated constitutional equality to allow marriages to be controlled by patriarchal religious laws. The state with its Hindu majority (Muslims are 10 percent of the population) refuses to honor its secular contract with women when it fears a religious backlash in the sensitive balance of power between Hindus and Muslims.

Honey's case serves as an example of a rural Indian woman's resistance to village patriarchy through law. Honey tried to negotiate the maze of male control that surrounded her by using both the village panchayat and the state court. Instead of public dispute-processing forums, the rural Indian woman often chooses covert actions. Indian women use gossip, folk songs, petty theft, sickness, spirit possession, flight from the affinal village, violence, and suicide as some of their avenues for resistance (Moore 1993, Moore manuscript). Scott (1985, 1986, 1990) used the term "everyday resistance" to include acts of foot-dragging, dissimulation, false complaint, pilfering, slander, and so forth, thus denoting a consistent pattern of action by an individual or a group directed against superordinates. Scott and Kerkvliet note that this resistance is a form of "self-help" that requires no coordination with others, is underwritten by a subculture of resistance, and

avoids any direct symbolic affront to authority (1986:1). Scott saw everyday resistance as a middle ground between passivity and open rebellion.

A lawsuit departs from the realm of Scott's "everyday resistance" and creates yet another middle ground between the everyday and the rebellion. The "occasional resistance" of a lawsuit is not a self-help measure, nor is it an act of defiance camouflaged within the quotidian. The open challenge of a public hearing invites redress and perhaps retaliation, but the tools of this open revolt are the tools created by the master. As such, there is a level of respect and accommodation, within the insubordination. Scott, citing Gramsci, recognized that hegemony "requires some actual sacrifices [compromises] or restraint by the dominant groups" (1985:337–38). The dominant group engenders loyalty by making promises to the subordinates and at the same time sows seeds of discontentment when promises are not fulfilled. The laws of the land are a good example of this compromise. Laws give the oppressed some modicum of power, while those in control create and manage the rules of the game.[3]

For Honey and rural Rajasthani women, both everyday resistances and an occasional appeal to the state system are part of a repertoire for action. There is not a simple dialectic—hegemony and resistance—but competing authoritarian ideologies and many resistances.[4] Scott envisioned that class consciousness would permeate everyday resistance but he excluded gender from his analysis (but see Scott 1986:33 n. 11; Hart 1991). This paper highlights gender relations and women's "occasional resistance" through the law.

THE MEOS: A HISTORIC AND CULTURAL CONTEXT

I conducted research on law and disputing in the village of Nara, in northeastern Rajasthan, India.[5] Nara is approximately one hundred miles south of New Delhi but isolated from the paved road by seven miles of cultivated land. It has a population of approximately 1,100 persons, Hindus, Sikhs, and Muslims, comprising fifteen castes. A village of this size and diversity is fairly typical of north Indian villages. Approximately 80 percent of the Indian population lives in scattered agricultural villages.

After the partition of India in 1947, many of the Muslim families, the dominant landowners in Nara, fled to Pakistan, while their Sikh counterparts came to Rajasthan. At the same time, the Indian govern-

ment gave the landless peasants small amounts of land, providing them the option to abandon their traditional caste-related work. Specifically, they could substitute a low-ranking caste identity for a higher status, and perhaps a higher income. The village has experienced tremendous demographic changes over the last forty years. Muslims and Sikhs changed places in their flight from hostile neighbors. Sikhs came to Nara for the first time and Muslim families were split between nations. Wealthier Hindu shop owners fled permanently to the cities, and low-caste families acquired land and new occupations, in some cases abandoning the hereditary landowner-service caste relationships.

Nara has a political organization typical of villages in northern India (Cohn 1959). Although there are a variety of castes, some castes may be represented by only one household and the village is dominated by one caste. In Nara the Meos are numerically strong (comprising 72 percent of the village population) and wealthy (owning 83 percent of the land). The Meos are a Muslim caste (*jati*) who are said to have converted from Hinduism in the sixteenth century (Aggarwal 1971, 1976). Their religious practices reflect an amalgamation of Muslim and Hindu traditions. They are the original landowners and farmers in this area, the largest single ethnic group, and economically and politically dominant.

The Meos inhabit a territory popularly referred to as Mewat. Before British rule, Mewat was an autonomous state with a great deal of decentralization of power (Aggarwal 1971:33). Because of its proximity to Delhi, parts of its history, beginning in the twelfth century C.E., are included in published accounts. Mewat lay in the corridor between deserts and hills to the south of Delhi. As a result of this position, Meo villages were in the path of conquering armies and the Meos were often caught up in the battles for the succession to the Delhi throne. The Meos garnered a reputation for lawlessness in the eyes of rulers, and the Meo villages were frequently burned and plundered (Bannerman 1902:157; Ram 1968:48; Tod 1960:717). In modern times the British historians labeled the Meos a criminal class of "blood-thirsty Mahomedan fanatics," reflecting the Meo opposition to the British (Aggarwal 1971:40). The Meos themselves take pride in their ethnic identity and their independence from the state. Meo ballads, sung by the men, sing the praises of male heros who have challenged the state (Aggarwal 1971:35–36; Moore 1990b:34–36). Male Meo resistance is a documented tradition, but the women too carry this tradition of resistance. Theirs is also a resistance against patriarchy.

At the time of my research Honey was probably the most vocally

unhappy wife in Nara. She was neither a "typical" village woman (if there was such a person) nor was she aberrant. Her circumstances exemplify gender relations within the village and some of her responses to oppression are the same as those of other village women. Just before puberty the marriage of a young girl is arranged by the male elders of her family to a member of her caste in another village, usually about ten miles away over dirt roads often not passable by vehicle. In her affinal village the young bride is expected to shield her face to male strangers as well as men that are her husband's age or older. This is the local expression of pardah. She is to be subordinate, subservient, and dependent on her in-laws.

In Nara most village men and women spend some part of their days farming. Men and women work side by side cultivating the fields, but it is not unusual for a woman to take charge of every aspect of farming except driving the oxen to plow the fields or marketing the grain. Women and their children often play the major role in irrigating, planting, weeding, harvesting, threshing, and winnowing. The Meo women have a reputation for their hard labor as opposed to their hookah-smoking spouses. Bannerman quotes O'Dwyer: "While the [Meo] men are lazy, the women are energetic and industrious and do most of the field-work except the ploughing" (1902:157). Ram adds, "Their [Meo] women . . . do more fieldwork than the men; indeed one often finds women at work in the crops when the men are lying down" (1968:130). Women today continue to be active farmers. Their competence at farm work and their shared access to the harvest (when they are still actively involved in the labor) give Meo women some source of economic power. Still, land is the greatest single symbol (and source) of wealth, power, security, and independence in Nara. The land, however, with rare exceptions, is owned by the men. At a man's death, the land passes to his sons and not his wife or his daughters. Landownership coupled with the political realities of patrilocal, patrilineal households, results in women's dependencies on their husbands and later their sons.

Hindu, Sikh, and Muslim men take a second wife, and usually abandon the first, if the first does not bear any children. The dominant ideology is that sons continue the family name and care for the parents in old age. The daughters are said to be a liability; they cost the family an expensive wedding and dowry, and their sexuality is a threat to the family honor. As is typical of many Hindu and Muslim societies today, fathers, older brothers, and husbands believe that it is their duty to control the women of their lineage. The concern over women's sexuality is part of the separate standard for male and female behavior.[6]

Srinivas notes that in rural India a woman who has an affair with a male of a lower caste is usually thrown out of the caste, while a man who has committed a similar offense is generally let off with a fine (1954:157). He comments: "In the former case, the panchayat would say that a mud pot defiled by a dog's touch must be thrown away, whereas in the latter, they would say that a brass pot touched by a dog should not be thrown away but purified. This is only one instance of a double standard of morality prevalent all over India" (ibid.).

In subtle ways men monitor the movement of Nara women. Men stop and share a hookah with their neighbors, pray together in the mosque, meet in panchayats, and go to the market towns. The only sanctioned chance that women have to visit with women from outside the joint household is while they are working: waiting in line to fill their water pots or to wash the buffalo at the well, gathering grasses in the far fields for buffalo feed, or collecting firewood in the hills. Even these chances are monitored by the household men to see that the women do not delay too long This is not to say that women, particularly older women, do not take time or visit and complain to neighbors as they like. Still, they may be rebuked. For the younger women, the isolation of life in the affinal village is countered with visits or flights home where women are pampered by their mothers and seek the support of fathers, brothers, and uncles in their battles in the affinal village.

DISPUTING WITHIN THE VILLAGE

The majority of public dispute processing in Nara takes place in the village panchayat. The panchayat is a principal means of affirming Meo community identity and solidarity. For members of any caste, it is one vehicle for resisting state intervention in local tradition. Sometimes this is at the cost of personal justice.

Panchayat, *panca:yat*, is derived from the Sanskrit root *panc*, meaning five, literally a gathering of five. The panchayat is a meeting of the powerful men in the village. There may be four, five, fifty, or more. Within the village, the term refers to a number of different meetings with both administrative and judicial functions. In short, any community gathering of any number of men is referred to by the Nara villagers as a panchayat (for example, a multicaste gathering to organize a Muslim funeral feast or to discuss a new government aid project). Even within the realm of disputes, the Nara panchayat takes many forms. It is a forum of flexible membership for male community interaction: to witness the repayment of a debt, to collect evidence, to air

grievances, or to work for a compromise in a dispute. A process more than an event, the panchayat entails a series of meetings with different degrees of privacy, leadership, and consultation with various members. There are discussions, groupings and regroupings, sharing of tea, stories and jokes, and breaks for prayers.[7]

In Nara this village panchayat is called the *bradri* panchayat, the council of brothers. Men from a variety of castes may attend the meeting, but very few Hindu and Sikh men speak publicly. Instead, they may offer their opinions when the panchayat breaks and men cluster in small groups between the formal sessions. In these splinter meetings, non-Meo caste members are influential and take part in panchayat leadership. Dumont questioned whether *egalitarian* village caste panchayats ever existed in India (1970:171–72). He concluded that there were only caste panchayats of the dominant caste that controlled village politics (see also Girtler 1976; Srinivas 1959, 1987). The forum I call the village panchayat is not an egalitarian forum, nor is it exclusively the arm of the Meos.

Panchayat ideology says that where five men gather, God will join them and the men will speak with honesty. They are said to be *panch parmishwar*, meaning "God is in the elders"; "honor them as God"; or "their words are God's words." Villagers often say that one man should not make a decision alone. Sharing the decision alleviates uncomfortable feelings about being the one held responsible for a decision, answerable to the parties, the villagers, or the police. The law of this all-male assembly is an oral tradition that is grounded in a religious context (a local mixture of Hindu and Muslim traditions that is characteristic of the Meos [Aggarwal 1971]). This "law" is in perpetual re-creation but it does not waiver far from its patriarchal foundations. If disputants are not happy with the outcome of the panchayat, they may call an appeal before a new panchayat by enlisting the help of a wider circle of villages, take the matter to the police to exert a different sort of power through the state system, or resort to self-help. The variety of options available to any one individual depends on one's sources of power.

The Nara panchayat leaders—the wealthy, the high-caste, or the large-lineage heads—generally voiced the most faith in village justice. To a large extent, the Meos control the settlement of disputes in the village. They will physically prevent villagers from taking disputes into the town where the state court is located. At the same time, a non-Meo has difficulty getting a fair decision in the panchayat against a prominent Meo. When an old Sikh man was beaten by the son of a Meo leader, the Sikh said, "The panchayat can't do anything. The

Meos don't make a decision for the Hindus. When it is their own problem, then they will immediately gather [form a panchayat], but never for us." I asked a Hindu Barber if the panchayat would give his family justice. He replied, "For us, no way would they give us justice. Everyone knows. It is this, where there are ten houses, there are ten houses sitting there [in the panchayat] where there is one house, . . . [He paused.] You understand? It is this, where they have ten families, they have ten sticks. Then the justice goes there. [The Hindu Barber caste has only two families in the village.]"

In his study of the panchayat, Srinivas quotes an informant who contrasts state court decisions, based on the merits of a case, with those of the village court that "has to look to the wealth and following of the disputants in the village" (1987:203). The informant continued, "If one of the disputants is capable of building a party against the elders then the law is not strictly enforced. You have to allow the string to sag (*sadila bidabeku*) for otherwise it will snap. Sometimes, facts have to be ignored. 'Let the facts slip through your fingers' (*beralu sandiyalli bidabeku*). An issue is sometimes 'floated away' (*telisi bittevu*), i.e. let off lightly" (ibid.).

This is the political reality in Nara as well. The law bends under the weight of numbers. Village justice ideology reflects and amplifies the voice of power. It is "might makes right," or as the villagers say, "He who owns the stick owns the buffalo," "He who owns the stick owns the land," "There is no decision for the poor, only for the stick [*lathi*]." It is the justice of the stick. One poor Meo said, "The shoes of the powerful are sweeter than a *jelabe* [a honeylike Indian sweet]."[8]

Nara women do not expect to find justice in the panchayats or the courts. These are the men's forums. I asked a Meo woman, "Where does a woman find justice?" She responded, "If there is any dispute, or you are angry, you are just angry within yourself and keep on working. You don't go anywhere." Another Meo woman said, "You don't go anywhere. Women are not elders of the panchayat; if you go to a neighbor woman and tell her about your trouble, it will create more trouble." A Sweeper woman, whose caste was the lowest in the village and was represented by only one household, said, "If someone curses me, I say go ahead and curse me. I don't care." If she was not paid her wages, she did nothing about it. She had no options. A Leatherworker woman described how her buffalo had been untied in the early morning hours while she was relieving herself in the fields. When she returned to her home and found it missing, she traced the tracks to the home of a powerful village elder. Knowing that the panchayat would not support her, I asked if she would call the police

to help her retrieve it. "Who is going to pay the police their bribe?" she asked rhetorically. To call the police results in a double loss, the loss of the animal as well as of the bribe money. The state, too, is in the hands of the wealthy and powerful.

Honey and the Village Panchayat

For months tensions had been mounting between Honey and her in-laws. Chachi and Rahiman had decided that it was time to arrange the marriages of Rahiman and Honey's two prepubescent daughters. Honey was not in agreement as to the timing or their choice of spouses. She enlisted the aid of Kamir (probably the biological father of the girls) to seek alternative choices. At the same time Honey's brothers-in-law would not allow Honey or Rahiman to remove their harvested wheat from the fields; they reasoned that it must be available to pay for the marriages. Honey retaliated through a series of petty thefts against her in-laws. Finally, it was rumored that Honey would ask for a divorce.

When Honey decided to publicly confront her in-laws, she asked her father and her brother to come to Nara to call a panchayat, in spite of all the shortcomings of this type of forum. On April 19, 1988, the panchayat began when about twenty-five men assembled in the men's bungalow of the extended family of Rahiman (Honey's husband). Honey's father and elder brother had arrived in Nara the afternoon before to call the panchayat. The men sat on cots or small cane stools that filled almost the entire interior of the bungalow. In the beginning most of the men crowded around the hookah at one end of the room. This panchayat would not be a multivillage affair. It was the more common family panchayat that involved several village families and their in-laws. There were a total of twelve women who had married into Nara from Kandi, Honey's natal village. Their husbands, for the most part, would speak on Honey's behalf along with Honey's father, her brother, and her uncles. Kamir was not present. Although Hindu and Sikh elders were called, they declined to attend.

It was 7:45 A.M. when Ali began the meeting. He was an influential member of Kamir's lineage: at thirty-eight years old he was a wealthy gentleman farmer and the most active member of Nara village panchayats. He asked Honey why she had called her father to initiate this panchayat. "Do you have some problem?" Honey was the only woman present. She squatted on the ground, covering her face. It was unusual for a woman to be called to speak for herself. From the start Honey's presence warned that she was not the "normal" female in this village

culture. She spoke through the small vertical crack in her shawl. "No problem, no problem." Slowly she formulated her complaint in terms of the wheat which she and Rahiman had harvested and her in-laws had impounded. Only as an afterthought did she challenge the recent marriage engagements of her daughters against her will. Raimut, Rahiman's second younger brother, had a quick temper and lashed out in anger.

> Raimut: If we make an engagement we have to spend money. We ran around after Honey to [another village to get her opinion]. I'll tell you the truth, the boys [grooms-to-be] are not each thirty-five years old. [He confronts the gossip that Honey had spread and responds, in essence. "We aren't selling the girls." When young girls are given to older men, the men often offer money to take the girls as second spouses, relieving the brides' families of the obligations of paying dowries.
>
> Honey (*angry, shouting over Raimut*): I don't know what the boys are. I didn't go.
>
> Raimut (*shouting over Honey*): The boys are not thirty-five years old. We went there with some men and said that we were arranging the marriage. Why would we lie? She refused to agree to the engagement but we made the engagement and gave Rs. 52 [money that was part of the ritual exchange].
>
> Honey (*shouting over Raimut's last words*): I don't know what they did.

In conflict cases, panchayat discourse tends to be disjointed, competitive, and overlapping. There is no neat linear progression from a statement of the conflict through to a conclusion. There are no lawyers carefully orchestrating what should or should not be said. Instead, it is a battle to see who can frame the issue under discussion, artfully duck uncomfortable topics, and redirect the discourse.[9] Topics are discussed a handful at a time and in the end few solutions are reached. In the beginning of this meeting there was little direction or interference from the elders. The principal complainants bickered. The actors were addressed by their first names, adding an air of informality to the already chaotic, informal atmosphere.

The panchayat began with the different interested parties attempting to focus the panchayat discussion on their issues. After the initial banter, Honey turned the discussion away from the engagements, her affair, and the rumored request for a divorce to her concern, the impounded wheat. Her brothers-in-law responded that engagements

and weddings cost a lot of money. If they were responsible for paying for the rituals, they argued, they needed to sell the grain to cover their expenses. The engagement issue was wrapped in economic subissues: the responsibility for payment of engagement and marriage costs; Honey's refusal to use her jewelry (as would be expected of the mother) to help pay for the marriages; and the accusations that Honey had stolen from her affinal family, taking most of the possessions from her marital home to the home of her lover. The elders became impatient and finally took charge.

OS (a Nara elder): Quiet everyone! This sort of thing happens daily. [He silences the discussion over the thefts and impounded grain.] Tell the truth and speak about the things that can be settled here. [He tries to redirect the focus of the meeting.]

FA (Honey's Father): Yes, enough!

OS: Don't talk "all around the bush" [*uper niche*]. Talk about the engagement. Now they [Honey's in-laws] have done the engagement.

Asin (*Rahiman's brother, politely acknowledges the authority of the elders*): Listen to us.

OS: Yes.

Asin: We will give [lend] Rahiman the money [for the marriage]. Where we live, Honey and Rahiman can also live.

OS (*to Rahiman*): Son, what do you want?

Rahiman: I am also happy with that. Where I live, she will also live. I will live with my brothers.

Honey (*shouting angrily*): What have you built there? [There is no house.]

OS: Quiet, don't get mad. Be silent. He can make you sit in a *chompri* [open-air shelter in the fields]. You have to live with him wherever he lives. Is this right or wrong?

FA: Yes.

OS: Where he gets wet, you will get wet too. Is this right?

Honey's Father: Yes.

OS: They have two stone houses, they live there [the three brothers-in-law] and there is a thatch hut that you can share.
[. . .]

OS: Chaudhri [Honey's father], now you talk next.

FA: What do you want? What should I say?

OS: Whatever they wanted to say, they have said. Now you talk. Isn't it this? She may starve with them, but she must stay with them. Honey, go to them. Today you are in front of your father.

At each juncture the Nara elder OS sought the confirmation of his speech from Honey's father. While he formulated a solution, he did not act alone but with the consensus of both Nara and Kandi elders. When Honey's protests fell on "deaf" ears, she sat silently. Her resistance would have to follow other paths of action.

Through the course of this April panchayat and a sequel three months later, the elders dealt with each aspect of the conflict in terms of the established norms of the Meo community. The appropriate role of a Meo woman was defined by the men, encoded as Meo "customary law."

> 1. A good wife stays with her husband, serves him, and raises the children, no matter how the husband keeps her, rich or poor— "wet or dry."
>
> 2. Mother and father must raise the children but the children belong to the father and his lineage. The father has the right and obligation to arrange the marriage of the children as he likes. In the April panchayat Ali, a Nara elder, stated: "The girls [Honey and Rahiman's daughters] belong to Chachi's sons [Rahiman and his brothers]. A lot of women leave their husbands, but the children belong to the husband. The girls' master is Rahiman, not you [pointing to Honey's father] or Honey. They will be given [away in marriage] by Sabat or OS [Nara elders]. It is their right. Isn't it?" Honey answered, "Give them. Do the engagement. But why aren't you giving me the grain? They took my buffalo." [She feels powerless to disagree in the face of the all-male audience. Instead she redirects the conversation and bickering begins again.]

There is no discussion of the male norms—if they are right or fair. They just exist. There is no question of which "law" to apply. These norms are stated as if they are timeless. Honey's only defense is to ignore them and flee when the time is right. The norms continue:

> 3. A mother's jewelry [often a combination of presents from both her parents and her in-laws] should be given to her daughters at their weddings. [Such jewelry would constitute a part of the expected dowry.]
>
> 4. The bride's family is "lower" than the husband's family.
>
> 5. Divorce is the sole prerogative of the husband and it hurts the family honor. [Instead, the husband can abandon one wife and marry another if he chooses to change spouses.]
>
> 6. Brothers have authority over and responsibility for the wife of a brother.
>
> 7. Sisters should not regularly visit each other in their affinal village. The elder sister [in this case Honey] has higher status and

should not visit her younger sister. [By encoding this behavior, the elders are implying that Honey should not visit her sister who is married to Kamir, Honey's lover.]

 8. Relatives must not take their disputes to the police or to the courts.

 9. Daughters-in-law should respect their mothers-in-law.

 10. Lineage heads should control the members of the lineage and their wives.

These were only part of the mandates. While the men recited the ideal norms for female behavior, Honey ignored their pleas for acquiescence. She gave her assent in words only. Honey's presence at the panchayat was one more of her many deviations from appropriate female behavior. Honey flouted many of the rules of expected behavior by (1) having the affair; (2) secretly, over time, removing family possessions from her affinal home and taking them to her lover's home; (3) refusing to help arrange the marriages of her daughters; (4) refusing to supply her own jewelry for her daughters' dowries; (5) working in the fields with her sister and her lover instead of with her affinal relatives; (6) buying land in her own name with resources taken from the extended affinal family; (7) secretly obtaining a sterilization; and (8) defying the will of her husband, her father, and the elders by continuing her affair and refusing to live peacefully with her spouse. She was neither respectful nor subordinate.

Within the panchayat Honey shouted her defenses saying that Rahiman is sick; he is often possessed by spirits and he does not provide for the family. The whole family, and many villagers, had seen him at times wandering in a trance, staring in a blank gaze, taking off his clothes inappropriately to a taunting crowd of children. It was true, he was not always well. Some villagers accused Honey of poisoning him with a local herb. Honey excused herself from the paramount duty expressed in both Hindu and Muslim ideology for a woman to serve and honor[10] her husband. Through exchanging favors with her sister's family (meaning that of Kamir), she was able to feed, clothe, and support her children. She pleaded a higher duty to her four children.[11] In addition, everyone knew that Rahiman, at times, allowed the affair to continue so that he could use Kamir's tractor to work his fields. There had been similar cases in Nara. A few other Muslim husbands had ignored their wives' affairs in order to benefit from a borrowed tractor or added acreage to sow. This was within the husband's prerogative, even though villagers continued to gossip. The key to Honey's plight lay not so much in the act of the affair but in the different standard of morality and behavior applied to men and women.[12]

In the panchayats, the men decided that Rahiman could arrange, against Honey's will, the marriage of their daughters; that he should refuse to divorce her; and that she must move from the heart of the village to live on the family farm where her brothers-in-law had recently moved. There she could be under careful supervision and it would be further from her lover's home.

The afternoon of the second panchayat, in July 1988, Honey's sisters-in-law packed Rahiman and Honey's family belongings and, together with Honey and Rahiman, forcibly moved the household out of the village. That evening, Honey excused herself from the family fire to relieve herself in the fields and fled from the village and its imposed norms. She has not returned since (for over four years). Instead, in spite of village pressure to use the panchayat and not the state courts for all dispute processing, Honey filed a lawsuit in the local municipal court asking Rahiman for maintenance payments.

DISPUTING WITHIN THE STATE FORUM

One of the most noted consequences of British rule in India was the formation of a unified national legal system. In all matters except personal laws, uniform territorial rules were established.[13] Attention to the individual and enforcement of standards without reference to the group meant that the new court system might offer new avenues for mobility and advancement for both the powerful elite and the village underclasses (Galanter 1989 [1968]:26). In response, the courts were flooded with cases (see Cohn 1959, 1965; Mendelsohn 1981; and Rudolph and Rudolph 1960).

The Nara villagers are not passive recipients of the modern system. The choice to use the state system can have very specific consequences on relationships within the village. There is significant village pressure to use the indigenous forums for dispute processing. To bring a dispute involving villagers before the panchayat is said to give honor to the community (see also Dumont 1970:181). In fact, it preserves the community power structure. A respected person is defined partly as someone who has no dealings with the courts or the police.[14] A villager maximizes or minimizes his or her "local" worth by the choice of forum. There is no jury system in India; a petition to the court asks for a decision by one man and a state defined solution, both alien to the panchayat.

In Nara I found that the majority of upper-caste men had had some experience with the state legal system. Generally the women only had had experience through their husbands. Nara villagers complained

about the corruption in the courts. "With money you can buy any result you want; if you put the skull of a man whom you have killed in the palm of your hand and five or ten thousand rupees on top of that, you will be set free," an Untouchable man told me. This same story was repeated by other villagers. The courts are seen as an arena of and for the powerful. The police are feared for their liberal use of the stick against both complainants and respondents. Lawyers are feared for their verbal skills which can turn truth into lies, and all the actors—witnesses, lawyers, judges, and police—are vulnerable to bribes.

The relationship between women, the state courts, and the conflict between secular and religious personal laws presents a complicated picture. In India there is a uniform civil code, as well as religious laws that can control personal domestic issues. Unless a marriage is specifically registered under the Special Marriage Act of India's Uniform Civil Code, the marriage (and the concerns arising from the union—divorce, maintenance, and inheritance) is governed by the religion of the parties. Most Indian marriages are controlled by the respective religious traditions.[15]

According to Islam, marriage is a civil contract and it is not considered an equal partnership between the husband and the wife. The husband can have four contemporaneous wives, while the wife can have only one husband. He has special rights of divorce that are not available to the wife. The most well known of these is the "triple talaq" where, without cause and not in the presence of his wife, a husband can utter the triple talaq before witnesses to dissolve his marriage. A wife could force a husband into a divorce only if he wrongly accused her of adultery and did not retract the statement. The kazi (Muslim priest, judge) would decide if the accusation were unfair.[16]

In 1937, the Shariat law was enacted in India to apply a uniform Muslim law in issues of marriage, divorce, succession, and property. The intention was to abolish regional custom and usage. It was not until 1939, however, with the passage of the Dissolution of Moslem Marriages Act, that Muslim women were granted the right to seek judicial divorce, yet only on grounds of cruelty, desertion, religious conversion, absence, and repudiation. Under the Shariat law, as practiced, the wife is entitled to maintenance for approximately three months after the divorce.

In 1949, independent India drew up a constitution that would continue to respect the variety of personal laws while at the same time aiming to create a secular, uniform civil code. The constitution guaran-

tees freedom of religion, the right to conserve one's culture, and freedom from discrimination on the grounds of religion, race, caste, or sex. The drafters of the constitution intended to guarantee religious freedoms by allowing the various religious groups jurisdiction over personal law matters. The inherent contradiction between freedom of religion and the demands of equality becomes manifest when we see that under the religious personal laws women do not receive equal treatment.[17] Where the Uniform Civil Code would guarantee Nara Muslim women, for example, equal rights in divorce, parenting, and inheritance, according to statutory Muslim personal laws and Meo tradition these matters are almost entirely in the hands of men. Women's rights activists in India protest the discriminatory nature of these laws.

A year after Honey had fled Nara and the panchayat's decision, she filed a petition in the local state courts asking that Rahiman be required to pay maintenance. The case was filed under the Code of Criminal Procedure. In order to understand this local action, it is necessary to frame it within the context of an internationally celebrated Indian Supreme Court case.[18] In 1985 Muslim personal laws as applied to women were challenged in the celebrated case of Shah Bano. Shah Bano, a sixty-eight-year-old Muslim mother of five who had been married for forty-three years, was forced from her home by her lawyer husband who allegedly had an income of 60,000 rupees a year (about $4,000; a comfortable middle-class lifestyle in India, comments Saijwani 1989:45). She filed a claim in court for maintenance (without a divorce), whereupon her husband pronounced the triple talaq to divorce her. The Muslim personal law allows a divorcée only the payment of her mehr (an amount settled upon at the time of marriage) and maintenance during the period of iddat (the period of required sexual abstinence, approximately three months), to begin after she is informed of the divorce. For this reason, Shah Bano had applied for maintenance relief under section 125 of the Code of Criminal Procedure which applies to all persons regardless of religion and compels a person to provide for a wife, children, and parents. The two laws, the Muslim personal laws and the Code of Criminal Procedure, were pitted against each other. After lengthy proceedings, the Indian Supreme Court affirmed the state high court's decision and awarded Shah Bano maintenance of 179.20 rupees per month (approximately $11.90). The Supreme Court held that the laws were not in conflict because Muslim law does not state how a destitute divorcée should be treated. It held that in a conflict between the personal law of any religious group and this section of the Code of Criminal Procedure, the latter prevails

(Rahman 1990:478–79). Saijwani notes, "This was the first time that the secular judiciary had applied a secular law to override Moslem personal law" (1989:46).

The Muslim community interpreted the Supreme Court's judgment as an attack on Islam and Muslim identity in the predominantly Hindu state. The ruling Congress Party feared Muslim backlash and repudiated the ruling in the Shah Bano case through legislation entitled the Muslim Women (Protection of Rights of Divorce) Act of 1986. Contrary to its title, this Act shifted the responsibility for maintenance of a divorcée after the iddat from the husband to her children, her parents, or Moslem charities. The effect of the Act was to exclude all Muslims from section 125 of the Code of Criminal Procedure and to rule that the payment of the mehr and maintenance during iddat were adequate (Rahman 1990:481). Shah Bano herself was made the subject of attack and ostracism until she repudiated the judgment and declared her loyalty to Islam.

This public drama of a Muslim woman's protest of Islamic patriarchy through the vehicle of the state court is repeated in the village setting with even less success. Faced with statutory contradictions and enmeshed in the framework of political reciprocities, local state court judges (all male) usually support the domestic traditions in the village. When domestic issues are filed in the courts, it is not unusual that the judges will call the village elders and ask them to settle the matter among themselves in a panchayat (Moore 1990b).

The choice to appeal a case to the state court from the village panchayat is a bold step of resistance. It is not the quiet, silent action envisioned in Scott's (1985) seminal work on resistance. For the Meo woman, however, the open defiance that is required for state intervention seems to offer little more than "jumping from the frying pan into the fire." To file litigation is one way to call attention to a plea. Even if not successful in court, the case might be used as leverage in the village arena. A court case is very expensive to fight and it harms the honor of the family. Honey could try civil litigation as a bargaining chip to obtain a divorce within the village, to pressure the panchayat to allow her to live again in her previous marital residence (with her spouse) in the center of the village, or maybe to get money for her living expenses.

Like Shah Bano, Honey petitioned the court for maintenance. Honey would not have known anything about the Supreme Court controversies surrounding Shah Bano, but the lawyer that helped her father file the petition would have. Honey alleged that her spouse drank, beat her, had a loose character, did not support her, and that she needed

money to provide for the children who lived with her. She asked only for maintenance, not for a divorce. This spared her from facing the same contradictions that Shah Bano faced over a Muslim woman's rights upon divorce. Soon after the case was filed, the judge met in chambers with Honey's brother, not Honey. He recommended that the village panchayat settle this matter and that the case be dismissed. Nara elders were called and, in the courtyard of the local state courthouse, the Nara panchayat created a "settlement" for Honey and Rahiman. The settlement read as follows: "The village elders have brought about the following agreement. We both, Honey and Rahiman Khan, will live as wife and husband and not fight. Honey will go out only with Rahiman's permission. She won't go anywhere on her own accord. Both will live peacefully. The land which Honey owns should be plowed and sowed by Rahiman and its product and income should be spent jointly by them. They should never fight. Rahiman's family should not trouble Honey." This agreement was read to Honey and Rahiman. It was typed by a court petition writer, signed with the parties' thumb-prints, dated, and stamped with the court filing fee stickers. The court proceedings were dismissed. Honey had no say in the matter.

The state court acted to usurp Honey's right to a hearing on her plea for maintenance by returning the case to the village panchayat. Connections among men bridged the gap between village and state, religious and secular rights, and limited Honey's remedies to self-help measures. Honey gained nothing from the so-called compromise. This agreement was similar to the earlier panchayat decisions. Whatever the cost, Honey was expected to live with and obey her husband's orders. But Honey did not return to live with her husband. The land that she had secretly bought in her own name and that of Kamir (using her affinal family's stored grain), she secretly sold to her lover in contravention of the agreement. Honey refused in spite of the law's commands. Instead, she attempted to use the law to her own benefit to fight the patriarchal village elders. When it failed her, she ignored it as she had ignored the panchayats' commands.

CONCLUSION

In India, patriarchal hegemony finds its expression in state, religious, and village systems for dispute-processing institutions. Women resist male domination through "everyday resistance" (Moore 1993) and through the "occasional resistance" of an open act of insubordination, taking a dispute to a public forum. Reliance on the law—state or

village—reflects an inherent, and in most cases, a futile compromise for women. In a patriarchal system such as that of village India, it is the men who get to decide "who does what to whom and gets away with it" (MacKinnon 1987:138). Women are not the rule makers; they are usually not even invited to speak. In the panchayat, women ask fathers, brothers, and uncles to voice their claims for them. But the village forum does not recognize a woman's claim to the right to divorce, maintenance, inheritance, and so on. Village law does not serve women in the sensitive issues of the family.

In the state forum, promises of gender equality made under the national constitution are constrained by the vocal Muslim minority which lost its land and population in the creation of Pakistan. Muslim's fear of disempowerment by the Hindu Supreme Court in the name of secularism brings threats of communal violence and outrage. Islamic women in India are caught in the crossfire between the state and religious or ethnic identities. Islamic women find themselves in positions of multiple subordinations and at the same time in conflicting alliances—with and against the state, with and against the local Muslim caste, with and against the religious leaders who have the voice to fight the state. Throughout this chapter I have used the vehicle of Honey's disputes to illustrate a rural Islamic woman's attempt to resist the male definitions of appropriate female behavior both at home and through public dispute-processing institutions. Honey's performances test the limits of women's multiple subordinations and resistances. She refuses to be silenced. She disobeys village law and gets away with it. She also uses the law in order to make her voice heard. Although she sought alliances with her male relatives for panchayat hearings and later made appeal to the state, in the area of personal law, Honey learned that "the master's tools will never dismantle the master's house" (Lorde 1981).

Notes

I wish to thank Susan Hirsch, Mindie Lazarus-Black, and Janet Hoskins for their helpful comments on this paper. This paper is based on field research generously funded by the Professional Studies Program in India; a University of California Humanities Grant; the Fulbright-Hays Foundation Doctoral Dissertation Research Abroad Program; and the Wenner-Gren Foundation for Anthropological Research, Inc. (Grant. No. 4866).

1. In *The German Ideology* Marx and Engels (1965) envision a ruling class that dominates material production as well as ideological production. Gramsci (1971) calls this ideological domination *hegemony* and believes that

society's institutions—culture, religion, education, and the media—spread ideas that reinforce the position of the ruling class.

2. The literature on Indian panchayats does not speak of women's active presence in this forum. At most it is recorded that a woman is invited to come only long enough to present her statement (Srinivas 1954), often in the case of sexual assault (Morab 1965). Women are never foregrounded even if they have been raped and bear children. It is still the father, brother, and uncle who carry the panchayat debate in her name. The absence of women in the panchayat literature may be due to the authorship as well as the nature of the panchayat. The investigators, mostly male, may not be sensitive to or interested in the role of women in the panchayat. In addition, many of the recorded disputes are recounted to the authors only later; it is easy for embarrassing details (such as an argumentative woman) to be "forgotten." Whatever the reason, it is unusual to record the presence of a woman, like Honey, who publicly confronts the elders and the stated village norms in the panchayat.

3. Indians have a reputation for using the court system in a spirit of resistance rather than resolution. Cohn (1965:105) observed that the courts were used to harass opponents, to satisfy insulted pride, and to maintain political dominance over one's followers rather than to reach a settlement, ending a dispute. Mendelsohn (1981) noted that the state courts of British India were congested with claims protesting British land-use policies.

4. Scott (1986:30, 272) also notes that resistance is not merely the work of the peasants. The wealthy resist when state policies are to their disadvantage.

5. In Nara, I live with Rahiman's mother in a mud and thatch hut next to that of Honey and Rahiman. It is often through the eyes of "*Chachi*" (Rahiman's mother, literally wife of father's younger brother, aunt) that I have observed the most intimate details of this conflict. In addition, I have had many conversations with Nara villagers of different castes, ages, and genders about the conflict and tape-recorded and video-recorded the panchayats for analysis.

6. See, for example, for Muslim culture in India, Jeffery 1979; for Islam in Morocco, Dwyer 1978 and Mernissi 1975; for Hinduism in India, Daniel 1984:163–84; Srinivas 1989:24; and Tambiah 1989; and for Hinduism in Nepal, Bennett 1983.

7. The "traditional" panchayat is discussed in the literature as being of one or the other of two types: a caste panchayat or a village panchayat (see Cohn 1959; Meschievitz and Galanter 1982; Moog 1989; Sharma 1978). In this part of north India, caste panchayats rarely convene and almost all panchayats include men from a variety of castes. For more detail on the village panchayat see Moore 1985, 1990a, 1990b; for detail of a caste panchayat see Hayden 1981, 1983.

8. While this paper has focused on gender inequalities, it is not to say that women are the only disenfranchised members of the village society. Ortner (1983) has cautioned against a "big man" bias and calls on scholars to see the natural alliances between women and dominated (in this case low-caste) men. This is important; men with few relatives, castes represented by only a few households in the village, and the poor are subjects for domination and have difficulty finding village or state justice (Moore 1993). However, patriarchal ideologies that include men staying in their home village to marry and raise children lead to some form of "natural alliance," a brotherhood, among

all village men. "There are only two castes," a man laughed, "men and women." When Omvedt (1975:48 n. 2) heard the same comment, she added, "Undoubtedly there is little question here as to which is the Brahman, which the Shudra [Untouchable laborer]!"

9. I have never seen the orderly turn taking that Hayden (1987) describes in the caste panchayats that he witnessed. Brenneis (1984a, 1984b) also describes more orderly speech in Fijian panchayats.

10. Guha notes, "the husband was said to be superior to his wife 'in every respect' and as such, a proper object of her Bhakti [devotion], . . . the husband provides the first step for access to God. That is why to a Hindu woman her husband is her god" (1989:263). Muslim women face similar ideologies. Rahman notes that the Prophet is reported to have said, "no one may prostrate himself or herself before anyone except God, but if it had been permissible at all for a creature to worship another creature, I would have required a wife to worship her husband" (1982:293). Metcalf notes, from her studies of *adab*, that a Muslim girl must learn to relate to her husband "as she relates to God, with obedience and gratitude" (1984:193).

11. Guha observes that a purely Indian idiom of resistance is not voiced in terms of rights but in terms of duty (*dharma*) (1989:267–69).

12. If Honey were a man, the advantages would be very different. A man would not marry away from the natal village but stay within the political framework of fathers and brothers and a patrilineage of allies. He would inherit the family land and from this position of economic and political strength he could arrange further marital or sexual arrangements (as Kamir had done). It would be his right to abandon an unwanted spouse or marry three other contemporaneous spouses. While he could not officially marry a village "brother's" wife (Kamir, now married to Honey's sister, cannot marry Honey), he could continue a blatant affair. Honey does not define the domestic unit in this patrilocal, patrilineal community. She flees from her spouse's home to her lover's home, to her father's home. Even within her natal village she is not completely welcome. A young girl is viewed as a "guest" in her own home until she marries; a grown woman is expected to remain with her husband and his family for the rest of her life (Jeffery 1979; Mamdami 1972; Roy 1972).

13. See Cohn 1989 and Galanter 1989 on the creation of "native law" in India.

14. As Mullings (1984) has discussed for the choice of a medical healer in Ghana, to choose the traditional system (whether it be the healer or the elders of the panchayat) is to reaffirm the solidarity of the lineage, the collectivity, the respect for the elders as leaders, and local reciprocity. Mullings associated the choice of an alternative healer with the growth of capitalism, a focus on the individual, and a breakdown of kinship ties. In a similar fashion, the state court undermines the village hierarchy and limits the area of dispute to the individual and this particular circumstance.

15. From the time of the Hindu emperor Ashoka in the fourth century B.C. to the present, rulers of the subcontinent feared that interference in the traditional laws of the religious communities relating to the family could be explosive (see generally Saijwani 1989). Even the British, while attempting to create one uniform law for India, hesitated to interfere with the variety of personal laws. In a compromise position, the British settled on codifying one

uniform personal law for all Hindus and practitioners of religions that were considered of Hindu origin (Sikhs, Jains, and Buddhists), another for all Muslims, and another for all Christians.

16. Even these basic Islamic tenets vary in other Islamic countries.

17. Pathak and Rajan point out that "under all [religious] personal laws, the male is the head of the family and succession is through the male line—women have no right to inherit an equal share of property, and the father is the natural guardian of minor children" (1989:560). (Saijwani comments that custody of Hindu and Muslim children *under* seven goes to the mother [1989:57].)

18. See the following materials concerning Shah Bano: Engineer 1987; Jai 1986; Mody 1987; and Pathak and Rajan 1989.

References

Abu-Lughod, Lila. 1990. "The Romance of Resistance: Tracing Transformations of Power through Bedouin Women." *American Ethnologist* 17(1): 41–55.

Aggarwal, Partap C. 1971. *Caste, Religion, and Power: An Indian Case Study.* New Delhi: K. S. Seshagiri.

———. 1976. "Kinship and Marriage among the Meos of Rajasthan." In *Family, Kinship, and Marriage among Muslims in India.* I. Ahmad, ed. New Delhi: Manohar Book Service. 265–96.

Bannerman, A. D. 1902. *Census of India, 1901.* Lucknow, India: Newal Kishore Press.

Baxi, Upendra, and Marc Galanter. 1989 [1979]. "Panchayat Justice: An Indian Experiment in Legal Access." In *Law and Society in Modern India.* R. Dhavan, ed. Delhi: Oxford University Press. 54–91.

Belenky, Mary Field, Blythe McVicker Clinchy, Nancy Rule Goldberger, and Jill Mattuck Tarule. 1986. *Women's Ways of Knowing: The Development of Self, Voice, and Mind.* New York. Basic Books.

Bennett, Lynn. 1983. *Dangerous Wives and Sacred Sisters: Social and Symbolic Roles of High Caste Women in Nepal.* New York: Colombia University Press.

Brenneis, Donald. 1984a. "Grog and Gossip in Bhatgaon: Style and Subsistence in Fiji Indian Conversation." *American Ethnologist* 11:487–506.

———. 1984b. "Straight Talk and Sweet Talk: Political Discourse in an Occasionally Egalitarian Community." In *Dangerous Words: Language and Politics in the Pacific.* D. Brenneis and F. Myers, eds. New York: New York University Press. 69–84.

Cohn, Bernard S. 1959. "Some Notes on Law and Change in North India." *Economic Development and Cultural Change* 8:79–93.

———. 1965. "Anthropological Notes on Disputes and Law in India." *American Anthropologist* 67(6): 82–122.

———. 1989. "Law and the Colonial State in India." In *History and Power in the Study of Law: New Directions in Legal Anthropology.* J. Starr and J. F. Collier, eds. Ithaca: Cornell University Press. 131–52.

Comaroff, Jean. 1985. *Body of Power, Spirit of Resistance: The Culture and*

History of a South African People. Chicago: University of Chicago Press.

Comaroff, Jean, and John Comaroff. 1991. *Of Revelation and Revolution: Christianity, Colonialism, and Consciousness in South Africa.* Vol. 1. Chicago: University of Chicago Press.

Craig, Donald. 1979. "Tradition and Legal Reform in an Iranian Village." In *Access to Justice.* K. F. Koch, ed. Milan: Giuffre Editore. 147–70.

Daniel, E. Valentine. 1984. *Fluid Signs: Being a Person the Tamil Way.* Berkeley: University of California Press.

Dumont, Louis. 1970. *Homo Hierarchicus.* Chicago: University of Chicago Press.

Dwyer, Daisy Hilse. 1978. *Images and Self-Images: Male and Female in Morocco.* New York: Colombia University Press.

Eisenstein, Zillah R. 1988. *The Female Body and the Law.* Los Angeles: University of California Press.

Engineer, Asghar Ali, ed. 1987. *The Shah Bano Controversy.* Hyderabad: Orient Longman.

Fineman, Martha Albertson, and Nancy Sweet Thomadsen, eds. 1991. *At the Boundaries of the Law: Feminism and Legal Theory.* New York: Routledge, Chapman and Hall.

Galanter, Marc. 1989. [1968]. "The Displacement of Traditional Law in Modern India." In *Law and Society in Modern India.* R. Dhavan, ed. Delhi: Oxford University Press. 15–36.

Girtler, Roland. 1976. "The Dichotomy of the 'Legal' and the 'Traditional' Panchayat—An Indian Dilemma." *Bulletin of the International Committee on Urgent Anthropological and Ethnological Research* 18:35–43.

Gramsci, Antoni. 1971. *Selections form the Prison Notebooks,* ed. and trans. Quintin Hoare and Geoffrey Nowell Smith. London: Lawrence and Wishart.

Guha, Ranajit. 1989. "Dominance without Hegemony and Its Historiography." In *Subaltern Studies VI. Writings on South Asian History and Society.* R. Guha, ed. Delhi: Oxford University Press. 210–309.

Hart, Gillian. 1991. "Engendering Everyday Resistance: Politics, Gender, and Class Formation in Rural Malaysia." *Journal of Peasant Studies* 19(1): 93–121.

Hayden, Robert. 1981. *No One Is Stronger Than the Caste. Arguing Dispute Cases in an Indian Caste Panchayat.* Ph.D. dissertation, Department of Anthropology, State University of New York, Buffalo.

———. 1983. "Excommunication as Everyday Event and Ultimate Sanction: The Nature of Suspension from an Indian Caste." *Journal of Asian Studies* 42:291.

———. 1987. "Turn-taking, Overlap, and the Task at Hand: Ordering Speaking Turns in Legal Settings." *American Ethnologist* 14(2): 251–70.

Henderson, Lynne. 1991. "Law's Patriarchy." *Law and Society Review* 25(2): 411–44.

Jai, Janak Raj, ed. 1986. *Shah Bano.* New Delhi: Rajiv Publications.

Jeffery, Patricia. 1979. *Frogs in a Well: Indian Women in Purdah.* London: Zed Press.

Lorde, Audre. 1981. "The Master's Tools Will Never Dismantle the Master's

House." In *This Bridge Called My Back: Writings by Radical Women of Color*, ed. Cherríe Moraga and Gloria Anzaldúa. New York: Kitchen Table: Women of Color Press. 98–101.

MacKinnon, Catherine. 1984. "Roe v. Wade: A Study in Male Ideology." In *Abortion: Moral and Legal Perspectives*. J. Garfield and P. Hennessey, eds. Amherst: University of Massachusetts Press.

———. 1987. *Feminism Unmodified: Discourses on Law and Life*. Cambridge: Harvard University Press.

———. 1991. "Reflections on Sex Equality under Law." *Yale Law Journal* 100:1308–24.

Mamdami, Mahmood. 1972. *The Myth of Population Control: Family, Caste, and Class in an Indian Village*. New York: Monthly Review Press.

Marx, Karl, and Friedrich Engels. 1965. *The German Ideology*. London: Lawrence and Wishart.

Massell, George J. 1968. "Law as an Instrument of Revolutionary Change in a Traditional Milieu: The Case of Soviet Central Asia." *Law and Society Review* 2:179–211.

Mendelsohn, Oliver. 1981. "The Pathology of the Indian Legal System." *Modern Asian Studies* 15(4): 823–63.

Mernissi, Fatima. 1975. *Beyond the Veil: Male-Female Dynamics in Modern Muslim Society*. Bloomington: Indiana University Press.

Merry, Sally Engle. 1988. "Legal Pluralism." *Law and Society Review* 22(5): 869–96.

Meschievitz, Catherine, and Mark Galanter. 1982. "In Search of *Nyaya Panchayats*: The Politics of a Moribund Institution." In *The Politics of Informal Justice*. R. Abel, ed. New York: Academic Press. 2:47–77.

Metcalf, Barbara Daly. 1984. "Islamic Reform and Islamic Women: Maulana Thanawi's Jewelry of Paradise." In *Moral Conduct and Authority: The Place of Adab in South Asian Islam*. Barbara Metcalf, ed. Berkeley: University of California Press. 184–95.

Mody, Nawaz B. 1987. "The Press in India. The Shah Bano Judgement and Its Aftermath." *Asian Survey* 27(8): 935–53.

Moog, Robert. 1989. "Disillusionment with the District Level Civil Courts: Are There Viable Options?" Paper presented at the 20th Annual Conference on South Asia, University of Wisconsin, Madison, November.

———. 1991. "Conflict and Compromise: The Politics of Lok Adalats in Varanasi District." *Law and Society Review* 25(3): 545–69.

Moore, Erin P. 1985. *Conflict and Compromise: Justice in an Indian Village*. Lanham, MD: University Press of America.

———. 1990a. "Dream Bread: An Exemplum in a Rajasthani *Panchayat*." *Journal of American Folklore* 409:301–23.

———. 1990b. *He Who Owns the Stick Owns the Buffalo: Gender and Power in the Study of Justice, Rajasthan, India*. Ph.D. dissertation, Department of Anthropology, University of California, Berkeley.

———. In press. "Gender, Power, and Legal Pluralism: Rajasthan, India." *American Ethnologist* 203:522–42.

———. Manuscript. "Whose Justice? Gender, Power, and Resistance in Rural India."

Morab, S. G. 1965. "The Bhandari Caste Council." *Man in India* 45(2): 152–58.

Mullings, Leith. 1984. *Therapy, Ideology, and Social Change: Mental Healing in Urban Ghana*. Berkeley: University of California Press.

Omvedt, Gail. 1975. "Caste, Class and Woman's Liberation in India." *Bulletin of Concerned Asian Scholars* 7(1): 43–49.

———. 1980. *We Will Smash This Prison: Indian Women in Struggle*. London: Zed Press.

Ong, Aihwa. 1987. *Spirits of Resistance and Capitalist Discipline: Factory Women in Malaysia*. Albany: SUNY Press.

Ortner, Sherry B. 1983. "The Founding of the First Sherpa Nunnery and the Problem of 'Women' as an Analytic Category." In *Feminist Re-Visions*. Vivian Patraka and Louise Tilly, eds. Ann Arbor: Women's Studies Program, University of Michigan. 98–134.

Pathak, Zakia, and Rajeswari Sunder Rajan. 1989. "Shahbano." *Signs* 14(3): 558–82.

Rahman, Anika. 1990. "Religious Rights vesus Women's Rights in India: A Test Case for International Human Rights Law." *Col Journal of Transnational Law* 28:473–98.

Rahman, Fazlur. 1982. "The Status of Women in Islam: A Modernist Interpretation." In *Separate Worlds: Studies of Purdah in South Asia*. Hanna Papanek and Gail Minault, eds. Columbia, Mo.: South Asia Books. 285–310.

Ram, Maya. 1968. *Rajasthan District Gazetteer*. Jaipur, Rajasthan: Bharat Printers.

Ramanujan, A. K. 1991. "A Flowering Tree: A Woman's Tale." Paper presented at the 20th Annual Conference on South Asia, Madison, Wisconsin.

Roy, Manish. 1972. *Bengali Women*. Chicago: University of Chicago Press.

Rudolph, Llyod I., and Susan H. Rudolph. 1960. "The Political Role of India's Caste Associations." *Public Affairs* 33(1): 5–22.

Saijwani, Vinaya. 1989. "The Personal Laws of Divorce in India with a comment on Chaudry v. Chaudry." *Women's Rights Law Reporter* 11(1): 41–59.

Scott, James C. 1985. *Weapons of the Weak: Everyday Forms of Peasant Resistance*. New Haven: Yale University Press.

———. 1986. "Everyday Forms of Peasant Resistance." *Journal of Peasant Studies* 13(2): 5–35.

———. 1990. *Domination and the Arts of Resistance: Hidden Transcripts*. New Haven: Yale University Press.

Scott, James C., and Benedict J. Tria Kerkvliet. 1986. "Introduction." *Journal of Peasant Studies* 13(2): 1–3.

Sharma, Miriam. 1978. "The Politics of Inequality, Competition and Control in an Indian Village." Asian Studies at Hawaii. No. 22. Honolulu: University of Hawaii Press.

Srinivas, M. N. 1954. "A Caste Dispute among Washermen of Mysore Village." *Eastern Anthropologist* 7(3): 149–68.

———. 1959. "The Case of the Potter and the Priest." *Man in India* 39(3): 190–209.

———. 1987. *The Dominant Caste and Other Essays*. Delhi: Oxford University Press.

————. 1989. *The Cohesive Role of Sanskritization and Other Essays*. Delhi: Oxford University Press.

Starr, June. 1978. *Dispute and Settlement in Rural Turkey: An Ethnography of Law*. Leiden: E. J. Brill.

————. 1989. "The Role of Turkish Secular Law in Changing the Lives of Rural Muslim Women, 1950–1970." *Law and Society Review* 23(3): 497–523.

Starr, June, and Jane F. Collier. 1989. "Introduction: Dialogues in Legal Anthropology." In *History and Power in the Study of Law: New Directions in Legal Anthropology*. J. Starr and J. F. Collier, eds. Ithaca: Cornell University Press. 1–30.

Starr, June, and Johnathan Poole. 1974. "The Impact of a Legal Revolution in Rural Turkey." *Law and Society Review* 8(4): 533–60.

Tambiah, Stanley J. 1989. "Bridewealth and Dowry Revisited." *Current Anthropology* 30(4): 413–35.

Tod, James. 1960 [1829]. *Annals and Antiquities of Rajasthan*. Delhi: Moti Lal Banarsi Das.

ON LAW AND HEGEMONIC MOMENTS: LOOKING BEHIND THE LAW IN EARLY MODERN UGANDA

Joan Vincent

The anthropology of law has, until recently, shared with Anglo-American jurisprudence a romantic attachment to normative legal theory. This has been reflected in a great deal of attention being paid to legal principles and rules, court proceedings and judgments. Both disciplines have tended to deemphasize statutory provisions, the various forms of delegated legislation, and, above all, administrative regulations, directives, guidelines, and codes of practice. Jurisprudes acknowledge that most law has been of the latter kind but anthropologists have been slow to respond to the possibility that much in the social construction of reality—or rather, the political construction of "social" reality— appears to occur at a remove from the exercise of state power. Even further in the background, I suggest, are state-orchestrated occasions that inculcate the very legal consciousness on which hierarchies and exclusions are based. This is where Gramsci's preoccupation with performance and the production of hegemony promises to be so valuable.

Recent shifts in anthropological jurisprudence toward an analysis of law that is sensitive to history, discourse, and regional contextualization (Starr and Collier 1989; Twining 1991) promise to open doors to the study of a wider range of legal processes, institutions, and performances, past and present. This is a considerable advance on the application of evolutionary theory and its search for a primal scene

in both legal (Hart 1961) and anthropological studies.[1] Here we may begin with Sir Henry Maine's theoretical insight (1861) into what Maine sees as a movement from status to contract in the historical development of society. This derives from his all-abiding interest in legal change and legal reform, but what we must point out here is that, while Maine recognizes "contract" as a legal concept, he takes the notion of status "as a given."

In this essay I would like to focus on the construction of "status" in the context of a colonizing state. My premise is that the structure and dynamics of a ceremonial performance event serve to orient those who participate in it (and no doubt its spectators as well) toward distinctions of class and rank that subsequently become inscribed in administrative regulations and codes of practices—even, under some circumstances, in the black letter of statutory law. To describe how this occurs it is useful to move from Maine to Gramsci and to construct the notion of a *hegemonic moment*.

Here I focus on one such hegemonic moment when it was possible to look "behind the law" at legal categories in the making. In the setting of colonial Uganda these were categories of race, class, ethnicity, and gender. In a colonial state yet in the making, as Uganda was in 1908, an agricultural exhibition provided the occasion for the making of hegemony. Law-related hegemonic constructions of identities, rights, entitlements, and political relationships were first comprehensively inculcated and legitimated through public ceremonial performance. The performance encouraged separation along each of these lines while at the same time excluding one category and fostering competition within others.

HEGEMONIC PROCESSES AND OPPOSITIONAL PRACTICES

It has been suggested that legal anthropology's taking up with Gramsci may be due to a convergence of interests with the Critical Legal Studies movement: "Both ask how law acts to legitimate particular ideologies and asymmetrical power relations, and both seek to analyze the mutual construction of legal and social orders in historical time" (Starr and Collier 1989:6). More specifically, I would suggest, it is a result of interpretive and critical anthropology's reading, first, of Raymond Williams, then of Michel Foucault.[2]

Gramsci's somewhat inconclusively formulated writings place law interstitially between the state and civil society. Law combines coercion

and consent. Most anthropologists appear to interpret Gramsci as viewing hegemony as the more subtle face of state or class power, following Michel Foucault and Pierre Bourdieu who develop Gramsci's view of the state not as a political society using a coercive apparatus to control the masses but as a momentary balance between political society and civil society, the hegemony of one social group over the nation (Gramsci 1971). Gramsci calls this the hegemonic *apparatus* of a class. Among its forms are the educational apparatus, the cultural apparatus (museums, libraries, etc.), the publishing apparatus, the organization of information, the church, the everyday environment, town planning, even the names of streets. The point I want to stress here is that, for Gramsci, hegemony is only unified into an apparatus by reference to the class that constitutes itself in and by the mediation of the various subsystems within the state.

Those critical of Gramsci's inclusive, unified model of class and state hegemony believe it less useful for the historical analysis of legal transformation. On the one hand, Gramsci's argument that a capitalist class does not maintain its power exclusively or even primarily by force, but through widespread moral and social beliefs that lead people to assume that the status quo is basically good, would appear to be valid. But the extension of this argument to the state deconstructs the concept of power to such an extent that domination by coercion and legitimized force virtually disappear from the hegemonic equation. To argue that the legal system buttresses capitalist hegemony reflects the extent to which normative legal philosophy and most professional lawyers, including those in the Critical Legal Studies movement, inflate law's place in society. Anthropological critics, such as Sally Falk Moore (1978:2), have long suggested that the effects of the legal system may be too marginal to legitimate anything. After all, most people are not affected by the sort of law that goes on in courts or that exercises the minds of judges. The lives of most people, and particularly of most women (Smart 1991:148), are far more widely affected by administrative law and more mundane, everyday regulations. Moore's suggestion that law *in effect* may be more marginal than lawyers like to suppose encourages explorations in decentering, such as that undertaken in this essay.

In order to begin to understand the effectiveness of less coherent, visible, and recognized devices of law in the making we need to recognize that there has indeed been a universalizing projection of twentieth-century-capitalist-state thinking onto law in general. Hegemonic capitalism may be extremely effective in Europe and the United States in

producing false consciousness within a consumer culture, but surely, when it comes to rock bottom, looking at the state and not the capitalist class, it is hard to believe that the legitimating effect of law is so powerful that people accept an otherwise intolerable political system.

Yet, I would suggest, what is critical is not victims learning to give voice, but their learning what voices will be heard. The hegemonic qualities of law manufacture protest at the same time as they subtly manufacture consent. Legal doctrines are framed, legal coercion flourishes, but Gramsci's theory of the hegemonic apparatus is complemented by a theory of the crisis of hegemony—the dialectic of hegemony whereby it contains in itself historical movement and resistance.[3] It is this that leads me to suggest a methodological focus on a critical hegemonic moment, one that encapsulates this crisis.

According to Gramsci, the dialectic of the hegemonic moment (of leadership, consent, or law) and the more restrictive moment of domination (state coercion) coexist. Indeed, it may be argued that the purpose of hegemony is to obscure coercion in the maintenance of law and order while at the same time ensuring compliance with it. Yet, hegemony, Gramsci argues, is a little more complicated than that (and it is here that he develops his most problematic argument for some of his orthodox Marxist critics) because hegemony "guarantees *a certain type of power*: its democratic expression and character" (Buci-Glucksmann 1980:184).

The English historian E. P. Thompson (1975) arrives at a similar conclusion toward the end of *Whigs and Hunters*, a classic study of oppressive legal sentencing in eighteenth-century England and of opposition to it. He suggests that law, although it "may be seen instrumentally as mediating and reinforcing existing class relations" also offers the grounds and site on which to oppose them since "class relations [are] expressed, not in any way one likes, but *through the forms of law*; and the law, like other institutions which from time to time can be seen as mediating (and masking) existent class relations (such as the church or the media of law), has its own characteristics, its own independent history and logic of evolution" (Thompson 1975:262). Susan Coutin's study (this volume) of the Sanctuary movement as an oppositional legal practice provides a fine example of this.

Considerable research in legal anthropology does indeed suggest that there is much to be gained from viewing contestations of laws and court appearances as hegemonic moments. The same dialectic underlies Robert Kidder's view of imposed law as a contested terrain (1979), a metaphor exceedingly useful in my own delineation of the

lawmaking process in colonial Uganda (Vincent 1989). And, as several papers in this volume demonstrate so effectively, the courtroom does indeed provide an ideal site for the dialectical hegemonic moment.

THE HEGEMONIC CONSTRUCTION OF LEGAL CATEGORIES

Besides exploring hegemonic processes and oppositional practices, Thompson also begins to explore the "logic" of law in a way that is particularly relevant to the analysis of Ugandan prelaw hegemony presented in this essay. "It is inherent in the especial character of law, as a body of rules and procedures," he writes, "that it shall apply logical criteria with reference to standards of universality and equity." He then qualifies this statement in the following manner: "It is true that certain categories of person may be excluded from this logic (as children or slaves), that other categories may be debarred from access to parts of the logic (as women or those without certain kinds of property). All this, and more, is true," Thompson admits before going on to argue that if too much of this is true, then the consequences are plainly counterproductive (1975:262–63).

Let us first consider Thompson's observation that law constructs categories of persons subject to it. Law has been described by some anthropologists as the activity of making representations of social life (Humphreys 1985; Strathern 1985; cf. Dworkin 1986). The extent to which anthropologists have uncritically reproduced administrative-legal discourse in talking about relationships in African societies (in particular) has been sharply criticized by both Talal Asad and Martin Chanock. Asad (1991:322) argues that the quasi-legal terms that they used to describe social relationships (e.g., "rights" and "duties" attached to roles) reduced the character of social structures to "the status of a precisely articulated and consistent legal-administrative document," obscuring, it might be suggested, counterhegemonic activities, protest, and resistance. In a similar vein, Chanock criticized Radcliffe-Brown and his colleagues for their emphasis on "jural relations" and deplored the unhistorical conception of law shared by lawyers, colonial administrators, and British functional anthropologists: a legal mythology, he calls it. The law, Chanock insists, "was the cutting edge of colonialism, an instrument of the power of the alien state and part of the process of coercion. . . . it also came to be a new way of conceptualising relationships, . . . many of which were fought over by those involved in moral terms" (1985:4).

Learning to give voice (to protest at inequities at law), I would suggest, logically/historically follows learning what voices will be heard. This knowledge is acquired from an experiential recognition of the principles and practices of exclusion—"as women or those without certain kinds of property" (Thompson 1975:262)—or, as the analysis that follows will suggest, as members of a certain race, class, or ethnic group. I want, therefore, to turn instead to a different site: to what Peter Fitzpatrick, following Foucault, has called "the *site*, the mute ground upon which it is possible for entities to be juxtaposed as a classification which 'we' [the hegemonicized 'we'] can understand" (Fitzpatrick 1992:1–2). A reading may then be offered of the politics of what I am calling (for want of a better term) a *prelaw* hegemonic moment.

In this essay the hegemonic moment I describe occurs during a critical phase in the early modern history of Uganda when the colonial power is faced with a transition from the conquest and pacification of its African peoples to the development of their economies along the lines required by the Colonial Office in London. An earlier analysis of the substantive content of a piece of British colonial legislation, the Uganda Trading Ordinance of 1938 (Vincent 1988b, 1988a), demonstrated how hegemonic categories received implementation through the manipulation of space, distinctions being made in racial terms of differential town and country trading regulations. But legislation per se required preexisting discourses which the combatants (to use Kidder's term) entered when they confronted each other in the legislative chamber, in committee sessions, or in the clubhouses and offices where the fine details of the law were thrashed out. One such confrontation took place in October 1938 during the committee phase of the trading bill when Mr. M. M. Patel, the Asian unofficial member of the legislative council, challenged the use of racial categories and the principle of racial discrimination in the proposed trading legislation (Vincent 1993).

Thirty years earlier in Uganda's history the coercive nature of class and racial categories in law were yet to be sanctioned and knowing one's place in colonial society was in its earliest formative phase.[4] I will suggest that what I will call for the moment law-related hegemonic constructions of identities, rights, entitlements, and relationships were earlier inculcated and legitimized through the public ceremonial of the agricultural show held on the occasion of the sixty-seventh birthday of King Edward VII. This was the mute ground of racial categorization in law; this hegemonic moment could be seen to structure the categorical terms of engagement between the races not yet crystallized in

colonial law. This essay thus looks *behind law* at the hegemonic making of the very legal identities that have subsequently patterned access to various forms of law. A state-orchestrated occasion served to inculcate the legal consciousness on which hierarchies and exclusions were and still are based. The categories adopted were made "real" by way of appearing "natural." It may be noted, however, that a military performance framed the event: domination and hegemony are expressed in "the dramaturgy of power" (Vincent 1988d:148).[5]

THE UGANDA AGRICULTURAL AND INDUSTRIAL EXHIBITION

Power and authority are dramatized in big, ceremonial occasions, and few dramatic events could have given the colonial administrators in Uganda so much satisfaction, such a glow of imperial pride, as the assembling of the Crown's subjects at the agricultural exhibition in Kampala on 9 November 1908. It was a sign that the pacification phase was over, law and order established, and the grounds for economic development fully prepared.

In spite of heavy showers of rain which marred the opening ceremony, the first Uganda Agricultural and Industrial Exhibition was opened by the governor, Sir Hesketh Bell, constitutionally the representative of the British sovereign. State officials were ranged on the dais alongside him, including the acting chief secretary (the chief secretary, the governor's second-in-command, being on leave at the time), the officer commanding the troops, the provincial commissioner of the Eastern Province, the acting provincial commissioner of Buganda, and an entourage of lesser colonial dignitaries. The high command of the new colonial state was thus "on parade." The dignitaries had entered the show ground through the ranks of a guard of honor made up of troops from India and the Bugle Band of the Fourth Battalion of the King's African Rifles. They were then greeted by the chairman of the organizing committee for the agricultural show who was no less a public figure than the attorney general, His Honor Judge Ennis. Any who might have thought that an attorney general would have had more pressing official duties to perform than organizing an agricultural exhibition in a newly established colonial state would have failed to appreciate the critical significance of the occasion.

The ceremonial drama that was being staged was directed at several audiences. First, I would suggest, a triumphal message was being sent back to the Colonial Office in London. Uganda had been transferred

from the Foreign Office to the Colonial Office fewer than three years previously, and the choice to stage an agricultural and industrial exhibition—rather than, say, a display of marching bands—was a clear statement that the economic development of the new protectorate was well under way. A colorful account of the proceedings was published in the *Uganda Official Gazette*, produced by the government printer and dispatched at regular intervals to the Secretary of State for the Colonies in England.

Secondly, the drama was staged for the rulers of the Buganda kingdom, the *kabaka* and his councillors. The exhibition was held in Mengo, the Buganda capital built on seven hills, not in Entebbe, the seat of the colonial administration, some twenty miles away on the cool shores of newly named Lake Victoria. This choice of site rewarded the Bagandan rulers for their collaboration in the carving out of the colonial territory and gave recognition to the fact that the current phase in the colonial state's expansion could not have been achieved without their involvement.

Nor was the dramatic impact of the event lost upon Africans other than the Baganda. For them, the exhibition demonstrated that the Bugandan kingdom was the heartland of the new protectorate. Most had to travel for several days to reach Mengo from their own districts; many had probably never been to the Buganda capital before. Several had in the recent past suffered military defeat at the hands of the Baganda who might have been acting on their own initiative or as surrogates, subimperialists, for the British expeditionary force that had entered the region at the end of the previous decade.

Finally, also participating in the drama was the merchant community of Mengo (Kampala), made up for the most part of traders and small industrialists from the Indian subcontinent—the third element in the plural society that had come into being with the construction of the colonial state.[6] For the members of Uganda's Asian community (perhaps for them above all), this was a hegemonic moment of critical importance: their place in the emergent colonial society was being defined and redefined. For the wealthier among them, as for the European merchants and traders and the protectorate's civil servants, an account of the exhibition in the *Gazette* would have made gratifying reading the following week. Their primary interest in Uganda lay in its economic development, in which they expected to play a prominent part. All three cultural constituencies within the colonial state—European and Asian merchants, Baganda subimperialists, and other African ethnic groups encapsulated in the new modern Uganda—were thus all subject to this moment of hegemony. In the performance they con-

curred unwittingly, as it were, in the making of their future statuses in colonial law.

The governor opened the proceedings with a speech that made it clear that, in the government's eyes at least, the event was a celebration of national integration. Those knowledgeable about what was happening throughout the outlying regions where newly encountered ethnic groups were in the process of being welded into the new protectorate might have thought the government's assessment a little premature. Indeed, the pacification of eastern and northern Uganda was still under way in November 1908, its outcome far from assured (Vincent 1982, 1988d). It was with some aplomb, therefore, that the governor welcomed to Kampala those kings and chiefs of neighboring regions whose territories had been incorporated by treaty into the new Uganda. He also singled out for a particularly warm welcome Semei Kakunguru, the Muganda conqueror of the "Bakedi" peoples in the eastern region of the country. The presence of all these "enlightened rulers," he asserted, was "a striking sign of the profound peace and security which now happily reign throughout the Protectorate" (Public Record Office 1908)—a claim that was quite untrue in November 1908 and one that did not become true for another twelve years.

There were, I would suggest, two subtexts to the governor's opening address and the civil drama that was unfolding. Students of jurisprudence have been generously exposed to the first—the myth of progress and civilization—through the work of H. L. A. Hart (1961, 1983), which was recently subjected to a sustained critique by Peter Fitzpatrick (1991). This myth did much to sustain Edwardian civil servants throughout the British Empire. On this occasion the governor spoke of the short history of civilization in the territory and the progress that had been made in the establishment of law and order with the advent of British rule. In accordance with the evolutionary theory of the times, conflict and pacification had conveyed the natives of the protectorate from a state of barbarism to a state of settled agriculture. Their embarking on industry would, it was believed, also follow at some time in the future. The plumed and uniformed imperial military presence at the agricultural show attested to the imposition of law and order; the exhibits on display would attest to the progress to be made thereafter.

The second subtext in the dramaturgy of power was more subtle. It was related more to the specific political-economic goals of the newly established colonial state than to that state's unification and legitimacy, since exhibited at the show were not simply stands of agricultural products and specimens of home industry but the "logical," moral, and political relations that were being created by the performance itself. Social and political relations were being given theatrical representation.

They were embedded in the categorization of exhibitors imposed by the judge's organizing committee and in the rules of the various competitions as well as in the acceptance of "impartial" judgments on the basis of constructed categorizations and rules. Whether or not His Honor Judge Ennis was given the responsibility of organizing the protectorate's first agricultural and industrial exhibition in order that his public office and the armor of the law might dispel any tendencies toward hostility and disagreement on such a unique occasion, his agricultural show committee certainly served to legitimate the social, political, and economic hierarchies that it created.

On the surface it might have appeared that the exhibition was an innocuous transplanting to Uganda of that bucolic English rural custom, the county agricultural show, such as many of the civil servants would have enjoyed during an English summer, along with their tennis matches and tea parties. To some extent, a reflection of the English class structure of the Edwardian agricultural show was indeed being reenacted in the new African state, but there were also significant differences. One of the purposes, and great joys, of the country show is to recognize excellence and achievement. The exhibitors who are successful in their respective categories receive elaborate ribands (often red, white, and blue) as well as prizes. Their names are recorded, with due attention to correct spelling and status, in the local newspaper— the *Shropshire* or, let us say, the *Warwickshire Gazette*. The *Uganda Official Gazette* of November 1908 carried no such recognition. No winners were named, no outcomes reported; it was the categorization that was critical, not public recognition of achievement. The Uganda Agricultural and Industrial Exhibition held in November 1908 was a performance event orchestrating the colonial plural society with its characteristically extractive and peculiarly tropical economy.

THE CLASSIFICATION OF EXHIBITORS

Let us look more closely at the two main areas of classification adopted at the show: (1) the classification of the exhibitors and (2) the classification of the exhibits.

Three classes of exhibitor were recognized:

Class I: Nonnatives of the Uganda Protectorate
Class II: Chiefs and landowners (natives of the Protectorate)
Class III: Peasants of the Uganda Protectorate

This broad hierarchy conveyed a great deal of imposed social distancing and meaning. First, it gave recognition to racial distinctions between

Asians (Indians) and Europeans, on the one hand, and Africans—natives—on the other. Second, it acknowledged class differences among Africans and it did so in terms of status differentials that the colonial power had itself introduced into law. "Chiefs" were those whom the Africans of the Ugandan kingdoms had recognized as rulers, princes, and nobles prior to conquest and incorporation in the colonial state. In African society, these had hereditary claims to office; the colonial officers recognized among them those who they thought most suitable to work within the framework of a new administrative hierarchy. In more egalitarian African polities lacking hereditary office holding, client chiefs were appointed by the colonial power, usually from among those who had welcomed their advent.

Even more significantly, the recognition of "landowners" gave public collective visibility to a category of Baganda men (mostly clan elders) who had held land under the *kabaka,* but who had been required by colonial law to register their land (called *mailo,* i.e., miles) under individual property ownership. In singling out this category, the exhibition again drew attention to the progress inculcated by evolutionary policies in colonial practice, but it also gave powerful promise to native advancement within a modern economy paralleling that of chiefly office. A great deal of early legislation subsequently had to be directed at controlling what Baganda landowners might and might not do with their land (Vincent 1988c).

The third class category was doubly significant. On the one hand, the term "peasants" might simply be taken as a translation of the Baganda word *bakopi,* frequently used interchangeably with "peasant" by those colonial administrators who viewed the Baganda kingdom as feudal. On the other hand, describing the Africans of the protectorate as peasants carried a clear message to the small European planter class, members of which had been drawn to Uganda's prospects from neighboring Kenya or South Africa. The Colonial Office had recently made it plain that the protectorate was to be developed as a peasant economy, for the well-being of its African population, and not as a plantation economy.

The Classification of Exhibits

There were four sections to the exhibition:

(A) agricultural exhibits;
(B) native manufactures;

(C) livestock; and
(D) industries.

Section A revealed, beyond the racial ordering of the plural society, the racial ordering of the agricultural economy itself. Of the thirty-four exhibits listed, some were clearly stated to be English (e.g., potatoes), European (vegetables), or native (vegetables).[7] Others were racially designated by permitting only exhibitors of one category or another to exhibit. Thus, the showing of bananas, cassava flour, groundnuts, and pigeon peas, for example, was limited to African peasants. Beans, chillies, hides and skins, honey, sesame, and native-grown rice, on the other hand, could be shown by both classes II and III (i.e., by African chiefs and landowners as well as peasants). European and Asian (nonnative) growers were excluded from this competition. One exhibit only was open to both classes I and II (nonnatives, chiefs, and landowners) and this was rubber, a new experimental crop that the Agricultural Department hoped to develop.

Sections B and C were open only to classes II and III, peasants and herders who had been nominated by their landlords to compete. Section D was an exhibit of the work of artisans and operators ranging from "traditional" industries, such as preparing bark cloth and making shields, to the operation of a sugar mill or cotton gin.

Only two exhibits were open to class I (nonnatives) alone: ghee and ginned cotton. Nonnative monopoly of the former was, as far as I know, never contested in the legal history of the protectorate. Ghee, a rancid-butter cooking oil, was introduced to the protectorate by the Asian community and I find it difficult to imagine why any other subjects of the Crown would want to make it. That it was in the agricultural show at all was, I would suggest, a kind of gesture toward that sense of "community" that the British common-law tradition stood for in the colonies. Ginned cotton was another matter.

The cotton economy (destined to be the first mainstay of the colonial state) was, from the beginning—even from the prelaw hegemonic moment—privileged. Of all the crops shown, cotton was king. The agricultural show had been planned originally to boost Uganda's nascent cotton industry, and it was a matter of some concern to the judge's organizing committee that the king's birthday in November was actually rather early for a collection of raw cotton truly representative of the state's praiseworthy achievement. Nevertheless, in his speech the governor singled out cotton for special mention as the most important of all of the 4,000 exhibits. "Three years ago," he told the gathering, "the exports of this product were worth only a few hundreds of pounds.

During the current year, the value of the out-put from the Protectorate is estimated to reach a total of at least £50,000. Such phenomenal progress," he suggested, "augurs well for the future and there seems no reason to doubt that, during the next five years, this territory will rank as one of the chief cotton-producing dependencies of the Empire."

Then followed the cautionary, qualifying phrase "It is essential, however, that the industry should be carefully watched and fostered, and that every precaution should continue to be taken to maintain the high standard of the staple" (Public Record Office CO612/1:256). And indeed, in the years that followed, statutory provisions, delegated legislation, bylaws, administrative regulations, directives, and guidelines issued forth by the score from the attorney general's office, from that of the chief secretary, and from the Uganda Department of Agriculture. Through law and coercion cotton became the country's chief export crop (Vincent 1989).

Of all the law-related hegemonic constructions of identities and hierarchies at the Uganda Agricultural and Industrial Exhibition of 1908, the categorization of cotton growers and the taxonomy of entitlements to exhibit unginned cotton and ginning operations most clearly revealed the dual distinction of access to Uganda's expanding political economy and exclusion at law.

Two forms of categorical distinction operated to distinguish cotton producers (exhibitors of unginned cotton) from cotton ginners. The first category was open to classes II and III (chiefs, landowners, and peasants), encouraging simultaneously a class spirit and competition among the most powerful Africans in the land. The peasants, it must be recalled, were dependent clients chosen by the chiefs and landowners. Further categories of cotton grower were then based on territorial distinctions, separate prizes being awarded to exhibitors from the Buganda, Bunyoro, Toro, Ankole, and Busoga districts exclusively. The early and constant privileging of the Baganda was also evident in the actual prizes awarded; the prize for classes II and III exhibitors from Buganda was £20 while that for the other four ethnic categories was £15. Thus were "tribal" or "ethnic" identities constructed within the show's categorizations. Although these did not later enter into statutory law, apart from the constant privileging of the Baganda required by the special agreement that the British had signed with the *kabaka* prior to the establishment of the protectorate, ethnic distinctions were critical for the construction of a political system based upon culturally homogeneous districts in which administrative regulations, directives, guidelines, and codes of practice took into account recog-

nized ethnic/"tribal" differences. As within global capitalism generally, ethnicization was an integral part of modern economic development.

The categorization of exhibitors and exhibits made it clear that cotton growing by natives throughout the protectorate was universally to be encouraged, nevertheless. Cotton growing stood, thus, in striking contrast to cotton ginning, in which only nonnatives were to be engaged. Cotton ginning was rewarded not with a cash prize but with a diploma. The distinction created by these differing awards was indicative, I suggest, of a specific degree of social distancing; money created an unequivocally asymmetrical relationship between native exhibitors and British judges, whereas the awarding of a diploma left the relationship between nonnatives, that is, Asians and Europeans, more ambiguous.

Yet the fundamental message of the hierarchical structure of power relations being established was conveyed quite unambiguously. However powerful the Baganda chiefs and landowners might be, and however necessary might have been their military support in the early establishment of the colonial state, they were, in the colonial scheme of things, ultimately natives. It was not envisaged that their economic participation in the plural society would include the vital process of cotton ginning. It could not have been foreseen by the colonial controllers of the economy in 1908 that this categorical exclusion would be challenged by some "natives" a few years later. Appreciating that ginning was the most profitable part of the cotton sector, Baganda landowners moved quietly into small-scale ginning operations. The colonial authorities were then obliged to turn openly to writing year by year a slew of legislative controls, arguing the need to protect high-quality cotton production and ginning so that the protectorate might meet the requirements of fiercely competitive Indian and British markets. As a result, the largest Ugandan cotton ginneries were owned exclusively by European and Asian firms for almost all Uganda's subsequent colonial history.

Measures were thus introduced into Uganda not simply to discourage but to prevent native entry into the cotton ginning industry, which rapidly proved to be the most lucrative part of Uganda's economy. The cooperative movement as it developed in that country in the following twenty years was, in effect, a struggle to overcome the exclusion of Africans from the same sectors of the economy from which they were barred by such categorizations as were initially adopted at the agricultural show in 1908. At that time, although it had become quite clear that the British government would not favor planters over

peasants in its development policy, it was equally clear that it did not yet view Africans as anything but producers of cotton. In the legal struggle that ensued (Vincent 1988c) the British and Asian merchants had a common interest in the world market, and that interest was upheld by racially discriminatory legislation in Uganda.

To summarize: The categorizations of exhibitors at the 1908 Uganda Agricultural and Industrial Exhibition provide at least a fore-taste of the classifications of legal persons and legally restricted commercial activities that were to be adopted and contested in the protectorate in the years that followed. Some, such as those based on race, were challenged in the subcommittees of the Legislative Council (Vincent 1988a); others in the courts (Vincent 1988c); and many in violent and disorderly ways (Vincent 1982).

Whether the reglementation and rule making of committees such as that which, under the chairmanship of the attorney general, organized the 1908 show should be considered hegemonic is a matter of semantics; here I have simply called them "law-related hegemonic constructions." I would be the first to agree that only a historical *narrative* of Uganda lawmaking and its contestation can lay bare the legal relationships that developed. The challenge for anthropologists and legal historians is to historicize the hegemonic moment, discerning its place in the process of domination in both the colonial state and the imperial economy. Since the exhibition committee was appointed by the governor of Uganda, the representative of the Crown, and chaired by the attorney general, its constructions of identity were most surely an integral part of the legal history of Uganda. Just as Arthurs's (1985) historiography encourages us to look *outside* the black-letter law of the centralizing English state, so, I would suggest, does looking *behind* the law in the Ugandan state allow us to look at colonial law's logic in the making.

CONCLUSION

In this essay, I have suggested the significance of the hegemonic moment as a theoretical construct. It allows us to begin to approach the sheer intricacy and embeddedness of interchanges between culture and power such as those Gramsci brings to our attention. It allows us to follow Victor Turner (1974) and other cultural anthropologists in describing culture in action, focusing upon an event or an anecdote (as jurists prefer to call it) as a social drama, rereading it in order to reveal through the analysis of the particular the logic of the society. Yet it is important to recognize the historically specific nature of

any hegemonic moment. Both colonialism and capitalism have long been recognized as complex historical movements involving domination and power, and their global lineaments have become increasingly familiar to anthropologists even as imperialism takes on new forms and capitalism overcomes new challenges. But it is toward differentials rather than universals that the work of Gramsci directs us. Thus, it is also important to recognize that history is made up of many voices and forms of power and that, perhaps, megaconcepts such as colonialism and capitalism, domination and hegemony, are too monolithic for our present purposes. Critical historicists have returned to the particular contextualized, to the marginal decentered, to the crystallizing moment and the activity backstage. They read not simply texts, but footnotes and marginalia; they observe not simply actors but performers; they push further and further back from the situation to the site— even, as in this essay, to the *mute ground* on which expected and accepted classifications exist. This, indeed, is the essence of "the new historicism," as it has been called for nearly twenty years now.

So it is that anthropologists now read as Gramsci and Foucault have taught us to read, abandoning conventional turfs, crossing boundaries between anthropology, history, law, politics, and literature, trying to get closer to the complexity of culture, domination, power, or whatever it is that concerns us. We juxtapose the social (the exhibition), the literary (the *Gazette*), the logical (the categories of the text), the political (the dramaturgy of power) in order to try and get at the marginalized and the silenced. We find racial discrimination and exclusion where the exhibition's organizers doubtless perceived only a "natural" order of things, a chain of being. We find, in fact, gender discrimination and exclusion so taken for granted, so "natural," that the question of gender identity does not even arise on the occasion of this public ceremonial—it is unstated that no exhibitors were women, but no categories invited their participation, and we may be sure that none were present among the exhibitors. When in Uganda law women are singled out for attention (Vincent 1993), we are struck by the idiosyncrasy and the novelty of their recorded presence.

To move from the hegemonic moment to analysis of why this moment occurred rather than another, or why it occurred when it did rather than at another time, is to move from the historicity of the moment to the moment in the legal system's history. We see how legal definitions are made and outcomes produced. We see how organizers of a historic event produce a classification that manipulates society itself. It is in this direction that anthropology is moving, in advance, I would suggest, of formal jurisprudence. So dominated has jurispru-

dence been for some time now by normative philosophy (even as anthropology was for so long dominated by structural functionalism and processualism) that it has wholly marginalized legal history within its bounded turf. And so culturally hegemonic has jurisprudence been over legal anthropology that, until recently, anthropologists failed to realize what riches lay at their feet. Now, straddling the boundary— aware of historical trajectories in English common law (Arthurs 1985) and British colonial law (Chanock 1985), for example—they find the way open to move from their past historicist concerns to causal history as well.

It is for these reasons that I have suggested in this essay that adopting Gramsci's concept of hegemony is likely to be less productive in jurisprudence than would be broadening the boundaries of this discipline's subject matter to embrace the many aspects of law (such as legal history) excluded by normative legal philosophy. If "new directions in legal anthropology" do indeed, as Starr and Collier maintain (1989), lead toward history, they truly lead to much that practicing lawyers have set aside. Yet it may be hoped that these new directions lead as well toward a critical new legal historicity that allows us to deal better with valued old political topics—such as power and class, race and gender, inclusion and exclusion, domination and hegemony—and all the other ways we have of logically constructing our disciplinary (or subdisciplinary) mute ground. This essay is intended as a small anthropological step in this new direction.

Notes

Field research in Uganda and in the Colonial Office Archives has been funded at various times by the Ministry of Overseas Development of the United Kingdom and a Barnard College, Columbia University, Faculty Grant. Some of the archival material in this essay was originally presented in a paper called "Changing the Colonial Office Mind: Producers and Traders in Uganda 1908– 1938" at the Wenner Gren international symposium on "Tensions of Empire: Colonial Control and Visions of Rule" held at Mijas, Spain, November 5– 13, 1988. Discussion in this essay of "the hegemonic moment" was initially presented in my comments on a panel, "Rethinking Hegemony," organised by Leslie Gill and Maria Lagos for the eighty-ninth annual meeting of the American Anthropological Association, held in New Orleans in 1990.

1. Thus Fitzpatrick writes of H. L. A. Hart's classic *The Concept of Law* (1961): "Like much legal anthropology, these studies are concerned with the existence of so-called law in so-called primitive or savage societies. They share with Hart the technique of bringing a preexisting conception of law to bear on the world, a conception corresponding to one type of Western law which claims to maintain or restore social order. The world then obliges by confirming

that this idea of law is universally real. Anthropology has often provided tales of transition not unlike Hart's, covering the development of societies from a primitive state and the distinctive genesis of law in this development when public or official organization emerges out of diffuse social norms (see, for example, Hoebel 1954, and Newman 1983)" (1991:13).

Fitzpatrick's view of much legal anthropology and what legal anthropology has often done requires, perhaps, both historicizing and, in part, correcting. For two anthropogical challenges to this evolutionary perspective see Moore 1978, 1985, 1986 and Strathern 1985 as well as the Starr and Collier 1989 volume. To place Fitzpatrick's "legal anthropology" in historical perspective, see Vincent 1990.

2. Donald Nonini (1992) has recently provided an excellent critique of Williams's use of Gramsci's writings, particularly the concept of hegemony. As for Foucault, it is now abundantly clear that he failed to acknowledge his debt to Gramsci, as the literary critic Renate Holub has recently shown in an extended discussion (1992) of the work of the two writers.

3. Hegemony is thus a creative process. Concurrently with the black letter of statutory or administrative law establishing, for example, certain marriage forms or specific individual landownership rights, so "illegal" marriage practices and the customary recognition of common rights to land "resist" the imposed law.

4. It is generally recognized that on the colonial frontier social relations between colonizers and native peoples, and between European men and native women, were equitable. The colonial secretary's edict on 11 January 1909 that threatened colonial officers with dismissal if they had sexual relations with local women brought this phase of colonization to a close.

5. The success of hegemonic domination lies not simply in its production but in its reproduction. As I have shown elsewhere, ceremonial occasions were created in Uganda on which expressions of loyalty could be voiced and inculcated. Commemorative events (like the king's birthday) were proclaimed through the pomp and circumstance of empire. "This was the vital dramaturgy of power in the colonial state: the symbols and rites of empire reflected and sustained its dominant feature" (Vincent 1988d:149).

6. Tropical economies such as that of Uganda inspired J. S. Furnivall's classic portrayal of the plural society.

> Each group holds by its own religion, its own culture and language, its own ideas and ways. As individuals they meet, but only in the market-place, in buying and selling. There is a plural society, with different sections of the community living side by side, but separately, within the same political unit. . . . In the economic sphere there is a division of labour along racial lines. Natives . . . Indians and Europeans all have different functions. (1948:304)

Furnivall explains the successful working of this system of cultural discrimination as a matter of social wills and social consciousness, an interpretation I challenge (Vincent 1993). The different groups, he says, have "no common standards of conduct *beyond those prescribed by law*" (Furnivall 1948:311; emphasis added).

7. In many East African languages, the names of such vegetables clearly reveal their provenance, and the vegetables are sometimes ranked racially, the largest, sweetest, or best being denoted as "European." In the earliest phases

of colonialism, the growing of "European" vegetables by Africans was often a claim to differential, even elite, status.

References

Arthurs, H. W. 1985. *Without the Law: Administrative Justice and Legal Pluralism in Nineteenth-Century England*. Toronto: University of Toronto Press.

Asad, Talal. 1991. "Afterword: From the History of Colonial Anthropology to the Anthropology of Western Hegemony." In *Colonial Situations: Essays on the Contextualization of Ethnographic Knowledge*, edited by George W. Stocking, Jr. Madison: University of Wisconsin Press, 314–24.

Buci-Glucksmann, Christine. 1980. *Gramsci and the State*. London: Lawrence and Wishart.

Chanock, Martin. 1985. *Law, Custom, and Social Order: The Colonial Experience in Malawi and Zambia*. Cambridge: Cambridge University Press.

Dworkin, R. M. 1986. *Law's Empire*. Cambridge: Harvard University Press.

Fitzpatrick, Peter. 1991. *Dangerous Supplements: Resistance and Renewal in Jurisprudence*. Durham: Duke University Press.

———. 1992. *The Mythology of Modern Law*. London and New York: Routledge.

Foucault, Michel. 1970. *The Order of Things: An Archaeology of the Human Sciences*. London: Tavistock.

Furnivall, J. S. 1948. *Colonial Policy and Practice in the Netherlands East Indies*. Cambridge: Cambridge University Press.

Gramsci, Antonio. 1971. *Selections from the Prison Notebooks*. London: Lawrence and Wishart.

Hart, H. L. A. 1961. *The Concept of Law*. Oxford: Oxford University Press.

———. 1983. *Essays in Jurisprudence and Philosophy*. Oxford: Clarendon.

Hoebel, E. Adamson. 1954. *The Law of Primitive Man: A Study in Comparative Legal Dynamics*. Cambridge: Harvard University Press.

Holub, Renate. 1992. *Antonio Gramsci: Beyond Marxism and Postmodernism*. London and New York: Routledge.

Humphreys, Sally. 1985. "Law as Discourse." *History and Anthropology* 1:241–64.

Kidder, Robert. 1979. "Toward an Integrated Theory of Imposed Law." In *The Imposition of Law*, edited by S. E. Burman and B. Harrell-Bond. New York: Academic Press. 289–306.

Maine, Sir Henry. 1861. *Ancient Law: Its Connection with the Early History of Society and Its Relation to Modern Ideas*. Boston: Beacon Press.

Moore, Sally Falk. 1978. *Law as Process: An Anthropological Approach*. London: Routledge and Kegan Paul.

———. 1985. "Legal Systems of the World: An Introductory Guide to Classifications, Typological Interpretations, and Bibliographical Sources." In *Law and the Social Sciences*, edited by Leon Lipson and Stanton Wheeler. New York: Russell Sage Foundation, 11–62.

———. 1986. *Social Facts and Fabrications: "Customary" Law on Kilimanjaro, 1880–1980*. Cambridge: Cambridge University Press.

Newman, Katherine. 1983. *Law and Economic Organization.* Cambridge: Cambridge University Press.

Nonini, Donald. 1992. "Beyond Resistance, Beyond Hegemony." Manuscript submitted to *American Ethnologist,* June.

Public Record Office (PRO). CO612. Uganda. *The Uganda Official Gazette.*

Smart, Carol. 1991. "Feminist Jurisprudence." In *Dangerous Supplements: Resistance and Renewal in Jurisprudence,* edited by Peter Fitzpatrick, 133–58.

Starr, June, and Jane F. Collier, eds. 1989. *History and Power in the Study of Law: New Directions in Legal Anthropology.* Ithaca: Cornell University Press.

Strathern, Marilyn. 1985. "Discovering 'Social Control.' " *Journal of Law and Society* 12(2):113–34.

Thompson, E. P. 1975. *Whigs and Hunters: The Origin of the Black Act.* London: Allen Lane.

Turner, Victor. 1974. *Dramas, Fields, and Metaphors: Symbolic Action in Human Society.* Ithaca and London: Cornell University Press.

Twining, William. 1991. "The Case Law System in America." *Yale Law Journal* 100:1093–1102.

Vincent, Joan. 1982. *Teso in Transformation: The Political Economy of Peasant and Class in Eastern Africa.* Berkeley: University of California Press.

———. 1988a. "Changing the Colonial Office Mind: Producers and Traders in Uganda (1908–1938)." Wenner Gren Foundation for Anthropological Research conference titled "Tensions of Empire: Colonial Control and Visions of Rule," Mijas, Spain, November 5–13.

———. 1988b. "Cultural Minorities in East Africa: Colonial Praxis and Theory." Panel on Legal Pluralism, 12th International Congress of Anthropological and Ethnological Sciences, Zagreb, Yugoslavia, July 24–31.

———. 1988c. "Equality and Enterprise: The Cooperative Movement in the Development Economy of Uganda." In *Who Shares? Cooperatives and Rural Development,* edited by D. W. Attwood and B. S. Baviskar. Oxford: Oxford University Press. 188–210.

———. 1988d. "Sovereignty, Legitimacy, and Power: Prolegomena to the Study of the Colonial State in Early Modern Uganda." In *State Formation and Political Legitimacy,* edited by Ronald Cohen and Judith D. Toland. New Brunswick: Transaction Books. 137–54.

———. 1989. "Contours of Change: Agrarian Law in Colonial Uganda, 1895–1962." In *History and Power in the Study of Law: New Directions in Legal Anthropology,* edited by June Starr and Jane F. Collier. Ithaca: Cornell University Press. 153–67.

———. 1990. *Anthropology and Politics: Visions, Traditions, and Trends.* Tucson: University of Arizona Press.

———. 1993. "Trading Places: Recognizing and Recreating Legal Pluralism in Colonial Uganda." Special issue on "Legal Pluralism in Industrial Societies" edited by Carol J. Greenhouse and Fons Strijdosch, *Journal of Legal Pluralism,* 33:147–159.

CHAPTER 5

"KIDSTUFF" AND COMPLAINT: INTERPRETING RESISTANCE IN A NEW ENGLAND COURT[1]

Barbara Yngvesson

This paper examines the relationship of resistance to power by discussing the use of criminal complaint hearings by low-income residents of a western Massachusetts mill town.[1] It focuses on how a legal procedure established at the district court for the governance of "community" problems (that is, neighborhood and domestic disturbances among the working class and welfare poor) is subverted by this "community," which may use it as a way of governing the court as well. This simultaneous process of governance and subversion is a dimension of policies that relegate the problems of the poor and the propertyless to "lower" courts, and of an ideology of entitlement that encourages the most disenfranchised citizens to seek justice in court when it is unattainable elsewhere. As a consequence, officials at the lowest levels of the legal system are locked into perpetual conversation with these citizens, through which shared understandings about crime and nuisance and about the work of "lower" courts in handling nuisance cases are produced. These understandings provide the basis both for governance by the court and governance of the court.

The repeated appearance of unruly complainants at the courthouse confirms their identity as disruptive subjects in need of the court's control. At the same time, court hearings become sites of momentary insurrection as complainants who are caught up in the power of law deploy the law in unconventional ways. By engaging court staff in

the enactment of what some local officials term "kidstuff" at the courthouse, the court itself is constituted as a site where unorthodox forms of justice can be found and where alternative stories about the meaning of law can be told. I illustrate this transformation of the court with case material about a homeless man whose familiarity with the court system and long-term relations with court staff allowed him to turn the law against itself by engaging clerks and judges in a mockery of court procedure. In conclusion, I examine the relevance of this analysis for a theory of power in which resistance is understood as a dimension of the complex ways that agents "lastingly bind each other" (Bourdieu 1977:196), opening up "a whole field of responses, reactions, results, and possible invention." (Foucault 1982:220).

COMPLAINT AND DISORDER

The hearings I studied took place at the Franklin County District Court in Greenfield, Massachusetts, a town of 19,000 in the Connecticut River valley. In Massachusetts, access to the court is controlled by the clerk, who has discretionary power to allow or deny applications by citizens or by police for the issuance of a warrant or summons. While issuance of an arrest warrant is fairly routine and is typically handled "over the counter" in the clerk's office, some nonarrest complaints by police, and all complaints brought directly by private citizens, are handled in what is known as a "complaint," "show-cause," or simply a "clerk's" hearing.[2] In these hearings, the clerk determines whether a complaint application should be issued or denied, shaping the role the court comes to play in a broad range of local conflicts, from family disputes involving parent and child or husband and wife, to neighborhood problems involving ethnic conflict, outpatients from mental hospitals, and fighting children.

Massachusetts trial court policy urges dismissal of non-arrest complaints such as these, which are referred to as "garbage cases."[3] While the majority of these cases are dismissed,[4] many are "held" for months[5] and may return in different forms over a period of years, engaging court staff, and particularly the court clerk, in relatively long-term relationships with local citizens. Thus, while complaint hearings serve as arenas for the dismissal of "garbage" cases, they are also places in which the clerks act as "watchdogs" (as one clerk described himself) in the family and neighborhood lives of low-income populations in the jurisdiction of the court. This is seen as increasingly important in the face of what is interpreted by court staff as the "retreat" of family,

schools, and churches, leaving only the local court as a source of order and restraint.

The clerk's role as watchdog is particularly important in complaints brought to the Greenfield court from the neighboring mill town of Turners Falls. Described by court staff (who are predominantly residents or natives of Greenfield) as "the other half of America," complainants from Turners Falls are perceived as "brainless," "irrational," and "like children" by local officials, who deal with them both in court and in various state and private social service agencies. Homeless people from the smaller towns roam Greenfield's streets, and "hoodlums" and "druggies" from Turners Falls are seen as the source of serious crime in Greenfield. Complaint hearings from Turners Falls are a key arena in which the contradictory meanings of "garbage" cases—as nuisance complaints and as potential danger from people for whom fighting is a "way of life"—are produced, as clerks monitor what local police refer to as "kidstuff," sifting it out from charges that may constitute a more serious crime.

For Turners Falls residents, by contrast, the tension between complaints as "kidstuff" and complaints as crime provides a creative space in which to mobilize the court and other local government agencies in their own struggles to obtain housing or to lay claim to particular kinds of neighborhood order. In doing this, they challenge the order of the court both explicitly and implicitly. As claims, the tales of complainants and others make specific demands for social justice to which they have limited access; as implied commentary, these tales juxtapose discordant ways of telling or doing (the distortion of a familiar story line, play with conventional time and space arrangements, the unfamiliar positioning of actors vis-à-vis one another) with conventional practices, engaging others at the court in these alternative tellings and constituting the court itself as a site of insurgency, however temporarily.[6]

This reconstitution of the court was sometimes a collective project; at other times it was accomplished by an individual's performance. In early 1982, for example, a series of fifteen separate complaints were brought to the court clerk form the "downstreet' section of Turners Falls, and specifically from two streets that were described as "bad" streets by complainants. The complaints focused on children's fights and described racial slurs, threats with knives and sticks, and fights that were keeping children out of school. Court officials and police initially described these as "kidstuff," interpreting them as part of a "fighting way of life." Complainants, however, all of whom lived in neighboring houses or apartments, appeared repeatedly at the court-

house to file complaints of assault and of threats, and insisted that these were not just cases of "kids pushing kids." Tales of children chasing each other with knives and of threats to "punch my face in" by adults alternated with charges of property destruction, of adults hitting children, and of parents fighting with each other, specifically over boundaries and fences dividing their property. The courtroom filled with people who had been involved as either participants or as witnesses to the fights, and hearings sometimes spilled out into the hallway as the parties continued to shout and to threaten each other. In one hearing, the clerk followed combatants out into the parking lot as he continued his efforts to mediate. In cases such as these, the legal disciplines established to contain "neighborhood trouble" at the court are disrupted as participants in this trouble transform the court itself into a battleground, expanding the time and the space delegated to the management of "garbage."

This strategy of expansion (which involved both tenacity, in the sense of repeated appearances over a period of months, and the capacity to colonize space)[7] undermined the clerks' efforts to transform charges of violence into ordinary trouble (a key strategy of governance in complaint hearings). Their suggestions that the fights were simply "kids pushing kids" and that they could be handled if the parents exerted control were countered by parties who insisted the incidents were occurring because "[the] street is a bad street. It's a violent street. Children on that street are apt to be violent."

Ethnicity was rarely the explicit focus of these complaints but was frequently a subtext in complainants' stories. As one complainant noted,

> We own our own home, and when you have a house, and there's kids next door setting fires!... They say it's because we're prejudiced. It ain't that! If it was white kids setting fires, we'd feel the same way. ... She complains that my kids call her kids "niggers." [But] there's one "nigger" that means "color" ... then there's another "nigger" that means "people that lie and steal and cheat." That's the true meaning of the word! They can claim it's discrimination, because they're colored.

Racial hostility expressed in fighting words about "coodies," "niggers," and "faggots" rapidly escalated into physical violence in these hearings at the courthouse; and the efforts of court officials to defuse tensions in complaint hearings with lectures about encounters that were "nothing real vicious," the need for "brains," and about "staying away from each other," led finally to an outburst by one enraged

complainant who stormed out of the courtroom, spitting on the floor and pronouncing the hearings "a farce."

These hearings, which repeatedly brought groups of ten to twelve neighbors to the courthouse, transformed the complaint procedure from a hearing on a specific charge of crime to an airing of generalized concerns about a "bad neighborhood." This, in turn, moved the clerks from dismissals and lectures about self-discipline, to the issuance of formal charges in several complaints. The clerk who issued the complaints noted that, while the judge might disapprove of his action, the court and the police were looking at the conflicts with what he termed "a different set of values" than complainants, "middle-class values, if that's what you want to call it." He recalled one woman's complaint about the neighborhood and about how the schools and the police didn't show any respect for the adults there, "and it was almost as if to say, 'If you don't issue this, you're no better!' "

While these complainants successfully moved the clerk, galvanizing support at the courthouse to control the violence that was increasingly paralyzing their neighborhood, their repeated appearances in court simply confirmed the view of court staff that *they* were the problem in need of control. In this sense, their efforts to resist classification of their complaints as "kidstuff" simply enmeshed them further in relationships of dependence (as, in effect, perpetual "kids") with state personnel. At the same time, the collective mobilization of neighbors, and the definition of collective interests through the complaint process, involved more than simply subjection to the state. Rather, "the state," as represented in the court clerk, became a vehicle for this collective action.

The following case, involving a homeless man from the streets of Turners Falls, illustrates the complexity of the process of mobilization and subjection, suggesting how the complaint procedure simultaneously "catches people up" in the disciplines and demands of law (Abu-Lughod 1990; see also Hirsch this volume), while providing a space for oppositional practices in which court staff themselves become engaged. The case is not intended as a celebration of resistance; indeed, it suggests, as Abu-Lughod notes (1990:42), the complexity of power, and the multiple levels at which it works. But it provides as well a sense of how being "caught up" enables particular kinds of movement, in relationships where power is located *in* the relationship, and where control is secured in practices which "bind" agents to one another (Bourdieu 1977:196) so that "even the most autonomous agent is in some degree dependent, and the most dependent actor . . . retains some autonomy" (Giddens 1979:93).

"CHARLIE"

"Charlie" was one of the best-known figures at the Greenfield court, as familiar in complaint hearings before the clerk as in criminal court, and a constant source of aggravation to police, who received repeated complaints about him from residents of Greenfield and Turners Falls. Listed officially as "of no known address," his local identity was defined in part by his affiliation in the 1970s with the Renaissance Church, a commune that had been active at that time in Turners Falls and continued to own property in that town in the 1980s. Reputed to come from a wealthy New York family, "Charlie" had been in and out of mental institutions for years and was said to have destroyed his life with LSD. At the court, his actions were viewed with an uneasy mixture of tolerance and fear, as his antics transformed trials and complaint hearings into parodies of the legal process, implicating court officials and local citizens in his own self-conscious mockery of law.

Charlie was tolerated, indeed he was an object of fascination, because of the multiple ways in which he was "known" to the court: a local enactment of the grotesque, he was also a figure with a specific local history that tied him both to the "low" of Turners Falls and to the "high" to which Greenfield's middle and working classes aspired.[8] Well over six feet tall, and weighing perhaps 300 pounds, Charlie clothed himself in a bizarre assemblage: top hat, soiled white shirt, and baggy pants that drooped far below his waist. With a stomach that bulged beyond his shirt, Charlie always overflowed the space he occupied, belching continuously, and commenting on court procedures in a loud, belligerent manner. His erratic behavior on the street and in court—variously interpreted as nuisance, disturbance, or crime— was in marked contrast to his mastery of a style of bargaining (as defendant) that was reserved for attorneys rather than for indigents. Part lawyer, part street person, Charlie connected through his actions and dress the key distinctions on which the identity of Greenfield's middle class was created: its capacity for moderation and self-control, as over against "the other half of America" whose life of "fighting" was a continual affirmation of uncontrolled passion.[9]

Tolerance of Charlie's performances emerged in part from his familiarity to court staff and from the implicit constraint of the court setting, as a privileged space that ensured his control by law even as he repeatedly transgressed the boundaries of acceptable behavior in court. In this sense, his performances were a way of tracking danger. What was "already known" about him by the court was the predictable "ground"

against which the "new" (as dangerous) could emerge.[10] At the same time, this knowledge made it possible to interpret his actions as ironic commentary, rather than as danger, just as it was Charlie's familiarity with court officials and court procedure that made possible the critique of local justice embedded in his parody of the court. His performances were compelling (and thus permitted) precisely because they spoke to the concerns of *court staff* about the gap between moral and legal sense and to the limitations of law in controlling "excess" of this kind. As the assistant clerk observed, "The problem is, we've got all these people walking around with all these rights—and some people just shouldn't have them." Noting that "the ones that make the laws are lawyers; the ones who figure out how to get around the laws are lawyers; the judges are lawyers—they're all lawyers!" he suggested the ambiguous potential of law, its lack of a fixed anchoring point, and its openness to meanings that subvert the "moral sense" of local knowledge.

Charlie's capacity to mimic defense strategy, creating a pastiche of legal practice, turned the law against itself, revealing its identity as a "wet noodle" (in the words of one local official), unable to fully contain "the other half of America" which regularly spilled over into Greenfield, taunting the model of civility and self-control it represented. This inversion of law was dependent on the complicity of clerks and judges, who in turn were "lastingly bound" to eccentrics such as Charlie, through whom the moral silences of rights discourse could be spoken.

Charlie appeared at the courthouse—on charges ranging from disturbing the peace to trespassing, to indecent exposure, and finally to indecent assault and battery on a child under fourteen—at least six times during my research. The following sequence is illustrative of his exchange with the court clerk during one complaint on a charge of exposing himself. The complaint was brought by the Montague chief of police, who explained that the incident occurred at a softball game where Charlie, who was standing by the foul line, dropped his pants.

> *Chief*: Officer K was playing in the game. He told Charlie to leave the park. He wasn't arrested at the time because Officer K was off-duty.
> *Charlie*: What happened that day . . . I was just walking down the right field sideline. Then the ball came that way. It went just to the left of Officer K, exactly like it was hit for me. No one was going after it, so I just took five or ten steps to get the ball; and

as I ran to get the ball, my pants fell down. Wait a minute! I think they fell down *after* I picked up the ball . . . My pants fit loosely.

Clerk: Are these the same yellow pants that were the subject of your last hearing?

Charlie: Yes, first of all, it's totally absurd . . . Second of all, with my reputation . . . I'd be a fool to pull down my pants in front of a cop who's playing first base. Number three, my pants were only down for a second or two. I pulled them back up as soon as I could.

Clerk: Officer K didn't arrest you then?

Charlie: No . . . And number four, out of three or four hundred people, most of the people thought it was very funny. They wouldn't think it was funny if I did it on purpose. And number five, I was charged with the same offense three weeks ago, and I went to court in front of Judge M, and he put $300 bail on me. I'm supposed to be innocent until proven guilty, but having no money, I had to go to jail for thirteen days.

Clerk: We're getting a little afield here.

Chief: After the first [complaint], Charlie, you got red suspenders, which you wore all the time.

Charlie: I wore those suspenders for about a week, and my shoulders started to hurt, so I took them off.

This complaint was dismissed by the clerk on grounds that "it isn't so much that I believe everything you said, but I suppose it's possible that what you say is true."

Charlie was not always intent on gaining a dismissal and sometimes turned the discourse of rights to his advantage in these situations as well. During one appearance in court, following an incident at the police station in which he had threatened to urinate on the floor so that he would be arrested, he bargained openly with the judge for a $25 bail (which he could not afford) and a one-week sentence in jail, so that he could shower and have some meals. Explaining to the judge that a two-week sentence would be "too long" to confine him with other inmates, he successfully negotiated a disposition that temporarily removed him from the street, while assuring his continued habitation of the street. These negotiations, repeatedly disrupted by the laughter of a full courtroom, transformed the hearing into a satirical performance in which Charlie, rather than the judge, was momentarily in control.

As the most visible and articulate of several well-known figures from downstreet Turners Falls who more or less openly defied the

order of the court, Charlie embodied the capacity of people "living without social resources and without trust" (Greenhouse 1988:696) to control the law, creating disorder at the very heart of order. While others stole nightsticks from police cars, caused "willful injury" to public property by carving their names on courtroom benches, kicking the courthouse door during a conference with attorneys, or by spitting on the floor of the courtroom during a private complaint hearing, Charlie's defiance was always enacted in public, intended as performance and interpreted as entertainment by onlookers.

Even as they laughed at his antics, however, court staff commented on the threatening subtext in his actions. No one was surprised when he was arrested for climbing the fire escape outside a child's window one night to pull the blankets off her as she slept. This incident was followed by a chaotic series of appearances in superior court in which he refused the counsel of a court-appointed attorney, insisting that he was competent to represent himself. In a trial which attracted widespread local media attention, Charlie was described in one article as he summarized his case to the jury, "speaking to them and eating at the same time" in a parody of professional behavior. This culminated in his forcible removal from the courtroom when he tried to speak during the judge's instruction to the jury. Judged competent to stand trial and guilty as charged, Charlie was given a sentence of seven to ten years at Walpole State Prison and thus indefinitely removed from the streets of both Greenfield and Turners Falls.[11]

This story, which interweaves what historian Michel de Certeau terms a popular "esthetic of tricks" (1984:26) with individual tragedy, points to the contradictions and the ambiguities of cases brought to the court from Turners Falls. Straddling an uneasy boundary between "kidstuff" and serious crime, complaints from Turners Falls inevitably seem to have the potential for both, and thus the parties involved are at once humored and watched by court staff. In hearings before the clerk, their actions are implicitly contrasted to an ideal of restrained adult behavior, a contrast embedded in a system of distinctions in which lower-class persons and lower-class trouble are set apart from the lifestyle and self-construction of Greenfield's middle-class citizens. For people from Turners Falls, by contrast, court appearances became a way of establishing control, however transitory, in lives that were clearly *not* self-fashioned. Living in the constant shadow of legal agencies, the spaces for self-assertion were constricted, dependent on relationships with others who were similarly situated, and typically contingent on creative use of the very institutions that dominated their lives.

INTERPRETING RESISTANCE

In a recent paper, Lila Abu-Lughod notes that "unconventional forms of . . . nonorganized resistance" are better viewed as a diagnostic of power than as evidence of creativity, and she suggests that "the most interesting thing to emerge from [recent] work on resistance is a greater sense of the complexity of the nature and forms of domination" (1990:41, 42). Abu-Lughod is concerned with the tendency of some work to romanticize resistance while ignoring the ways "resisting at one level may catch people up at other levels" (ibid.:53) and argues for theories of power that acknowledge the creativity of resisters while as the same time locating their actions in the context of intersecting local and transnational power structures. In this way, resistance becomes a tool for examining power as "fields of overlapping and intersecting forms of subjection" (ibid.:52–53).

I agree with the general thrust of this critique, in that it is attentive to the ways resistance is implicated in power. But I question the privileging of subjection in Abu-Lughod's analysis, a perspective that is signaled in her inversion of Foucault's statement "where there is power, there is resistance" to "where there is resistance, there is power" (ibid.:42).[12] "Where there is resistance, there is power" points to the ways resistance is always *contained* by relationships of power, and permits us to trace the complex intersections of these relationships. It facilitates a mapping of power as "sets of authority structures" and as "fields of overlapping and intersecting forms of subjection" (ibid.:52); but it does not speak to Foucault's understanding of power as a relationship in which " 'the other' (the one over whom power is exercised) [is] thoroughly recognized and maintained to the very end as a person who acts" so that "faced with a relationship of power, a whole field of responses, reactions, results, and possible inventions may open up" (1982:220).

In a recent interview, Jamaica Kincaid observed that she "wouldn't have known how to write and how to think" had she not been forced to memorize Wordsworth and Milton as a child growing up in a colonial school on the island of Antigua (Perry 1990:507). She added, "I wouldn't have known my idea of justice if I hadn't read *Paradise Lost*, if I hadn't been given parts of *Paradise Lost* to memorize." These statements suggest the complicated interplay of subjection and creativity that is implied in Foucault's understanding of power, and how oppressive forms and practices can provide grounds for intervention. Kincaid's recent novel *Lucy* (1990) incorporates this author's

experience of memorizing Satan's part in *Paradise Lost*, but rewrites her childhood performance of Lucifer as a recalcitrant and unforgiving au pair (Lucy) working in New York (Perry 1990:507).

Kincaid's autobiographical statements suggest some of the blind spots in an analysis that focuses primarily on what resistance can tell us about "structures of power" and on how people are "caught up in them" (Abu-Lughod 1990:42) without retaining a sense of *power* as struggle (Williams 1977:113; Comaroff and Comaroff 1991:26) and of agents as lastingly binding *each other* (Bourdieu 1977:196, my emphasis). If power is seen not only as structure but as struggle, then the same events may be seen "either from inside the history of struggle or from the standpoint of the power relationships" (Foucault 1982:226). Kincaid's statements suggest that from inside the history of struggle, resistance can be seen as a long-term project that emerges in and through the experience of being "lastingly bound" in particular relations of power. To be "caught up" in these relations means to "know" how to write and to think from memorizing Wordsworth and Milton. It means to embody Satan as a child in a colonial school and— many years later, in another enactment of this colonial relationship— to transform Lucifer into Lucy, writing this transformation into a story of refusal that reworks the experience of subjection into "something new." Always, there is a sense of how being caught up in power is a "two-edged thing" (Perry 1990:507).

In a similar way, court hearings involving parties from Turners Falls also reveal the double edge of the power of law, allowing them to colonize the court even as they strengthen its dominion in their lives. Complaint hearings at the courthouse contain and marginalize, but also induce unruliness, as officials call a halt to "backyard arguments," move fights (and hearings) into the courthouse parking lot, and occasionally engage as active participants in the struggles for justice—and the mockeries of justice—that are enacted before them. In this sense, complaint hearings are at the same time moments of reproduction and of disruption, as people "of no known address" inhabit the court, occupying conventional legal spaces and forms in parodies of legal procedure to insist on their right to safety, to shelter, and to justice.

Notes

1. This paper draws on material included in Chapter 6 of my book *Virtuous Citizens, Disruptive Subjects: Order and Complaint in a New England Court* (Routledge, 1993). Some parts of that chapter are reproduced, while other parts have been abbreviated. This material was originally presented as a paper

on the panel *Hegemonic Processes and Oppositional Practices: Law and Bureaucracies as Arenas of Transformation* at the annual meeting of the American Anthropological Association, Chicago, November 1991.

2. MASS. GEN. LAWS ANN. ch. 218, sec. 35A:55.

3. The *Standards of Judicial Practice*, issued by the Administrative Office of the District Court Department (1975), urges dismissal of citizen complaints (1975:3:00). The term "garbage case" is used colloquially at the court in Greenfield and elsewhere in the state to describe citizen-signed complaints (see Yngvesson 1985, 1988; Merry 1990). For a more general discussion of the management of garbage cases in trial courts, see Harrington 1985:137–68.

4. Of 293 complaints brought by citizens to the clerk between June and December 1982, 55 percent were denied or withdrawn, 33 percent were issued as formal criminal charges, and 12 percent were continued, transferred, or handled in some other way. For a discussion of the handling of citizen complaints in other Massachusetts courts, see Yngvesson 1985, 1993 and Merry 1990.

5. This form of disposition was used in 23 percent of the complaints filed by citizens. Of 163 denials in citizen complaints, 37 were "held at the show cause level," "issued technically," or "continued for a few months to see if there is any more trouble."

6. My analysis here draws on Hebdige's (1979) discussion of punk culture, and specifically on his observation that "the challenge to hegemony which subcultures represent is not issued directly by them . . . [but] is expressed obliquely, in style" (1979:17). Transformations of style can "go 'against nature,' interrupting the process of normalization" (1979:18). See also Comaroff and Comaroff 1987:192–94; 1991:27–32.

7. See de Certeau 1984:26 on the "ethics of tenacity (countless ways of refusing to accord the established order the status of a law, a meaning, or a fatality)."

8. See Stalleybrass and White's discussion (1986:20–25, 43–44) of the grotesque body as a "register" of low culture. Here I am using "grotesque" not as a binary opposite to "classical," however, but as hybrid, as the "inmixing of binary opposites, particularly of high and low, such that there is a heterodox merging of elements usually perceived as incompatible, and this . . . version of the grotesque unsettles any fixed binaryism [*sic*]" (ibid. 44).

9. See Comaroff and Comaroff (1987:191–94) for a discussion of a similar figure among the Tswana of South Africa.

10. For a related analysis, see Abu-Lughod's analysis of the emergence of meaning in Awlad 'Ali poetry in the context of what the audience knows about the performer (1986:175–77).

11. Keller 1983a:3; 1983b:3; 1983c:3.

12. Abu-Lughod notes that Foucault himself advocates this inversion in his later (1982:211) work.

References

Abu-Lughod, Lila. 1986. *Veiled Sentiments: Honor and Poetry in a Bedouin Society.* Berkeley: University of California Press.

————. 1990. "The Romance of Resistance." *American Ethnologist* 17:41–55.

Administrative Office of the District Court Department. 1975. "The Complaint Procedure." In *Standards of Judicial Practice*. The Committee on Standards. Boston: District Court of Massachusetts.

Bourdieu, Pierre. 1977. *Outline of a Theory of Practice*. Cambridge: Cambridge University Press.

Comaroff, John L., and Jean Comaroff. 1987. "The Madman and the Migrant: Work and Labor in the Historical Consciousness of a South African People." *American Ethnologist* 14:191–209.

Comaroff, Jean, and John L. Comaroff. 1991. *Of Revelation and Revolution: Christianity, Colonialism, and Consciousness in South Africa*. Vol. 1. Chicago: University of Chicago Press.

de Certeau, Michel. 1984. *The Practice of Everyday Life*. Berkeley: University of California Press.

Foucault, Michel. 1982. "The Subject and Power." In *Michel Foucault: Beyond Structuralism and Hermeneutics*. Hubert L. Dreyfus and Paul Rabinow, eds. Chicago: University of Chicago Press. 208–226.

Giddens, Anthony. 1979. *Central Problems in Social Theory: Action, Structure, and Contradiction in Social Analysis*. Berkeley: University of California Press.

Greenhouse, Carol. 1988. "Courting Difference: Issues of Interpretation and Comparison in the Study of Legal Ideologies." *Law and Society Review* 88:687–708.

Harrington, Christine. 1985. *Shadow Justice: The Ideology and Institutionalization of Alternatives to Court*. Westport, Conn.: Greenwood Press.

Hebdige, Dick. 1979. *Subculture: The Meaning of Style*. New York: Methuen.

Keller, Charles. 1983a. "Exam Asked for Man Convicted on Morals Charges." *Greenfield Recorder*, May 18:3.

————. 1983b. "Man Defends Self on Morals Charge." *Greenfield Recorder*, May 17:3.

————. 1983c. "Wertheimer Sentenced to 7–10 Years." *Greenfield Recorder*, May 27:3.

Kincaid, Jamaica. 1990. *Lucy*. New York: Farrar Straus Giroux.

Merry, Sally Engle. 1990. *Getting Justice and Getting Even: Legal Consciousness among Working-Class Americans*. Chicago: University of Chicago Press.

Perry, Donna. 1990. "An Interview with Jamaica Kincaid." In *Reading Black, Reading Feminist: A Critical Anthology*. Henry Louis Gates, Jr., ed. New York: Meridian, 492–509.

Stalleybrass, Peter, and Allon White. 1986. *The Politics and Poetics of Transgression*. Ithaca: Cornell University Press.

Yngvesson, Barbara. 1985. "Ideology and Justice in the Clerk's Office." *Legal Studies Forum* 9:71–87.

————. 1988. "Making Law at the Doorway: The Clerk, the Court and the Construction of Community in a New England Town." *Law and Society Review* 22(3):409–48.

————. 1993. *Virtuous Citizens, Disruptive Subjects: Order and Complaint in a New England Court*. New York: Routledge.

Williams, Raymond. 1977. *Marxism and Literature*. Oxford: Oxford University Press.

THE PARADOXES OF
LEGAL PRACTICE

BATTLING OVER MOTHERHOOD IN PHILADELPHIA: A STUDY OF ANTEBELLUM AMERICAN TRIAL COURTS AS ARENAS OF CONFLICT

Michael Grossberg

In a Swiss church on August 22, 1837, Ellen Sears married Paul Daniel Gonzalve Grand d'Hauteville.[1] She was eighteen and on a European tour with her wealthy Boston family. He was twenty-four and the eldest son of a minor Swiss noble. The marriage unraveled rapidly over charges of mistreatment, broken promises, failed duties, and meddling mothers-in-law.[2] Pregnant and unhappy, Ellen secured Gonzalve's permission to sail home in the spring of 1838. On September 27, 1838, she gave birth to a boy and named him Frederick. Gonzalve demanded that his wife and son return to Switzerland; Ellen refused. In the spring of 1839, he sailed for America to retrieve his family. When Ellen heard of his arrival, she grabbed Frederick and fled. While she hid, the couple negotiated by way of lawyers.[3] A year later, the couple's fight over their child erupted into a highly publicized habeas corpus trial that began on Monday, July 13, 1840, before a three-judge panel.[4]

In the months that followed, the d'Hauteville case produced a voluminous record that reveals a complex experience in the legal structuring of conflict.[5] To capture the experiential reality of this parental struggle, I want to depict the Philadelphia courtroom as an arena of conflict.

By an arena of conflict, I mean a way of conceptualizing legal institutions and rules as public sites for contests over the meaning and application of the law. As a historian, I think the concept of legal arenas of conflict can best be understood through examples situated in time.[6] Historicizing the legal arena compels us to explain why and when within a hegemonic legal order certain ideologies and distributions of power became privileged while others were rendered oppositional or ignored. Doing so encourages a study of legal change that acknowledges the existence at any particular moment in time of conflicting ideological visions of law drawn from such cultural influences as professionalism, institutional roles, class, race, ethnicity, gender, and regionalism.[7] And it compels us to examine both the agency and ideology of particular social groups like married women and men and the constraints of power and context on each group's legal activity.[8] In this way, the paradoxes of legal practice become clearer through examples of how the exercise of legal power not only contributes to the law's hegemony, but also encourages resistance to specific forms of legal authority. Bringing such paradoxes into historical analysis can avoid overly linear and unitary visions of legal rules and institutions that tend to render them static at any particular time and to ignore the significance of timebound struggles over legal change like the d'Hauteville case.

The fight for Frederick cannot be understood without recognizing that it erupted at a particular moment in time. It occurred during a critical convergence in American legal and social history. Trial courts were the most visible manifestations of a powerful new American legal order. In the new republic, law and lawyers assumed hegemonic authority over dispute resolution. As a dominant set of cultural ideas and institutions, the legal system seemed to be penetrating deeper and deeper into American society, even gaining a hold over individual consciousness by providing many Americans in conflict with a sense of self expressed in terms of rights, duties, and power. Testimonies to this newfound authority abounded. They ranged from Tocqueville's declaration a few years before the trial that in America every major issue becomes a judicial question to Lincoln's sermon a couple of years after it that law must become the nation's civil religion. Such comments, and subsequent historical arguments labeling the period American law's formative period or transformative era, suggest the need to understand the importance of trials as arenas for conflict during these critical years.[9]

The case also occurred at a crucial juncture in the history of the American family. The Philadelphia courtroom, like others around the

country, became an arena for voicing and contesting gender beliefs in a society experiencing fundamental gender realignments. Newly constructed visions of the family as a nurturing private enclave committed to child rearing and maternal authority spawned practices and beliefs that challenged established patriarchal authority over the household. These challenges sprang from three intertwined developments. First, a growing transatlantic conviction emerged that women had primary responsibility for public virtue, especially its transmission in the family. Middle-class Americans translated this belief into the ideal role of republican wife and republican mother. Second, a new sense of children as plastic, malleable beings vital to the fate of the American republican experiment heightened the importance of child rearing. And finally, changes in gender beliefs and parenting responsibilities occurred amidst a broader postrevolutionary revolt against patriarchal authority that spurred attempts to reshape family life, politics, and culture. Though historians would look back on the first decades of the nineteenth century as the spawning period of the modern American family, at the time these developments ensured that the social status and duties of fathers, mothers, and children would be unusually murky and constantly contested.[10]

The law became an arena for many of the conflicts over household roles and responsibilities. Though children stood at the heart of many of these legal disputes, their voices were generally silent. Instead parents and other adults fought each other for power over children's lives. The d'Hauteville case was one such contest. It pitted a defense of received patriarchal authority against demands for a new gender order and in the process revealed how legal disputes could turn gender resisters into legal rebels.

To pursue these issues, I want to narrate briefly four stages in the d'Hautevilles' fight over their son: the legalization of the struggle; the construction of courtroom stories; the arguments of counsel; and the judicial verdict on the dispute.

BRINGING IN THE LAW

The fight over Frederick erupted in a Philadelphia courtroom because Ellen and Gonzalve failed to settle their conflict privately. In a series of negotiations by correspondence, the couple's dispute became irreconcilable. As the possibility of successful bargaining faded, Gonzalve and Ellen felt what Tocqueville had recently called "the shadow of the law" fall over them. In that darkening space, legal rules and prac-

tices and even words began to take over the couple's struggle and dictate their actions.[11]

The couple bargained during the summer and fall of 1839. At first, Gonzalve played the supplicant, pleading for Ellen to return and bring him his child. He urged her to accept that "if we have both done wrong, my friend, it has been less our own faults than from the consequences of unfortunate circumstances; and if you feel yourself offended, Ellen, pardon as I do, for I have always ended in doing that, in the greatest griefs which your injustice has so often exposed me to." But he clothed his pleas in a threat: "We have the opportunity of being reconciled, I pray you my dear Ellen, to think much of it and to pray much before you shut the door and force me to act, before you make us both miserable for life perhaps and prepare sorrows for our dear child." She remained defiant and spurned his efforts at reconciliation. Instead Ellen implored him to "pity my situation and disturb me no more. No power on Earth shall separate me from my child, it is weak and feeble and night after night I have watched by it and suffered for its safety; by the affection you once expressed for me and in which I so surely trusted I beseech you to spare me further trials."[12]

As his frustration mounted, Gonzalve consciously brought the "law" into the fight. Once he did so a role reversal occurred. Gonzalve became the author of dogmatic demands: Ellen must return or lose her child. His legal threats turned her into the supplicant, who pleaded that they continue negotiating and avoid the courtroom.

The switch occurred after each parent underwent a crash course in the law of divorce, separation, and child custody. Experiencing the legalization of their dispute, the couple learned some blunt lessons about the power of gendered rules. And yet they also found in the law ways the native-born mother and the Swiss father could explain who they were and what they wanted. For them, as for others, law's appeal was both instrumental and constitutive.

The d'Hautevilles learned that in Ellen's native Massachusetts, as in other American states, she had neither the grounds nor the legal standing to file for a divorce or separation. Her claims that Gonzalve's tyrannical behavior—forcing her to read portions of the Bible that stressed wifely subordination, breaking promises to spend portions of each year in Paris and to let her return to America periodically, mistreating her mother, and trying to kidnap her in Paris—constituted marital cruelty would not be convincing to American judges. They defined cruelty as physical attacks not mental abuse.[13]

Since both spouses learned that American law offered no grounds upon which Ellen could seek relief as a wife, they realized that her

only hope lay in claiming the legal protections of motherhood. A rapid education in American custody law taught them two lessons about mothers and the law.

First, Anglo-American law gave fathers primary rights to the custody of their children against their wives as well as others.[14] A glimmer of hope remained for Ellen, though. Since the late eighteenth century the conceptual assumptions of custody law had been changing. Child welfare began to displace paternal rights as the focus of judicial inquiry. The shift had created a new legal doctrine, "the best interests of the child rule," to guide custody fights. It granted judges broad discretion to weigh competing claims of would-be custodians. Through this discretionary power, some judges turned the doctrine into a vehicle for bringing new ideas of child rearing and gender roles into the courtroom and translating them into legal rules; and, conversely, the doctrine could also be used to structure legal contests so that they became vehicles by which revised legal definitions of gender entered the larger society. In 1840, the outcome of these doctrinal developments could not be predicted, however, in part because of the complications Ellen and Gonzalve learned in their second legal lesson.

Second, American federalism had spawned differing interpretations of custody law. Though paternal rights reigned supreme throughout the Union, judges defined the best interests of the child differently. Instead of producing a certain and predictable set of rules, as had the old standard, the new doctrine turned courtrooms into arenas where lawyers and clients fought over the meaning of child welfare and proper standards for judging clashing custodial claims. As a result, a new indeterminacy bedeviled custody law. The law's central concerns—judicial discretion, child welfare, and parental fitness—suddenly became contested. Trapped by Gonzalve into going to law, Ellen learned that federalism meant she could shop for the best forum. So while the bargaining continued, she trekked from New Hampshire to New Jersey searching for a maternal haven.[15]

Ellen searched because Gonzalve had learned his legal lessons quite well. He found in American custody law words to express and means to apply the paramount patriarchal rights he assumed he held. The Swiss father expressed those sentiments first in phrases drawn from his religious and familial beliefs. He claimed his rights and duties as a husband and father: "There is a duty reposing in me as a father, as a Swiss, as a member of society, that leaves me no alternative. . . . I am no longer disposed, either, to see the most sacred rights of nature thus violated with respect to me. . . . No, Ellen, that cannot be." But law promised not merely expression but empowerment and coercion.

It was simply too potent a weapon in his bargaining arsenal to ignore. It was the trump that promised victory without compromise: "As to my incontestable legal rights, in that respect I am assured by everyone, and they are all freely acknowledged, as I am told, by your friends." He could not resist playing his hand and even hoped that the mere threat of legal proceedings would force his wife to return rather than risk losing Frederick.[16]

Legal learning offered Ellen a very different lesson. She learned that wealth could not erase the reality that as a married woman she was trapped in a regime of patriarchal dominance and that she could not shield herself from Gonzalve's legal threats. Instead his demands forced her not only into flight but into resistance. She denounced a legal order that would sever what she believed to be the natural ties between mother and infant. In hiding, Ellen discovered a legal language of opposition percolating through the society and legal tools to challenge patriarchy. She resisted her husband's demands by voicing her claim to Frederick in an emerging oppositional language of maternal responsibility for children. Ellen expressed a "contradictory consciousness" that blended acceptance of the authority of law with resistance to specific patriarchal rules.[17] She vented her rage by distinguishing between natural and positive law and, as had her husband, by drawing upon cultural regimes other than law, most notably religion and gender ideology, to defend her claim: "The law may be on your side, for I know nothing of these matters, but ah, Gonzalve! there are other laws than the laws of man, and in the quiet stillness of your own chambers, consult the laws of your God! Would he counsel you to tear your child from the arms of its mother? Would he counsel you thus to persecute an unfortunate being, whom, in following the path of her duty, you pursue with unrelenting zeal—tell you to consign her, in the spring-time of her life, to rest in an early grave?" And like others forced to confront their powerlessness, Ellen denied the legitimacy of Gonzalve's patriarchal power by protesting what seemed to her to be a contradiction between law and justice: "Remember, you are accountable to your final Judge for the suffering you occasion. Arbitrary and artificial rights will not weigh in the balance against humanity and mercy before Him."[18]

But her pleas failed. Gonzalve and his lawyers still pursued her. They tried to initiate legal proceedings in Massachusetts, but could not serve her with a writ there or later in New York City.[19] Finally, unable to prevent the legalization of their struggle, Ellen seized her only remaining legal weapon—forum shopping. In March of 1840,

she took up residence in Philadelphia and waited for Gonzalve to find her.

Angered by his failure to have the case heard in other jurisdictions, Gonzalve protested that his wife took her stand in the "City of Brotherly Love" because "the laws of Pennsylvania were more favorable to maternal rights than those of Massachusetts."[20] As he had learned, a string of decisions since the 1790s had defined the best interests of the child in terms of child nurture not parental ownership and had begun to institutionalize a belief in mothers as naturally endowed caretakers of the young. More than in any other state, doctrinal interpretations by Pennsylvania judges had thus carved out a place for—and structured—maternal custody claims within a dominant paternal regime through the mediums of maternalism, child welfare, and judicial discretion.[21]

The decision to fight for Frederick in Philadelphia represented a strategic decision that revealed the weakness of Ellen's legal claim. Try as she might, Ellen could not avoid the courtroom once Gonzalve turned to law. Her counsel could only find the most favorable forum to oppose the patriarchal legal power she could not ignore. Yet her legal tactics and convictions also thwarted Gonzalve's bargaining strategy. His legal threats failed to force Ellen to give him Frederick and return herself. Bargaining in the shadow of the law had turned the d'Hautevilles' struggle into a legal conflict.

CONSTRUCTING COURTROOM STORIES

The Philadelphia Court of General Sessions entered the dispute on July 3, 1840, when Gonzalve requested a writ of habeas corpus charging his wife and her parents with illegally detaining the boy.[22] In doing so he launched a trial that would last through fits and starts into October.

By the 1840s, habeas corpus, the ancient Anglo-American constitutional protector of individual rights, had become the primary vehicle for defining the new best interests of the child doctrine. Seizing jurisdiction under the broad but vague doctrine of *parens patriae*, habeas corpus hearings allowed judges wide discretion to award custody by assessing a child's needs rather than merely balancing the legitimacy of parental claims. Custody hearings turned the courtroom into an arena for determining the suddenly contested meaning of parental fitness and child welfare.[23]

The indeterminacy of legal doctrines like the best interests of the child rule turned the Philadelphia court into an arena of conflict in ways that highlighted each half of the phrase, "arena of conflict."

First, doctrine spawned conflict by forcing lawyers and litigants to fight over the meaning of legal rules. The uncertain application of general rules to any individual dispute compelled attorneys to engage in what legal historian Lawrence Friedman has aptly called the "narrative competition."[24] Neither Gonzalve nor Ellen could plead their case any way they wanted; instead they had to enter a storytelling contest with specially constructed courtroom stories. These were tales made as convincing as possible within the constraints imposed by the facts of their conflict, the rules of custody law, and the procedures of habeas corpus trials. These constraints on narrative construction represented one source of the law's power. Once a conflict has been brought to law, doctrine, as anthropologist Sally Merry has argued, has the "ability to establish a dominant way of constructing events and to silence others, thus channeling and determining the outcome of legal proceedings."[25]

And second, doctrinal conflict turned the courtroom into an arena for these narrative competitions. In this instance, the indeterminacy of custody law made the Philadelphia Court of General Sessions a public theater in which a ritualized performance with recognizable acts and actors had to be presented to the court and the community.[26] Indeed, as rumors about the case flew around town, Presiding Judge George Washington Barton and Associate Judges Robert Conrad and Joseph Doran had to depart form their usual procedure of hearing custody disputes privately in their chambers.[27] As Barton ruefully acknowledged on July 18: "After a careful consideration of the circumstances of the case, we think it is our duty to sit in public. The affair has already gotten into the newspapers, and, by a private hearing, great injustice would probably be done to one party, if not to both. Perfect privacy or entire publicity is desirable. The former being out of the question, we must decide upon the latter. It is with pain and reluctance we make this decision, but nothing else is left us."[28]

The dual realities of the legal arena became evident early in the trial. During the first two months, amidst constant and successful motions for delay, growing numbers of spectators and reporters heard each party present their stories in elaborate briefs and rebuttals. Drafted and read to the court by the lawyers but expressed in the clients' voices, these documents retold the couple's star-crossed history as separate tales constructed to turn the ambiguous rules of custody law to each parent's favor while simultaneously competing for the sympathies of the judges and the public.

As the lawyers had drafted and then begun to read Ellen and Gonzalve's stories, it became clear that one rule would dominate the narrative competition. As with all doctrines, judges in Pennsylvania and

other states had begun to modify the best interests of the child rule by creating collateral rules for specific situations. Amidst the story writing, the d'Hautevilles and their lawyers discovered one of these, the "tender years rule." It dictated that infants, young children, and girls should be placed with their mothers unless the mother proved unfit. A legal translation of the era's maternalist ideology, the rule created a new legal fiction: the responsible mother. This family-law character joined the law's existing corps of fictional actors, among them the "reasonable man," as an artificial standard against which the actual conduct of men and women would be judged.[29]

The story writers also learned the uncertainties of applying such fictions to the actions of real parents. In 1813, the state supreme court had granted Barbara Addicks the custody of her two young daughters despite adultery, divorce, and marriage to her lover in violation of state law. The justices had decided that the girls needed their mother and that adultery had not compromised maternal nurture. But three years later, the same court sent the girls to their father. The justices then concluded that the girls' ages made them less dependent on maternal care. Claiming a discretionary authority over child placement and a responsibility to look to the children's best interests, they transferred custody on the grounds that two potential wives ought not be reared by a mother who violated her marital vows.[30] *Addicks* served as an unavoidable legal precedent for turning Pennsylvania custody hearings into adversarial contests over marital conduct, parental fitness, child welfare, and judicial discretion.

The results emerged as attorney William B. Reed began the trial by telling Gonzalve's story. Rephrased by his lawyer to accommodate the formal rules of custody law, Gonzalve again proclaimed the traditional patriarchalism he had hurled at Ellen in their private bargaining. Forced to make narrative choices, Reed emphasized marital unity as the central issue of the case. He insisted that family integrity and conjugal responsibility were the proper determinants of child welfare and assailed Ellen as a marital sinner unworthy of custody. Arguing that she had left husband and home "without any just cause," Reed universalized Gonzalve's demand for Frederick: "By the laws of this and every Christian land, the wife is bound to adhere to her husband, to remain with him, to make his home her home, and his country her country; and if a wife, causelessly, abandons her husband and refuses to live with him, she forfeits all those privileges which the law so largely bestows on a faithful wife. She ceases to be the exclusive guardian of the children even for nurture, and has no reason to complain of the hardship of a separation, which she has the ready means of removing, by herself

returning to her duty." He thus articulated and applied to marriage the fault ideal so deeply embedded in Anglo-American legal culture.[31]

Forced to confront the demands of custody rules, Reed insisted on defining child welfare in paternal terms. Fathers had the primary responsibility of rearing and educating their children, especially their sons and heirs. With equal fervor, through his lawyer Gonzalve refused to concede superior parental capacity to any mother let alone one who had deserted her home without justification. Yet sensing the rising power of a nurture definition of child welfare, Reed also tried to use Gonzalve's narrative to activate masculine solidarity by warning the judges against succumbing to a maternal reading of the tender years rule: "even at a tender age, a child's best interests" lay with "delivering it to its father."[32]

In resisting Ellen's challenge, however, Gonzalve and his lawyers issued one of their own. They attacked the court's power "to arraign him on these points of domestic government," when he denied abusing his office. "The domestic hearth is protected, and the domestic government is justly administered," Reed asserted for Gonzalve, "by its domestic head." A patriarch's jurisdiction "in its narrow but important sphere, is perfect and supreme as long as it is exercised within the limits which divine and human wisdom have prescribed." Reed expressed Gonzalve's patriarchal conviction that the only legitimate judicial role in the case was to enforce his rights. Declaring Ellen's demands "unsupported by judicial precedent" and "inconsistent with sound reason," Reed ended Gonzalve's story by returning to his master theme of marital unity. He urged the judges not to "sanction and reward the voluntary abandonment of that union, pronounced by the laws of God and man, the most holy and indissoluble on earth."[33]

Ellen's counsel, John Cadwalader, entered the narrative fray with a very different tale. He too faced storytelling choices. Through his pen, Ellen's story only faintly echoed her bargaining letters. Assertions of marital abuse, which had dominated her complaints but resisted legal categorization, now played second fiddle to declarations of maternal responsibility. And, in a revealing tactical decision, Cadwalader rejected the obvious strategic appeal of chauvinism in a city already feeling the heat of nativism. The Philadelphia lawyer emphasized gender, not nationality. He made Ellen challenge Gonzalve as a father, not a foreigner. Like Reed and the other participants in this drama, Cadwalader silently assumed a division of society into gender spheres based on categorical sexual differences.[34] But he swaddled Ellen's claim to Frederick with assertions of maternal duty, not patriarchal prerogatives.

Using maternal responsibility as a counterweight to paternal rights, Cadwalader had Ellen claim her son not as a right but as a duty of hers and a need of Frederick's. He defined child welfare in terms of nurture not marital unity.[35] After assuring the judges of Ellen's ability to rear her son and her father's willingness to be the male protector antebellum gender ideology assumed women needed, Cadwalader legally categorized her as Frederick's "guardian by nature and for nurture." Then he invoked the emerging tender years rule to particularize her claim: "the present age of her said child does not admit of his separation from her, without the greatest danger to his health, which requires care, and even to his life, which has been more than once seriously threatened by attacks of illness. He needs, and for some years to come will need, a mother's nursing care, which no one else can supply."[36] In requesting that the Philadelphia judges give priority to maternal claims for young children, Cadwalader legitimated Ellen's challenge to patriarchal power by playing on his era's doubts about fathers and invoking its icon of motherhood: "No male person is competent to take the necessary care of so young an infant, and no female, but a mother, can be expected to bestow upon it the care and protection which are necessary for its health and welfare."

Recognizing that Ellen's claim for the boy required a judicial redistribution of family power because of its direct assault on paternal authority, Cadwalader appealed to the judges' Pennsylvania chauvinism and masculine paternalism. He rejoiced that in the progressive commonwealth judicial discretion could finally be wielded "with an exclusive view to the safety and benefit of the child." Cadwalader offered the court a reading of Pennsylvania law that resisted defiant patriarchalism with responsible maternalism: "Upon the question, whether the court will interfere to change the custody of an infant, who has been from its birth in its mother's exclusive custody, her own merits or demerits are of no importance, otherwise than as they may influence the question of the child's welfare, and if considerations of this sort do not bear upon the question of her capacity to perform towards it the present duties of a mother, her custody of it is, for the present, recognized as the most appropriate custody."[37]

And quite unlike her husband, Cadwalader had Ellen welcome judicial intervention. Only the judges could out-trump Gonzalve. Cadwalader ended Ellen's narrative by having her throw "herself on the protection of the court" and plead with the judges not to use the power she acknowledged they held to take Frederick from her.[38]

LAWYERS' PERFORMANCES

The next phase of the trial began on Friday, September 4, 1840, when counsel began telling a new set of courtroom stories as they presented opening arguments, evidence, and closing statements. The lawyers now performed before a large, boisterous crowd. As the parents' narratives had been recited, interest in the case rose steadily. Day after day trial audiences listened to stories detailing Ellen and Gonzalve's marital troubles in far-off European cities. Enthralled Philadelphians followed these tales of meddling mothers-in-law, broken promises, and domestic intrigues in the local newspapers and by word of mouth.[39]

The theatricality of the trial arena made the case an unavoidable legal experience for much of the public as well as its main protagonists. While Ellen, Gonzalve, and their lawyers worried about how their press clippings would affect the judges, the heart-wrenching struggle of parent against parent captured local attention. Countless articles and diaries proclaimed that "everyone is talking about the case" and choosing sides.

In the midst of the lawyers' arguments, gentleman farmer and occasional lawyer Sidney George Fisher attended the trial to watch William Meredith, one of Ellen's attorneys. After recording in his diary that the trial had "for some time excited much interest," Fisher reviewed Meredith's performance: "clear thought, correct and strong feeling, sarcasm, indignation, declamation and rebuke, humor and pathos, all expressed in language plain but frequent, nervous, and perspicuous and with a manner and voice, never o'stepping the modesty of the nature, but according always with the varying sentiments of his case." Leaving the courtroom for a ride in woods adorned with autumn foliage, Fisher also found that the trial forced him to muse on the contrast between the divinity of nature and the deviousness of humans. His thoughts again turned to Meredith: "He was telling in strong and fiery language a tale of sorrow, vindicating a beautiful and injured woman, claiming for her and her infant the protection of law against a persecuting and tyrannical husband. The deepest feelings, the most interesting scenes and circumstances of life were his theme, the best sympathies of the heart were appealed to. He himself was a fine object: a strong man using his strength, a powerful intellect of eloquent words, making them think its thoughts, kindling them with its passions, acting upon them, governing them. I enjoyed it, I was interested and excited."[40] For Fisher and countless others, the d'Hauteville case became a drama that turned the Court of General Sessions into a theatrical

arena of conflict and thus multiplied the difficulties for all of its actors while magnifying its importance as a public event.

Reed had begun the counsels' performances back in September by returning to the theme of marital unity to counter the growing dominance of the tender years rule over the hearing. He demanded that the judges acknowledge marital unity and its concomitant patriarchal rules as the only legitimate basis for sound domestic relations. Though Reed acknowledged that the "incontestable" right of a father to the custody of his child had been postponed "during a tender age," he insisted that it had never been done when "no reason existed to prevent the parents from nurturing it together." Ellen's failure to obtain a divorce or secure legal justification for deserting her husband distinguished her claims from those of all other mothers who had won custody of their children and made her a violator of the law of the hearth and thus unworthy of custody. Now speaking for, instead of as, his client, Reed portrayed Gonzalve as the innocent victim of the "perverse and misguided conduct of his wife and her friends." And he declared that two-year-old Frederick's real interests lay with his father and life in Switzerland.[41] Yet Reed also realized that he had to confront Ellen's oppositional vision of the family and her attempt to forge a legal link between child welfare and maternal care. He cautioned the judges against succumbing to a sentimentalized vision of motherly love that ignored fatherly feelings: "No one can pretend to say . . . with whose affections a child is most closely entwined, and whether the manly fibres of a father's heart endure more or less agony in his bereavement, than do the tender cords which bind an infant to a mother's breast."[42]

Reed spent five days presenting evidence. His case rested on a presentation of letters from the pair's courtship designed to show the viability of the marriage and from their private bargaining to demonstrate Gonzalve's reasonableness. Reed and his cocounsel John Scott and Joseph Ingersoll read this extensive correspondence into the record to document the couple's affection for each other before Ellen's return to Boston. And they used depositions of Ellen's friends to suggest the young bride's unnatural attachment to her mother and thus make Mrs. Sears a second mother on trial in Philadelphia. During these sessions Reed tried to convince the bench that his client was the victim of parental—primarily maternal—intrigues to which Ellen had been a hapless accomplice. The aim of this plotting, he argued, was to force the couple to live in Boston so the filial bond would remain intact.[43]

When his turn came, Cadwalader tried to undercut the power of Reed's defense of patriarchy by highlighting the human particulars of

the case. He reminded the court that "this is the case of an infant, not yet two years old, from its birth in the custody of its mother, who is not denied to have taken proper care of it." And he took Ellen's challenge to patriarchy one step further by urging that custody disputes be rephrased: "The term *paternal power* is improper: instead of it should be used *parental power*." The Philadelphia lawyer defined that power as deriving from the particular needs of a child and not universal patriarchal rights. Custody should be conferred "merely to facilitate the performance of a duty" and for the "good of the child." Claiming that Pennsylvania decisions like *Addicks* had redefined custody as a transferable nurturing duty instead of a vested property right, Cadwalader proclaimed that nature and state law united to decree that infants belonged with their mothers. Separating the roles of mother and wife, he argued that Gonzalve had questioned Ellen's marital conduct not her motherly skill. Whatever the causes of the spousal rift, he concluded, "it is clear, that they in no way affect the moral character of the respondent, or her parents, so as to render her an unfit nurse for her child."[44]

Cadwalader and his cocounsel, Meredith, took six days to present their case.[45] A parade of servants, friends, and family spoke of Ellen's suffering at the hands of her husband and of her extraordinary care of her child. Her family physician testified that marital dissension and homesickness—what he labeled as the malady "nostalgia"—had threatened the young wife's life in Europe. He also diagnosed Frederick as a sickly infant in dire need of a mother's unique nursing. Two eminent Philadelphia doctors also testified to the child's sickliness and offered their scientific opinion that children fared best in the irreplaceable care of their mothers. Filling out their depiction of the case as a contest pitting arbitrary rights against a child's needs, Cadwalader and Meredith painted a picture of Ellen as a victimized wife courageously sacrificing herself to care for a sickly child and thus deserving custody.[46]

Gonzalve's lawyers returned to the rostrum to sum up their case. Guaranteeing the superiority of a blameless husband's custody rights was, they argued, the best protector of a child's welfare: "To whom belongs the custody of this child? The answer is in the human heart, and in the practice of all nations. The father, responsible for its maintenance and education, for its moral standing—his title is indisputable. The legal authorities on this subject are conclusive." Declaring custody a vested paternal right, Scott conceded that decisions like *Addicks* authorized judicial discretion in child placement but resisted reading it as dictating deference to maternal claims. He insisted that the two-year-old boy was not in any particular need of maternal care, and

counseled against establishing the principle "that a wife, leaving her husband without cause, may carry all his children with her, for the sake of their health." Scott emphasized that nothing stood in the way of reconciliation and raised the specter of unrestrained feminine power that would be unleashed by defining child welfare primarily in maternal terms: "The best interests of the child demand the reunion of its parents—its health, its wealth—all its prospects for the future. It is due, too, to the laws and to the peace of society, to establish the broad principle of the father's right; otherwise all the power is in the hands of the wife."[47]

Cadwalader closed Ellen's case by again shifting the argument from vested paternal rights to child nurture and again insisting that the indeterminate rules of custody law could only be understood through maternalism. For an infant, he declared, "considerations connected with its nurture are paramount to all others." He cited Pennsylvania decisions through and beyond *Addicks* to support the primacy of maternal custody during those years, and again invoked maternal essentialism: "A man cannot nurse a child; a woman is born a nurse. And no other woman can supply a mother's place: a child's chance of life is diminished by removal from its mother." Denouncing all legal authorities that would empower a father "to tear a nursling from its mother's arms, unless she cannot take proper care of it," Cadwalader argued that the law and morality demanded that the judges use their discretionary power to confer custody on his client.[48]

On Tuesday, October 6, Gonzalve's counsel, Ingersoll, ended the lawyers' combat with a plea that the three male jurists preserve patriarchal rights: "The right decision of this case demands great courage and nerve. Give the father his child, and you set an example of practical morality."[49]

JUDGES REACH A VERDICT

The judges spent more than a month mulling over the case. Finally on Saturday, November 14, they ruled unanimously for Ellen. In an opinion read to the court and reprinted locally and nationally, Presiding Judge Barton blended the facts of the case with his own version of the tender years rule, the best interests of the child doctrine, maternalism, and fatherly irrelevance. The verdict not only settled the immediate question of Frederick's custody, it also revealed how judges translated individual circumstances into legal rulings and how those rulings helped shape professional and popular debate.

Barton began by rejecting Gonzalve's assertion that a wife could

flee only if her husband's misconduct constituted a legal ground for divorce. In this way he sidestepped the dilemma of having to decide the issue of marital fault: "our decision must refer alone to the question, who is entitled to the custody?" The court had accepted Ellen's division of her spousal and parental roles and her counsels' separation of the legal issues of marital fault and parental fitness as legitimate means of opposing patriarchal power.[50]

Barton also dismissed Gonzalve's central claim of universal paternal authority in favor of Ellen's demand for maternal particularism. He denied that "custody of the child is the vested and absolute right of the father" to be forfeited only if he was proven unfit. In a lengthy review of precedents, Barton concluded that custody rulings demanded a "sound" use of judicial discretion tailored to the circumstances of an individual case.[51] The judge praised Gonzalve's attributes as a father, but reiterated that a father's rights could be limited on grounds other than paternal fitness: "The reputation of a father may be stainless as crystal; he may not be afflicted with the slightest mental, moral, or physical disqualification from superintending the general welfare of an infant; the mother may have separated from him without the shadow of a pretence of justification; and yet the interests of the child may imperatively demand the denial of the father's right, and its continuance with the mother." Citing Ellen's financial and moral ability to rear the child, Barton made nurture the primary ingredient of child welfare: "the circumstances of this case render her custody the only one consistent with the present welfare of her son."[52]

As Barton read the opinion it became apparent that the victorious mother and her lawyers had told stories that forged a link in the judges' minds between the tender years doctrine and the legitimacy of maternal custody claims. For the Philadelphia bench, as for an increasing number of courts around the nation, the responsible mother epitomized the law's emerging parental ideals. Doctrines like the tender years rule seemed an obvious and necessary means of applying those ideals to individual cases. The judge even issued a paean to motherhood: "The tender age and precarious state of [the child's] health, make the vigilance of the mother indispensable to its proper care; for, not doubting that paternal anxiety would seek for and obtain the best substitute which could be procured, every instinct of humanity unerringly proclaims that no *substitute* can supply the place of HER, whose watchfulness over the sleeping cradle or waking moments of her offspring, is prompted by deeper and holier feelings than the most liberal allowance of a nurse's wages could possibly stimulate."[53]

Significantly, however, Barton's final declaration invoked another

emerging reality of custody law. He declared that Ellen's award referred "only to the *present custody* of the child." Barton claimed the power of continued judicial supervision being embedded in the American common law of custody. The judge emphasized the contingent nature of Ellen's victory constructed as it was from doctrinal rules that blended child nurture, feminine deference, and judicial discretion.

Friedman has suggested that "arguments presented in trials are often important clues to what stories count as good, or true, or compelling stories within a particular culture."[54] Ellen and her lawyers triumphed in this "narrative competition" by picking a favorable forum and by devising stories that effectively used her oppositional maternal ideology to gain the power to define the contested idea of child welfare at the center of the new custody rules. In this way, they were able to shift the focus of the trial from patriarchal rights to child nurture. Litigant and counsel persuasively drew on the era's words and symbols to devise a courtroom strategy that turned emerging doctrinal rules to her advantage in a society increasingly inclined to regard parenting as a woman's natural and singular role. Conversely, Gonzalve failed to tell a story that secured the deference for the paramount paternal rights that he so adamantly defended. His arguments could not sustain a traditional paternal definition of child welfare. In a society beginning to question the parenting abilities of fathers and the legitimacy of unrestrained patriarchal power, Gonzalve and his counsel were on the defensive. They simply could not define the best interest of the child doctrine in his favor.[55]

Finally, the verdict of the three Philadelphia judges reveals some of the sources and implications of an ideological reversal of fortune that began to take place in this and other American courtrooms. Ellen's oppositional maternal ideology was beginning to dominate American custody law, while Gonzalve's once dominant patriarchalism was slowly being rendered oppositional. In orchestrating this shift, opinions like Barton's, steeped as they were in declarations of the era's prevailing gender beliefs, demonstrated the power of the law to "inscribe the arbitrary and cultural features of social life with the aura of the natural and inevitable."[56] Indeed part of the power of the law surfaced in the words of the decision that made changes like custodial maternalism seem natural and inevitable and thus ordinary.

In a society that assumed the metonymic equation of woman and mother, custody decisions like this one embedded the era's gender ideology in legal rules.[57] Maternal preference would order parental struggles over child custody late into the twentieth century. Such a process of institutionalization explains why, as historian Carol Smith-

Rosenberg has argued, gender is "central to any understanding of the ways the hegemonical discourses of the eighteenth and nineteenth centuries took form, institutionally reproduced, and altered themselves."[58] Ellen's victory in the narrative competition thus discloses not only the power of individual agency but also the authority of what anthropologists Jean Comaroff and John Comaroff call the "nonagentive power" to shape individual legal experiences like the d'Hautevilles'. These nonagentive forces were both internal to the legal order, such as a deep-seated faith in the adversarial resolution of conflict, as well as external, such as the era's equally fervent belief in separate gender spheres. They are, Comaroff and Comaroff explain, "internalized, in their negative guise, as constraints; in their neutral guise, as conventions; and, in their positive guise, as values. Yet the silent power of the sign, the unspoken authority of habit, may be as effective as the most violent coercion in shaping, directing, even dominating social thought and action."[59]

At the same time, some consequences of this gender realignment also emerged in courtrooms like the Philadelphia Court of General Sessions. Though Ellen found that in the end she could squash Gonzalve's patriarchal trump, the nature of her triumph was equally telling. Political scientist Mark Kann has identified the larger implications of victories like Ellen's within the dominant antebellum ideology of male liberal individualism: "domestic feminism demanded that women make a primary commitment to marriage, motherhood, and morality, and, by extension, accept their exclusion from the politics of self-interest, materialism, and power. Meanwhile, men continued to control the social, economic, and political institutions that enabled them to use law and coercion to deny or limit women's claims to individualism and political power."[60]

In terms of custody law, triumphs like Ellen's illustrated how judges could renegotiate family power by accepting the logic of Ellen's oppositional ideology without eliminating paternal authority or granting women autonomous legal rights. In this way, the opinion revealed how doctrinal interpretation could simultaneously empower and redirect power. Ellen's narrative victory meant that individual women could mount successful legal challenges to patriarchal rules, but only by telling courtroom stories that conformed to the recast gender and legal assumptions of the courts. In that way, Ellen and other mothers secured a legal privilege dependent upon judicial discretion, not a legal right assertable as a trump in disputes with their spouses or others. Forced into the courtroom, Ellen's determination to fight for Frederick thus had a double-edged result. Through her resistance to Gonzalve's do-

mestic patriarchy she kept her child, but in victory she also participated in the creation of a new mix of gender power and subordination in the law. Decisions like Barton's thus lengthened the shadow of the law over American families and ensured law's hegemony over troubled families like the d'Hautevilles.[61]

The d'Hauteville trial ended with a declaration that the "infant be remanded and restored to his mother."[62]

CONCLUSION

The d'Hautevilles' experience at law had its own meaning for the participants.[63] As a story from the past, its importance lies in the way the case reveals the intricacies of the antebellum American legal system's hegemonic power to frame and resolve disputes. The law provided a dual arena for these parents to stage their conflict: a set of rules that structured the presentation of their claims and a public forum for resolving them. The legal arena attracted each parent for instrumental and constitutive reasons. Gonzalve and Ellen turned to the law for strategic purposes, but also found in it a way to express their own respective claims to Frederick. As they used law to fight over their child, the couple participated in law creation. Their dispute suggests that they, like other litigants, helped construct the law by supplying issues and aggressively pursuing claims.[64] Their actions challenge a positivist vision of law that ignores the agency of laypeople in legal change by consigning them primarily to the role of supplicants. On the contrary, the case suggests the need to begin examining the varied roles clients have played in the construction of legal rules.[65]

And yet looking at the d'Hauteville case as a contest between contending and changing normative orders, it is important to emphasize how a hegemonic legal order structured this parental conflict.[66] The couple's private and public pleas disclose that once they turned to the law to resolve their fight over Frederick, the law's very contestability made them dependent on the legal validation of their aspirations. In this dependency we can see how the custody battle forced the couple to "shape their own meanings and public values to conform to a language recognized as legal discourse."[67] In doing so, the "law" served as an external regime that channeled the couple's claims into the prescribed legal forms, first, in an inchoate way in their private bargaining, and then more directly in the lawyers' translations of their stories and in the judges' verdict.

By going to law individuals like the d'Hautevilles not only had their claims translated, they also entered a partially autonomous realm

within American society that had its own institutional hierarchy and commitments. These had a significant impact on the presentation and resolution of conflicts like theirs. In the law office and the courtroom, lawyers and judges had a privileged ability to set the terms of conflict and report the results. In agreeing to listen to and then to accept disputes like the d'Hautevilles', they allowed litigants to participate in the boundary-making ceremonies that helped define legal rules.[68] The bench and bar, however, had the dominant power to mark those boundaries and create a doctrinal language that could then be used in other struggles. And they could decide which stories to accept and which to discard. As historian T. Jackson Lears argues, such authority included "cultural as well as economic and political power—the power to help define the boundaries of common-sense 'reality' either by ignoring those views outside of those boundaries or by labeling deviant opinions 'tasteless' or 'irresponsible.' "[69] The d'Hauteville case suggests the interactive legal reality of antebellum America: the power of the law to shape social conflict and popular consciousness, while at the same time the form and substance of the law was being constituted by the disputes brought by litigants.[70]

Though the d'Hauteville case slowly faded from public view, it remains a dramatic dialogue in antebellum law. During and after the trial, lawyers and laypeople fiercely debated the merits of the case, especially the legitimacy of a mother claiming custody without either obtaining a divorce or separation and not even proving the father unfit. The intense contemporary interest in it testifies to the popularity of trials in the cities and towns of the new republic.

The d'Hauteville case's notoriety demonstrates the lure of the courtroom as a ritualized arena for defining social relations. Trials served as public theaters in which complex issues like gender realignments could be understood through evocative and understandable clashes over their meaning. As media critic Robert Hariman has recently noted, the courtroom has long been attractive as a stable format for dealing with unsettling changes. Its attractions lie in the way trials translate complex human dilemmas into adversarial stories with identifiable actors as well as clear beginnings, middles, and ends. Popular trials, Hariman argues, provide "the social practice most suited formally to comparing competing discourses."[71] They do so, in part, because these human dramas tell stories in which trial audiences can imagine themselves as participants and even judges as well as observers. As a result, trials also helped construct the memories and consciousness of those audiences.[72]

The d'Hauteville case is a vivid example from the past of that

process. Capturing the public mind was one way trials like this one extended the law's hegemony. Antebellum America became littered with relics of past struggles like the d'Hauteville trial. They institutionalized the era's tendency to turn to the law as an arena for confronting conflicts over change.

Notes

1. To avoid confusion, I have chosen to use the couple's first names. Ellen never remarried and used d'Hauteville for the rest of her life.

2. *Report of the d'Hauteville Case* (Philadelphia, 1840). This volume, published shortly after the hearing, is the single most valuable source on the case. It contains many of the couple's letters, trial testimony, lawyers briefs and arguments, and the final opinion. The pair's irreconcilable differences are described in great detail in letters that fill about half the *Report*. Letters introduced at the trial chronicled the demise of the marriage. Mrs. Sears stayed on to live with the couple for their first year. Ellen accused her husband and his family of mistreating her mother; Gonzalve countered that his mother-in-law poisoned the mind of his wife against him and refused to cut her apron strings. Ellen charged that her husband would not let her friends visit and that he demanded a wifely obedience too servile for her to accept. Gonzalve insisted that he always had his wife's best interests at heart. They clashed over their residence as well. Ellen claimed that before the wedding an agreement had been struck to spend part of each year in Paris and to visit Boston frequently. Her husband denied both pledges.

3. In a letter Ellen said "that under the protection of my father's roof," she could finally express herself freely. She accused Gonzalve of wounding her and destroying her health through mental anguish. Her husband denied all of her charges and urged her to recant and return. Their son was born a month later. Gonzalve learned of the birth in a letter from Ellen's father to a Swiss *notaire* serving as curator of her interests. Angered by these events, and by Ellen's decision to ignore his choice of names for the child and have the boy baptized in a different faith than his father's, Gonzalve sailed for America to claim his son. He arrived in New York City on July 12, 1839. Ellen learned of his arrival from a friend who saw Gonzalve on a Manhattan street. She took her son, named after her brother, into hiding. *Report*, 37–38.

4. The trial garnered extensive coverage in Philadelphia as well as in New York and Boston. The case also generated comments in various legal publications.

5. Historian Joan Scott, for example, argues that making "visible the experience of a different group exposes the existence of repressive mechanisms, but not their inner workings or logics; we need to know that difference exists, but we don't understand it as constituted relationally. For that we need to attend to the historical processes that, through discourse, position subjects and produce their experiences. It is not individuals who have experiences, but subjects who are constituted through experience. Experience in this definition then becomes not the origin of our explanation, not the authoritative (because seen or felt) evidence that grounds what is known, but rather that which we

seek to explain, that about which knowledge is produced. To think about experience in this way is to historicize it as well as to historicize the identities it produces. This kind of historicizing represents a reply to the many contemporary historians who have argued that an unproblematized 'experience' is the foundation of their practice; it is a historicizing that implies critical scrutiny of all explanatory categories usually taken for granted, including the category of 'experience.'" "The Evidence of Experience," *Critical Inquiry* (Summer 1991); and see Ruth Roach Pierson, "Experience, Difference, Dominance, and Voice in the Writing of Canadian Women's History," in Karen Offen, Ruth Roach Pierson, and Jane Rendall, eds., *Writing Women's History: International Perspectives* (Bloomington, Ind., 1991), 79–94.

6. For the use of disputes as sources of social history see Simon Roberts, "The Study of Disputes: Anthropological Perspectives," in John Bossy, ed., *Disputes and Settlements: Law and Human Relations in the West* (London, 1983), 1–24. And for a valuable discussion of the issues raised at the intersection of history and anthropology in the study of the locality see Aletta Biersack, "Local Knowledge, Local History: Geertz and Beyond," in Lynn Hunt, ed., *The New Cultural History* (Berkeley, 1989), 72–96.

7. My understanding and use of the concept of hegemony has been greatly influenced by the work of Jean Comaroff and John Comaroff, especially *Of Revelation and Revolution: Christianity, Colonialism, and Consciousness in South Africa* (Chicago, 1991), 13–32. Particularly valuable, I think, is the Comaroffs' argument about the difference between hegemony and ideology: "Whereas the first consists of constructs and conventions that have come to be shared and naturalized throughout a political community, the second is the expression and ultimately the possession of a particular social group, although it may be widely peddled beyond. The first is nonnegotiable and therefore beyond direct argument; the second is more susceptible to being perceived as a matter of inimical opinion and interest and is therefore open to contestation. Hegemony homogenizes, ideology articulates" (ibid:24). And I have also relied upon the notion of cultural hegemony developed by T. Jackson Lears, "The Concept of Cultural Hegemony: Problems and Possibilities," *American Historical Review* 90(1985), 567–93.

8. For further development of this idea see Grossberg, "Social History Update: 'Fighting Faiths' and the Challenge of Legal History," *Journal of Social History* 25(1991), 189–95. And for one example of the depiction of law as an arena of conflict see E. P. Thompson, *The Poverty of Theory and Other Essays* (1978), 266–67. For a useful critique of Thompson's approach see Adrian Merritt, "The Nature and Function of Law: A Criticism of E. P. Thompson's *Whigs and Hunters,*" *British Journal of Law and Society* 7(1980), 205–6. And for other helpful discussions of these issues see David Sugarman, "Theory and Practice in Law and History: A Prologue to the Study of the Relationship between Law and Economy from a Socio-Historical Perspective," in Bob Fryer et al., *Law, State, and Society* (London, 1981), 70–106; and, Neal Milner, "The Denigration of Rights and the Persistence of Rights Talk: A Cultural Portrait," *Law and Social Inquiry* 14(1989), 631–75, esp. 633–35.

9. See, for example, Roscoe Pound, *The Formative Era of American Law* (Boston, 1938); Morton Horwitz, *The Transformation of American Law, 1780–1860* (Cambridge, Mass., 1977). For an overview of the legal changes of the era see Kermit Hall, *The Magic Mirror* (New York, 1989), chaps. 4–8.

10. For the most comprehensive analysis of family changes in the era, see Stephen Mintz and Susan Kellogg, *Domestic Revolutions, A Social History of the American Family* (New York, 1988), chap. 3. And for a valuable discussion of the larger challenge to patriarchy see Jay Fliegelman, *Prodigals and Pilgrims: The American Revolution against Patriarchal Authority, 1750–1800* (Cambridge, 1982).

11. I use the word "shadow" purposefully. I mean to invoke the metaphor used by Tocqueville to depict the hold of the American legal order over the larger society: "It is a strange thing, this authority that is accorded to the intervention of the courts of justice by the general opinion of mankind! It clings even to the mere formalities of justice, and gives a bodily influence to the mere shadow of the law." *Democracy in America*, ed. Francis Bowen (New York, 1956), I, 140. I think the shadow metaphor is a compelling period-specific way of thinking about both the relative autonomy of the legal order and its dominion over antebellum definitions of the self and of individual and group rights, duties, and status. These ideas will be developed more fully in my book-length study of the d'Hauteville case tentatively titled "A Judgment for Solomon: The d'Hauteville Case and Legal Experience in Antebellum America." For an insightful recent application of Tocqueville's metaphor see Kristin Bumiller, *The Civil Rights Society: The Social Construction of Victims* (Baltimore, 1988), 60–62; and see Robert Mnookin and David Kornhauser, "Bargaining in the Shadow of the Law: The Case of Divorce," *Yale Law Journal* 88(1979), 950.

12. *Report*, 132, 134.

13. For a discussion of the development of legal rules on mental cruelty during the era see Robert Griswold, "The Evolution of the Doctrine of Mental Cruelty in Victorian American Divorce, 1790–1900," *Journal of Social History* 20(1986), 127–48.

14. Indeed, only a few years before the Massachusetts Supreme Judicial Court had renewed its commitment to paramount paternal custody rights in *Commonwealth v. Briggs*, 16 Pickering 203 (Mass. 1834).

15. Forum shopping was possible in part because most contested custody fights occurred as a result of habeas corpus proceedings. One parent or the other, or another custodian such as a grandparent, filed a writ demanding that the other parent produce the child and justify his or her possession of the child. Doctrinal changes had resulted from such contests. Since the writ could be sought in any jurisdiction because it applied only to those within its boundaries, litigants like Ellen willing to engage in legal hide-and-seek could choose where the writ might be served. She, for example, quickly decided against being served in Massachusetts because of the *Briggs* case. For a general discussion of custody law changes in this period see Michael Grossberg, *Governing the Hearth: Law and the Family in Nineteenth-Century America* (Chapel Hill, 1985), chap. 7.

16. *Report*, 136.

17. Historian Joan Kelly has argued that oppositional consciousness like Ellen's emerged in the past in situations like hers when women were forced to confront the discrepancy between cultural definitions of women and their own experiences as women. See, for example, her discussion of Christine de Pizan, an early modern woman forced into such an oppositional consciousness, in *Women, History, and Theory: The Essays of Joan Kelly* (Chicago, 1984),

chap. 4 and esp. 79–80. For discussions of the idea of republican motherhood at the heart of maternal oppositional ideology see Linda Kerber, "The Republican Ideology of the Revolutionary Generation," *American Quarterly* 37(1985), 485–88; Mary Beth Norton, "The Evolution of White Women's Experience in Early America," *American Historical Review* 89(1984), 593–619; Jan Lewis, "The Republican Wife: Virtue and Seduction in the Early Republic," *William and Mary Quarterly*, new series, 44(1987), 721. For discussions of the notion of the Gramscian idea of contradictory consciousness see Comaroff and Comaroff, *Of Revelation and Revolution*, 26–27; and Lears, "The Concept of Cultural Hegemony," 569.

18. *Report*, 138–139. For another example of the tendency for antebellum women to take a particularistic approach to law see Suzanne Lebsock, *The Free Women of Petersburg* (New York, 1984), chaps. 2–3, 5. For a valuable discussion of the interconnections with women's legal claims and religious beliefs evident in Ellen's letters see Elizabeth Clark, "Religion, Rights, and Difference: The Origins of American Feminism, 1848–1860," *Legal History, Working Paper Series 2*, February 1987, Institute for Legal Studies, University of Wisconsin, Madison, School of Law. And for valuable discussions of gender beliefs in the era see Karen Halttunen, *Confidence Men and Painted Women: A Study of Middle-Class Culture in America, 1830–1870* (New Haven, 1982), chaps. 3–4; and Karen Lystra, *Searching the Heart: Women, Men, and Romantic Love in Nineteenth-Century America* (New York, 1989), chaps. 7–8.

19. Apparently Ellen was not willing to let her claim rest only in the hands of common law judges. During her stay in New York City, the state legislature passed a bill entitled "An Act for the Protection of Minors." It would have allowed chancery courts to deprive alien fathers of guardianship rights if they tried to take their children out of the country without the mother's permission. A chancellor would then determine the custody and support of the child. Governor William Seward vetoed the bill arguing that it unfairly singled out alien fathers. Important to an understanding of the debate over married women's legal rights that surfaced in the d'Hauteville case, Seward addressed the twin struggles that dominated the case: maternal versus paternal rights and state versus parental rights. He acknowledged that male domination of the law had led to "domestic tyranny." He pledged to support legislation that secured "married women a more faithful discharge of the obligation of the marriage contract, the better preservation of their just rights, and the security of their property." But, he insisted, the bill did none of these; it merely substituted a chancellor's determination of a child's needs for that of a father if the parent happened to be an alien. Seward went on to argue that everyone would object if the act applied to native as well as alien fathers: "who would not revolt at the idea that the Chancellor should have the power to enter the family circle of our citizens, and, without convicting the parent of neglect or omission of duty, overrule parental authority and separate the helpless children from unoffending parents upon the arbitrary pretext of promoting the children's welfare?" Like others drawn into this and other custody and family disputes, Seward expressed ambiguous and contradictory views. He championed rights and yet questioned state intervention into the family to enforce them. But, as the d'Hauteville case suggests, conferring rights on individual family members invited judicial intervention. Though Gonzalve charged Ellen with promoting the vetoed act, she denied the charge. However, similar legisla-

tion failed in Pennsylvania during her stay there. *Report*, 48–49, 50, 34. For Ellen's denial of the charge of seeking private legislation see 111.

20. *Report*, 148. Throughout the trial, however, Ellen maintained that, when served, she was traveling around seeing to the health of her son, not shopping for a favorable forum.

21. The most significant of these decisions came in the *Addicks* cases in 1813 and 1815. For a discussion of these cases see text below at note 30. And for a valuable discussion of the significance of forum shopping see Neil Komesar, "In Search of a General Approach to Legal Analysis: A Comparative Institutional Approach," *Michigan Law Review* 79(1981), 1350.

22. Early in the case the judges ruled that the writ did not apply to Ellen's parents. For a general description of the court and its jurisdiction see John Hill Martin, *Bench and Bar of Philadelphia* (Philadelphia, 1883), 81–82.

23. For an analysis of the use of habeas corpus in American custody law see Grossberg, *Governing the Hearth*, 234–37, and see note 15 above.

Commenting on similar changes and conflicts late in the twentieth century, the Comaroffs note: "Distinctions of sex and color are obviously still inscribed in common linguistic usage, in aesthetic values and scientific knowledge; they continue to be a matter of widespread consensus and silent complicity; they also remain inscribed in everyday activity. Yet ever more articulate political and social protest has forced these issues on the collective conscience and into ideological debate. Formerly taken for granted discriminatory usages have been thrust before the public eye. As a result, the premise of racial and sexual inequality is no longer acceptable, at least in the official rhetoric of most modern states—although, in the world of mundane practice, the battle to control key sites and ostensibly neutral values rages on. This follows a very common pattern: once something leaves the domain of the hegemonic, it frequently becomes a major site of ideological struggle." *Of Revelation and Revolution*, 27. In 1840, parenthood and patriarchy had become such sites.

24. Lawrence Friedman, "Law, Lawyers, and Popular Culture," *Yale Law Journal* 98(1989), 1559. For a broader analysis of trials as storytelling sites see W. Lance Bennett and Martha S. Feldman, *Reconstructing Reality in the Courtroom: Justice and Judgment in American Culture* (New Brunswick, N.J., 1981).

25. Sally Merry, "The Discourse of Mediation and the Power of Naming," *Yale Journal of Law and the Humanities* 2(1990), 2. In the same vein anthropologist Jane Collier argues that "powers available to people are important, not because of what they allow powerholders to do or to prevent others from doing, but because they structure the context in which people negotiate the consequences of actions and events." *Marriage and Inequality in Classless Societies* (Stanford, 1988), 6.

26. For an insightful discussion of the courtroom as a moral theater see Robert L. Griswold, "Adultery and Divorce in Victorian America," *Legal History Working Papers*, Series 1, no. 6 (School of Law, University of Wisconsin, Madison), 14–17; and see Daniel Cohen, "The Murder of Maria Bickford: Fashion, Passion, and the Birth of a Consumer Culture," *American Studies* 31(1990), 5–30.

27. The couple's lawyers fought over the question of opening up the hearing to large crowds, see *Report*, 51.

28. *Report*, 52–53.

29. For a compelling discussion of the power of legal fictions see Lon Fuller, *Legal Fictions* (Stanford, Calif., 1967); and for an insightful use of the concept historically, and one quite relevant to the subject of this essay, see Norma Basch, "Invisible Women: The Legal Fiction of Marital Unity in Nineteenth-Century America," *Feminist Studies* 5(1979), 346–66.

30. *Commonwealth v. Addicks*, 5 Binney 520 (Pa. 1813); *Commonwealth v. Addicks*, 2 Serge & Rawle 174 (Pa. 1816).

31. For an analysis of the persistence of this ideal even into an era of no-fault divorce, see Austin Sarat and William L. F. Felstiner, "Law and Social Relations: Vocabularies of Motive in Lawyer/Client Interaction," *Law and Society Review* 22(1988), 744–54.

32. *Report*, 2, 15, 185.

33. Ibid., 186, 189.

34. On the significance of such silences see Collier, *Marriage and Inequality*, 214.

35. For a discussion of the period's use of categorical gender differences see the comments by Ellen DuBois in Isabel Marcus, et al., "Feminist Discourse, Moral Values, and the Law—A Conversation," *Buffalo Law Review* 34(1985), 64–65; and see Clark, "Religion, Rights, and Difference: The Origins of American Feminism, 1848–1860," 2–3, 40, 42.

36. *Report*, 9, 10.

37. Ibid., 59.

38. Ibid., 83, 90–91, 108, 108–9.

39. See, for example, the regular stories on the case in the *Philadelphia Daily Ledger*, the city's penny daily.

40. Fisher, "Diary of Sidney George Fisher," Historical Society of Pennsylvania, 144.

41. The most fulsome statements on male custody prerogatives came from John Berry in an extensively litigated case, *People v. Mercein*, 3 Hill 322(NY. 1842). For a full assessment of the case see Hendrik Hartog, "Constitutionalism and Custody," paper presented at the Organization of American Historians Annual Meeting, Reno, Nevada, April 1988.

42. *Report*, 193, 194.

43. Ibid., 196–233.

44. Ibid., 233–35. Emphasis in original.

45. Eminent Philadelphia laywer Horace Binney served as third counsel, but he did not take part in the actual hearing.

46. *Report*, 276, 277, 278.

47. Ibid., 236–75.

48. Ibid., 278, 279, 280, 281, 282.

49. Ibid., 285.

50. Ibid., 286.

51. Ibid., 287, 288, 292.

52. Ibid., 292–93.

53. Ibid., 293. Emphasis in original.

54. Friedman, "Law, Lawyers, and Popular Culture," *Yale Law Review* 98(1989), 1559.

55. For insightful discussions of the declining faith in fathers see E. Anthony Rotundo, "American Fatherhood," *American Behavioral Scientist* 29(1985), 13; Rotundo, "Body and Soul: Changing Ideals of American Middle-

Class Manhood, 1770–1920," *Journal of Social History* 16(1982), 23–38; and John Demos, "The Changing Face of Fatherhood," in Demos, ed., *Past, Present, and Future: The Family and the Life Course in American History* (New York, 1986), 56.

56. "Editors' Introduction: Special Issue, 'Law and Ideology,' " *Law and Society Review* 22(1988), 632–33.

57. The emergence of a maternal preference out of legal experiences like this one also illustrates the time-bound character of foundational beliefs. Scott argues, for instance, that exploring the relationship between the power of the historian's analytical frame and the events that are the object of his or her study can be used to "historicize both sides of that relationship" and deny "the fixity and transcendence of anything that appears to operate as a foundation, turning attention instead to the history of foundationalist concepts themselves. The history of these concepts (understood to be contested and contradictory) then becomes the evidence by which 'experience' can be grasped and by which the historian's relationship to the past she writes about can be articulated." "The Evidence of Experience," 40. And for a general discussion of the use of metaphor and metonym in defining women's legal status see Sarah Slavin, "Authenticity and Fiction in Law: Contemporary Case Studies in Exploring Radical Legal Feminism," *Journal of Women's History* 1(1990), 130–36.

58. Carol Smith-Rosenberg, quoted in Linda Kerber et al., "Forum: Beyond Roles, Beyond Spheres: Thinking about Gender in the Early Republic," *Wiliam and Mary Quarterly*, 3d Series, 46(1989), 570. And in comments quite relevant to the d'Hauteville story, Smith-Rosenberg notes the need to blend feminist theory with studies of actual historical actors: "The approach to discursive analysis that contemporary feminists are developing complicates the analysis of hegemonical discursive construction with a new social history in ways that help us understand how real women, located in material worlds, as well as in discursive fields, perceived and utilized the contradictions inherent within liberal ideology and its construction of the liberal subject, and so subverted that ideology and transformed that subjectivity." Ibid.

59. Comaroff and Comaroff, *Of Revelation and Revolution*, 22; and see Collier, *Marriage and Inequality*, 244–45.

60. Kann, "Individualism, Civic Virtue, and Gender," 76–77.

61. For an argument about nineteenth-century judicial power as patriarchal see Grossberg, *Governing the Hearth*, chap. 8.

62. *Report*, 294, 295. Emphasis added. For a parallel contemporary appellate decision see *State v. King*, 1 Ga. Dec. 93 (1842). For a full discussion of the origins and character of nineteenth-century custody law see Grossberg, *Governing the Hearth*, chap. 7.

63. Controversy continued to swirl around the case. Ellen found herself denounced in newspapers and legal journals. For instance, the ruling drove Boston lawyer Peleg Whitman Chandler to pen a bitter polemic attacking Barton and his brethren as incompetent judges who had played to the crowd and undermined needed male supremacy in the home. He called on courts to ignore the decision. David Sears finally took to the pages of the *Boston Daily Advertiser* to champion his daughter's legal victory as correct in law and in morals. Gonzalve, though, helped to take the glare of public attention off Ellen by following his lawyers' advice and not appealing. Instead he sailed home and obtained a Swiss divorce. He later wed the daughter of a Swiss

Grand Count and died in 1890 at the age of seventy eight. Ellen led a more star-crossed life. She lived with Frederick in Philadelphia for a couple of years after the trial before moving to Nashua, New Hampshire, in the mid-1840s. Throughout her son's childhood, she feared that Gonzalve's agents would abduct him and carry him off to Switzerland. Mother and son lived in Boston from 1850 to her death from hepatitis in 1862. She never remarried. Frederick did preparatory studies at the Boston Latin School and graduated from Harvard College in 1859. He served in the Union Army attaining the rank of Adjunct Captain General, though he resigned from the army in 1862 after a "short and undistinguished career." He married Elizabeth Hamilton Fish of New Jersey in 1863. They lived in New York City until her untimely death a year later. He then led a nomadic life living in New York, Newport, and throughout Europe. In 1872 he remarried. He and his new bride, Susan Watt Malcomb, reared three children and spent much of their lives in Europe. Frederick died in 1918 at the age of eighty. He was buried next to his mother. Chandler, *A Member of the Boston Bar: Review of the d'Hauteville Case* (Boston, 1841); *Boston Daily Advertiser*, January 13, 1841. Family information was obtained in an oral interview with John Winthrop Sears, a descendant of Ellen's.

64. Legal skirmishes between the pair continued after the trial. Ellen continued her lobbying efforts. She helped secure passage of a statute in Rhode Island that made child custody a judicial matter when the husband of a state resident secured a foreign divorce and sought his child. Gonzalve's counsel filed a petition to have the act rescinded; Ellen's lawyers filed a remonstrance in its favor. After a spirited two-day debate, the act withstood repeal by a comfortable margin. *The Petition of Henry C. DeRham to the General Assembly of Rhode Island in the d'Hauteville Case* (Providence, R.I., 1841), 39.

65. In fact, historian Samuel Hays has argued that, because of relatively ready access, the courts have exhibited more directly the impact of society on political institutions than other branches of government. He contends that, as a result of the greater responsiveness of courts, judicial proceedings document "more immediately and directly emerging public values than was the case with other governing bodies." "Society and Politics: Politics and Society," *Journal of Interdisciplinary History* 15(1985), 496, 497.

66. It is important to note that the legal arena also structured the role of lawyers and judges. A statement by Justice Shirley Abrahamson of the Wisconsin Supreme Court is a contemporary example of the point. In a 1978 address at the twenty-fifth anniversary of the first class of Harvard Law School women graduates, she tried to explain why the mere presence of women on the bench would not eliminate gender discrimination: "You have to remember, and I have to remember, that I do not write on a clean slate. I write on a slate that's been marked up. . . . For a consistent jurisprudence in my state I must fit within the marks on the slate. It doesn't mean I can't erase, it doesn't mean I can't write large. It just means that I write on a slate in a particular context." Quoted in Ann C. Scales, "Toward a Feminist Jurisprudence," *Indiana Law Journal* 56(1980–1981), 388, n. 68.

67. William Forbath, Hendrik Hartog, and Martha Minow, "Introduction: Legal History Symposium," *Wisconsin Law Review* (1985), 765.

68. For a discussion of trials as boundary-making devices see Friedman, "Law, Lawyers, and Popular Culture," 1594–95.

69. Lears, "Concept of Cultural Hegemony," 572.

70. For a valuable discussion of this point see "Editors' Introduction: Special Issue, 'Law and Ideology,' " 631–35.

71. Robert Hariman, "Introduction," in Hariman, ed. *Popular Trials: Rhetoric, Mass Media, and the Law* (Birmingham, Ala., 1990), 12, and see generally "Introduction."

72. Carol Rose, "Property as Storytelling: Perspectives from Game Theory, Narrative Theory, Feminist Theory," *Yale Journal of Law and the Humanities*, 2(1990), 55.

References

Basch, Norma. 1979. "Invisible Women: The Legal Fiction of Marital Unity in Nineteenth-Century America," *Feminist Studies* 5, 346–66.

Bennett, W. Lance and Martha S. Feldman. 1981. *Reconstructing Reality in the Courtroom: Justice and Judgment in American Culture*. New Brunswick, N.J.: Rutgers University Press.

Biersack, Aletta. 1989. "Local Knowledge, Local History: Geertz and Beyond." In *The New Cultural History*. Lynn Hunt, ed. Berkeley: University of California Press. 72–96.

Bumiller, Kristin. 1988. *The Civil Rights Society: The Social Construction of Victims*. Baltimore: Johns Hopkins University Press.

Chandler, Peleg. 1841. *A Member of the Boston Bar, Review of the d'Hauteville Case*. Boston.

Clark, Elizabeth. February, 1987. "Religion, Rights, and Difference: The Origins of American Feminism, 1848–1860," *Legal History Working Papers Series 2*. Institute for Legal Studies, School of Law, University of Wisconsin, Madison.

Collier, Jane. 1988. *Marriage and Inequality in Classless Societies*. Stanford: Stanford University Press.

Cohen, Daniel. 1990. "The Murder of Maria Bickford: Fashion, Passion, and the Birth of a Consumer Culture." *American Studies* 31, 5–30.

Comaroff, Jean and John Comaroff. 1991. *Of Revelation and Revolution: Christianity, Colonialism, and Consciousness in South Africa*. Chicago: University of Chicago Press.

DeRham, Henry C. 1841. *The Petition of Henry C. DeRham to the General Assembly of Rhode Island in the d'Hauteville Case*. Providence, R.I.

Demos, John. 1986. "The Changing Face of Fatherhood." In *Past, Present, and Future: The Family and the Life Course in American History*. Demos, ed. New York: Oxford University Press.

DuBois, Ellen. 1985. "Feminist Discourse, Moral Values, and the Law—A Conversation." *Buffalo Law Review* 34.

"Editors' Introduction: Special Issue 'Law and Ideology.' " 1988. *Law and Society Review* 22.

Fliegelman, Jay. 1982. *Prodigals and Pilgrims: The American Revolution against Patriarchal Authority, 1750–1800*. Cambridge: Cambridge University Press.

Fisher, Sidney George. "Diary of Sidney George Fisher." Historical Society of Philadelphia.

Forbath, William and Hendrik Hartog, Martha Minow. 1985. "Introduction: Legal History Symposium." *Wisconsin Law Review.*

Friedman, Lawrence M. 1989. "Law, Lawyers, and Popular Culture." *Yale Law Journal.* 98.

Fuller, Lon 1967 *Legal Fictions.* Stanford: Stanford University Press.

Griswold, Robert L. "Adultery and Divorce in Victorian America." *Legal History Working Papers, Series 1.* Institute for Legal Studies, School of Law, University of Wisconsin, Madison.

———. 1986. "The Evolution of the Doctrine of Mental Cruelty in Victorian American Divorce, 1790–1900," *Journal of Social History* 20:127–48.

Grossberg, Michael. 1985. *Governing the Hearth: Law and the Family in Nineteenth Century America.* Chapel Hill: University of North Carolina Press.

———. 1991. "Social History Update: 'Fighting Faiths' and the Challenge of Legal History," *Journal of Social History* 25:189–95.

Hall, Kermit. 1989. *The Magic Mirror.* New York: Oxford University Press.

Halttunen, Karen. 1982. *Confidence Men and Painted Women: A Study of Middle-Class Culture in America, 1830–1870.* New Haven: Yale University Press.

Hariman, Robert, ed. 1990. *Popular Trials: Rhetoric, Mass Media, and the Law.* Birmingham: University of Alabama Press.

Hartog, Hendrik. April, 1988. "Constitutionalism and Custody." Paper presented at the Organization of American Historians Annual Meeting, Reno, Nevada.

Hays, Samuel. 1985. "Society and Politics: Politics and Society." *Journal of Interdisciplinary History* 15.

Horwitz, Morton. 1977. *The Transformation of American Law, 1780–1860.* Cambridge, Mass.: Harvard University Press.

Kann, Mark. 1985. "Individualism, Civic Virtue, and Gender." *Studies in American Development 5.*

Kelly, Joan, ed., 1984. *Women, History, and Theory: The Essays of Joan Kelly.* Chicago: University of Chicago Press.

Kerber, Linda et al. 1989. "Forum: Beyond Roles, Beyond Spheres: Thinking about Gender in the Early Republic." *William and Mary Quarterly* 3rd Series, 46.

Kerber, Linda. 1985. "The Republican Ideology of the Revolutionary Generation." *American Quarterly* 37.

Komesar, Neil. 1981. "In Search of a General Approach to Legal Analysis: A Comparative Institutional Approach." *Michigan Law Review* 79.

Lears, T. Jackson. 1985. "The Concept of Cultural Hegemony: Problems and Possibilities." *American Historical Review* 90 567–93.

Lebsock, Suzanne. 1984. *The Free Women of Petersburg.* New York: The Free Press.

Lewis, Jan. 1987. "The Republican Wife: Virtue and Seduction in the Early Republic." *William and Mary Quarterly* 3rd Series. 44.

Lystra, Karen. 1989. *Searching the Heart: Women, Men, and Romantic Love in Nineteenth Century America.* New York: Oxford University Press.

Martin, John Hill. 1883. *Bench and Bar of Philadelphia.* Philadelphia.

Merritt. 1980. "The Nature and Function of Law: A Criticism of E. P. Thompson's *Whigs and Hunters.*" *British Journal of Law and Society* 7.

Merry, Sally. 1990. "The Discourse of Mediation and the Power of Naming." *Yale Journal of Law and the Humanities* 2:1–36.

Miller, Samuel, ed., 1840. *Report of the d'Hauteville Case: The Commonwealth of Pennsylvania, at the Suggestion of Paul Daniel Gonzalve d'Hauteville versus David Sears, Miriam C. Sears, and Ellen Sears Grand d'Hauteville.* Philadelphia.

Milner, Neal. 1989. "The Denigration of Rights and the Persistence of Rights Talk: A Cultural Portrait." *Law and Social Inquiry* 14:631–75.

Mintz, Steven and Susan Kellogg. 1988. *Domestic Revolutions, A Social History of the American Family.* New York: The Free Press.

Mnookin, Robert and David Kornhauser. 1979. "Bargaining in the Shadow of the Law." *Yale Law Journal* 88.

Norton, Mary Beth. 1984. "The Evolution of White Women's Experience in Early America." *American Historical Review* 89:593–619.

Pierson, Ruth Roach. 1991. "Experience, Difference, Dominance, and Voice in the Writing of Canadian Women's History." In *Writing Women's History: International Perspectives.* Karen Offen, Ruth Roach Pierson, and Jane Rendall, eds. Bloomington, Ind.: Indiana University Press.

Pound, Roscoe. 1938. *The Formative Era of American Law.* Boston: Little, Brown.

Roberts, Simon. 1983. "The Study of Disputes: Anthropological Perspectives." In *Disputes and Settlements: Law and Human Relations in the West.* John Bossey, ed. London: Cambridge University Press.

Rose, Carol. 1990. "Property as Storytelling: Perspectives from Game Theory, Narrative Theory, Feminist Theory." *Yale Journal of Law and the Humanities* 2:37–58.

Rotundo, E. Anthony. 1985. "American Fatherhood." *American Behavioral Scientist* 29.

———. 1982. "Body and Soul: Changing Ideals of American Middle-Class Manhood." *Journal of Social History* 16:23–38.

Sarat, Austin and William L. F. Felstiner. 1988. "Law and Social Relations: Vocabularies of Motive in Lawyer/Client Interaction." *Law and Society Review* 22.

Scales, Ann C. 1980–81. "Toward a Feminist Jurisprudence." *Indiana Law Journal* 56.

Scott, Joan. Summer, 1991. "The Evidence of Experience." *Critical Inquiry.*

Slavin, Sarah. 1990. "Authenticity and Fiction in Law: Contemporary Case Studies in Exploring Radical Legal Feminism." *Journal of Women's History* 1.

Sugarman, David. 1981. "Theory and Practice in Law and History: A Prologue to the Study of the Relationship between Law and Economy from a Socio-Historical Perspective." In *Law, State, and Society* Bob Freyer, et al. London: Croom Helm. 70–106.

Thompson, E. P. 1978. *The Poverty of Theory and Other Essays.* New York: Monthly Review Press.

Tocqueville, Alexis de. 1956. *Democracy in America,* ed. Francis Bowen. New York.

STANDING AT THE GATES OF JUSTICE: WOMEN IN THE LAW COURTS OF EARLY-SIXTEENTH-CENTURY ÜSKÜDAR, ISTANBUL

Yvonne J. Seng

The image one gains of the women of early-sixteenth-century Üsküdar, Istanbul, through the law registers of the district goes against the commonly held and slowly disintegrating stereotype of Ottoman women as closeted and powerless victims of law and custom.[1] It is true that by the process of Islamic law itself, the testimony of a female, like that of a non-Muslim, was assigned a fraction of the weight of that of a Muslim male. But this restriction did not mean that the courts were closed to women, that women could not seek redress, or that they were denied recourse according to Islamic law or *shariah*. To the contrary, the court was considered the protector of women and as cases recorded in the court registers show, the women of Üsküdar both were conscious of their access to the court and used it. Moreover, whereas the literature of the period inscribed either the imperial focus of Ottoman chroniclers or the random glances of European observers, thereby glazing over the subject of women and adding to their mystery and invisibility, my analysis of court records provides evidence that women were actively and openly engaged in the everyday life of their communities.

Several distinct tensions become apparent in studying the court records of the Ottoman Empire and the women who lived within one

of its suburban communities. The perspective we gain of Muslim-male social hegemony is that of a set of irregular boundaries, porous in some places, firm in others; yet these boundaries were, in turn, framed by the protected role ascribed by law to women. The women of Üsküdar used the legal system within this hegemonic structure to resist attempts at subordination. Although the court became an arena in which male and female legal roles could be publicly affirmed, immediate resolution of inter- or intragender disputes was sought first among the family, or among the community, and was acted upon and guided by the community will. The use of law courts by both Muslim and non-Muslim women to settle disputes was doubly weighted, for the act of bringing a case to court meant that a woman had overridden the social authority of negotiation within her own community, and that by turning to legal authority, she publicly sought a position of power through protection of the court.

The contents of the court cases were predominantly intrafamilial and, as such, resonate clearly with the Gonzalve case and the antebellum court of Philadelphia presented by Michael Grossberg (this volume). In Üsküdar, however, the community court was not an arena where lawyers framed or resolved issues. Because of the rotation system whereby a judge was assigned to a community for usually less than two years, local authorities, expert witnesses from the community, played an unusually important role. They maintained the communal memory, complemented the legal expertise of the judge, and ensured the power of community norms in the legal arena. Therefore, when a woman chose to take her case to a court of Islamic law, she was placed in the paradoxical position of, on the one hand, having to rely on the evidence of her community representatives while, on the other hand, challenging and transcending custom.

The interplay of the community tradition as embodied in the local authorities or expert witnesses who investigated and assisted the judge and Islamic law in the form of the judge or *kadi* who protects women and the family comes to the fore in cases where women address the court, in person or by proxy. Whereas the judge in the courts of Hawaii described by Merry (this volume) is central to court performance, it is clear that in the court of Üsküdar community tradition—in the guise of community experts—also enters the discourse of the court. With each successive generation, community memory, and therefore tradition, shifts subtly, and *shariah*, interpreted within new, altered communities with accumulatively subtle changes in communal memory is, of course, liable to change.

A second and critical paradox emerges from these court records:

the tension between the abstract image of the ideal behavior of a Muslim woman and the reality of the degree of activity undertaken by women in the community also runs throughout the court documents. What we see are two dimensions: on the one hand, the social customs of an elite in which veiling and domestic partitioning are paramount, and, on the other, the status of women before the court, regardless of their social status. The disjuncture between hegemonic social and legal structure was negotiated by women and the minority religious communities on a daily basis. The practical outcome of this interaction was that a number of subterfuges became accepted ways in which women negotiated their place in the social hierarchy. We shall dwell further on these strategies for the everyday in detail below.

THE HISTORICAL CONTEXT

In the 1520s the legal district (*kaza*) of Üsküdar formed one of the three administrative units of the city of Istanbul, the capital of the Ottoman Empire. Situated on the Asian shores of the Bosphorus, directly overlooking the imperial palace on the opposite side, the town was a growing commercial center and a nascent center of religious learning. The character of the town after which the district was named was marked by its role as a conduit, of both people and goods on their way to or from the imperial city: the docks and the adjacent square were filled not only with residents, tradesmen, merchants, and tax collectors going about their business, but also periodically with military troops assembling for their campaigns in the East, and with soldiers of another ilk, pilgrims commencing their journey to Mecca. Radiating from the caravansaries and storehouses, the workshops of coppersmiths, saddlers, and tailors, among the mosques and religious schools, the inns and bureaus clustered along the immediate shores, were smaller communities of residents, *mahalles*,which continued up into the villages in the rural hills skirting the town. Here, and in the satellite villages along the shores, were the market gardens, vineyards, grazing pastures and fields of grain, the fisheries and dairies which supplied the capital on a daily basis.

The administrative and legal district of Üsküdar extended approximately two days' journey (approximately fifty miles) north to the Black Sea and southeast toward the Bay of Izmit, and approximately twelve miles inland into Anatolia. The resident population of the district, estimated at thirty thousand, was an intermixture of Turks, Greeks, Armenians, and Jews, of which non-Muslims constituted at least 10 to 20 percent. Churches and synagogues were intermixed with mosques

and, although non-Muslim populations clustered together in communities or neighborhoods, economic and social borders were permeable and conversion was not a policy enforced by the state. Members of the ruling military-administrative class, the *askeri*, were neighbors with the taxpaying subject class (*re'aya*).[2] This heterogeneity was due in part to the policy of pluralism encouraged by the Ottoman rulers and by Islam. Moreover, although the walled city of Constantinople on the opposite shore was conquered in 1453—approximately seventy years before the cases under study—Muslims, Christians, and Jews had cohabited on the Asian shores for several generations prior to the conquest.

This general description can be gleaned from the literature of the sixteenth century, but there is a paucity of material written about or including Ottoman women. The observations of two European male observers therefore provide a rare background against which to present the legal situation of women. Given that Ottoman chronicles and court literature were preoccupied with the actions of the imperial court, the image that Dernschwam and Busbecq, two travelers and sojourners in Istanbul and Anatolia, present of women is an especially valuable one, albeit not without important limitations to be described below.

Dernschwam's observations of Anatolian Turkey show that the public and private spheres of society were divided between the genders, but also that women were divided by religion. "Turkish" [that is, Muslim] women, he commented, did not have the same freedom as local Christians: they stayed in their homes and were not seen by strangers (Dernschwam 1987:59). Nor did Ottoman women in general have the same degree of freedom of movement enjoyed by their counterparts in Europe: when they traveled, they were escorted by their husbands (or male relatives) and, rather than stay in caravansaries, which harbored all types of lowlife, they stayed in special guesthouses in the towns. Dernschwam also exclaimed that, while these women may have been restricted with regard to those with whom they could come in contact when they traveled, they rode freely in the style practiced by men. This was in direct contrast to their proper European counterparts who could fraternize freely but were restricted to riding in ladylike side-saddle style.

In addition, he reported that these women never went to market to buy or sell; jobs undertaken by boys of the house or by servants. As a result, women were idle and extremely lazy. They never cooked; instead they sewed or lay around and ate soup, yogurt, *ayran* (a yogurt-based beverage), fruits, onions, and garlic. Only old ladies went to the mosque, where they prayed in quarters separate from men's. Younger

women prayed at home. Dernschwam relates that the women's only regular excursion was the weekly visit to the public baths and that the way they were "packaged" for the public segment of this outing stood in stark contrast to the naked female companionship which the women were about to enjoy. In what Dernschwam refers to as a "fountain of layers," women covered themselves with thin black tulle through which they could comfortably see but not be seen, an intricate array of headdresses, and a long silk cloak (Dernschwam 1987:179–80). As testimony to the visual ordering and regulation of Ottoman society evident in the public costume of women (as well as men), he further noted that, even among the veiled, the ethnic origin of women could be determined from their street clothing (Dernschwam 1987:78).

According to Dernschwam's report, the only women who moved freely through the streets, presumably unimpaired by veilings and other coverings, were Greeks or non-Muslims. However, it is likely that many of these "Greek" women were working-class Muslim women, since it is improbable that they had servants to run their errands or that the male members of the family were free to do so. The estate inventories of Muslim women registered with the court confirm that, indeed, although most women owned a multitude of headscarves in a veritable rainbow of colors, few owned what we could designate as face veils or body mantles, and the few women who did were of higher socioeconomic status or showed signs of religious commitment. This suggests that women of low socioeconomic level passed in the streets without body mantles, largely unnoticed, discounted, or misidentified by the few observers who left a literary record.

This relation between veiling, seclusion, and social status was also noted by Busbecq, emissary of the Holy Roman Empire at the court of Sultan Süleyman, who reported that Turkish (that is, Muslim) women were kept "shut up at home and so [hidden] that they hardly see the light" (Busbecq 1968:1:117). Although they may have been seen by other women and by canonically related men, in public they were completely covered to ensure their modesty, a property by which Muslim Turkish men set great store and which reflected their wealth and status. According to Busbecq it was even claimed that men of the wealthier classes and higher ranks made it a condition "that when they marry, that their wives shall never set foot outside their houses" (ibid.:118). In general, these women were referred to by the honorific title of *hatun*, or "lady."

The observations of these travelers were limited in that the latter were confined to their immediate surroundings. Much of their information was based on secondhand reports and concerned the actions of

women of the elite sequestered behind the walls of homes to which men did not have access.[3] Moreover, the court records suggest that, in their desire to see beyond the wall, they overlooked the jostling street life around them. The court records provide much of the intimate detail of everyday transactions and relationships which escaped the eye of these sojourners.

Most of the women of Üsküdar whose estates were included in the register were not of high-status households and for them Muslim cultural strictures were probably practiced to a lesser degree. Thus, a tension is created in the ideal or perceived behavior of a Muslim woman, or a woman of high socioeconomic status or "quality," and the reality of the degree of activity undertaken by women in the community.[4] Whereas non-Muslim women in Üsküdar may not have been bound by the same socioreligious system as their Muslim counterparts, the physical mobility of all women of lower socioeconomic status was often a necessity; that is, their access to the street was not for leisure activities, and their access to the markets was to buy or sell products, often of their own manufacture. Furthermore, as the court records substantiate, the confinement of women of upper socioeconomic levels did not prevent them from participating in the social and economic dealings of their communities. From their perceived chambers of idleness many were engaging in long-distance trade, establishing charitable foundations, making sizable loans to men and women alike, and sending their male representatives to court on their behalf. The scope of these activities becomes evident in the records of the law courts.

THE RECORD

The source used for this paper is the earliest complete law court register available for the city of Istanbul and environs.[5] Beginning in November 1520, it coincides with the ascent of Sultan Süleyman (d. 1566) to the throne of the Ottoman Empire. It is the third in the series for the legal district of Üsküdar—the first two are partly destroyed—and is housed in the archives of the Office of the Grand Müftü of Istanbul, adjacent to the Imperial Mosque of Süleymaniye. The register contains nine hundred eight cases over a forty-month period during which the district court of Üsküdar was presided over by five judges or substitute judges, and recorded by at least six scribes.[6]

The register is important not only for the period it covers, but for the range of material it includes, for in contrast to the practice of the later sixteenth century where cases of the subject class and military-administrative classes were recorded in separate registers, here we find

both together.[7] As in other registers, we also find women and non-Muslims appearing in the register as both claimants and defendants, surety and witnesses. Thus the register incorporates the activities of a wide range of society, where the cases of cavalry officers, footsoldiers, and local grandees are juxtaposed and interrelated with those of lepers, oarsmen, manumitted slaves, Greek vintners, and baker's wives. From this volume we are able to gain a rich and varied picture of the legal position of women both in context and in action.

As a record of the social and economic transactions of a community such as Üsküdar, the law registers are limited, not by prohibition but by the role of the law courts themselves as adjunct to the community. The intermeshing of customary and religious law, of heterogeneous communities of divergent religious and ethnic backgrounds, allows for some "sway" in the everyday implementation of law.[8] In addition, although the *kadi* was the official and schooled arbitrator in a decision, representatives of the community to which he was posted (usually for a two-year term) upheld the memory and relations of that community. The final decision in a case may have rested in the hands of the judge, but he received input from both "expert witnesses" and "expert investigators," respected members of the Muslim business and religious community who were called upon to explain local custom and to investigate the veracity of a claim.

The process of custom and compromise within a community and the social pressure to resolve a problem out of court may well have served as a deterrent to the overuse of the law courts.[9] The financial obstacle of travel to the local court together with various fees, often amounting to a week's wages, paid for business undertaken in the court would also have discouraged small claims from being brought before the judge. Except for deceased itinerants, the cases of the poor are therefore underrepresented in the court records, and even when they do appear in the record the estates of the very poor were left unclaimed by relatives who could ill afford the combined expenses of travel, wage loss, and court fees. The result is that although the court register served as a record for economic transactions or any actions for which a written record may have future value, not all such transactions were formalized through the court. Instead, as becomes evident in the documents, the oath or word of a person was widely used in social and financial transactions and could be later produced as proof of claim in court.

Since the records do not include disputes which could be brought to a satisfactory conclusion within the community, the result of which may or may not be registered with the judge, we rarely see the process

of compromise which preceded these records, only the outcome. Murder, for example, was considered a public and therefore a community concern and could be settled out of court among the involved parties, usually the family of the deceased and the murderer.[10] The murderer was required to recompense the family of the deceased and, until the murderer was found, the village or quarter in which the victim died was responsible as a whole for the payment of the required amount and subsequently for investigating the murder and finding the murderer. An entry in the court records would simply state whether or not the family had been recompensed. Disputes which could not be solved within the community were only then brought before the judge or his deputy. The claim and subsequent defense were recorded, often in vernacular, and if warranted, the aforementioned "committee of experts," Muslims of high regard, investigated the complaint and returned with their information to the *kadi*, who made the final decision. A copy of the process and decision was then inscribed in the court register and witnessed and an original given to the parties involved.

The court also served as a registry for transfers of real or movable property, bonds of surety, loans made by individuals or institutions, and business partnerships. As economic transactions, marriage and divorce were also registered. Again, however, evidence in the estate records which list the business transactions of the deceased at the time of death shows that even the formation of business partnerships of limited duration but sizable investment was not always registered with the court. Loans, again captured in the estate inventories, appear to have been rarely formalized. These informal arrangements were verified by the oath of the creditors and by the testimony of witnesses in the settlement of an estate or dispute.

Administrative concerns were more dutifully recorded: copies of decrees by the sultan were entered, as were the capture, incarceration, claim, and auction of fugitive slaves and livestock; the fees from which contributed to the salaries of the local administrators. Prices of certain comestibles for the local markets were fixed on a seasonal basis and listed along with any transgressions such as hoarding or overpricing. In other cases initiated by the judge, the police attached to the local administrator, or the special police attached to the market inspector (the *muhtesib*, who was also the overseer of public morals for the community), appeared before the judge. The diverse matters addressed included public drunkenness, theft, adultery, coin shaving, and slander. Finally, the estates of individuals who died without heirs or known heirs (particularly in the case of travelers), and estates which were disputed either by family members or creditors, were listed, evaluated

by a court appointee, divided, and duly registered. These estate inventories are a rich source for the study not only of the most intimate and mundane possessions of individuals, but also of their daily social and economic transactions. Collectively, the individual and interrelated contents of the registers offer a bounty of information on community life.

STRATEGIES FOR THE EVERYDAY

Two main categories of material relating to women appear in the court registers. The first is the wide range of cases in which women were actively involved on a daily basis, in which they appear not only as claimants or defendants but as witnesses and surety. These include the registration of financial transactions. Their numbers are few but they speak loudly: of the 711 cases in the register not initiated by local authorities, sixty (9 percent) were initiated by women, several of whom were represented by proxy (vekil). Four of these women were non-Muslims. Women appeared as defendants in thirty-four (6 percent) of the 562 cases in which defendants were named and, of these, six were non-Muslim.

The second source is a core of estate inventories belonging to twenty-two women, all but one of whom were Muslim. As with the fifty-seven estates recorded for males in the district during the same period, these estates listed not only a woman's personal possessions and their market values, but also her heirs, place of residence, outstanding financial transactions, any real property or livestock, and any legal disputes which arose prior to or during settlement. The range of values of the estates of women was more limited than that of the estates of men, whether travelers or residents: women's estates ranged from 514 akçe to 6,431 akçe, and, although the lowest was barely above the poverty line, eighteen belonged to women of the solid lower middle socioeconomic level.[11] Only four of the women had estates valued below 1,000 akçe. Two akçe per day was given by the court as the bare minimum for sustenance. Although analogy may not have been intended, it is interesting that this amount was assigned both for the upkeep of stray water buffalo, and as the daily allowance for divorced women as well as the basic daily wage for laborers.

The estates of women were also not present among the highest valued, the most expensive having been assessed at 6,431 akçe while the highest valued male estate was assessed at approximately 30,000 akçe. All but one of the women resided in the suburban area of Üsküdar. The exception was Selime bint ("daughter of") Kemal, married

to an artilleryman and a member of the military-administrative class, who died while traveling through the town escorted by her son, mother, and female slave. Of the twenty-two women whose estates were registered, eight were proprietors.

These raw figures clearly indicate that, although they were protected by the law, it was not the social norm for women to use the courts. As with all members of society, apart from the notarization of transactions, the courts were usually used as a last resort in those cases where disputes could not be settled within the community and high court fees and expenses may have dissuaded the less wealthy. The informal social pressures applied to women not to resort to the law courts, not to take a matter, especially one involving a male relative, before the judge, thereby bringing shame to the family, may further have discouraged women in the pursuit of formal justice. What is important, then, is not the number of cases initiated by women or in which women appear, but the contents of these cases and the issues for which they sought redress or in which they figure.

According to the Hanefi school of Islamic law applied throughout the Ottoman Empire, women were considered the equal of men with regard to the law of property and obligations (Schacht 1964:126n). Property which they acquired, regardless of the source—by inheritance, dowry, industry, or investment—was inviolable.[12] Upon marriage, their property did not pass into the possession of their husbands as was the case in contemporaneous Europe, nor were they obliged to contribute any of that property toward their own support or that of their families. In theory, women had the unassailable right to maintain and accumulate separate property, to buy, sell, and invest it according to the same laws that governed the male segment of society. In practice, however, law and custom often consorted to frustrate this right.

That the women of Üsküdar owned real property is clear in the court records. In addition to the primary residence of the family, women often owned orchards and gardens, the produce from which formed part of the family economy. When individual property was assigned in the distribution of men's estates, women usually inherited the orchards and gardens attached to the main house. The proportional value of gardens and orchards was equal to the proportion of an estate that women were to inherit, that is, usually half that of the male heirs, the value of an orchard or garden being approximately half that of a residence. Women also inherited and owned shops as indicated in the estate of Fatma bint Mustafa (36r), the wealthiest woman and one of the more prosperous residents whose cases were recorded. Like their more prosperous male counterparts, women also owned slaves. Two

arrangements were recorded in estate inventories, and another two in dispute cases. Paşabeği, a manumitted slave whose case will be detailed below, provides a noteworthy example of the ability of both women and slaves to obtain and control property.

The estates also show that women owned and purchased livestock; not only the water buffalo upon which the workings of an agricultural farm were dependent, but also cows and sizable flocks of sheep for sale to local meat markets or for use in wool production. The case of one farm woman, Ayşe bint Mürsel (12r), shows that some women were both actively involved in animal husbandry and unabashed at using the courts to protect their investment. Ayşe did not hesitate to march into court with a claim that she was no longer responsible for payment of the water buffalo she had bought on credit since it had been devoured by a wolf. Even among the highest valued estates, where women owned more finery and jewelry than their less wealthy counterparts, it was not uncommon to find items of a more practical nature, especially spades and scythes, in their possession; and, most likely, they used them.

Although social pressures may have discouraged women from using the courts in matters involving the transfer of real property, several cases show that whatever hesitations they may have had could be overcome. These transactions were not bound by religion or gender and involved nonrelated members of the community as well as close relatives. Fatma bint Durmuş (16r) disagreed with the claim filed against her by the heirs of Kara Hasan for four hundred akçe she owed the estate for the annuled purchase of a house bought "on condition."[13] Her debt was voided by the judge. In another transaction involving two women (46v), Gülbahar bint Abdullah registered that Surur bint Abdullah had purchased her house for five hundred akçe on an eight-month loan. Devlet bint Abdullah (81r) asserted her option by law (hiyar) over Sunduk bin ("son of") Abdullah to buy the shophouse which belonged to his brother who, although not mentioned, was likely her deceased husband. Devlet was not going to allow Sunduk to usurp her legal right.

As indicated in these cases involving real property, rights of inheritance were protected in law even if they were not always upheld by other heirs, in which case women could seek recourse from the court. This has also been found to be common in the sixteenth-century town of Kayseri where, although the heirs' shares were canonically regulated, they were not always implemented and women resorted to the courts to force payment (Jennings 1975:69–70). A study of Bursa in the following century shows that, although the judge may have carried

out the letter of the law in assigning the legally determined share of an estate to the female members of a family, "other means" may have contrived to deprive them of that share (Gerber 1980:232). In Üsküdar, for example, when Melike bint Mürsel (2r), represented by her husband, claimed that she had not received her inheritance due from her father's estate, she was accorded two vineyards in Bulgurlu as part of a compromise agreement (*bedel-i sulh*). In another dispute, [Tohin] bint Abdullah (20r), represented by Haci Bekir bin Abdullah, claimed twenty-seven hundred akçe outstanding from an estate. The amounts in dispute were often small: in a dispute involving the division of property between a surviving wife and daughter in one family (106r), a compromise agreement of 150 akçe was reached for the remainder of the possessions in the estate; and Hadice bint Fatma (4r) took her brother, Musa bin Kutbeddin, to court to ask why she had not yet received the two hundred akçe appointed to her from her father's estate by the previous substitute judge, Sinan Halife. Occasionally, the courts were used simply to register the receipt of an outstanding inheritance.

Women, themselves, were also subject to inheritance disputes, and claims were made against them by creditors of the deceased. The husband of the deceased Emine (14v) made a claim on behalf of her estate for a debt outstanding from another woman, the wife of Hamza Fâkih, a man trained in law, also represented by another male. Two claims were made against a Greek woman, Todora bint Yani (98v), for a sizable total of 1,814 akçe in debts her husband had incurred before his death.

As with men, women could legally bequeath up to one-third of their own property to whomsoever they pleased, usually outside the line of inheritance. Often this measure was used as a subterfuge to escape the strictures of inheritance divisions: in several estates, women took advantage of this financial leverage over their own property, leaving such decimated amounts as to cause their estates to be evaluated and distributed by intervention of the court. These bequests were often left as contributions to the support of children who had not yet reached maturity, although this support was the responsibility of the surviving father (or appointed guardian). In controlling their own finances, women also established or contributed to charitable foundations or *vakifs* some of which were involved in feeding the poor and ill, or providing for orphans, while others were established as revenue-producing enterprises which would provide future incomes for favored heirs as described below (Jennings 1975:71; Esposito 1982:39–48).

A case of interest concerns the specific designation of inheritance

by Paşabeği bint Hoş-kadem, a resident of Üsküdar. Paşabeği enjoyed a high level of economic independence—she owned a small self-contained house with livestock and an orchard, and she gave and took loans from nonrelated men in the village. Moreover, she willed one-third of her estate, almost to the penny, thereby taking a sizable amount out of the hands of her sole heir. The case is of special importance since Paşabeği was a manumitted slave and her heir, Isa bin Yusuf, was her former master (*asaba-i sebebiye*) through the special "derived relationship" (as opposed to *bi-nefsihî* an extended or collateral blood relationship).[14] Paşabeği's bequest, as both a woman and a manumitted slave, was upheld.

In addition to seeking enforcement of inheritance settlements, women were also vocal about receiving their divorce settlements as accorded by law. Central to these cases was the issue of support (*nafaka-i iddet*), a daily allowance assigned to the woman for three menstrual periods after the divorce. During this time she could not remarry. Occasionally such basic furnishings as a mattress, rug, and pillows were assigned as part of the divorce settlement. Equally important was the "delayed dowry" (*mehr-i müeccel*), a portion (usually half) of the dowry which the husband withheld from his wife until either his death or divorce. In general, a woman forfeited her right to the delayed dowry if she requested the divorce (*hul'*); she received it when divorce was initiated by the husband (*talak*) (Esposito 1982:24–28).

Such punitive economics kept women from initiating divorce and, as with widowhood, encouraged rapid remarriage. This is clearly seen in the case of one of the wealthiest individuals for whom an estate dispute was recorded in the register and which also documents one of the few instances of polygyny in the community. When Hizir, a prosperous grain farmer and member of the *askeri* class died, he was survived by two wives, two grown sons by his first wife, and a minor son by his second. The entries following the estate settlement point to friction not only between the wives, the second of whom appears to have been quite a bit younger than the first, but also between the second wife and the oldest son, who was executor of the estate. Both women made substantial claims upon the estate for their delayed dowries, for five thousand and two thousand akçe respectively, in addition to their share of inheritance. Since resolution could not be reached within the family, it is likely that these combined sums were sufficient to cause the resulting dismemberment of the family property through public auction.

To exacerbate the problem, Hizir's estate was responsible for the

upkeep of his minor child until majority was reached (at age twelve), and the upkeep was to be computed on a daily basis and to be given to the mother by the executor monthly until that time. This amount, plus the delayed dowry claimed by the second wife, would greatly diminish the inheritance of the two mature sons by the first marriage and of their mother. Under these chafing conditions, the remarriage of the young widow within three months of Hizir's death was a logical step, especially when the new husband agreed to support the young child. Indeed, as previously mentioned, records for the Anatolian town of Kayseri in the following century underline that marriage was an economic necessity for both men and women, and that the Muslim value placed on virginity and first brides was second to that of creating a solid economic unit, a viable household.[15]

As with inheritance, the records show that although their divorce settlements were protected by law, women often had to resort to the courts to retrieve them. Thus, Mehri bint Mahmud (54r), represented by Kara Bali bin Aslihan, the market inspector of the outlying village of Samandira, made a claim against her former husband, Mü'min Reis, who had initiated the divorce against her and who was late in paying eighteen hundred akçe in support and eight hundred akçe from her delayed dowry.[16] Although a divorce by *hul'* was usually at the request of the woman and she thereby gave up claims to her dowry, customary support, or some other debt to be paid by the husband, the records give evidence of support agreements made in favor of the women. Asiya bint Ishak (91r), for example, registered that she had yet to receive one thousand akçe in cash, support, and her dowry as the settlement of a divorce from Piri bin Aslihan at her request. In addition, she was yet to receive a waistband of expensive silk, a mattress, cushion, pillow, quilt and sheet, a rug, and a kilim, the bare essentials of a household.

Non-Muslim women also registered their divorce settlements in the Muslim courts. For example, the Greek woman [Sekani] bint Mihal (55v) registered a divorce at her request in which she received a seven hundred akçe compromise settlement (*sulh*). Another Greek, a Christian, Kindi bin Kosta (102r), divorced his wife, Todora, with the formula "I divorce you, three times" (*iiç talak boş olsun, deyucek*), an Islamic pronouncement often used as a curse but with dire and immediate consequences since the oath is legally binding (Esposito 1982:32). Under this kind of divorce, not only can the husband not remarry his repudiated wife until three months after the divorce, but she must first marry and divorce another partner in the interim. Extralegal devices were often employed to expedite the formalities of intermediary

marriage and divorce. Todora received 150 akçe (or seventy-five days' equivalent support) as a settlement (*bedel-i hul'*) for the divorce.

That women of means sought out the court to solve everyday problems was particularly evident in the case of Gümüş bint Abdullah. Gümüş stands out in the register for her financial enterprise: not only was she the major partner in an international trading investment with six men and another woman (92r–93r), but she and a male partner granted loans (16v). Moreover, she turned to the courts for more mundane matters: she placed a claim against her female slave for ruining a piece of expensive gauze (*dülbend*) the servant had been given to launder (73r). In the outcome of the laundry case, the servant had to pay Gümüş Hatun one hundred akçe, the value of the cloth and an amount which represents many month's allowance for a servant. From her name, it is quite likely that Gümüş Hatun herself was of slave origin and had risen in both social and economic status. It is interesting that neither financial arrangement, the trading activities and loans undertaken by Gümüş, was formalized through court registration—they appear in the context of other cases—whereas, by contrast, the situation involving the servant warranted the attention of the *kadi*. Although Gümüş could have appeared in court herself, she sent a representative to court to take care of the case on her behalf.

Several cases illustrate that in contrast to the descriptions of women being closeted away, women not only moved freely through the streets, but behaved forthrightly in public, and in court. The case of a public argument between two women provides examples of the range of access women held to the courts and of the accommodation of the legal process itself concerning women of status. Nergis bint Abdullah (51r) was brought to court for swearing at a second woman, Mansure. Whereas Nergis did not appear in court but chose to be represented by her husband, Mustafa bin Abdullah, the wife of one of the highest notables in the area, Hayreddin Çavuş Beğ, by marked contrast, appeared in person as a witness to the argument. Traditionally, the testimony provided by women was given half the value of that of their male counterparts; therefore, the testimony of at least two women was required in addition to that of a man.[17] In this case, the social weight within the community of Hayreddin Çavuş's wife appears to have borne the weight of at least two women—or one man—since the testimony of only one male was added as proof of the event.[18]

Women also appeared as defendants in cases brought against them by court officials, male residents, and other women. Several women were brought to court for immoral or unsuitable public behavior as was the abovementioned Nergis. Kismet bin Davud (83r), for example,

brought a claim against his stepdaughter for having behaved offensively toward his male friends while they were guests in his house. On three separate occasions, Husni bint Abdullah (7v), Fatma bint Abdullah (8r), and Emine bint Abdullah (73r), all converts, were brought to court for fighting with, or attacking men. Women such as [Zühal] bint Hamza (88v) were brought to court for adultery (2r; 8r–9r) and prostitution (*zina*) and, as was the case with their male counterparts, were flogged for immoral behavior. Women likewise brought complaints against members of the community for "inappropriate" behavior. Dervişe bint Mehmed (58r), for example, brought a claim against Nasuh bin Abdullah for obstructing her path on her way to the nearby village of Istavros, a charge amounting to assault. On the basis of her name, Dervişe was likely a member of a heterodox sufi order or lodge (which generally accepted women) and Nasuh appears elsewhere in the register as a police officer.

Perhaps one of the most graphic examples contained within the register with regard to access to legal redress by women is a series of cases concerning Nefise, an accused adultress. At the end of June 1523, Nefise, the daughter of Abdullah and wife of Şahkulu Mustafa bin Kasim (87r) was summoned to court by the administrator (*emin*) of Üsküdar, Timurhan bin Ismail, for improper behavior involving an Arab (or African) servant who had been sent to her husband's kaftan shop with some cloth.[19] Again, names indicate background, that she was likely a convert and her husband a low-ranking soldier, a member of the nontaxpaying military class. In the entries that followed (87r), the *emin* registered his accusations against her, not only for cursing, trickery, and deception, but also for having committed adultery and prostitution for "who knows how many days and nights?" He demanded that bond be posted by her husband, who tentatively defended her by replying that "if all the liars and busybodies in the community [who had apparently laid the claims] were to come to his shop, they would find kaftans and *dülbend* cloth but no adultery or prostitution." He was then asked why men who were *na-mahrem* (canonically nonrelated to the woman) were taken to his house when his wife was present: things were not according to law.[20] The accusations were then ordered to be investigated. The decision of the *kadi* is not recorded, but in the next entry we learn that Mustafa has repudiated his wife and divorced her, events which usually follow a decision of adultery or prostitution.

Even so, we find that Nefise, who by all social standards was a persona non grata, a social outcast, still had legal standing. She later brought a claim against her ex-husband for payment of her daily upkeep (to which she was legally due for three months after the divorce)

and for her share of her delayed dowry which he was delinquent in paying. Furthermore, she again insisted that her voice be heard in court by defending herself against the original accusation concerning the Arab/African servant coming to the shop with the cloth and the ensuing immoral behavior. End of case—and, one would expect, the last of Nefise.

Six months later, however, Nefise again turned up in court to assert her rights (90v). During the intervening period, her daughter, Huma bint Mustafa, had died. Her ex-husband had also died during this time. The daughter, having survived her father, inherited part of his estate, to which Nefise, as mother, could now lay claim as her survivor and heir. Since there was no proof of the inheritance arrangement, her oath was taken and accepted by the court and she was awarded her claim. By indirectly laying claim to part of his property through her daughter's estate, she had gained a small victory over her deceased husband. The importance of this extensive entry, apart from the local color, is the extent to which a woman of dubious social and moral standards, who had transgressed the system of laws governing society, could still seek protection and recourse from that same court and, under the protection of that same system of laws, receive it.

The independence which many women exhibit in the court cases is partly related to the protection which Islamic law ensured women over their own finances. Through inheritance, marriage contracts, and their own industry, most women had disposable income to invest at their discretion, although the frequency of cases involving male relatives meddling with a woman's finances suggests that this situation was an ideal. The records underline that women did not confine their economic transactions to their families or to other women but seem to have invested their finances wherever they could make a profit. As mentioned in passing, the estates show clearly that the women of Üsküdar engaged in credit transactions, not only within their immediate families but also with nonrelated men and other women within the community. Both debts and credits outstanding at the time of death were to be honored by the estate before dividing the remainder among the heirs. Six of the twenty-two women for whom estates were recorded had a total of thirteen loans outstanding at the time of their deaths. All of the loans had been made to men and ranged from a mere two akçe to five hundred akçe with most above three hundred akçe. By contrast, outstanding debts ranging from nineteen akçe to 305 akçe were held by four women. These atomistic and informal loans were also characteristic of the estates of men within the community.

The complementarity of information recorded in the estates, disputes, and other registered transactions shows both sides of the coin: the unintentional record of informal loans outstanding at the time of death and the intentional, formalized recording of loans with the court. From these we learn that although women engaged in informal loans on a frequent basis, few transactions in which women either lent or borrowed money were actually formalized by registration with the court. But, of the sixty-two registered loans with "hidden interest" (*karz-i hasen*), although only four were undertaken by women, the amount of debt was still substantial.[21] The size of any of these loans was enough to buy a small house in the town with an enclosed orchard or garden.

Other entries in the register showed that women engaged freely in ·such transactions, although not with the same frequency as their male counterparts, and in at least two cases had established charitable foundations (*vakifs*) which generated income from the interest forthcoming from loans. The *vakif* of Sara bint Mehmed (52v), the wife of Yahşi bin Abdullah, gave two loans totaling fifteen hundred akçe to two Muslim men at the end of April 1522, for example, and the foundation established by Şahkhoban bint Hamza Beğ (98v) gave a single loan for nine thousand akçe to a Muslim male in July of 1523. This last loan was the largest single loan recorded in the register.

The religious, ethnic, and social mix of both the creditors and the debtors in these transactions was quite indicative of the financial interaction of the town in general: the Muslim woman Ayşe bint Sinan (56v) borrowed twelve hundred akçe at 10 percent interest from her coreligionist Haci Ali bin Mustafa; Hiristiniye bint Todori (71r), an obvious Christian by name, borrowed one thousand akçe at 10 percent interest from a Muslim, Emir bin Mustafa, and then repaid him a debt of twelve hundred akçe outstanding from the estate of her deceased husband (71r). Of the fifty-two registered loans without stated interest, only three involved women, but these again showed the same characteristics: a Greek woman, Manula bint Mihal (3r), disputed a loan claim for an undisclosed amount from an Istanbul Jewish physician, Hâkim Sinan Yahudi; Hadice bint Hizir (14r) had borrowed five hundred akçe from Hasan bin Evhad; and the aforementioned Gümüş bint Abdullah and Hamza bin Abdullah (16v) concluded that Hizir bin Mehmed had repaid his debt to them of two thousand akçe. Not all of these loans were registered but, rather, appear in cases involving disputes. As with the records of Dernschwam and Busbecq, the small, mundane activities of these women passed unnoticed.

CONCLUSION

The image one acquires of the women of Üsküdar through their court records is one of activity, one in which women are not only counting their pennies, but investing them. Üsküdar is also a community in which women used their right of access to the courts to promote their interests, in which a manumitted slave could restrict the claim of her past master to her estate, where a farm woman could challenge the claim of a creditor upon the expensive livestock she had purchased, where a widow could assert her priority right to buy her husband's share in real property, and where a woman traveling alone from one village to another could charge a police officer with obstructing her path.

Although Islamic law emphasizes that women enjoy similar legal privileges and obligations as men, the transactions and possessions captured in the estate lists of women can be clearly differentiated from those of their male counterparts. For women, it is the diversity and range of material possessions rather than restrictiveness which stands out. This diversity also marks the manner in which they used the law courts and in which they negotiated societal frames. By custom, the social and economic realm of these women radiated from the hearth or private sphere rather than the public sphere, but the register confirms that they were not limited to that private sphere. We find that the radius in which they operated was also quite varied, reaching, albeit by way of proxy, as far afield as international trade or as close to home as small loans to the Greek vintner next door. Few of these transactions were formalized by the court and may have passed unnoticed in history but that they were captured in their own estates or of those with whom they had engaged in financial dealings.

By far the most numerous cases bringing women to court were intrafamilial and involved the demand for lapsed divorce payments and inheritance settlements. This active use of the courts emphasizes that women had a strong financial stake in the stability and operation of the family unit and that they used the law courts and local markets to protect their interests. In some cases, especially where livelihoods depended upon agriculture, they owned not only the family residence despite the existence of a male head of household who was, by tradition, the economic mainstay of the family, but also farm implements and animals upon which the operation of the farm truly rested. Their estates show that they engaged in domestic industry for local markets. The ideal of woman as closeted and virginal bride was even set aside to preserve the familial social unit in an expanding society where

the divorced or widowed were readily reintegrated into a community through remarriage and where the luxury of an idle woman was ill afforded.

The practices of solving a dispute within one's family or with the assistance of community members and of transacting business based on trust (and without a court fee) partially account for the lack of cases involving women in the courts. Two voices recorded in the documents, however, illustrate the strategies adopted by women in using the law courts to overcome the hegemonic structures of sixteenth-century Üsküdar. The subdued voice of Paşabeği, the manumitted slave, who used her will to prevent her former master from inheriting more of her estate than she wished, is no less robust than the bawdy shouts of Nefise, the adultress, who used the same court that convicted her to pursue her husband even after the grave.

The records clearly demonstrate that, although some women may have entered the gates of justice with trepidation, against the approval of the community, others appear to have been more unabashed in their approach. Moreover, testimony given and actions taken in these cases demonstrate that those women who used the courts did so based on either prior knowledge or belief; that is, they were either aware of their specific rights or believed that the courts would establish and enforce them. Finally, the range and number of cases remove the claim that these women were exceptional; rather, we must begin to think of their actions as strategies for the everyday.

Notes

1. The following is based on research undertaken in the Müftülük Archives of Istanbul using records from the earliest series of *shariah* court records available for the city of Istanbul: Istanbul Şeri' Sicilleri: Üsküdar Series 6, volume 3. When cited, a case is referred to the recto or verso page number on which it appears. See also Yvonne J. Seng, "The Üsküdar Estates (Tereke) as Records of Everyday Life in an Ottoman Town, 1521–1524," Ph.D. dissertation, University of Chicago, 1991.

2. In general, Ottoman society was studiously class based in that residents were divided by taxpaying status: the taxpaying subject class (*re'aya*) provided a major source of support for the nontaxpaying military-administrative *askeri* class in the employ of the state. Members of the *askeri* class may have formed the elite of society, but the desire to generalize should be moderated. The *askeri* also included such persons as royal gardeners and cooks, or footsoldiers and blacksmiths who serviced the military—in short, long-term employees on the imperial payroll.

3. An example of this phenomenon is seen in the works of the nineteenth-century Orientalist school of painting, artists from which, having never entered

an occupied harem, still managed to produce fantasies of oriental beauty. Delacroix, for example, hired traveling dancers as models, or used the domestic settings of Jewish acquaintances, to paint many of his harem scenes in Algeria. By contrast, the observations of Dernschwam are ethnographic in scope and far from Orientalist fantasies; nevertheless, the above-mentioned limitations of his actual observations of women and domestic life should still be borne in mind.

4. This tension is also noted by Jennings in discussing the town of Kayseri in seventeenth-century Anatolia: the willingness with which apparent adulteresses were restored by their husbands to their households suggested that the socioeconomic role of women in Kayseri society "was more important than sexual virginity and chastity," two characteristics again highly valued by Muslims (Jennings 1975:96).

5. Except for foreigners covered under capitulations, all residents of the Ottoman Empire, regardless of religion, were regulated by Islamic law in matters concerning the community. Non-Muslims had their own courts regulated by church or Jewish law with exclusive jurisdiction over subjects associated with religion and family, i.e., betrothal, dowry, marriage, divorce, and inheritance. Non-Muslims, however, especially Christians, were quick to seek out the Muslim court when it was to their advantage, choosing the court which most benefited them in a specific situation. See Pantazapoulos 1967; Jennings 1978; and Cohen 1984:passim.

6. In addition to *shariah*, Ottoman residents were also regulated by sultanic codes or statutes known as *kanun*. In contrast to religion, family life, and personal conduct, which comprised the general contents of the *shariah*, these *kanun* consisted primarily of administrative law and included the regulation of officials, taxation, and ad hoc decrees (Inalcik 1978). Their contents ranged from the introduction of new taxes for underwriting military campaigns to orders directed at a specific community for failing to pay their taxes, from charges of fermentation of grape juice by Muslims and the destruction of the vineyards of those who did so, to the registration of new fares to be charged by boatmen in transporting goods across and along the shores of the Bosphorus. The Ottoman rulers themselves enforced the custom of their pre-Islamic forefathers that they, rather than a body of legislators, were empowered to introduce and change law. Thus, when Sultan Süleyman ascended to the throne in 1520, he became known to his subjects not as The Magnificent, a term coined by European admirers, but as The Lawgiver (*Kanunî*). The foundation for the prosperity of his reign was rationalized as the system of justice by which he ruled and his empire was governed: by custom and by law.

7. Whereas legislation of the subject class was undertaken by a local judge (*kadi*), in general, the military-administrative *askeri* class was overseen by a special court and military judge, the *kaziasker*. Two separate sets of record books were usually kept, one for each court, one for each class, and by the mid-sixteenth century when the Ottoman bureaucracy became increasingly institutionalized, it was not unusual for the records of the two classes to be kept in separate registers.

8. Customary law provided the final leg of the tripod of justice: in the information submitted to a local *kadi* for settling disputes, the term "from the times of old, it was the custom that" was favorably weighted. This type of law was known as *örf*.

9. This modification or accommodation of Islamic law to local practices has recently become a point in the study of more contemporary Islamic societies. For examples see Antoun 1980:458; Doumani 1985:156–57; Starr 1978:passim; Stirling 1965:271–72; and Toledano 1984.

10. For an explanation of the Ottoman criminal code, see Heyd 1974:passim and Schacht 1964:89–93.

11. Based on a survey of estate records for the area between 1520 and 1530, poverty level was established at five hundred akçe or less, and lower-middle socioeconomic level at between one thousand and five thousand akçe (Seng 1991).

12. In his study of court cases in Kayseri in the seventeenth century, Jennings stressed that the inviolability of women's property holdings was consistently upheld by the Kayseri court (1975:65–66).

13. To establish a relative value for the amounts cited in these cases, the amount assigned by the court to maintain a fugitive slave in jail can be used. The amount of four hundred akçe therefore represents approximately seven months' subsistence allowance.

14. For a description of "derived relationships," see Barkan 1966:21–22. The *asaba-i sebebiye* was especially disadvantageous if no other heir but the spouse (usually the wife) of the ex-slave existed. In that case, only one-fourth of the estate could be claimed by the spouse, with the remainder going to the past master. If the past master was no longer alive, his share was inherited by his son or sons; daughters were excluded from this second-level inheritance.

15. Jennings observed that "one suspects that generally speaking, the homework-mother (socio-economic) role of the woman in Kayseri society was more important than sexual virginity and chastity" (1975:96).

16. Only two entries were made concerning the settlement of a dowry on a bride, one for five thousand akçe (79r) and another for one thousand akçe (90r). Support (*nafaka-i iddet*) was customarily given for the three-month period following the divorce during which the woman could not remarry. The women of Kayseri also took their husbands to court to retrieve their divorce settlements (Jennings 1975:82). In two cases in Üsküdar (104r, 24r), the daily allowance was given as two akçe regardless of whether the individual was Muslim or non-Muslim.

17. Although women were permitted to provide testimony, they did not serve as witnesses to the court procedure (*şuhûd ul-hâl*).

18. It should be noted that women could also stand bond or surety for their husbands although men standing bond for others was more common. The Greek woman Irine, along with two men, Petro bin [Kine] and Mihal bin Sari, stood surety for her husband, Kafirî (literally, the Unbeliever), the owner of a Greek *taverna* or *meyhane* in Üsküdar (103v).

19. In Ottoman Turkey, when referring to slaves, the term "Arab" was often synonymous with Abyssinian or African.

20. For more information on adultery, see Imber 1983:passim.

21. Various methods were engaged to circumvent the Islamic ban on charging interest. One of the most widely used was the *karz-i hasen*, "hidden interest," often referred to as the "cloth purchase." Under this arrangement, the borrower agreed to buy a small piece of cloth (or another article such as a kaftan), the value of which was recorded as a percentage of the value of the loan. This amount was usually 10 to 12 percent, an amount considered as "legal."

References

Antoun, Richard R. 1980. "The Islamic Court, the Islamic Judge, and the Accommodation of the Traditions: A Jordanian Case Study." *International Journal of Middle East Studies* 12:455–67.

Barkan, Ömer Lutfi. 1966. "Edirne 'Askeri Kassimi'na Ait Tereke Defterleri (1545–1659)." *Belgeler* 3:1–497.

Busbecq, Ogier Ghislein de. 1968. *The Turkish Letters of Ogier Ghislein de Busbecq*. 2 vols. Charles Thornton Forster and F. H. Blackburne Daniell, trans. Oxford: Clarendon Press.

Cohen, Amnon. 1984. *Jewish Life under the Ottomans: Jerusalem in the Sixteenth Century*. Cambridge: Cambridge University Press.

Dernschwam, Hans. 1987. *Istanbul ve Anadolu'ya Seyahat Günlügü*. Yasar Önen, trans. Ankara: Kültur ve Türizm Bakanligi.

Doumani, Beshara. 1985. "Palestinian Court Records: A Source for Socioeconomic History." *Middle East Studies Bulletin* 19:155–72.

Esposito, John. 1982. *Women in Muslim Family Law*. New York: Syracuse University Press.

Gerber, Haim. 1980. "Social and Economic Position of Women in an Ottoman City, Bursa, 1600–1700." *International Journal of Middle East Studies* 12:231–44.

Heyd, Uriel. 1974. *Studies in Ottoman Criminal Law*. Oxford: Clarendon Press.

Imber, Colin. 1983. "*Zina* in Ottoman Law." In *Turcica III: Contribution à l'histoire économique et sociale de l'Empire Ottoman*. J. L. Bacque-Grammont and P. Dumont, ed. Leuven, France: Editions Peeters.

Inalcik, Halil. 1978. "Kanun." *Encyclopedia of Islam*. 2d. ed. Leiden: E. J. Brill 4:556–62.

Jennings, Ronald. 1975. "Women in Early 17th-Century Judicial Records—The Sharia Court of Anatolian Kayseri." *Journal of Economic and Social History of the Orient* 18:53–114.

———. 1978. "*Zimmis* (Non-Muslims) in Early Seventeenth-Century Ottoman Judicial Registers." *Journal of Economic and Social History of the Orient* 21:225–93.

Pantazapoulos, N. J. 1967. "Church and Law in the Balkan Peninsula during Ottoman Rule." *Journal of the Institute of Balkan Studies* 92:3–121.

Schacht, Joseph. 1964. *An Introduction to Islamic Law*. Oxford: Clarendon Press.

Seng, Yvonne J. 1991. *The Üsküdar Estates (Tereke) as Records of Everyday Life in an Ottoman Town, 1521-1526*. PhD dissertation, University of Chicago.

Starr, June. 1978. *Dispute and Settlement in Rural Turkey: An Ethnography of Law*. Leiden: E. J. Brill.

Stirling, Paul. 1965. *Turkish Village*. London: Weidenfeld and Nicholson.

Toledano, Ehud R. 1984. "Law Practice and Social Reality: A Theft Case in Cairo, 1854." In *Studies in Islamic Society*. Gabriel R. Warburg and Gad R. Gilbar, eds. Haifa: Haifa University Press. 153–74.

KADHI'S COURTS AS COMPLEX SITES OF RESISTANCE: THE STATE, ISLAM, AND GENDER IN POSTCOLONIAL KENYA

Susan F. Hirsch

INTRODUCTION

At the time of Kenya's Independence in 1963, political and religious leaders of the small Muslim population living primarily on the Kenyan coast demanded that the new Kenyan Constitution recognize and retain the existing system of Islamic courts, called Kadhi's Courts. Those leaders sought to ensure that Muslims in independent Kenya could turn to Islamic legal authorities to resolve disputes involving marriage, divorce, inheritance, and other matters of personal law. At the urging of many Muslims, including representatives of the sultan of Zanzibar (the former ruler over the Kenyan and Tanzanian coastal region), the constitution was written to establish the Kadhi's Courts as a branch of the Kenyan judiciary. Muslims from the Swahili ethnic group—the most prominent community of Muslims in Kenya—were especially gratified at the position granted the courts. For Swahili Muslims, the Kadhi's Courts are among the few remaining symbols, albeit the last vestiges, of nineteenth-century Swahili Muslim hegemony in the coastal region.

In postcolonial nations, the retention of Islamic courts for even limited legal matters is an important influence on the religious practice,

community identity, and social relations (especially gender relations) of Islamic people. This is certainly the case in secular nations, such as Kenya, and especially when Muslims constitute only a minority of the population.[1] Situated amidst multiple legal and normative orders, the Kenyan Kadhi's Courts provide a forum for negotiating relations of power involving multiple and interrelated processes of domination. As the postcolonial period stretches into its fourth decade, the Kadhi's Courts have become complex sites of resistance, the locus for struggles pitting Swahili men and women against each other and the Muslim community against the Kenyan state.

This chapter examines the Kenyan Kadhi's Courts to understand how courts operate as complex sites of resistance. After a brief theoretical discussion of resistance and legal arenas, the discussion focuses on two oppositional practices associated with the Kadhi's Courts in the postcolonial period: (1) the use of the courts by Swahili women seeking to transform their experiences of domestic patriarchy and (2) community protest of attempts by the Kenyan government to interfere in the application of some Muslim laws. These kinds of resistance are reactions against specific forms of domination associated with the Swahili community; yet, analyzing them as discrete processes would fail to illuminate how oppositional practices articulate with one another. In this chapter I conceptualize sites of resistance broadly to acknowledge that several kinds of oppositional practice converge in any one arena and, more important, to focus on the interconnections among these practices.

THEORIZING RESISTANCE IN COMPLEX SITES

As recent overviews suggest, the concept "resistance" has been over-used, romanticized, and defined both too narrowly and too broadly (see, e.g., Abu-Lughod 1990; Giroux 1983; Hirsch and Lazarus-Black this volume; Holland and Eisenhart 1990; Keesing 1992; Merry 1990; Ong 1987; Scott 1990; Sholle 1990; Vincent 1990). This conceptual imprecision is perhaps an artifact of the heterogeneity of sites of resistance considered by scholars, such as schools, cultural performances, mass media, factories, courts, and homes. In examining these sites, scholars worry over whether what they see is really "resistance" or some less explicit, less conscious, or less collective oppositional practice. Given variations in the power dynamics associated with each site, it follows that resistance is subtly different across contexts.

The ethnographic study of resistance in particular sites offers an

exceptionally rich approach to delineating the complex dynamics of power and opposition. Abu-Lughod (1990) advocates interrogating acts of resistance—in their various contexts and forms—to reveal the heterogeneous relations of power in which those who resist are caught (cf. Foucault 1980). Emphasizing the mutually implicative nature of power and resistance, Abu-Lughod's approach highlights the intricacy of power, envisioning it as multiple webs that configure class, gender, ethnicity, and other hierarchies in sometimes contradictory ways.

Scholars face the challenge of presenting a concise sketch of the dynamics of resistance in specific sites while appreciating how each site is inflected by relations of power that operate throughout society. The influential literature on resistance in schools offers a good example of how scholars have addressed this challenge in increasingly constructive ways. In reviewing this literature, Holland and Eisenhart (1990) criticize the initial, narrow focus on resistance as proceeding from bottom to top, along one dimension of power (e.g., students resisting against schools). From their perspective, studies such as that of Willis (1977), while enormously important in documenting how working-class boys reproduce their class position by resisting school discipline and teachers, overlook power dynamics *within* subordinate populations, such as between male and female students (Holland and Eisenhart 1990:58; see also McRobbie 1981). The critique of unidirectional and unidimensional analyses of resistance is relevant to contexts other than schools and serves as a caution against developing simplistic paradigms of resistance built around the idiosyncrasies of particular sites. At the same time, studies mindful of this critique (e.g., McLaren 1989) are useful in that they document the multiple dimensions of power that are generally implicated in processes of resistance across many contexts.

Recent feminist scholarship also recognizes the multilayered character of power and resistance (see, e.g., Diamond and Quinby 1988; Fraser 1989). Studies of gender and the state demonstrate that capitalism and patriarchy are inextricably linked, with sometimes devastating effects on women's lives (see, e.g., Connell 1987; Eisenstein 1979; Gailey 1987; Hatem 1987; MacKinnon 1989; Sacks 1979). Such studies find that men and women often experience and confront oppression in gender-patterned ways. Given, for example, that women are situated in positions of multiple subordination, their oppositional practices might differ from those of men, might be directed against men, or, if pursued in concert with men (e.g., against the state), might have gender-specific outcomes. Understanding the gendered nature of oppositional

practice requires careful consideration of how men and women are positioned in the sites where resistance occurs and how they utilize different strategies and goals within them.

The conceptualization of legal phenomena as processual; of normative orders as overlapping, clashing, competing, and borrowing legitimacy from one another; and of legal institutions and practices as tools of force and ideology in social struggles reflects the trend toward analyzing the complexities of power and resistance in legal arenas (see, e.g., Comaroff and Roberts 1981; Merry 1988; Moore 1986; Starr and Collier 1989).[2] As the introduction to this volume asserts, courts are critical sites for mediating power and resistance. Recent studies explore how people contest and transform power relations through the active use of courts (see, e.g., Conley and O'Barr 1990; Merry 1990; Moore 1986; Nader 1990; Yngvesson 1993; and other chapters in this volume). These studies examine how people take claims to court to oppose domination and how they contest the terms of legal procedure, among other kinds of resistance. However, courts can also serve as symbols to legitimate an oppositional political position or to assert group identity in the face of hegemony. Particularly in situations of legal pluralism, courts can become the focal point for community definition and cohesion. Through these kinds of resistance, the courts themselves are ultimately positioned and repositioned in ongoing power struggles.

Courts are "complex sites of resistance" in part because they have the potential to play pragmatic, ideological, and symbolic roles in contestations over power. Yet, as the above discussion demonstrates, this complexity is generated as well by the fact that people use courts to contest multiple relations of power, reworking understandings of gender, race, class, and other hierarchies sometimes simultaneously. Thus, oppositional practices in courts, emerging in response to a range of dominations, assume many forms and generate diverse outcomes. All these factors need to be considered to understand the significance of courts as sites of resistance.

Recent studies of Muslim family law courts demonstrate the range of roles these courts play in diverse societies, thereby underscoring the need to view courts as complex sites of resistance (see, e.g., Antoun 1990; Beck and Keddie 1978; Dwyer 1978, 1979, 1990; Hatem 1986; Hirsch 1990; Mayer 1991; Moore this volume; Starr 1978, 1989). Such courts are frequently the last bastion of Muslim law in a secularized judicial system, as is the case in Kenya and some other African and Middle Eastern countries, and they constitute forums where power struggles involving politics, religion, and family take place (Dwyer

1990). The symbolic role of Islamic courts varies across Muslim communities and with respect to different historical and cultural circumstances (Dwyer 1990). For example, in recent years, increased reliance on Muslim law allows some communities to identify with a global Islamicization process linked to religious fundamentalism and anti-Western sentiment (as in Pakistan, Sudan). In other communities, however, ideological opposition to local political arrangements is a more relevant concern, as the Kenyan demand to retain the Muslim courts at Independence suggests. The role of Muslim courts in symbolizing patriarchy and male control in many communities can also be an important factor in their retention, legitimacy, and symbolic use (Hatem 1986).

Dwyer's observation that "having embraced the symbol [of Islamic law], a broad range of legal alternatives sometimes becomes available for use in the eyes of the users" (1990:12) alludes to the multiple possibilities for resistance offered by Muslim courts. Some variations among Muslim courts (e.g., legal interpretations and patterns of use) can be attributed to differences in schools of Muslim law. To a large extent, however, most variation is shaped by local dynamics of culture, economy, and power. Thus, contrary to popular stereotypes, the effect of Muslim family courts on gender relations is quite diverse across the range of national and cultural contexts. In many societies, Islamic courts apply family law to support patriarchal relations, yet the courts can also be the site where reforms are implemented to improve women's status.[3] Whether as invincible symbols of male dominance or as contexts where women's complaints against men are brought to public awareness, Muslim courts are instrumental in constituting gender relations.

Although coastal Kenyan Muslims take disputes to Kadhi's Courts to mount resistance of various kinds, they also turn to the courts and the kadhis to demonstrate their resistance against the Kenyan state. These practices raise the question of how to conceptualize the relation among types of resistance occurring in the same context. Following a discussion of the history of the Kadhi's Courts and their relation to the Kenyan state in the next section, this chapter examines two seemingly dissimilar and contradictory oppositional practices associated with Kenyan Muslim courts and suggests that they are best understood as related struggles. Oppositional practices pursued in response to *different* dominations might appear as separate struggles proceeding along discrete trajectories. But, as this chapter argues, the points of interconnection among resistant acts are quite telling, capable of revealing that some struggles over power facilitate or preclude others.

SHIFTING ROLES FOR THE KENYAN KADHI'S COURTS

The Coastal Swahili Community

The coast of Kenya, on the Indian Ocean, has been home for over a thousand years to people who call themselves Waswahili.[4] Since their migration from Somalia centuries ago, Waswahili have witnessed the comings and goings of many people: Portuguese navigators; Omani dhow (boat) crews seeking mangrove, ivory, and seasonal marriages; Shirazi people with mysterious, possibly Persian origins; Muslim plantation owners from Arabia who settled more or less permanently in the nineteenth century; thousands of slaves brought from central Africa for labor or transport abroad; British slave merchants and colonizers who admired the literate Muslims; laborers from India; Kikuyu traders and farmers from upcountry; and, most recently, Japanese tour groups, American Navy personnel, and Italian retirees in private villas. The Swahili Muslim population experienced economic, political, and ideological effects from all these "visitors." Some were incorporated into the local community, but, in both the colonial and postcolonial period, the Swahili community was overwhelmed, outpaced, and eventually dominated by those who moved in and through the area (for historical details see, e.g., Cooper 1977, 1980; Middleton 1992; Nurse and Spear 1985; Pouwels 1987; Strobel 1979). Though colorful Swahili rituals, dances, and symbols dominate representations of "coastal culture," the Swahili community occupies a marginal position in the postcolonial Kenyan society and economy.

The encounters and impositions on the coast over the last century have left a community crosscut by relations of dominance and subordination along several dimensions. In the late nineteenth century, the heyday of Muslim economic and political prominence at the coast, Swahili society was rigidly stratified. Social status was reckoned by clan affiliation, history of servitude, and family honor. Clans with claims to *ustaarabu* (civilized Arab status) were more prestigious than those with closer ties to "African" roots, who risked being labeled uncivilized (*ushenzi*) or people of the bush (*wanyika*). Status continues to be a dimension of social hierarchy reflected in dress, residence, and ceremonies, like weddings and funerals (see, e.g., Porter 1992; Strobel 1979). Yet, in the capitalist postcolonial economy, other dimensions of social position, such as class and education, merge with and crosscut traditional emphases on family and blood.

In contrast to their nineteenth-century position, Swahili people are

not major players in the postcolonial Kenyan economy. Swahili men made the transition somewhat awkwardly from being farmers, fisherfolk, and merchants to working in service positions in transportation and as clerks. Depending on fluctuations in the local and global economy, young men seek their fortune outside the country, mostly in Saudi Arabia. Most married Swahili women manage households and engage in petty commerce from their homes. Educated young women, a small but growing minority, pursue jobs in offices and as teachers. Women face at least some restrictions on their movements outside the home in the name of Muslim modesty. Compliance with such restrictions varies among women and is influenced by an individual's class, status, and personal circumstances (Mirza and Strobel 1989; Strobel 1979).

Throughout the postcolonial period, the Swahili community has been losing ground in an economy that depends on the labor of coastal people in the shipping and tourist industries yet funnels profits to the capital and outside the country. Economic policies that benefit those ethnic groups in control of the national government and those areas that surround the capital have not escaped the attention of Kenyans in more maginalized regions, such as the coast. The Kenyan state, administered by individuals from "up-country" rather than the coast, has been expanding its political control over populations—such as the Waswahili—who are skeptical about the economic and political benefits that they receive from an increased governmental presence. A rigid one-party system for most of the postcolonial period, the Kenyan state has been oppressive in its control of the population and against acts of overt resistance (e.g., the 1982 attempted coup and rallies for multiparty democracy in the early 1990s) have been countered with harassment, torture, and detentions without trial.[5]

As Sunni Muslims, coastal Swahili people have strong ties to countries in the Middle East, especially Oman and Saudi Arabia. The ideological and economic relations forged with other Muslim nations reflect a strong sentiment of solidarity that contrasts with the resentment expressed by many Waswahili toward the secular Kenyan government. The influence of Islamic fundamentalism is less overt on the coast than in some other African nations, probably because there are few Shi'a Muslims and those Sunnis swept into the fundamentalist surge face opposition from factions in the Swahili community who value its local, "impure" particularities. The Nairobi government has used the "threat" of fundamentalism to monitor and prohibit demonstrations and assemblies by Muslims.[6] In general, the Swahili community is increasingly marginalized economically, politically, and with respect

to religion in a nation where Christian faith and Western education are markers of success.

The Kadhi's Courts

Situated on the physical edge of the expanding Kenyan state, the coastal Kadhi's Courts are a remnant of the strong Muslim government which controlled the region in the nineteenth century. The courts are ideologically important to the Swahili community, which is striving to retain some connection to a glorious past when Islam was central to social and political life at the coast. Yet, as described below, the Kadhi's Courts are contested symbols of that romanticized era. Older Swahili people remember that the kadhis and their courts have always been vulnerable to the whims of dominating groups, including Omani Arabs from Zanzibar and the British (Hirsch 1990; see also Anderson 1976). More recently, the paradoxical position of the courts has intensified as the courts have become not only the last vestige of coastal Muslim governance but also a primary site for state intervention in Swahili life.[7]

The Kadhi's Courts are part of the larger Kenyan legal system, which is characterized by the "classic legal pluralism" common in many nations with a colonial past and ethnic and religious diversity (Merry 1988:872). For example, there are secular government civil and criminal courts for the adjudication of most matters, Islamic courts for family law involving Muslims, and diverse offices and councils where judges, chiefs, and laypeople invoke customary law. The conceptualization of overlapping legal spheres not as benignly "plural" but as imposed normative orders that reflect the power relations of colonialism and neocolonialism applies to the array of legal institutions in the coastal region (Burman and Harrell-Bond 1979; Merry 1988; Starr and Collier 1989; Vincent 1990). Specifically, the administration of the Kadhi's Courts by the secular Kenyan government and judiciary has been characterized as an imposition by many Muslims.

For the Swahili community, the role of the Kadhi's Courts—as symbols and as functioning legal institutions—has shifted over time in relation to changes in coastal politics, movements in population, and state interests in monitoring Muslims. Although the Islamic courts have a long history on the coast, they have been controlled by Swahili people only rarely (see Anderson 1976). In the precolonial period, sultans from the Arabian Peninsula and then Zanzibar supervised the courts with minimal input from the local population. The British colonial government initially allowed local Muslim judges, primarily resi-

dent Arabs, to hear most civil and criminal cases involving Muslims. During the colonial period, though, the British limited the jurisdiction of the Kadhi's Courts to civil matters and insisted on the application of British-modeled rules of procedure and evidence (Anderson 1976; Ghai and McAuslan 1970). The control of the courts by Arabs and then the British led Swahili people to regard the courts with suspicion, and the kadhis were thought to be especially vulnerable to political co-optation. By the end of the colonial period, a few Swahili elders had obtained positions as kadhis, although the legacy of the courts as imposed on a dominated population and controlled by outsiders remains at the heart of their paradoxical role as legal institutions and authorities that both govern and represent the Swahili community.

In the postcolonial period, the Kenyan government has instituted a variety of measures to monitor the Kadhi's Courts ever more closely. The courts are physically located in the same buildings as the secular magistrate's courts, thus facilitating observation by government officials and the circulation of documents that convey state concerns. The caseload and disposition of cases is frequently the subject of circulars from court administrators who believe that the kadhis clog the courts by encouraging extended periods of mediation rather than efficient settlements or dismissals. The kadhis are increasingly urged to refer some matters (e.g., child custody, inheritance) to secular authorities like the Public Trustee or the Children's Officers for resolution.[8] Through the appeals process the secular legal system intervenes directly in the affairs of the Kadhi's Court. Judges from the secular Kenyan High Court decide on all appeals from Kadhi's Courts, with profound effects on individual cases and interpretations of Islamic law. The imposition of secular law is potentially the most sweeping at the level of policy. In attempting to "standardize" laws of inheritance and marriage through legislation—some passed, some only proposed—the state has included provisions that contravene Islamic practices.[9]

For a brief time in the early postcolonial period, the secular government had yet to establish hegemony over the Kadhi's Courts. Rather, the courts were sites of Swahili hegemony, where powerful elders with status claims of religious orthodoxy and clan affiliation used their positions as kadhis and court advisers to affirm and implement the dominant values of the male Swahili community. With reference to this time, Swartz (1979) interprets the Kadhi's Courts as symbolizing Swahili ethnicity, distinguishing the Swahili community from other Muslim ethnic communities in Kenya, such as South Asians and Somalis.

Swartz's interpretation has become less relevant in recent years, as

the courts, while still controlled by Swahili men, are no longer associated with the influential high-status echelon of the community.[10] Rather, at the insistence of the Kenyan state, younger, Western-educated men have taken positions as kadhis. Government requirements that all civil servants (including kadhis) keep court records in English have resulted in kadhis who are marginal to the traditional sources of authority in the Swahili community, particularly the elders associated with mosques and Koranic schools.[11] To some extent, the kadhis of recent years are in competition for authority with these elders, who frequently advise disputants, accompany them to court, and sometimes denounce Kadhi's Court decisions publicly.

As the courts and the kadhis are pulled more firmly toward the secular state through the policy interventions and local practices described above, the role of Islamic legal institutions as symbols of either the Swahili community's celebrated past or its recognition as an autonomous enclave in the postcolonial state is further strained. For many coastal people, the Kadhi's Courts are symbols not of Swahili community autonomy, ethnicity, or religiosity but of their actual and potential co-optation by the secular state and their tenuous presence as a Muslim community. The Kadhi's Courts have become a contested symbol, a complex site of opposition for Swahili Muslims. The contestation is stimulated by increasing intervention in the courts on the part of the state and, as described in the next section, the perceived favoritism of the courts to women's claims.

THE KADHI'S COURTS AND SWAHILI WOMEN'S RESISTANCE

As is the case in many other Muslim societies, a Swahili woman's "modesty" reflects her personal character and her family's status (see, e.g., Beck and Keddie 1978; Dwyer 1978; Porter 1992; Strobel 1979). Modesty requires policing—by the self, family members, and the community—through practices such as veiling, gender segregation, the seclusion of women from public view, and the denial of female sexuality. Some aspects of life in a secular postcolonial nation, such as the increase of girls and women in schools and workplaces, make it increasingly difficult to maintain strictly "gendered spheres" of social life. However, in accordance with frequently cited Muslim ideology, many Swahili husbands and fathers still retain significant control over the life choices and daily activities of their wives and daughters. For example, most marriages are arranged by family members who seek to unite

first cousins and thus solidify patriarchal control of women. Brides-to-be have some opportunity to express their preferences for a mate, and older female family members (e.g., mothers and aunts) play an influential role in these decisions.

In the Swahili community, many arranged marriages end in divorce, especially if they are first marriages and the bride and groom are immature. In general, marital relations are points of particular strain in Swahili society, and divorce is common. In one coastal town in the mid-1980s, the court clerk expressed shock that the number of divorce certificates issued that year by the Kadhi's Court had surpassed the number of marriage certificates. In accordance with Islamic law, most divorces are initiated by the husband who needs only to "pronounce" divorce to begin the short process of ending a marriage.[12] By contrast, women seeking a divorce must make a claim in court and such claims can take years to resolve. The ability of husbands to divorce more easily than wives is one example of how men and women are differently positioned in Muslim marriage in ways that further patriarchy.

Conflicts among Swahili couples arise over many restrictions on women, and many other issues concerning domestic life. A man must provide his wife (or wives, in the case of polygamy) with food, shelter, and new clothes at reasonable intervals. In return, he is permitted to demand sexual access to his wife and her obedience to his restrictions, such as informing him of her activities outside the house. To an increasing extent in the postcolonial period, most disputes arise out of the inability of Swahili men to fulfill their duties as providers for the household. Often wives "persevere" when finances are tight and, though not required under Muslim law to contribute to the household budget, they help out economically by cutting expenses and using their own resources to maintain the family. If a man abandons his family, squanders money, or acts abusively as well as failing to provide, his wife may decide to initiate divorce proceedings. Most serious conflict has multiple causes that include personal temperaments and the dynamics of the extended families.

The case of Fatima, a Swahili woman living near Mombasa, illustrates a common progression of marital conflict. Fatima and Mohammed were married in 1974. They lived together peacefully for eight years, though they struggled to feed and clothe their five children. Fatima claims that Mohammed began to neglect her and the children in 1982, shortly after he married a second wife. When she complained that Mohammed was not providing sufficient maintenance for the family he beat her. Taking a second wife, allowable under Islamic law, often results in severe strain in an existing marriage, particularly if the

first wife has been "persevering" through strained economic circumstances with a belief in the good-faith efforts and commitment of her husband. After numerous attempts to resolve the problem, Fatima filed a case in Kadhi's Court. She was granted a divorce by the kadhi, though she has little hope of obtaining the maintenance due her children.

Fatima is among a growing number of Swahili women who refuse to endure marriages that subject them to poverty, personal restrictions, and physical and emotional abuse. For Swahili women in the postcolonial period, the Islamic courts have become an important site for resisting the oppression experienced in marriage in a patriarchal society (Hirsch 1990). Over the past two decades, claims in Kadhi's Courts have been brought in increasing numbers by women against men (Hirsch 1990; see also Brown 1987).[13] Through the Kadhi's Courts, women claim for divorce, maintenance and postdivorce payments, child custody, and protection from domestic abuse.[14] Most of the few cases brought by men involve requests for "return of a wife" who has left the matrimonial home without permission. Other cases handled in Kadhi's Court involved inheritance or personal status.

In most Kadhi's Court cases and mediations, women and men appear before the kadhi or his clerk without counsel. Parties to a claim are generally accompanied to court by family members or friends, although women no longer rely on designated agents (formerly male relatives) to represent them and, most important, to speak for them before the court. Indeed, the judges encourage women to tell the story of their difficulties in their own words. Kadhis admit to being moved and persuaded by women's long narratives describing domestic conflict extending over the years of a marriage. Men's attempts to defend themselves with references to their rights under Islam are frequently dismissed by the kadhis, who sometimes interpret them as challenges to the authority of the court (Hirsch 1992).

Most women who bring claims to court are awarded with favorable decisions in cases and mediations. In 108 cases brought by women against men in the Kadhi's Court of a large coastal town in 1985–86, only two were decided against the woman.[15] Even those cases which were settled, rather than decided through a trial, favored the claims of the woman. Some judgments lead to immediate changes in women's lives: they receive a divorce certificate, they are paid their dowry, they get custody of children. But many decisions exist on paper only. The enforcement of rulings is mostly haphazard, although kadhis can rely on municipal police to seize property and enforce custody decisions.

In the colonial period, Swahili women made claims in court much less frequently, with more constraints and personal sacrifices, and they

received fewer favorable decisions. In part, this was because conservative community elders controlled the courts and explicitly supported the domination of women through conservative ideologies and practices. The new kadhis accede less readily to the demands of patriarchal elders. However, they do not describe their role as expanding women's rights but rather speak of deciding each case on its merits. They insist that women's cases are generally quite strong and thus deserve their favorable consideration.

Swahili women's ability to use the courts to their advantage in recent years results at least in part from the Kenyan state's role in monitoring the work of the kadhis (Hirsch 1990). Paternalistic oversight by the state—resulting in more equitable and impartial procedures that benefit women—is not uncommon in colonial and postcolonial situations where normative orders overlap (Antoun 1990; Chanock 1985; Collier 1973; Lowy 1978; Starr 1989). Yet the intervention of the Kenyan state in the Kadhi's Courts, while bolstering women's position, should not be interpreted as proceeding from an ideological commitment to the pursuit of women's rights or the protection of Muslim women. Rather, the Kenyan state seeks to monitor the courts as part of its general control over the administration of ethnic minority communities, a strategy directed primarily at monitoring men, not aiding women. Among the outcomes of that control is the transformation of the Kadhi's Courts into forums where Swahili women realize justice.

A quiet resistance to the patriarchy of Swahili women's use of the courts to resist oppressive domestic circumstances is not, however, a collective or conscious resistance articulated by women on explicitly gendered terms. For example, Swahili women, even those who have experienced favorable outcomes in court, rarely characterize the Kadhi's Courts as contexts where women can obtain their legal rights with respect to men. Rather than describing their experiences through the discourse of rights, they focus on the kadhis as people who can "help" when few other options for resolving conflict exist. The pursuit of claims in Kadhi's Courts thus provides little ground for Swahili women to conceptualize collective resistance against patriarchy or to develop a discourse of women's rights that implicates the courts. Rather, women who win in court experience limited, highly personal empowerment or benefits, like relief from an abusive marriage or a monetary award. For some, the act of going to court may increase their marginality with respect to family, neighborhood, and the community more generally; thus, they serve as only silent and ambivalent examples for others.

Swahili men are more likely to interpret women's use of the courts in gendered terms. Mention of the success of a woman's claim in court prompts mutterings from Swahili men, including former kadhis, about the Kadhi's Courts as "women's courts" and the kadhis as "bewitched" or "lecherous," favoring women out of their own personal weaknesses. Although the men who mutter the loudest are those who have lost cases in Kadhi's Courts, many Swahili men voice concern that the character of the courts has changed in recent years and that, by favoring women, kadhis no longer serve Islam or the Swahili community. The condemnation of the kadhis on the grounds of personal character dovetails with accusations of their co-optation by a secular state uninterested in Islamic values. Some Swahili men avoid the courts entirely, ignoring court decisions and refusing to deal with the kadhis, even for routine matters (e.g., marriage vows). The mutterings of these men may never grow any louder, however, as the community rallies around the courts in the face of direct interventions by the Kenyan state, as described in the next section.

WASWAHILI RESISTANCE
TO STATE DOMINATION

Throughout the postcolonial period, Kenyan government intervention in the Kadhi's Courts has taken a variety of forms. Those forms that contribute to Swahili women's ability to use the courts more effectively involve primarily procedural and personnel changes (e.g., equal access to the courts for men and women; the application of British-modeled, rather than Islamic, rules of evidence). Aside from complaints about several of the new kadhis, many of these changes are unremarked by Swahili men or women. Certainly, they do not speak of procedural changes as contributing to the success of women in court or to the declining role of the courts in the community. By contrast, government efforts to alter Muslim substantive law are more widely recognized and publicized and thus more provocative for a Swahili community concerned about its marginalization in the postcolonial state. Specifically, the standardization of succession law by a Kenyan parliamentary act in 1972 initiated protests from the coastal Muslim community that have continued into the 1990s. As I describe below, the kadhis and the Kadhi's Courts have come to play central roles in that unresolved controversy.

In 1968, the Kenyan Commission on the Law of Succession proposed the nationwide act, passed four years later, which called for

rules of succession "applicable to all the inhabitants of Kenya, without regard for the religious or customary laws by which they had previously been bound" (Commission on the Law of Succession 1968:8). The act was adopted at a time when the Kenyatta government—particularly Charles Njonjo, the controversial attorney general—sought to streamline and "modernize" Kenyan law and society. Customary laws, erratic legal procedures, and indigenous (nonprofessional) legal practitioners and decision makers were important targets of a range of legislative efforts designed to develop a standardized Kenyan legal system rather than to maintain differences among the new nation's many ethnic and religious groups.[16] The act was intended as well to defuse the sometimes explosive question of land tenure by simplifying procedures for inheriting property.

The 1972 Law of Succession Act includes several provisions that contravene the customary and religious laws of most Kenyans. Several key provisions of the act differ significantly from Muslim law as practiced at the coast. For example, in the event of intestate succession, a surviving spouse inherits the entire estate in trust for other dependents; whereas Muslim practice requires division of the estate among specific heirs (including the spouse) as designated in the Koran. In addition, and perhaps more controversially, the act provides that all children inherit equally regardless of gender or, in some cases, legitimacy.[17] According to Islamic law, male dependents receive larger shares than female dependents and illegitimate offspring have no claims on an estate (see Anderson 1976:204–5 for a full discussion of these and other contrasts). Muslims are permitted to write wills; however, they are supposed to adhere to Islamic provisions with respect to who inherits and how much of the estate they are entitled to. In wills, Swahili Muslims sometimes provide for relatives, friends, and institutions other than those who would normally inherit, although the total amount set aside for these "extra" successors must not exceed one third of the entire estate.

Through newspaper editorials, petitions, and a violent public demonstration in Mombasa, the Kenyan Muslim community protested against the succession act when it was proposed but failed to stop its passage. Numerous organizations mounted protests against government interference in the practice of Islam, and some called for coastal secession, an issue raised a decade before at the time of Independence. The coastal Women's Islamic Association was actively involved in opposing the act, and association leaders commissioned several of their most educated members to draft a written summary of their objections. When the law passed, many in the Muslim community vowed to

continue to apply Islamic law in matters of succession. In the mid-1980s, a legal scholar at the University of Nairobi, in response to my questions about the act, admitted with irony, "Yes it has been implemented, but Muslims are ignoring it."

Passage of the act put the kadhis and the Kadhi's Courts in an awkward position. Many Swahili Muslims bring succession claims to court, and they rely on the kadhis or their assistants to interpret wills, determine successors, calculate the division of shares in the event of intestate succession, and supervise the disposition of property. As I observed in the mid-1980s, these transactions are conducted without reference to the succession act. The kadhis openly refuse to apply the act in intestate succession or to recognize wills written with provisions contrary to Islamic law, even if they are in accordance with the act. In interviews, they defend their decision to continue to apply Islamic principles, even those that contravene the act, by referring to the Kenyan Constitution which guarantees the autonomy of the Kadhi's Courts in matters of inheritance. The few Muslims who have tried to invoke the succession act in Kadhi's Court have had their claims dismissed. The kadhis point out, rather uncharitably, that these rare cases almost always involve individuals who converted to Islam for the purposes of marriage, and on the death of the spouse, seek as much of the estate as possible. Although there is some confusion about the status of the act in the Swahili community, in general, people continue to write valid wills and to accept Islamic principles when someone dies intestate. Even those persons who would stand to gain considerably from the act (i.e., wives or daughters) do not invoke it.

The Kenyan government has made few overt attempts to enforce the succession act. Over the past decade the state has conveyed mixed messages concerning the legal autonomy of ethnic and religious groups. On the one hand, the state has used a variety of strategies to weaken the authority of customary and religious law and legal practitioners. Throughout Kenya, the application of customary law is quite limited and frequently attacked and reversed by a judiciary that is moving rapidly toward professionalization. On the other hand, a widely publicized legal case which concerned who had the right to bury a prominent Nairobi lawyer—his widow by state law, or his clan by custom—brought the steady disregard for customary law to an abrupt halt with a ruling that favored the clan (Cohen and Odhiambo 1992; Ojwang and Mugambi 1989; Stamp 1991).[18] Though the kadhis express concern that the act gives Muslims a rationale for ignoring or violating Muslim law, most of them have been relatively passive in their opposition, merely participating for many years in the court process in ways

that contravene state efforts to standardize and secularize succession law.

In the early 1980s, Muslim leaders convened a committee of scholars and community elders to express their continuing opposition to the succession act and to monitor its implementation. The main objective, as articulated by several committee members, is to encourage Parliament to adopt an amendment that exempts Muslims from the act's provisions. After a decade of deliberations, the substance of the amendment has yet to be agreed on by the committee. Power struggles around religious interpretation, political affiliation, and regionalism may play some role in preventing committee members from coming to an agreement. However, one of the main sticking points concerns a proposal by the Chief Kadhi, a committee member. He insists that the amendment, in addition to exempting Muslims from the succession act in the event of intestate succession, must also specifically forbid Muslims from writing wills that violate Islamic law. The Kenyan government has repeatedly refused to consider this request if included as part of an amendment to the act. The government position is that Muslims should feel duty bound to write wills that reflect Islamic legal principles, and that the state has no standing to compel adherence to religious law.

In 1990, the Chief Kadhi took a public and vocal stand against the succession act at a time when opposition to the government led for many to detention and torture.[19] His resistance to the strong arm of the state, though brave, was rather ironic. In effect, he sought a secular legal means of compelling Muslims to apply Islamic law. The particular configuration of normative orders led him to demand further collaboration with the Kenyan state in order to maintain the autonomy of the Islamic courts and the practice of Muslim law. His appeal to the Kenyan government was an attempt to transform hegemony to accommodate the interests of a Muslim population struggling to retain its autonomy. By making a public stand, the Chief Kadhi bolstered the legitimacy of the courts as sites that represent the Muslim community in a hostile secular state. As I suggest below, perhaps he also used this strategy to remind the community, especially Swahili men, that the courts, far from being weak remnants of past Islamic authority, could still serve as focal points for Swahili identification.

CONCLUSION

Islamic courts serving Muslim minority populations are complex sites that heighten our appreciation of the elaborate dynamics of resistance. In recent years Swahili women have turned to these courts to resist

domestic patriarchy, and, to a large extent, their claims have succeeded with the watchful assistance of the Kenyan state. Yet these women also actively protest against the state's attempts to secularize Muslim substantive law. Among coastal Muslims, there is virtually no public discourse that depicts state intervention as a positive contribution to Swahili life. Swahili men are the most vocal in their opposition to the state, and many of them extend their critique of the state to the kadhis, whom they view as abandoning Islam under pressure from both the state and women with invalid claims. In the postcolonial period, however, these men find themselves in a paradoxical position. Though generally hostile to the Islamic courts, they collaborate with the kadhis to resist explicit state intervention in Islamic law on the issue of inheritance.

The various oppositional practices of Swahili men and women are best understood as related processes converging in and around the complex site of the Kadhi's Court. The vehemence with which community members pursue state recognition of their claims can be understood as attempts to demonstrate the inviolability and strength of the Muslim courts, courts that are in reality declining in influence in the community and passing out of the control of traditional male authorities. The acts of public resistance can be understood as reactions to the changing character of the courts, which, as tainted symbols, are sources of tension and embarrassment for many men in the community. Public defense of the courts and Islam, especially on the part of the kadhis, perhaps constitutes an attempt to reinvigorate courts weakened in part through their characterization in recent years as "women's courts." Although Swahili men, by refusing to accept the succession act, certainly protect certain rights to devolve property, often in ways that disadvantage women, their resistance also speaks to fluctuations in the symbolic role of the courts as sites of Swahili community autonomy. The predicament of the Chief Kadhi, seeking legitimacy for weakened courts by dictating the role to be played by the state, further reveals dimensions of the complexity. Understanding this complexity requires a broad conceptualization of courts as resistance sites, one that attends to the related processes of how courts are constructed as symbols for community resistance and how they are used by those who resist other dominations.

Notes

This analysis is based on research conducted in coastal Kenya for twelve months in 1985–86 and for shorter periods in 1988 and 1990. The research was supported by a Shell–Duke University International Studies grant, the

Northwestern University Law and Social Sciences Program, and the American Bar Foundation. I am grateful to the Kenyan government for granting me permission to conduct this research. Many thanks to Donald Brenneis, Mindie Lazarus-Black, and Michael Musheno for comments useful to me in revising my argument.

1. Even the most generous estimates put the Muslim population of Kenya at less than 20 per cent. Most Swahili Muslims live at the Kenyan coast.

2. Merry argues that "the dialectical analysis of relations among normative orders provides a framework for understanding the dynamics of the imposition of law and of resistance to law, for examining the interactive relationship between dominant and subordinate groups or classes" (1988:890).

3. Many women who use Muslim courts, however, develop formal and informal means of avoiding particularly oppressive outcomes (Dwyer 1978, 1990). In many countries, reforms of Muslim law, demanded by women, have improved women's status, particularly in guaranteeing access to divorce. For example, Starr's studies of the legal system in Turkey document how women avoid patriarchal Muslim law by taking claims to secular state courts (Starr 1978, 1989). These courts provide more regularized procedures and limit the influence of Muslim community elders (see also Lowy 1978). Antoun (1990) describes how Lebanese women use Islamic courts to resist attempts by consanguineal and conjugal kin to control their behavior. He argues that the secular state plays a crucial role in facilitating women's use of the courts to leave troublesome marriages and to avoid returning to the guardianship of their fathers (see also Hirsch 1990).

4. A precise definition of Swahili identity has remained even more elusive than for other ethnic groups, producing a small community of scholars who steadfastly pursue an answer to the question "Who are the Waswahili?" (e.g., Arens 1975; Bakari 1981; Eastman 1971). This chapter offers no new or definitive resolution to the question but rather adopts the approach of Swartz (1979), Strobel (1979), and others who identify Swahili people quite broadly as East African coastal Muslims who recognize both African and Arab ancestry (see also Middleton 1992).

5. The repressive measures taken by the Kenyan government have been documented extensively by international human rights organizations as well as the Kenyan and international press (see, e.g., Human Rights Watch 1992).

6. In the early 1990s, the ban on political parties was lifted and some Muslims called for the organization of an Islamic Party of Kenya (IPK). Some factions of this group drew on understandings of Islam associated with fundamentalist movements in other countries, although many of those who sought government recognition for the IPK were more interested in gaining coastal political strength than in altering Islamic practice in the region (Hirsch 1993; Jaffer 1993).

7. The Kenyan state generally avoids regulating religious institutions like mosques or Koranic schools unless they are thought to be overtly antigovernment.

8. Disputants are often confused by the multiple legal contexts for bringing claims. Yet, sometimes they learn to manipulate these forums strategically using one against another. I observed one dispute over child custody that involved the Kadhi's Court, the Children's Officer, the juvenile court, and criminal courts in both Kenya and Tanzania.

9. Changes in substantive law were initially broached by commissions appointed by Kenya's first President, Jomo Kenyatta, in the early 1960s. These changes were developed in the Report of the Commission on the Law of Succession and accepted by the Commission on the Law of Marriage and Divorce (1968). The latter commission was asked to consider exempting Muslims from standardized provisions, which they declined to do:

> We accept that Islam is a complete way of life and, indeed, it is for this reason that Kenya, like most other countries in the world, including Muslim countries, has already found it necessary to enact laws which restrict the application of Islamic law. We think that marriage and divorce and the structure of the family are matters which vitally concern the State and we do not think that the fact that they are also intimately bound up with religion would justify or excuse the State abdicating its responsibility. (Commission on the Law of Marriage and Divorce 1968:5)

10. In terms of ethnicity, many kadhis are Waswahili; however, several from other ethnic groups (e.g., Digo) have been appointed in recent years. It is still the case that "Asian" Muslims have not entered the Islamic judiciary, although many serve as magistrates in the secular courts.

11. Kadhi's Court records used to be kept in Arabic using Arabic script. In the colonial period, kadhis wrote in Swahili using Arabic or Roman script. Records are currently kept in English. During a trial the kadhi transcribes court speech, translating Swahili into English for the record, a procedure which lengthens the trial process.

12. A husband can initiate divorce by pronouncing it in the presence of his wife and two male witnesses. If the couple then separates and stays apart for three months, they can obtain a divorce certificate. This type of divorce is viewed as revocable, and couples often get back together during the three-month period. Revoking a divorce is permitted, indeed encouraged, unless the man has pronounced divorce three times. A third pronouncement results in an irrevocable divorce. The couple may not marry again until the wife has been married and then divorced by another man.

13. The number of cases filed in the Malindi Kadhi's Court has increased steadily since the mid-1970s, from a low of twenty-nine in 1976 to a high of eighty in 1985 (Hirsch 1990:143).

14. Men must provide three months of support to a wife after divorcing her. Fathers are obligated to support their children until the age of majority for boys and marriage for girls.

15. The two Kadhi's Court cases decided against women were a maintenance case denied because the woman had been disobedient in several ways, including perhaps adultery, and a claim for maintenance by a divorced woman whose husband had fallen ill before finishing the required payments.

16. During the colonial period, kadhis sometimes allowed a panel (*baraza*) of community elders to resolve certain familial disputes. Parties were told to appear before the panel which convened outside the court. The elders had a good deal of free rein in handling disputes, and several Swahili people, remembering that time, accused them of bias, particularly against women from low-status families. These panels were abolished by the state in the 1960s as part of the effort to professionalize the judiciary.

17. Anderson explains that the original law allowed for equal shares to

any child regardless of legitimacy. This was amended to include only those children whom a parent recognized or assumed responsibility for (Anderson 1976:205).

18. Stamp (1991) makes the excellent argument that the S. M. Otieno case was primarily about ethnicity and its relation to Kenyan politics. She criticizes the Western media and academics for portraying the case as concerning gender and the oppression of African women.

19. In the mid-1980s another kadhi was jailed without charges for several days after writing a pamphlet that criticized remarks made by a government official about gender relations in the Swahili community.

References

Abu-Lughod, Lila. 1986. *Veiled Sentiments: Honor and Poetry in a Bedouin Society*. Berkeley: University of California Press.
———. 1990. "The Romance of Resistance: Tracing Transformation of Power through Bedouin Women." *American Ethnologist* 17(1): 41–55.
Allen, James de Vere. 1993. *Swahili Origins: Swahili Culture and the Shungwaya Phenomenon*. Athens: Ohio University Press.
Anderson, J. N. D. 1976. *Law Reform in the Muslim World*. London: Athlone Press.
Antoun, Richard. 1990. "Litigant Strategies in an Islamic Court in Jordan." In *Law and Islam in the Middle East*. D. Dywer, ed. New York: Bergin and Garvey.
Arens, W. 1975. "The Waswahili: The Social History of an Ethnic Group." *Africa* 45(4): 426–38.
Bakari, M. 1981. *The Customs of the Swahili People*. Berkeley: University of California Press.
Beck, Lois, and Nikki Keddie, eds. 1978. *Women in the Muslim World*. Cambridge: Harvard University Press.
Brown, Beverly. 1987. "Gender and Islamic Law in Kenya." Paper presented at the American Anthropological Association Annual Meeting, Philadelphia, November.
Burman, Sandra, and Barbara Harrell-Bond, eds. 1979. *The Imposition of Law*. New York: Academic Press.
Chanock, Martin. 1985. *Law, Custom, and Social Order: The Colonial Experience in Malawi and Zambia*. Cambridge: Cambridge University Press.
Cohen, David William, and E. S. Atieno Odhiambo. 1992. *Burying SM: The Politics of Knowledge and the Sociology of Power in Africa*. Portsmouth: Heinemann.
Collier, Jane. 1973. *Law and Social Change in Zinacantan*. Stanford: Stanford University Press.
Comaroff, John, and Simon Roberts. 1981. *Rules and Processes: The Cultural Logic of Disputes in an African Context*. Chicago: University of Chicago Press.
Commission on the Law of Marriage and Divorce (Kenya). 1968. *Commission on the Law of Marriage and Divorce Report*. Nairobi: Government of Kenya.

Commission on the Law of Succession (Kenya). 1968. Commission on the Law of Succession Report. Nairobi: Government of Kenya.

Conley, John, and William M. O'Barr. 1990. *Rules versus Relationships: The Ethnography of Legal Discourse*. Chicago: University of Chicago Press.

Connell, R. W. 1987. *Gender and Power: Society, the Person, and Sexual Politics*. Stanford: Stanford University Press.

Cooper, Frederick. 1977. *Plantation Slavery on the East Coast of Africa*. New Haven: Yale University Press.

———. 1980. *From Slaves to Squatters*. New Haven: Yale University Press.

Diamond, Irene, and Lee Quinby. 1988. *Feminism and Foucault: Reflections on Resistance*. Boston: Northeastern University Press.

Dwyer, Daisy Hilse. 1978. "Bridging the Gap between the Sexes in Moroccan Judicial Practice." In *Sexual Stratification: A Cross-Cultural Perspective*. A. Schlegel, ed. New York: Columbia University Press. 41–66.

———. 1979. "Law Actual and Perceived: The Sexual Politics of Law in Morocco." *Law and Society Review* 13(3): 740–756.

Dwyer, Daisy Hilse, ed. 1990. *Law and Islam in the Middle East*. New York: Bergin and Garvey.

Eastman, Carol. 1971. "Who Are the Waswahili?" *Africa* 41(3): 228–36.

Eisenstein, Zillah, ed. 1979. *Capitalist Patriarchy and the Case for Socialist Feminism*. New York: Monthly Review Press.

Foucault, Michel. 1980. *Power/Knowledge: Selected Interviews and Other Writings, 1972–1977*. New York: Pantheon Books.

Fraser, Nancy. 1989. *Unruly Practices: Power, Discourses, and Gender in Contemporary Social Theory*. Minneapolis: University of Minnesota Press.

Gailey, Christine. 1987. *Kinship to Kingship: Gender Hierarchy and State Formation in the Tongan Islands*. Austin: University of Texas Press.

Ghai, Yash, and J. McAuslan. 1970. *Public Law and Political Change in Kenya: A Study of the Legal Framework of Government from Colonial Times to the Present*. London: Oxford University Press.

Giroux, Paul. 1983. "Theories of Reproduction and Resistance in the New Sociology of Education: A Critical Analysis." *Harvard Education Review* 55(3): 257–95.

Hatem, Mervyn. 1986. "The Enduring Alliance of Nationalism and Patriarchy in Muslim Personal Status Laws: The Case of Modern Egypt." *Feminist Issues* 6(1): 19–41.

———. 1987. "Class and Patriarchy as Competing Paradigms for the Study of Middle Eastern Women." *Comparative Studies in Society and History* 29:811–818.

Hirsch, Susan F. 1990. *Gender and Disputing: Insurgent Voices in Coastal Kenyan Muslim Courts*. Ph.D. dissertation, Duke University.

———. 1992. "Language, Gender, and Linguistic Ideologies in Coastal Kenyan Muslim Courts." *Working Papers on Language, Gender, and Sexism* 2(1): 39–58.

———. 1993. "Challenging Power Through Discourse: Cases of Seditious Speech from Kenya." Paper presented at the Law and Society Association Annual Meeting, Chicago, May.

Holland, Dorothy, and Margaret Eisenhart 1990. *Educated in Romance: College Culture and Achievement*. Chicago: University of Chicago Press.

Human Rights Watch. 1992. *Kenya: Taking Liberties.* New York: Human Rights Watch.

Jaffer, Murtaza. 1993. "Islam and the New World Order." Paper presented at the Yale University Council on African Studies Lunchtime Series, April.

Keesing, Roger. 1992. *Custom and Confrontation: The Kwaio Struggle for Cultural Autonomy.* Chicago: University of Chicago Press.

Lowy, Michael J. 1978. "A Good Name Is Worth More than Money: Strategies of Court Use in Urban Ghana." In *The Disputing Process—Law in Ten Societies.* Laura Nader, ed. New York: Columbia University Press. 181–208.

MacKinnon, Catharine A. 1989. *Toward a Feminist Theory of the State.* Cambridge: Harvard University Press.

Mayer, Ann Elizabeth. 1991. *Islam and Human Rights: Tradition and Politics.* Boulder, Colo.: Westview Press.

McLaren, Peter L. 1989. "On Ideology and Education: Critical Pedagogy and the Cultural Politics of Resistance." In *Critical Pedagogy, the State, and Cultural Struggle.* H. Giroux and P. McLaren, eds. New York: SUNY Press. 174–202.

McRobbie, Angela. 1981. "Settling Accounts with Subcultures: A Feminist Critique." In *Culture, Ideology, and Social Process: A Reader.* T. G. Martin Bennett, C. Mercer, and J. Woollacott, eds. London: Batsford Academic and Education Ltd. 66–80.

Mernissi, Fatima. 1975. *Beyond the Veil: Male-Female Dynamics in a Modern Muslim Society.* Cambridge: Schenkman.

Merry, Sally Engle. 1988. "Legal Pluralism." *Law and Society Review* 22(5): 869–96.

———. 1990. *Getting Justice and Getting Even: Legal Consciousness among Working-Class Americans.* Chicago: University of Chicago Press.

Middleton, John. 1992. *The World of the Swahili: An African Mercantile Civilization.* New Haven: Yale University Press.

Mirza, Sarah, and Margaret Strobel, eds. 1989. *Three Swahili Women: Life Histories from Mombasa, Kenya.* Bloomington: Indiana University Press.

Moore, Sally Falk. 1986. *Social Facts and Fabrications: "Customary" Law on Kilimanjaro, 1880–1980.* Cambridge: Cambridge University Press.

Nader, Laura. 1990. *Harmony Ideology: Justice and Control in a Zapotec Mountain Village.* Stanford: Stanford University Press.

Nurse, David, and Thomas Spear. 1985. *The Swahili: Reconstructing the History and Language of an African Society, 800–1500.* Philadelphia: University of Pennsylvania Press.

Ojwang, J. B., and J. N. K. Mugambi. 1989. *The S. M. Otieno Case: Death and Burial in Modern Kenya.* Nairobi: Nairobi University Press.

Ong, Aihwa. 1987. *Spirits of Resistance and Capitalist Discipline: Factory Women in Malaysia.* Albany: SUNY Press.

Porter, Mary. 1992. "Swahili Identities in Postcolonial Kenya: Gender Representations in Educational Discourses." Paper presented at the American Ethnological Society Annual Meeting, Memphis, April.

Pouwels, Randall Lee. 1987. *Horn and Crescent: Cultural Change and Tradi-*

tional Islam on the East African Coast, 800–1900. Cambridge: Cambridge University Press.

Sacks, Karen. 1979. *Sisters and Wives: The Past and Future of Sexual Equality.* Westport, Conn.: Greenwood Press.

Scott, James. 1985. *Weapons of the Weak: Everyday Forms of Peasant Resistance.* New Haven: Yale University Press.

———. 1990. *Domination and the Arts of Resistance: Hidden Transcripts.* New Haven: Yale University Press.

Sholle, David. 1990. "Resistance: Pinning Down a Wandering Concept in Cultural Studies Discourse." *Journal of Urban and Cultural Studies* 1(1): 87–105.

Snyder, Francis. 1981. *Capitalism and Legal Change: An African Transformation.* New York: Academic Press.

Stamp, Patricia. 1991. "Burying Otieno: The Politics of Gender and Ethnicity in Kenya." *Signs* 16 (4): 808–45.

Starr, June. 1978. *Dispute and Settlement in Rural Turkey: An Ethnography of Law.* Leiden: E. J. Brill.

———. 1989. "The Role of Turkish Secular Law in Changing the Lives of Rural Muslim Women, 1950–1970." *Law and Society Review* 23(3): 497–523.

Starr, June, and Jane F. Collier, eds. 1989. *History and Power in the Study of Law: New Directions in Legal Anthropology.* Ithaca: Cornell University Press.

Strobel, Margaret. 1979. *Muslim Women in Mombasa, 1890–1975.* New Haven: Yale University Press.

Swartz, Marc J. 1979. "Religious Courts, Community, and Ethnicity among the Swahili of Mombasa: An Historical Study of Social Boundaries." *Africa* 49(1): 29–40.

Vincent, Joan. 1990. *Anthropology and Politics: Visions, Traditions, and Trends.* Tucson: University of Arizona Press.

Widner, Jennifer A. 1992. *The Rise of a Party-State in Kenya: From "Harambee!" to "Nyayo!"* Berkeley: University of California Press.

Willis, Paul. 1977. *Learning to Labor: How Working-Class Kids Get Working-Class Jobs.* New York: Columbia University Press.

Yngvesson, Barbara. 1993. *Virtuous Citizens, Disruptive Subjects: Order and Complaint in a New England Court.* New York: Routledge.

CHAPTER 9

WHEN EMPIRES MEET: EUROPEAN TRADE AND OTTOMAN LAW

June Starr

Several generations of historical sociologists have studied the modern
bureaucratic state within the Barrington Moore tradition, as portrayed
in Moore's classic book *The Social Origins of Dictatorship and Democ-
racy* (1966), a tradition which has been the starting point of my recent
work (Starr 1992).[1] Within this tradition, Theda Skocpol's *States and
Social Revolutions* (1979) extends both the liberal and the Marxist
conceptions of the nation-state.[2] Skocpol discusses the state as an arena
where different state institutions may fight over resources (1979:25).
Each bureau may have conflicting agendas, and even different sectors
and agents within a department of state may have agendas that are
directly opposed to those of other members of that department.
Moore's followers do not conceptualize "the state" as one conglomer-
ate, oppressive whole but consider significant oppositional units,
breaking state structures down into different bureaus, units, agencies,
and sometimes even individual agents, which are described within a
delineated time period. This suggests that in analyzing resistance to
nation-states, it may be necessary to differentiate and describe sepa-
rately several different units.

Secondly, within this framework the social organization of states
need be analyzed in terms of different strata and classes, not merely
as elites and commoners, or as rulers and the oppressed (see Moore
1966; Skocpol 1979; Starr 1992; Starr and Collier 1987, 1989a,
1989b). This more nuanced approach allows understanding of how
alliances and oppositions between elites and *some* segments of society
become driving forces within the state. Third, the state needs to be

viewed as a system for amassing and redistributing resources, which sometimes brings the state into conflict with its dominant elites or with its middle or working classes. Fourth, following Max Weber, nation-states need to be seen as fundamentally bureaucratic organizations "geared to maintain control of home territories and populations" (Skocpol 1979:22). Fifth, bureaucratic states are in competition with other nation-states either implicitly or explicitly. They may compete over territories, shipping lanes, or resources, but all compete in the international system for trade and commerce.

In discussing resistance to the state's hegemony, Gramsci argues that the proletariat needs to develop political strategies which undermine the consent to the practices of the ruling classes. The working classes need to build alternative proletarian hegemonies within existing civil societies. As instances in which groups succeeded in developing alternative ideologies, Gramsci cites the cotton workers' strike in Italy during the 1840s and the wars for independence of dominated colonies in Algeria, India, Tunisia, and Tonkinesia (Adamson 1980:59–60).

This paper suggests that the cross-cultural project for legal anthropologists is to study local initiatives and nation-state responses to them to see how, when, and where any of the various approaches to hegemony and resistance apply. It asks questions such as: To what extent are local events shaped by a state's ideology? How do widespread local practices influence and sometimes (often?) cause changes in the ways a state carries out its policies and even writes its laws? For example, Lawrence Friedman, a legal historian, advocates the view that local-level social practices and events sometimes call into existence a milieu in which national legal change needs to occur (Friedman 1985b:47–48). Many factors—widespread disregard of the law, or widespread changes in attitudes, or the introduction of roads or railroads—create social climates in which national law needs to adapt to changing circumstances; otherwise the state may collapse.[3] Therefore, cultural anthropology needs complex models of hegemony and resistance to provide a systematic way to compare how local responses to nation-state hegemony vary across cultures, societies, and time periods.

The place to begin, I believe, is with in-depth understandings of state structures. In proposing a different view of the nation-state, and what hegemonic domination and resistance might mean, this paper explores what happens when two hegemonic systems—the Ottomans and the Europeans—compete in international trade at the local level. Where would "resistance" to hegemony lie in this context, a context

in which different customs, different legal traditions, and different languages of trade and dispute resolution interact? Analyses of complex, *historically situated* practices of international trade illuminate the *variety* of local responses to the opportunity for trade. In this study of European trade in Asia Minor, only part of the complex analysis has any bearing on "resistance to" hegemonic structures.

Rural, localized notables (*ayan*s) appear in the Izmir region in the eighteenth century (Veinstein 1976:71). By the mid-nineteenth century, these notables had overturned the existing landholding system, thus subverting the state's control of land and agricultural production, the state's law, and the state's conceptions of landed property. The *ayan*s also worked for other changes in law and in rural administration. What they wanted and successfully obtained was the right to hold land as private property instead of being mere vassals in a huge state-owned agricultural system, and the right to pass on both their property in land and their accumulated wealth to their heirs instead of to the state. They also lobbied for a rural police force to keep the newly created landless, rural, labor force in line. Another issue quite important to productive agriculture was the *removal* of the obligation to provide a standing army unit from the local community. Later, in the 1860s, in addition to making the changes outlined above, the Ottoman central bureaucracy responded to local concerns through the empire by creating a *new* (and presumably uncorrupted) rural administrative system based not on Ottoman but on French models of rural administration.

This paper focuses on commercial interaction among European traders and Ottoman subjects in the nineteenth century in Izmir and its surrounding hinterland. It analyzes the ways changes in international trade shaped the other local-level institutions. Izmir had become the most important Ottoman port of trade by the late eighteenth and early nineteenth centuries (Frangakis 1988:261, 269; Frangakis-Syrett 1992:xi).[4] In this period, Izmir and the rest of Asia Minor were corporal parts of the Ottoman Empire, whose institutions of state were centralized in Istanbul.

The case study brings together three different kinds of scholarship usually pursued separately: Ottoman scholarship on agrarian relationships in Asia Minor and the regions surrounding Izmir, Ottoman scholarship concerning international trade in the port of Izmir, and European legal history concerning what is glossed among Ottoman scholars as "traders' law." The term "traders' law" refers to three things: first, to the customs and the procedures that became everyday practices in international trade; second, to the legal concepts used for judging trade

disputes; and third, to the ad hoc tribunals which were convened to settle commercial disputes themselves. In European legal scholarship, traders' law is referred to as the Law Merchant.

This case study of local influences on national legal change in the Ottoman Empire in the nineteenth century takes a different view of legal change from the one explored in my book *Law as Metaphor: From Islamic Courts to the Palace of Justice* (Starr 1992). In this paper the goal is to explain how complex social and trading relations in a *local area* created dispute settlement forms that greatly differed from those of the Islamic commercial law courts that were the official courts of the Ottoman state.

By demonstrating that local-level challenges to the hegemonic ideology of the Ottoman state mostly occurred, not through organized resistance, but through everyday ordinary practices performed by a certain stratum of the society in and around Izmir, this paper provides an alternative to other approaches to hegemony and resistance. The analysis shows that only the local landed gentry, the *ayan*s, presented any real resistance to the Ottoman state. To anticipate the full analysis, the viewpoint advocated here is that widespread social and legal practices created a legal culture[5] which led to social change in society and in law. In responding to challenges by the local gentry, the ruling elites had only three choices: acceptance, co-optation of the challengers, or suppression. Rather than fight the landed gentry, the ruling elites agreed to change the laws of landownership, inheritance, and rural administration. Thus, the ruling bureaucrats kept control of state structures of administration, even as the social and legal order was evolving in port cities throughout the empire. The case study of Izmir is presented in considerable detail to illustrate the theoretical model of local-level/nation-state relationships I am advancing.

ISLAMIC LAW, SECULAR LAW, AND TRADE

The Role of Islam and Islamic Law in the Ottoman Empire

For six centuries the Ottomans were almost constantly at war with the Christian West—first to impose Islam and then in its defense (Lewis 1966:13). This meant Islam left its mark on all institutions of state. For centuries the Ottoman Turks had identified themselves with Islam, submerged their identity in Islam, to a greater extent than perhaps any other Islamic people (ibid.:13).

The Ottoman Empire produced an all-embracing, hegemonic cul-

ture. In its glory in the sixteenth century, it embraced lands from Central Asia through Persia, Anatolia, Greece, and the Balkans, extending to the gates of Vienna. In the south it stretched through the Arabian peninsula, Cyprus, Malta, and all across North Africa. To the north, the Ottoman empire penetrated far into Central Asia. It was a multiethnic, multilinguistic, multireligious empire like the Arab-dominated Islamic empire it had replaced. Its institutions of state—its law and its state religion—were Sunni Islam. In the classical periods, Islam and state, law and religion, were not separate entities, but were interwoven (Von Grunebaum 1962).

Although the "popular Islam" of the rural people and the classical Islam of the ruling elites differed during Ottoman times, Islam itself formed a common bond between these groups (Mardin 1971:201–6). At the very heart of Islam was Islamic law. Traditionally, "the Islamic view . . . [did] not regard religion and law as separate entities" (ibid.:144). Muslims defined jurisprudence as "the knowledge of the practical rules of religion" (ibid.). Historically, Islam was both a system of religious belief and practice and a "system of state, society, law, thought, and art—a civilization with religion as its unifying, and eventually dominating factor" (Lewis 1960:133). Its holy law, the Şeriat, was developed by jurists from the Qu'ran and the traditions and sayings of the prophet Muhammad (Starr 1989:497). The holy Şeriat governed all commercial disputes. When Muslims engaged in trade and disputes arose from trade, these disputes were governed by Islamic legal rules and would be settled in Islamic courts. No matter if trade disputes arose in town or in the countryside, commercial disputes between Muslims were to be settled by *Kadi* courts (Islamic courts). Over the centuries Islamic law had expanded and become refined to cover almost any of life's situations. A hierarchy of Islamic clergy and Islamic courts existed throughout all Ottoman domains in which Muslims of any Islamic sect could settle their commercial disputes.

International Treaties: The Capitulations

Islamic commercial law was in fact older than European commercial law, which evolved from the early Middle Ages. Arabs had dominated Mediterranean trade from the ninth century. With the first Crusade in the eleventh century, the new European contact with the East led to a renewed intensity in international trade. Islamic trading networks stretched across the broad belt of lands lying between Arabia and the Black Sea that in the ancient world had been the great staging area for trade between the East and the western Mediterranean countries

(Bewes 1923:2–3). Thus, the Arabs' greater experience in long-distance trade meant that their concepts and norms of trade greatly influenced the development of European commercial law.

In the early medieval period, European diplomats visited the Arab sultans to make treaties governing trade and the status of European merchants and diplomats within the Arab Islamic empire. These Europeans won a series of rights that would be renewed each time a new sultan ascended the throne. The practice continued even in later periods when the Ottomans dominated the Islamic world and the sultan came from Ottoman not Arab ruling families. Similar to Arab treaties, the international treaties between Europeans and Ottoman sultans governed both trade and the status of European traders in the Ottoman Empire (Inalcik 1986).[6]

Trading privileges granted to the Europeans by treaty included: general security of persons and property; freedom of worship, burial, and dress (Inalcik 1986:1179); the right to repair ships in Islamic ports, to get emergency rations, and to obtain aid against attack by corsairs; and the abolition of the *lex naufragii*, the law of ships wrecked at sea. The early treaties granted Europeans the right to address complaints to the head of the Muslim community. Extraterritorial rights were also granted, which included the right to establish a consulate which had jurisdiction over its own nationals; the right for the head of the consulate, the consul, to be given a salary which was untaxed by the Islamic authorities; and that collective responsibility (i.e., a situation of feud) not prevail against foreign nationals who had a consulate within an Islamic jurisdiction.

Thus, governed by treaty, a customary international law developed between the sovereign Christian states and the Islamic Ottoman Empire. The treaties were signed between heads of states, but did not list the laws underlying international trade. Local norms developed in port cities on the Mediterranean and in the great European fairs that were held along permanent trade routes from the twelfth to the sixteenth century (Walker 1980:727). As time went on, and English common law began to influence the international customary law of trade, it became known to European scholars as the Law Merchant. Thus, European traders law, which had been the lingua franca of trade in the Mediterranean, the Baltic, and within the Hanseatic League of cities, became the customary law and norms for trade of Europeans who traded with the Islamic world. In effect, by the nineteenth century, Ottoman merchants in ports and market towns were interacting with Europeans in the same way earlier Ottoman merchant traders had, and trade was governed by traders law.

Trading Licenses: Foreigners

European traders carried documents which had come to resemble licenses by the beginning of the nineteenth century (Inalcik 1986). These licenses stipulated the place where the bearer must go to have a trading dispute heard. Before the licenses, European traders in dispute had recourse only to their own consul, who resided in the trading port, or to the major administrative bureau of the ruling Islamic elites, the *Porte* in Istanbul (Inalcik 1986:1180). By 1800–1801, however, the licenses permitted recourse to ad hoc traders tribunals (Mardin 1961:189–91), which had become customary tribunals of trade under the Law Merchant.

Serif Mardin's unique study (1961) of nineteenth-century European traders licenses in Istanbul is relevant to this analysis, because the same system would have existed in Izmir, and to date no Ottoman scholar has studied Izmiri trading licenses. The earliest known licenses to trade (*berats*), given under treaty, have been dated to the eighteenth century (Mardin 1961:189). A *berat* initially was granted only to Europeans. In regard to commercial cases, European license holders (*Avrupa Tüccai*) were also exempt from the jurisdiction of the Islamic courts.

The licenses that European merchants purchased allowed them to import and export goods for a low customs fee which did not exceed 3 or 5 percent. Each license further specified the place where disputes between Europeans and between European and Islamic merchants would be heard (Mardin 1961:190–91). One type of license, issued in Istanbul, referred the disputants to the central Ottoman government at the *Porte* in Istanbul. Another type of license stated that commercial disputes would be settled by an employee of the Ministry of Commerce. A third type of license arranged for lay judges to be selected by the Ottoman minister of commerce with the help of the counselor of the city's markets (the *Şeybender*) and his assistants, and by the parties to the dispute. The tribunals in question here consisted of lay judges who were familiar with the norms of trade, but were untrained in Islamic law. When imprisonment was a possible punishment, licenses issued in Istanbul stated that the defendant was to be held in jail in the Istanbul commerce building. The law to be used in these disputes would be "traders' law," (called *Kaide-i Tüccar* in Ottoman Turkish).

Trading Licenses: Ottoman Subjects

By the nineteenth century Muslim traders claimed they were at a disadvantage because they lacked the privileges and reduced customs fees granted to European license holders, as well as access to the ad

hoc merchants courts. They sought access to these traders tribunals, because these lay courts were known for the simplicity of the well-known legal rules and for the dispatch of the decision-making processes.

The right to purchase a license was later extended to non-Muslim Ottoman subjects (the *Raya* merchants), who previously only could purchase a license from a European consulate and trade under its protection and discipline (Frangakis 1985:35). And by 1810 even Muslim Ottoman merchants (*Hayriye Tуccai*) were granted the right to purchase licenses directly from the Ottoman bureaucracy (Mardin 1961:190).

Lay Tribunals for Trade

Lay tribunals of trade were clearly in evidence in the Ottoman empire by the beginning of the nineteenth century. These tribunals were ad hoc "mixed panels" of lay judges. The term "mixed" refers to the multiethnic and the multireligious composition of the tribunal which included Ottoman, Christian, and foreign nationals. These were not recognized as official courts of the land. They were ad hoc forums convened under the traders licenses when a problem arose and used the customary international law of trade, the Law Merchant. Traders tribunals were not governed by the Islamic law of commerce that held sway in Islamic courts; nor was the Law Merchant employed in Islamic courts; the two systems were at variance with each other on some points of law.

By 1810 Muslim traders had more choices of commercial dispute-resolving forums than European traders did. A Muslim trader could bring his dispute with another Muslim trader to an Islamic court. In Istanbul the judge with jurisdiction was the mufti of public utility who held court in the Ministry of Commerce. A Muslim in any dispute could lodge an appeal with the *Seyhülislâm* (the leader of the Islamic community) (Mardin 1961). After Muslim traders gained the right to buy trading licenses, any Muslim trader could opt to have a dispute heard in the traders court by secular law, the Law Merchant.

The Law of Lay Trading Tribunals

The Law Merchant refers to the habitual customs, practices, and rules of law used by merchants in the conduct of trade and commerce.[7] It was a customary system for local and international trade that defined reasonable commercial standards (Trakman 1983:18).[8]

The practices and legal concepts pertained to contracts, sales, part-

nerships, limited partnerships, unpaid vendors, mercantile agents, pre-scription,[9] interest, bankruptcy, accounts of husbands and wives, bills of exchange and lading, transport by land or sea, insurance, credit and debt, jettisoning cargo at sea, double-entry bookkeeping, and the commitment to honor promises. Good faith and trust were the essence of a contract between merchants. A contract was based on a promise and the giving of "earnest money." In England the symbol of reaching an agreement was a hand shake (Pollock and Maitland 1895:186).

An essential element of the practices of international trade was that disputes should be settled quickly by members of the trade who were cognizant of local rules of trade. Although practices differed from place to place, in every locale where international trade occurred there was general acceptance of the forms and substance of the informal rules of international trade (Walker 1980:726–27).[10]

INTERNATIONAL TRADE SHAPES THE LOCAL CONTEXT: THE CASE OF IZMIR

Izmir's population was 100,000 people in the eighteenth and beginning of the nineteenth centuries (Frangakis 1985:27). It would have grown considerably larger if there had not been annual outbreaks of the plague. Other calamities also haunted Izmir, such as devastating earth-quakes and the wide-ranging fires which followed in their wake (ibid.:30).

The demand of Europeans for the raw materials of the Ottoman empire brought European merchants to establish mercantile communi-ties in Izmir beginning in the early seventeenth century. French, British (Field 1885:30), Dutch, and later Austrians (Kasaba 1988:19) had settled there with their families, forming communities of foreigners (Frangakis 1985:29, 32).[11] Each European neighborhood was repre-sented by a consul under a written decree from the sultan (Inalcik 1986:1180).

The governance of Europeans and non-Muslim Ottoman subjects within the empire was different from the system of governing Muslim subjects. Each non-Muslim group, called *raya* in Ottoman Turkish, was allowed to govern itself as long as members of its sect paid taxes to the state. Taxes differed for each status group. *Raya*s were non-Muslims possessing sacred texts, for example, Christians, Armenians, and Jews. Each group was allowed to live in its own denominational group and to practice self-governance, but they paid higher taxes than Muslims did. In disputes with Muslims they were subject to the Islamic courts. Exceptions were the European merchants trading and often

living within the empire who were under the *berati* system, the system of trade licensing described above.

Of non-Muslims in Izmir, the Greeks, Armenians, and Jews had extensive ties to Ottoman producers. The Armenians controlled the caravan trade that linked Izmir to points east (Frangakis 1985:30). The Greeks, Armenians, and Jews became the intermediaries between foreign merchants and both the Ottoman food producers and the caravan traders, linking Izmir to interior Anatolian areas and to the silk road via Aleppo (Frangakis 1985:33). By the early eighteenth century, the Jews had become Ottoman subjects and throughout the century were active economically, sometimes rivaling the Europeans in trade (Frangakis 1985:30). Some Jewish families had entered Asia Minor before the eighteenth century, coming from Spain and Portugal, and had migrated within the empire to Ankara, Crete, Corfu, and Yanina (ibid.:30). In eighteenth-century Izmir the Turks outnumbered the Greeks, but this was reversed in the nineteenth century (Frangakis 1985:29). Not surprisingly, Izmir was the most cosmopolitan city in the Levant in the eighteenth century. It was called *gavur* Izmir (infidel Izmir) because of the prominence of the Christians.

Like other Islamic cities, Izmir was divided into separate quarters. The Europeans lived along a fifteen-foot-wide street, Frank Street, that extended nearly half the length of the city (Frangakis 1985:29). Their quarter was next to the market and the caravan inn, in the economic center of the city. Neighboring them were the Greek and Armenian quarters. The Turkish quarter was in the highest part of the city around the citadel and away from the bazaar. The Jewish quarter abutted the Turkish quarter and the Jewish cemetery. Just outside the city, the cemetery was considered an important landmark at that time, indicating the high status of the Jewish community in the city (ibid.:29).

The cosmopolitan nature of Izmir and the general religious tolerance of the Ottoman Empire toward *raya*s in that period, is evident in the existence in Izmir of nineteen Turkish mosques, two large Greek churches, one Armenian church, and eight Jewish synagogues. The Europeans had three convents. Yet social activities between the Europeans and the *raya* communities rarely occurred. The vital link between them was commerce, although the Greeks had much more social interaction with the European traders than did the other communities.

The Social Organization of Trade in Nineteenth-Century Izmir

Greeks, Jews, and Armenians were engaged in different spheres of trade. Armenians controlled the caravan trade, meeting the caravans

as they entered the city and sending caravans loaded with goods (such as European cloth) from the city's market to points further east. They had the "monopoly" for provisioning Izmir's market with silk, goat's wool, and other goods from Iran, after "capturing" the silk trade from Aleppo (Frangakis-Syrett 1988:1). Armenians also controlled a "considerable share" of the trade with Ottoman cities to the east— Erzerum, Tokat, Sivas, Diyarbakir, Kayseri, Antalya, and Ankara (Frangakis 1985:30–31). Later, as the caravan trade diminished due to British penetration of the interior trade routes in the mid-nineteenth century, Armenians became the agents and secretaries of the Turkish landowners both in the city and in the surrounding countryside (ibid.:31), where cotton, wheat, and figs were cash crops. A few Armenians of lesser wealth were the shopkeepers in the silk and cloth trade.

The Jewish merchants were involved in the trade between the cities of Izmir and Bursa. The Jews were "the brokers and money-lenders par excellence of Smyrna" (Frangakis 1985:31). Jews were the middlemen in all commerce in Izmir, forging links between European merchants and other ethnic groups. One Frenchman reported in his memoir that it was simply "not possible to negotiate with a Turk, Greek or European without dealing with the Jewish agent who was exclusively attached to the manor house" (Fourcade, quoted in Frangakis 1985:31). Jews managed the retail trade of imported coffee, indigo, and pepper. They carried silk from Bursa, cotton from Manisa, and chevron wool, wax, and galls and prepared and cleaned items for export (Peyssonel, quoted in Frangakis 1985:31).

The Muslim Turks were the primary rivals of the Armenians for the inland trade with the rest of the empire to the east (Frangakis 1985:30–33). When the British penetrated the Anatolian interior early in the nineteenth century and began supplying Iran with cloth from Basra (an inland Ottoman city), they undercut and diminished the number of Armenian caravans arriving at Izmir each week (ibid.:31).

But by then the Armenians had found a new niche in the social structure of commerce. They had become the agents and secretaries of the Ottoman Turks who were acquiring freehold land as private property and entering commercial agriculture. Sometimes an Armenian agent might lend the landowner money, but the Armenians never rivaled the Jewish merchants in providing informal banking services. Money always was scarce in the eighteenth- and nineteenth-century Ottoman empire, and banking was informal until 1840 when the first Ottoman national bank was established through an imperial order (Lewis 1966:109).[12]

Under Islamic law, usury was unallowable, but lending money at

interest was not forbidden under the religions of the Greeks, Armenians, and Jews. Jewish merchants were most involved in "negotiated loans." The Greeks were the usual tax collectors, collecting money from other *raya* communities for the state. Greeks also inspected import/export ships for a clean or foul "certificate of health" (inspection for the plague, typhoid fever, etc.), certified that the city was free or not of the plague, and controlled the wholesale and retail trade in cloth of all qualities (Lewis 1966:31–32).[13] Both before and after European penetration, it was usually Greeks who went inland, acting as agents for European firms and selling European-manufactured cloth— wool, cotton, linen, silk, and gold braiding (Frangakis 1985:32).

Despite the importance of the *raya* communities, the Europeans dominated international trade with Europe (Frangakis-Syrett 1988:3), in part because Muslim merchants were forbidden by European laws to live in central European cities. In contrast, European traders had family members or agents resident in all the principal ports of the empire: Izmir, Istanbul, Salonika, Cairo, Alexandria, and Alexandretta (the port of Aleppo).

The Dutch were the first to allow Ottoman *raya* merchants to trade directly with their country and to establish their own commercial houses in Dutch ports (Frangakis-Syrett 1988:7). Within the empire, too, *raya* merchants were at a disadvantage compared to Europeans because of the preferential treatment and lower customs fees which European merchants were granted under the *berat*s, discussed earlier. At all times a few *raya* merchants could purchase a *berat* from a European power, and could trade under the protection of a European nation. This entitled them to the same discounts as European *berati* holders. This protection was extended in 1810 by the Ottoman government to the Ottoman merchants for a fee.

Çifthane and Çiftlik Agriculture

An eminent historian of the Ottoman Empire has suggested that even as early as the eighteenth century changes were taking place under the impact of Europe in certain coastal areas of the Ottoman empire, changes which ultimately led to the reorganization of agrarian production into "big farms" (Inalcik 1984:125).[14] By the nineteenth century, these farms produced cotton, rice, and wheat for French, Dutch, and later Austrian markets (Inalcik 1984:120 n. 33, 124–26). Wills from this period indicate that Ottoman Turks were amassing fortunes in the export trade, and that the plantationlike "big farms" of the era were indeed owned by Turks (Nagata 1976) rather than by English-

or Frenchmen, as was occurring in the West Indies and later in Africa. Rural Ottomans who amassed family fortunes did so as governors of provinces, as plantation owners, as middlemen in the trade between European merchants and Turkish producers, or through usury or tax farming (Inalcik 1984:124; Veinstein 1976).

The change in agricultural production can best be illustrated by contrasting the new big farms with the previous household farms. The household, or *çifthane*, farms were part of the early structure of the Ottoman tax-farming system. Each *çifthane* was inhabited by a man, his wife, and his unmarried children, and perhaps a widowed parent. The law guaranteed the peasant a perpetual lease that amounted to actual possession of land by the tiller of the soil. The state saw to it through its agents that the parties did not alter the original status of the land, or the relationship of the peasant household to the land. The peasant household head was given a plot of land (called a *çift*) sufficient to sustain one peasant household and to pay the rent as a tax to the state (Inalcik 1984:106). In earlier times in Asia Minor the *çifthane* system had been a moderate and conservative social and economic structure. Peasants were charged low rent and relatively few services were demanded of them. The *çifthane* system was an integral part of the *timar* system that had been the basic military institution in the classical period of the Ottoman Empire, in the sixteenth century. *Timars* were indivisible and unalterable units recorded in the survey books, and the *Çifthane* units were similarly indivisible and unalterable to protect the state's fixed tax-farming income. State control of the *timar* and of the *çifthane* system was one of the reasons why the organization of Ottoman agricultural production stagnated (Inalcik 1984:107).

The European demand for raw materials and produce stimulated in Izmir and its vicinity the growth of market-oriented agriculture by Ottoman entrepreneurs. This emerging class of rural notables used land reclaimed from coastal marshes, or subverted state-owned land from the old tax-farming system which they registered in their own names, or purchased land at state-run auctions. Land auctions by the Ottoman government became more common because the Ottoman state needed capital. But in auctioning off land around Izmir to private bidders, the state was forced to allow these purchasers to hold land as freehold (i.e., private) property, and to allow land title holders to pass agricultural land to their heirs at death.

Unlike the *çifthane* system, the *çiftlik* system of agriculture represented a new productive system in plantationlike farms which developed in response to the demands of the European market. Some of

the titleholders of tax-farming lands managed to get these estates into full legal freehold status, alienable and inheritable, according to the *Şeriat* laws governing freehold property (see Tute 1927:1, 47). Land auctions had become even more frequent, and purchasers were steadily able to extend and confirm their ownership. Finally, in the nineteenth century there was an expansion of land reclamation and improvement of marginal lands, especially in the pastoral and flooded lowlands (Inalcik 1984:116). Changes in the law concerning land titles during the reform period of 1839–1876 increased the value of such titles, which over time became true freehold title deeds (Lewis 1966:443).

A nineteenth-century traveler gives this description of the big farms: "a *çiftlik* was composed of a manor where the landlord or his agent resided, a number of huts for quartering laborers, a stone tower for defense against rival *ayan*s (a new indispensable element), the stalls for animals, storehouses, a bakery, and a smithy. The plantation-like *çiftlik* consisted of a whole village, or one might say that the big farm was, as a rule a *çiftlik*-village" (Inalcik 1984:115). This big-farm system arose next to a state-owned, tax-farming system which encompassed small peasant farms. The new landowners, the *ayan*s, charged the peasants excessive rents and exacted extensive services from them (Stoianovitch 1953). These new burdens on the peasantry made the Turkish peasant as oppressed as any European peasant or Russian serf.

Izmir Trade, Elites, and Legal Change

In the Ottoman central government, the statesmen of the translation office and the embassy drafted the important reformist proclamation of 1839, known as the *Hatt-i Humayun*, which set the agenda for change for the next thirty years. Of all government officials, these statesmen had the most contact with European embassies, ambassadors, diplomats, and travelers. Their exposure to new ideas and their knowledge of foreign languages made them receptive to reform. In the next year, 1840, they successfully urged the sultan to extend official recognition to the traders tribunal in Istanbul (Starr 1992:22–27).

The extension of official recognition beyond the port of Istanbul to existing, informal, secular "mixed traders' tribunals" occurred in 1847. At that time every trading port and international market throughout the Ottoman domains was officially ordered to create "mixed traders' tribunals" using traders' secular law. These same reformist elites also were interested in promoting an Ottoman commercial code to replace Islamic commercial law. This new Ottoman commercial code would be based on French models.

Official recognition and formalization of the previously ad hoc secular traders tribunals was brought about by a number of forces. First, customs levies on import/export trade provided the most important source of revenues for the Ottoman government during this period. Second, there was external pressure from the English and French ambassadors, who were interested in expanding the protection of their Christian subjects. Third, there was internal pressure from national and local elites involved in export agriculture and trade. They wanted more freedom, new laws, and a new rural police force to keep the agrarian workers in line.

The *Hatt-i* instituted some of these reforms. It affirmed that is was illegal to confiscate the property of non-Muslim Ottoman subjects. It stated that henceforth criminal trials would be public and in accord with recognized procedures. It affirmed that adequate salaries would be paid to provincial officials to eliminate the temptations of bribery, and that a new penal code would be drawn up which would apply to all Islamic clergy, ministers of state, and other civil servants.

Therefore, the lively trade relations occurring in Izmiri markets and rural manor houses in Izmir's hinterlands shaped the social context of everyday norms and practices of trade, including the ways disputes were resolved between European merchants and Ottoman farmers and tradesmen. The Europeans had the money and the bills of exchange drawn on European currency so needed by the Ottomans. In this prospering market nexus, the norms and rules of trade were European, based on traders' law, the Law Merchant.

CONCLUSION: RESISTANCE TO HEGEMONY?

The thriving international market at Izmir created a context in which enterprising land title holders found ways to circumvent existing state rules and institutions in order to reap large profits. Their reorganization of peasant farms into "big farms" allowed the production of a considerable surplus for export. This marked a change from the earlier state-owned land system where peasants had continual rights in land. In this new agrarian system the previous plantation *managers* became plantation *owners* and the peasants had hardly any rights at all. The Ottoman government tolerated the growth in power of the rural notables for several reasons. First, Ottoman troops were occupied elsewhere putting down violent rebellions in the empire and could not be deployed to crush the lawbreakers and land usurpers in western Anatolia.[15] Second, this new productive system brought needed cash into the

empire through state land sales to the notables, and through state taxes on imports and exports.

As the rural notables gained strength, they became a social stratum with special features of their own. This new agrarian social stratum, represented, first, by the *ayan*s and later by a variety of entrepreneurial farming and commercial groups demanded, in the nineteenth century, a rational legal system capable of meeting the needs of the increasingly differentiated system in which they acted (Starr 1992:51). They called for a new land-recording system, a rural police force, and an uncorrupted rural administrative system. At this time Muslim traders were demanding licenses similar to those given European traders, and the European traders in the empire wanted expanded traders tribunals. Would the central bureaucracy accede to all these demands?

Hegemonic systems can respond in a variety of ways to local corruption, violence, mayhem, and resistance. They can ignore it, hoping the problems will go away. They can reward one stratum of the local population at the expense of others, hoping to gain the loyalty of the rewarded group who will use sanctions or force against resisters. Or the central state can send in troops to use force to put down dissent. Adaptation, co-optation, and suppression are the more general categories under which these responses can be grouped.

A complex analysis must take account of the fact that while change and resistance are occurring at a local level, the central state bureaucracy is also responding at a local level, the central state bureaucracy is also responding to *other* changing local, national, and international circumstances. In addition, as new groups gain power, national law evolves.

Ottoman secular commercial courts followed in the wake of international trading relations; they did not arise because one hegemonic system, the Islamic Ottoman Empire, was subverted by another, that of the Christian Europeans and their capitalistic economy. Secular commercial courts sprung up because of the flourishing commercial market in Izmir and its environs, which occurred as Asia Minor was incorporated into the world capitalist system (Wallerstein 1980). As agrarian and commercial relationships were being transformed in Izmir and its hinterlands, a new class of national administrators arose in the Ottoman central bureaucracy who were more secular and more future oriented. In the 1840s and 1850s, as the reformist elements in the ruling elites gained power, most of the central government recognized that the Ottoman tax-farming system was in shambles. Many among the reformist elite had studied or traveled in France and had been

impressed with the system of private farming in the French countryside, a productive system they viewed as worth emulating.

In these decades, 1840–1860, many localized ethnic and religious groups throughout the empire were in revolt to gain more rights; this created additional pressures on the empire. Meanwhile, the productive region of Izmir promised stability, if the landholding and commercial strata were given institutional support.

What was occurring in and around the port of Izmir was not armed resistance to institutions of state. Nor did locals of any stratum use guerilla or sniper tactics. However, the emergence of the big farms created a new stratum of landless laborers, quite recently dispossessed of family farms to which they had had entitlement rights under the older state tax-farming system. This stratum of erstwhile tenant farmers now were little better than Russian serfs, and they felt more oppressed than ever as Turkish folk songs from this period attest.

In the commercial sector of agriculture and international trade, a variety of extralegal, ad hoc norms, and lawlike but illegal practices had developed. A new outlook forced on the central bureaucracy because of rebellions elsewhere (Napoleon invaded Egypt in 1798 and the Russians invaded Anatolia in 1877, and the Greeks rebelled in 1821), and the state's continuing need for cash, led reformist elites to expediently recognize and legitimate existing local practices and demands. Thus, reformist Ottoman officials changed the law to bring it into conformity with the prevailing social reality.

I have attempted in this paper to give a complex view of the bureaucratic state, and to define resistance to state hegemony as consisting of conscious actions on the part of groups. Following Gramsci, I suggest that resistance to hegemony involves a conscious choice on the part of each individual to partake in activities of resistance. My perspective also holds that the goal of resistance must be in behalf of a cause larger than one self or one's family.

Legal change does not occur in a vacuum. It is grounded in social and legal realities. Over time, a segment of a nation's bureaucrats, pursuing their own objectives for the state, may take these realities as national priorities for change. Thus, in the Ottoman Empire, certain reformist elites within the central bureaucracy saw opportunities for increasing their power and saving the empire at the same time. They wrote into law changes advocated by a newly emergent landholding and merchant stratum.

Between social change and legal change stands legal culture. When a legal culture such as the one I have described here has widespread

usage and reflects human beings' needs, then the national law must change.

Notes

1. I would like to thank Avner Grief of Stanford University, Department of Economics for his extensive references to the Law Merchant, and Tom Grey and Jim Whitman of Stanford Law School for comments on various versions of my work on traders law and social structural change in Izmir and Anatolia.

2. Although they acknowledge that Foucault has brilliant insights, they are critical of Foucault's methods. Foucault's use of history takes things out of context to provide evidence for his theories, and he sometimes mixes up historical sequences.

3. See, for example, *History of American Law* (Friedman 1985a:341) for an explanation of how the expansion of the railroad across America influenced property relations and the growth of small towns; or how state legislatures' response to the widespread occurrence of widows as heads of family farms led to new laws concerning the widow's share of the homestead so that property could once more be bought and sold.

4. Toward the end of the eighteenth century, the Ottomans lost exclusive control of the Black Sea to the Russians. This sharing of Black Sea trade routes meant that Istanbul was gradually reduced from a major center of trade to a mere port of call. Istanbul's decline allowed Izmir's ascendancy (Frangakis 1988:261, 269).

5. In fact, there are multiple legal cultures.

6. This and the following material concerning the capitulations comes from Inalcik (1986).

7. For a fuller discussion of the sources, legal rules, and context of the Law Merchant, see Bewes (1923), Malynes (1986), and Trakman (1980, 1983).

8. The Law Merchant had multiple sites of origin and varied from place to place. Some scholars trace it back to the Arab trade caravans or to Maghribi traders of North Africa in the eleventh century (Grief 1989:860). Others suggest that before the Arab traders were Greek traders. Before them, were the Phoenician trading settlements in ancient Greece (Bewes 1923:2). Some of the *Law Merchant* originated in the great fairs of the Middle Ages (ibid.:93), which flourished from the twelfth to the sixteenth centuries. Certain ideas from Roman law were contributed by the Italian merchants in the Middle Ages (ibid.:1), and trade with Britain meant that some common-law ideas entered the customary law of international trade as well. The Law Merchant has been identified with the Hanseatic League (Lopez 1991:114–19) and Islamic port cities, and for at least three centuries has been studied by European and common-law historians.

9. "Prescription" is a legal concept which bars court action when a creditor has been silent for a specified length of time without urging his claim. Under the Law Merchant there was no right to acquire a thing by mere possession, however long it was in a nonowner's keeping.

10. In Italian port cities and in some ports of the Hanseatic League, by the

fifteenth century the rules of trade had become codified as the official law of the ports.

11. Frangakis (1985) doesn't mention the Austrians, whom Kasaba ranks as second only to the French during the same period. See Kasaba 1988:19–20.

12. The rich men who "farmed the customs" in Izmir were either Jews or Ottoman Turks. For example, the Sidi brothers at the end of the eighteenth century were brokers for the powerful Dutch commercial house of Richard van Lennep, while a third brother was a "hare skin merchant" (Frangakis 1985:31).

13. Cloth was the most important import into Izmir from Western Europe. By the end of the nineteenth century Greeks (and particularly those from the island of Chios) were distributing cloth to all the cities of Anatolia (Frangakis 1985:31–32).

14. This system of big farms had been known as early as the eighteenth century in Ottoman territories in the Balkan states, which were the first to export to Europe (Stoianovitch 1953). For information on "big farms," see generally Inalcik (1984), McGowan (1981:1–44), Nagata (1976), Rahman and Nagata (1977), and Veinstein (1976).

15. See Inalcik (1984), McGowan (1981:171–72), Veinstein (1976), and Wallerstein (1980).

References

Adamson, Walter. 1980. *Hegemony and Revolution. A Study of Antonio Gramsci's Political and Cultural Theory.* Berkeley: University of California Press.

Bewes, Wyndham A. 1923. *The Romance of the Law Merchant.* London: Sweet and Maxwell.

Femia, Joseph V. 1981. *Gramsci's Political Thought: Hegemony, Consciousness, and the Revolutionary Process.* Oxford: Clarendon Press.

Field, Henry. [1885]. *The Greek Islands and Turkey after the War.* London: Sampson, Law, Marston, Searle, and Rivington.

Foucault, Michel. 1977. *Discipline and Punish: The Birth of the Prison.* Alan Sheridan, trans. Harmondsworth, Eng.: Penguin Books.

Fourcade. 1920. *Mémoire sur le commerce de Smyrne.* [Archives Nationales de France, Affaires Etrangères Série; sous-série Bi.] Paris.

Frangakis, Elena. 1985. "The *Raya* Communities of Smyrna in the Eighteenth Century (1690–1820). Demography and Economic Activities." In *Actes du Colloque International d'Histoire: La Ville néohellénique, Héritages ottomans et état grec.* Athens. Centre for Asia Minor Studies 1:27–42.

———. 1988. "The Port of Smyrna in the Nineteenth Century." In *War and Society in East Central Europe.* Vol. 23 of *Southeast European Maritime Commerce and Naval Policies from the Mid-Eighteenth Century to 1914.* Social Science Monographs. Boulder, Colo.: University of Colorado Press. 261–72.

Frangakis-Syrett, Elena. 1988. "Trade between the Ottoman Empire and Western Europe: The Case of Izmir in the Eighteenth Century." *New Perspectives on Turkey* 2 (1): 1–18.

————. 1992. *The Commerce of Smyrna in the Eighteenth Century (1700–1820)*. Athens: Centre for Asia Minor Studies.

Friedman, Lawrence M. 1985a. *A History of American Law*. New York: Simon and Schuster.

————. 1985b. *The Legal System: A Social Science Perspective*. New York: Russell Sage Foundation.

Gramsci, Antonio. 1977. *Selections from the Prison Notebooks of Antonio Gramsci*. Trans. Quintin Hoare and G. Nowell Smith. New York: New York International Publishers.

Grief, Avner. 1989. "Reputations and Coalitions in Medieval Trade: Evidence on the Maghribi Traders." *Journal of Economic History* 49 (4) :857–82.

Inalcik, Halil. 1984. "The Emergence of Big Farms, Çiftliks: State, Landlords, and Tenants." In *Collection Turcica III: Contributions à l'histoire économique et sociale de l'Empire Ottoman*, ed. J. L. Bacque-Grammont and P. Dumont. Leuven, France: Editions Peeters. 105–26.

————. 1986. "Imtiyazat [Foreigners]." *Encyclopedia of Islam*. New ed. 6:1179–89.

Kasaba, Resat. 1988. *The Ottoman Empire and the World Economy: The Nineteenth Century*. Albany: SUNY Press.

Lewis, Bernard. 1960. *The Arabs in History*. 2d ed. New York: Harper and Row.

————. 1966. *The Emergence of Modern Turkey*. London: Oxford University Press.

Lopez, Robert S. 1991. *The Commercial Revolution of the Middle Ages, 950–1350*. Englewood Cliffs, N.J.: Prentice-Hall.

Malynes, Gerald. 1986. *Consuetudo, vel. Lex Mercatoria. [The Ancient Law Merchant.]* London: George [Press].

Mardin, Serif. 1961. "Some Explanatory Notes on the Origin of the Mecelle (Medjelle)." *Muslim World* 51:189–96, 274–79.

————. 1971. "Ideology and Religion in the Turkish Revolution." *International Journal of Middle East Studies* 2:197–211.

McGowan, Bruce. 1981. *Economic Life in Ottoman Europe: Taxation, Trade, and the Struggle for Land, 1600–1800*. Cambridge: Cambridge University Press.

Mitchell, W. 1904. *Essay on the Early History of the Law Merchant*. New York: Franklin.

Moore, Barrington, Jr. 1966. *The Social Origins of Dictatorship and Democracy. Lord and Peasant in the Making of the Modern World*. Boston: Beacon Press.

Nagata, Yuzo. 1976. "Some Documents on the Big Farms (Çiftliks) of the Notables in Western Anatolia." Tokyo: Institute for the Study of Language and Culture of Asia and Africa. *Study Culturae Islamicae*. No. 4:105–26.

Peyssonel. 1751. *Mémoire* [of the French Consul]. Paris.

Pollock, Sir Frederick, and Frederick William Maitland. 1895. *The History of the English Law before the Time of Edward I*. Vol. 2. Cambridge: Cambridge University Press.

Rahman, A. Abdul, and Yuzo Nagata. 1977. "The Iltizam System in Egypt

and Turkey." *Journal of Asian and African Studies* [Tokyo] 14:169–94.

Schacht, Joseph. 1964. *An Introduction to Islamic Law.* Oxford: Clarendon Press.

Scott, James C. 1985. *Weapons of the Weak: Everyday Forms of Peasant Resistance.* New Haven: Yale University Press.

———. 1990. *Domination and the Arts of Resistance: Hidden Transcripts.* New Haven: Yale University Press.

Skocpol, Theda. 1979. *States and Social Revolutions: A Comparative Analysis of France, Russia, and China.* Cambridge: Harvard University Press.

Starr, June. 1989. "The Role of Turkish Secular Law in Changing the Lives of Rural Muslim Women, 1950–1970." *Law and Society Review* 23 (3): 497–523.

———. 1992. *Law as Metaphor: From Islamic Courts to the Palace of Justice.* Albany: SUNY Press.

Starr, June, and Jane F. Collier. 1987. "Historical Studies of Legal Change." *Current Anthropology* 28(3): 367–72.

———. 1989a. "Dialogues in Legal Anthropology." In *History and Power in the Study of Law: New Directions in Legal Anthropology.* Ithaca: Cornell University Press. 1–30.

———. eds. 1989b. *History and Power in the Study of Law: New Directions in Legal Anthropology.* Ithaca: Cornell University Press.

Stovianovitch, T. 1953. "Land and Tenure and Related Sectors of the Balkan Economy." *Journal of Economic History* 13(4): 398–411.

Trakman, Leon. 1980. "The Evolution of the Law Merchant: Our Commercial Heritage. Part 1 of Ancient and Medieval Law Merchant." *Journal of Maritime Law and Commerce* 12 1: 1–24.

———. 1983. *The Law Merchant: The Evolution of Commercial Law.* Littleton, Co: Fred B. Rothman and Co.

Tute, Sir Richard C. 1927. *The Ottoman Land Laws. With a Commentary on the Ottoman Land Code of the Seventh Ramadan 1274.* [Jerusalem]: n.p.

Veinstein, Gilles. 1976. "Ayan de la région d'Izmir et commerce du Levant (deuxième moitié du XVIIIe siècle)." *Etudes Balkaniques* 12:71–83.

Von Grunebaum, E. 1962. *Medieval Islam: A Study in Cultural Orientation.* 2d ed. Chicago: University of Chicago Press.

Walker, David M. 1980. "The Law Merchant." In *The Oxford Companion to Law.* Oxford: Oxford University Press. 726–28.

Wallerstein, Immanuel. 1980. "The Ottoman Empire and the Capitalist World-Economy: Some Questions for Research." In *Turkiyenin Sosyal ve Economik Tarihi (1701–1920) [Social and Economic History of Turkey (1701–1920)].* Papers presented to the First International Congress on the Social and Economic History of Turkey, Hacattepe University, Ankara, 1977. Ankara: Meteksan Sirketi. 117–22.

SLAVES, MASTERS, AND MAGISTRATES: LAW AND THE POLITICS OF RESISTANCE IN THE BRITISH CARIBBEAN, 1736–1834

Mindie Lazarus-Black

> The magistrate and the evangelical police have, or ought to have, a more "honored" place in the history of popular culture than they have usually been accorded.
>
> Stuart Hall
> "Notes on Deconstructing 'the Popular' "

In 1736 the slaves of Antigua, West Indies, conspired to murder their masters and to establish a kingdom. The rebellion was to begin on the eve of a celebration of King George II's coronation, but the festivities were postponed, and in the interim the plot was discovered. Greatly alarmed, the colonists engaged in a public display of the meaning and consequences of law and justice in a slave society: they established a court to investigate the matter. Over the next several months, judges interrogated a great number of witnesses and executed eighty-eight rebels, sentencing them to gruesome deaths on the wheel, by gibbeting, or by burning (Gaspar 1985:29).[1]

Much scholarly attention has been given to the causes, characteristics, and consequences of slave rebellions in the Caribbean (see, e.g., Patterson 1967, 1970; Price 1973; Mintz 1974; Craton 1980, 1982;

Higman 1984b; Beckles 1984; Gaspar 1985). Historians have also documented a variety of other forms of resistance to slavery, including poisoning, running away, refusing to work, petty larceny, "sassy" talk and satire, feigned illness, and abortion (see, e.g., Patterson 1967; Price 1973; Mintz 1974; Mintz and Price 1976; Craton 1978; Lewis 1983; Higman 1984b; Gaspar 1985; Morrissey 1989; Beckles 1989; Bush 1990). Little attention has been paid, however, to the rule of law and courts in the politics of slave resistance in the English-speaking Caribbean. The oversight is ironic in the Antiguan case because the man who led the slave rebellion was named Court, and he belonged to Thomas Kerby, a justice of the peace and speaker of the colonial assembly.

The present research focuses on the Leeward Islands,[2] including Antigua, and on Jamaica, one of the most volatile of the British-controlled islands and one for which there is extensive documentation (e.g., Patterson 1967:273–79; Brathwaite 1971:251–52; Dunn 1972: 259–62).[3] I argue that courts, cases, and legal consciousness[4] were important to the internal politics of slave communities and to the politics of slave resistance.[5] I challenge the old but persistent argument in Caribbean studies which holds that issues of law and justice remained within the province of elites and that the few legal rights slaves had had little impact upon their daily lives (see, e.g., Goveia 1965, 1970; Smith 1965; Patterson 1967; Lewis 1983; Gaspar 1985; Morrissey 1989; Beckles 1989; Bush 1990). To contest this long-standing argument, I identify and analyze three different forms of courts used by West Indian slaves: (1) courts consisting solely of bondsmen and in which masters played no part; (2) estate courts run by planters or their appointed hands; and (3) formal colonial tribunals.[6] These courts differed in personnel, in the kinds of cases they aired, in procedures to determine guilt or innocence, in interpretations of crime and injustice, in the sanctions they mandated, and in the ways that judges responded to gender conventions. Some data suggest, for example, that while slave men presided over courts within the slave quarters, slave women found colonial courts particularly useful.

Slaves' participation in a variety of courts lies at the heart of a general theoretical problem in anthropology, history, and Critical Legal Studies concerning the sources and development of hegemony (Thompson 1975; Hay 1975; Femia 1981; Abel 1982; Cain 1983; Scott 1985; Forgacs 1988; Starr and Collier 1989; Merry 1990; Comaroff and Comaroff 1991). Gramsci comes closest to defining hegemony in *The Prison Notebooks* when he refers to "a conception of the world that is implicitly manifest in art, in law, in economic activity and in all

manifestations of individual and collective life" (cited in Comaroff and Comaroff 1991:23).[7] As John and Jean Comaroff have recently commented, "hegemony" is a "concept good to think," in part because it is so vaguely defined (ibid.:19). Still, Gramsci's work clearly invites anthropologists to compare cross-culturally the methods by which certain constructs, behaviors, and perspectives become naturalized and part of commonsense understanding. In the English-speaking Caribbean, these processes are enmeshed with the development of slavery and its juridical structures (Lazarus-Black 1992a, 1994). How often and with what success did West Indian slaves use law? To what extent did West Indians create alternative juridical arenas indicative of the limits of law? Why did slaves and then people "freed," or, as Williams would contend, slaves "unowned" and "disowned" (1991:21), embrace the very structures that chained them? What happened to those other juridical forums?

Examining slavery in the American mainland colonies reveals interesting points of comparison with the West Indian data.[8] I do not find support in Caribbean records, for example, for two consequences which Genovese suggests were characteristic of American slaves' evaluations of their masters' law. He claims slaves found in law evidence of white hypocrisy and few protections and that, therefore: (1) slaves accorded law little respect, and (2) they searched instead for human protectors (1974:48). Genovese argues that the character of the American legal system drove slaves deeper into paternalism (ibid.:48–49).[9] In contrast, I find much less evidence of paternalism among West Indian slaves and much more evidence for participation in their own legal arenas in which they investigated and resolved disputes and resisted unjust behavior.[10] Comparing the Leeward Island and Jamaican data with Higginbotham's investigations of American colonial slave law (1978), with recent studies by Jones on slave control (1990) and Schwarz on slave crime (1988), and with Fox-Genovese's work on black and white women in the American South (1988), I find interesting parallels in the forms of slaves' techniques of resistance, in their criminal practices,[11] and in slave women's use of magistrate's courts. I draw some of these similarities to the reader's attention in this paper. I have not found evidence that West Indian slaves turned to lawyers to represent them in court or to help them locate documents proving free status, activities found in Southern cities in the United States (Wade 1964:256–57).[12]

My central purpose, then, is to draw attention to the everyday practices that transformed the meaning and possibilities of "law" in slave societies and which constitute the genesis of a West Indian hegem-

ony forged around slave huts and cooking pots as well as in courts of law.[13] Mine is an effort to glean from the historical and legal record the origins, character, and pervasiveness of alternative legal forums in the Caribbean. The point is to challenge the way we have conceptualized slavery, the character of the rule of law, and the possibilities of resistance.

METHODOLOGICAL NOTES

Three methodological notes described in this section are pertinent to this investigation. First, Caribbean legal records from the eighteenth and early nineteenth centuries are relatively rare, though they become less so as we approach the emancipation period. Second, West Indian legal accounts share the advantages and disadvantages of legal records generally; that is, if they are windows on the times they are nonetheless windows tinted by the hues of class, color, and gender. Third, I find that historians focus too heavily upon slave codes and courts as instruments of oppression and punishment, and too little upon the activities and processes that made law hegemonic.

There are admittedly few published accounts of West Indian slaves' involvement with courts. Catterall found published law reports concerning British West Indian slaves available only from Jamaican courts for the years 1774 to 1787 (1968:349).[14] Higman (1984a) has published other cases from Jamaica, and I can add trials from St. Kitts and Antigua, supplemented by some secondhand discussions of litigation from Trinidad. This sample is reduced further if one is less interested in cases in which masters brought slaves to court than in situations in which slaves brought other slaves, free men, or their own masters to court.[15] However, even if the cases in the surviving records are few, their presence indicates slaves' decisions to argue publicly about legalities and rights, thereby forcing the state to acknowledge critical relationships and the rules which governed them (see Yngvesson 1985:637).

Tushnet (1975:125–31) and more recently Schwarz (1988:35–58) review the advantages and limitations of using legal cases as historical sources.[16] Legal briefs and opinions delineate what and how judges thought about slaves and slavery. They provide important insights about the ideological structure of slave societies in part because "judicial opinions are public documents designed to convince" (Tushnet 1975:129). Court records of the criminal trials of slaves indicate the minimum number of illegal acts slaves committed and yield a wealth of information about the temper of the times (Schwarz 1988:36–

37). Moreover, even if they are "white sources," legal records are advantageous to historians because they "reflect the pressure for accuracy and not for distortion, they were firsthand, and they were recorded soon after the event" (Schwarz 1988:42).

Tushnet argues that judges in the American South wrote for an audience of slave masters, and, secondarily, for nonabolitionist leaders in the North (1975:130).[17] But as Genovese (1974) and Schwarz (1988) remind us, there was another intensely interested audience—the slaves. Perhaps because Tushnet is primarily interested in the autonomy of legal development, he neglects the effect on slaves caused by the mere adjudication of some of these cases. The point is relevant to the investigation of the roots of hegemony, especially in light of recent findings in procedural justice that litigants are often very concerned about explaining their circumstances and experiencing fair and dignified court procedures (see, e.g., Merry 1986, 1990; Tyler 1988; O'Barr and Conley 1988; Lind et al. 1990; Conley and O'Barr 1990; Stalans 1991).[18] I certainly found this to be true of Antiguans I interviewed during my fieldwork. Research using an "ethnography of legal discourse" (Conley and O'Barr 1990) alerts us to the fallacy of limiting to case decisions investigations of the impact of law and legal processes upon commonsense understanding.[19] In short, a more comprehensive historical analysis requires that we move beyond investigating how frequently masters took slaves to court and beyond the assumption that law offered to slaves only punishment.

I present evidence demonstrating that a variety of legalities, tested in a variety of forums, contributed to the processes through which law became a part of commonsense understanding, a resource for the commoner as well as the king's appointee. First, however, I review briefly the central characteristics of Caribbean slave societies and the hardships of slave life. I explain the character of formal political control in the islands and establish how early precedent was set for slaves to participate in colonial courts.

OF CARIBBEAN COLONIES AND THE TRIALS OF SLAVE LIFE

Although each of the British West Indian colonies in the Caribbean has a unique history, all these colonies share a number of economic, social, and political features. As Mintz explains, "They were, in fact, the oldest 'industrial' colonies of the West outside Europe, manned almost entirely with introduced populations, and fitted to European

needs with peculiar intensity and pervasiveness" (1971:36; see also Brathwaite 1971:63–64). By the middle of the eighteenth century, most were characterized by fully developed plantation economies in which slaves produced sugar for export to Great Britain, Europe, and elsewhere in the Americas.

Broadly speaking, these were societies of free white persons, free people of color, and black slaves, separated by social custom and law. The slave/white ratio in Jamaica for the period 1770–1820 was almost ten to one; it was eighteen to one in Antigua in 1790 (Brathwaite 1971:152). Free people of color amounted to only twenty-five hundred to three thousand persons in all of the Leeward Islands at the end of the eighteenth century. Their numbers were greater in Jamaica, but there too they were systematically excluded from prominent economic, social, and political positions.[20] Very early, racial inequality became a principle feature of life in the Caribbean.

Almost 80 percent of Antiguan slaves and 73 percent of Jamaican slaves worked as field laborers on very large sugar plantations (Higman 1984b:48). Exceedingly brutal regimes were devised, so much so that most of the islands showed yearly population declines despite the continuous importation of new Africans. Slaves worked a minimum of ten hours a day in the fields and picked grass at night (Goveia 1965:130). Their agricultural routine of hoeing, planting, weeding, and harvesting crops was an almost year-round affair accomplished without much technological assistance. Slaves were typically divided into three or four "gangs" based upon age and physical prowess. Both men and women were assigned to the "great gang," the group performing the hardest manual labor. A few fared better as skilled craftsmen, sugar boilers, drivers, coopers, masons, midwives, nurses, and domestics. Those who worked around the planter's home, or tended to the needs of his white managers, gained freedom from the monotony of field labor but were subjected to other more intimate experiences of subordination.[21] Still, the sheer size of the labor force on most Caribbean estates ensured that slaves from different societies in Africa would work together, fight, and learn from each other.[22]

Ideas about how disputes can be resolved, and deviants properly punished, are central to the problem of government. During the century under consideration here, the Leewards and Jamaica were almost entirely self-governing with respect to their internal affairs. The Leewards shared a governor and a General Assembly that met intermittently to legislate matters of general concern, but each island adamantly defended the right to maintain its own local assembly and to legislate its own affairs (Goveia 1965:51–55). In Jamaica, the assembly, the

governor, and the governor's advisory council were responsible for local lawmaking. "From the outset," claims Brathwaite, this assembly "asserted its right to speak and act on behalf of the colony, to control local taxation, and supervise its expenditure within the colony" (1971:8). The result, as Goveia has remarked, was that slave masters, and not London Parliamentarians, wrote slave laws and they wrote them to serve their own interests (1970:19).

The first slave laws were mainly police codes, expressing the colonists' fears that their "property" might revolt at any time. These early statutes were later supplemented by economic regulations to prevent slaves from acquiring property or doing away with that of their masters (Goveia 1965:158). However, precedent for slave participation in courts was established as early as 1702 in Antigua, only seventy years after the island was settled. In that law, slaves accused of minor offenses were tried before a justice of the peace. They could be punished with a public whipping if the justice found them guilty. Slaves accused of "heinous crimes" were tried by two justices and punished at their discretion. Slaves' evidence against free persons was not admitted, although it was left to the justices to decide if other slave evidence should be admitted (Gaspar 1985:150). In 1784 "An Act for Settling and Regulating the Trial of Criminal Slaves by Jury" commanded that a jury of six persons try slaves accused of criminal acts (Goveia 1965:63).[23] In both the Virgin Islands and Montserrat, slaves were tried by three or more magistrates in all cases. If they disagreed in a capital trial, two other justices were called in (ibid.:176). St. Kitts passed a bill similar to Antigua's, and in 1784 magistrates there tried and convicted two masters who had mutilated their slaves and another who had beaten a young slave boy mercilessly (ibid.:186).

The most comprehensive changes with respect to the legal rights of slaves in the Leeward Islands came in 1798 with the Amelioration Act.[24] Thereafter, severe maltreatment of a slave became a criminal offense, and a person accused of causing the death of a slave was tried as if the deceased were a free person. Other provisions limited hours of field labor, provided compulsory allowances of food and clothing, ensured better medical attention, and encouraged masters to protect slave marriages and families (ibid.:191–99). Slaves could not yet give evidence against whites, but justices gained authority to inspect the body of any slave claiming to be mistreated. By Act No. 636 of 1812, magistrates and vestries were appointed in each parish to serve as "Councils of Protection" for slaves. They were to ensure that slaves received their lawful allotment of food and clothing, to protect them

from maltreatment, to investigate all complaints, and to try offenders and commit them to jail if necessary (Antigua 1818:257–61).

The Jamaican slave laws followed a pattern similar to that developed earlier in the Leewards. According to Patterson, Jamaica's laws remained "largely confused, vague, in parts, even contradictory" between 1655 and 1788 (1967:71). For most of this period, relations between masters and slaves were guided by custom rather than statute. After the British Parliament began investigating the slave trade and the abolitionist movement gained momentum, however, the Jamaicans passed ameliorating acts to alleviate the living conditions of slaves.[25] A 1787 statute substituted three justices and nine freeholders to sit in judgment of slaves accused of crimes instead of two justices and three freeholders (Brathwaite 1971:292). Parochial Councils of Protection appeared in 1801 and their powers were enlarged in 1816 (ibid.:342). As was true in the Leewards, these measures offered to Jamaican slaves legal protection against nefarious conditions and the opportunity to bring complaints of ill treatment to the attention of public officials.

Because these Amelioration Acts lacked effective enforcement clauses and did not permit slaves to give evidence against free persons, Caribbean scholars have argued that the legal entitlements granted to slaves in these bills were mostly shams. Smith's argument that structural realities "made fiction of the law" (1965:97) is still advanced twenty-five years later (see, e.g., Lewis 1983:119; Gaspar 1985:150; Beckles 1989:5; Bush 1990:30).[26] I am not suggesting the point is erroneous, but rather that it is incomplete. As Genovese reminds us, "Only those who romanticize—and therefore do not respect—the laboring classes would fail to understand their deep commitment to 'law and order.' Life is difficult enough without added uncertainty and 'confusion.' Even an oppressive and unjust order is better than none" (1974:115).

The assumption that the legal entitlements granted to slaves were of little consequence to them ignores Genovese's insight that issues of law, order, and justice were as vital to slaves as they were to masters. It is further weakened by Schwarz's recent contention that "the relative predictability of the system of *legal* control is that many of those slaves who chose to challenge it could do so on the basis of their own values" (1988:30). Perhaps because Caribbean historians focused upon the brutality of the slave codes, and on punishment, they have missed the essential points that slaves participated in formal legal arenas almost from the initial days of colonization and claimed courts as one of their own forums for expressing rights and resolving disputes.

Throughout the Americas, slaves recognized that the very idea that law would safeguard some of their rights was important (see, e.g., Goveia 1965:197; Genovese 1974:25–49; Trotman 1986:235). They also understood that some slave codes were invoked only in emergencies (Goveia 1965:163, 176). As we see next, West Indian slaves also created their own courts and made use of juridical forums established by some planters. As soon as they gained the legal right to take other slaves and their masters to the magistrates, they did. West Indian ideas about rights and entitlements, order and disorder, and crime and punishment do not derive solely from the men who made the statutes, but neither does Caribbean legal consciousness ignore the possibilities law holds for resistance.

THE SLAVE TRIALS

Disputes within the slave quarters developed over work routines, love relationships, child rearing, contested claims to status, personality conflicts, stealing, gambling, and property rights. Higman's accounts of slaves brought to trial in Jamaica, for example, describe lovers' quarrels and acts of passion, conflicts over provision gardens and produce, verbal abuse, and contests of authority (1984a:64–69). "That slaves were adamant about their 'rights,' customary and legal, is attested to in many contemporary accounts" (Smith 1965:104).

Like people everywhere, slaves used a variety of means to contend with disputes: they practiced avoidance, gossiped, cursed, resorted to violence, and organized group retaliation. West Indians also used obeah as a form of social control and to exact retribution from other slaves and masters.[27] And Caribbean slaves dealt with conflict by using courts.

We know least about the courts that slaves convened among themselves. White observers related that they were presided over by respected members of the slave community. Eyewitnesses contended that "it [was] not surprising to find extralegal or illegal tribunals set up by and within estate slave communities in which the highest-ranking slaves adjudicated, advocacy being prominently by gift, and decisions, however unfair, being necessarily accepted" (Smith 1965:105). From another source we learn that "on many of the estates the headmen elect themselves into a sort of bench of Justice, which sits and decides privately, and without the knowledge of the whites, on all disputes and complaints of their fellow slaves. The sentences of this court were frequently severe, and sometimes partial and unjust" (cited in Forsythe

1975:21). A visitor to Jamaica accused these judges of excessive drinking and bribery:

> The courts usually consisted of three judges who, having taken their seats, began the session by consuming a great quantity of rum provided by both plaintiff and defendant. When sufficiently inebriated they sat and listened patiently, sometimes for hours on end, to the arguments put forward by both parties. At length, the hearing was closed and the judges gave their verdict, which often involved the imposition of excessive fines. Apparently these sentences were often very partial and influenced to a great extent by bribery. (Patterson [citing Madden] 1967:230–31)

Just after emancipation, Antiguan historian Flannagan wrote about a different kind of trial, trial by ordeal:

> They procure some of the leaves of the "flower fence," or "Barbados' pride," (called by the negroes 'doodle doo,') and lay them in a heap, in some peculiar manner, with a black dog (not a quadruped, but a small copper coin of about three farthings sterling, current in this island a few years ago) in the middle. They do not tie this bundle together, but by the manner in which it is placed they are enabled to raise it to the neck of the suspected person without its falling to pieces. The accused is then to say, (holding the bundle under their throat at the same time,) "Doodle doo, doodle doo, if me tief de four dog (or whatever it may be that is missing,) me wish me tongue may loll out of me mout." If nothing takes place, the person is innocent, and the charm is tried upon another, until the guilty one's turn comes, when immediately their tongue hangs out of their mouth against their will. (Flannagan 1967:2:55)[28]

These examples suggest that the resolution of conflict sometimes proceeded through formal channels of the slaves' own making. They indicate that as slaves devised a hierarchical ordering of statuses within their own community, power was sometimes expressed juridically. Moreover, there is evidence that extralegal courts persisted in Jamaica after emancipation, serving as an alternative to the sometimes capricious and corrupt colonists' courts of the mid-nineteenth century.[29]

A second type of court utilized by slaves was convened by the planters themselves to settle disputes among bondsmen and between slaves and free workers. Smith found evidence of this court in Jamaica and St. Vincent and concluded that complaints to estate managers were most likely to come from the domestic workers with whom they were in most frequent contact (1965:106).[30]

Among Smith's sources is planter "Monk" Lewis (1929), an English

novelist who made two trips to his Jamaican estates in 1815 and 1817 and kept a journal of his experiences. Lewis was a liberal by Jamaican standards and he was ostracized by his neighbors for spoiling his slaves and listening to their testimony against whites. If Lewis was atypical, he was not the only Jamaican to listen to his slaves. On the contrary, masters listened to enough slave evidence to draw the conclusion that the bondsmen had distinct ideas about crime. Here is Phillippo's tale of a Jamaican slave accused by his master of stealing sugar: " 'As sugar belongs to massa, and myself belongs to massa, it all de same ting— dat make me tell massa me don't tief; me only take it!' 'What do you call thieving, then?' 'When me broke into broder house and ground, and take away him ting, den me tief, massa' " cited in Mintz and Price (1976:20).[31] Moreover, Jamaican planter and historian Edward Long found slaves held certain crimes to be more serious, and others less serious, than did their masters:

> They [the slaves] do not consider certain acts to be criminal, which are usually reputed such among true believers. Murder is with most of them esteemed the highest impiety. Filial disobedience, and insulting the ashes of the dead, are placed next. But for petty larcenies, affairs of gallantry, fornication, etc. they are reputed only peccadilloes, which are sufficiently punished in this world, with the bastinadoe, or the distempers occasioned by them. The greatest affront that can possibly be offered a Creole Negroe, is to curse his father, mother, or any of his progenitors. This generally provokes a speedy revenge on the aggressor, after every other mode of provocation has failed. (1970:416)

These examples reveal "crime" as cultural construction mediated by class relationships. After slavery ended, some plantation owners stopped personally intervening in conflicts on their estates and created "manager's courts" for arbitrating tensions among workers and between workers and management.[32]

The third type of court used by Caribbean slaves was that created in colonial statutes. The earliest cases involving charges of harm done to slaves by free men that I have uncovered thus far come from Jamaica and date from the 1770s, long before slaves could testify for themselves. Whites brought these suits on behalf of slaves. Exemplifying the contradiction of a state which made men into commodities but then defended them against crime, the slave plaintiffs become "Rex" (under king's protection) in the law reports. Here is an excerpt from Grant's volume:

> *Rex v. Fell* . . . February 1777. "This is a remarkable case of an indictment against a white man, for beating a negro slave, and for

taking from him a piece of meat, bought in the public market for his master, Mr. Welch. The facts were proved by white witnesses, with many circumstances of aggravation. . . . it was questioned, Whether an indictment could lie in the case of a slave? The affirmative was satisfactorily established. Fell was convicted; and though a refractory turbulent man, on account of his poverty, fined only L. 20." (1794:29)

After this case, Judge Grant learned from a former chief justice that two earlier but similar cases had failed (ibid.:29). In *Rex v. Jones* (June 1778), a proprietor tried to prosecute his neighbor's overseer for wounding and whipping his slave (ibid.:45). *Rex v. Davis* involved a slave who had had his ear cut off. According to the law report, "the traverser appeared to have acted otherwise barbarously, which doubtless weighed against him with the jury" (ibid.:45). Edwards (1966:2:170–71) reports other cases in which masters were punished for harm to slaves by fines and/or imprisonment.

Slaves applied to magistrates either on their own initiative or on the advice of free persons. Planter Monk Lewis learned, for instance, that when one of his overseers persisted in behaving abusively, his slaves "fled to Savannah la Mar, and threw themselves upon the protection of the magistrates, who immediately came over to Cornwall" (1929:117–18). Public exposure caused the overseer to be dismissed by Lewis's attorney. After the incident Lewis advised his slaves "to apply to the magistrates on the very first instance of ill-usage, should any occur during my absence" (ibid.:119). On February 20, 1816, he attended the slave court where he observed the trial of one slave for sheep stealing and of a servant girl for attempted poisoning of her master. The sheep stealer was convicted and sentenced to be transported. About the young girl's case Lewis wrote:

> The trial appeared to be conducted with all possible justice and propriety; the jury consisted of nine respectable persons; the bench of three magistrates, and a senior one to preside. There were no lawyers employed on either side; consequently, no appeals to the passions, no false lights thrown out, no traps, no flaws, no quibbles, no artful cross-examinings, and no brow-beating of witnesses; and I cannot say that the trial appeared to me to go on at all the worse. Nobody appeared to be either for or against the prisoner; the only object of all present was evidently to come at the truth, and I sincerely believe that they obtained their object. The only part of the trial to which I disapproved was the ordering the culprit to such immediate execution, that sufficient time was not allowed for the exercise of the royal prerogative, should the governor have been disposed to commute the punishment for that of transportation. (Ibid.:179–80)

The following January he reported:

> A man has been tried, at Kingston, for cruel treatment of a Sambo female slave, called Amey. She had no friends to support her cause, nor any other evidence to prove her assertions, than the apparent truth of her statement, and the marks of having been branded in five different places. The result was, that the master received a most severe reprimand for his inhuman conduct, and was sentenced to close confinement for six months, while the slave, in consequence of her sufferings, was restored to the full enjoyment of her freedom. (Ibid.:324)

Another vicious master, however, escaped punishment when he murdered a slave in the presence of other bondsmen who were unable to give evidence in court against a white man (ibid.:398–99).

What is most important about these cases is not whether the slaves won or lost a particular decision; it is the fact that it was becoming part of the legal consciousness of the times to presume that the Crown could take free men to court for crimes against slaves. Undoubtedly, the intention of the slave master was to control slaves and uphold bondage. As one historian notes, "good Anglo-Saxons all and supporters of the emerging bourgeois ideology of individual rights before the law," white authorities did offer slave defendants some protection (Schwarz 1988:14).[33]

It was not, however, merely the fact that law offered some protections to slaves that compelled its gradual acceptance across the social ranks. In practice, colonial tribunals operated in fickle ways, sometimes punishing, sometimes ignoring, and sometimes protecting those accused of illegal acts. In fact, colonial judges acted with discretion to a far greater extent than has usually been assumed by historians.[34] Analyzing the Montserrat record of trials of criminal slaves, for example, Goveia found the death penalty inflicted only two times. Moreover:

> Perhaps the most striking fact of all was that the majority of cases brought before the Council were dismissed either because no prosecutor appeared or because the evidence was considered insufficient to justify a conviction. Until the judicial records of the other islands are investigated it will be impossible to say whether the Montserrat experience was representative. It does indicate . . . the early slave laws were not all enforced with equal rigour at all times. (1965:176)

Recent work on American slavery, and my reinterpretation of the significance of some statistics in earlier works, suggests that slaves' experiences with formal courts varied widely. Masters everywhere used courts to control their slaves, but not always with the consequences

that we formerly imagined. It seems that it was just as common to dismiss slave cases in the mainland colonies as it was in Montserrat. For example, in one year (1839) a police court in Charleston, South Carolina, heard 1,424 cases against slaves, of which 270 (almost 19 percent) were discharged (based on Wade 1964:103). The other slaves encountered various punishments; some quite serious, others less so: "330 punished in the work house, 26 fined 'or committed to workhouse until fine paid,' and 115 runaways 'disposed of according to law.' Owners or guardians paid 'penalties' in 398 cases, and in 252 cases slaves were 'delivered to the orders' of their masters" (ibid.:103).[35]

Cases against slaves were regularly dismissed, abandoned, or lost in Virginia too. Schwarz computes "simple rates of conviction—that is, the percentage of persons actually tried who were found guilty of various offenses" for Virginian slaves between 1705 and 1865 (1988:40). He found conviction rates fluctuated widely, depending upon the crime and the local context. Of 751 slaves tried in Virginia between 1706 and 1785, for example, 42.7 percent were found not guilty (ibid.:50n.26). Between 1786 and 1865, the conviction rate for slaves accused of crimes "against system" was 100 percent, but it varied from 35 to 78 percent for crimes against property and between 44 and 100 percent for crimes against persons (ibid.:41–42). Not surprisingly, conviction rates increased when authorities perceived a crime as threatening to white lives or to the stability of the society as a whole (ibid.:46).

Schwarz claims slaves' legal status as property compelled judges to hear cases responsibly and to separate criminal from noncriminal activity. Owners had substantial investments in slaves and therefore judges had to balance their desire to punish subversive behavior with their need to protect their neighbors' property: "The percentage of *not* guilty verdicts reflects the effort of many judges to convict only those slaves whom they thought to have actually broken a law. . . . Moreover, a sufficiently high percentage of slave trials—30 percent—resulted in not guilty verdicts to demonstrate that judges frequently made a real, though obviously not perfect, attempt to differentiate credible and incredible firsthand testimony" (Schwarz 1988:47, 50).[36]

In other words, unless they were convicted of murder or rape of whites, or of conspiracy to rebel, or had committed crimes in the presence of white witnesses—crimes for which punishment was almost inevitable—slaves could not have predicted the outcome of a trial. Charges might be dropped or reduced for lack of evidence. Slaves would have known that sometimes courts offered them a way out of "trouble."

I have cited Schwarz's findings at some length because his work makes use of trial court data and is one of the most comprehensive analyses of slave criminality in the United States (Friedman 1990:612). The record of criminal behavior by West Indian slaves still remains to be documented. Nevertheless, I hypothesize that the predictability of masters' resort to legalities, combined with the lack of predictability of verdicts in all but a few kinds of cases, was critical to the development of the hegemonic force of the rule of formal law in British Caribbean slave societies. By the nineteenth century, West Indian slaves had also won the right to challenge their own masters in the courts.

A document titled "Return of Slave Complaints in Basseterre, St. Kitts, from August 1822, to 26 December 1823" includes summaries of nineteen cases of complaints brought by slaves to justices of the peace. The cases include complaints of "insufficiency of food and severe treatment," excessive punishment for minor infractions of duty, assignment to a task which the slave was physically incapable of performing, and being forced to work on the overseer's personal estate (Great Britain 1826:3:236–40). The justices ruled in favor of the slaves in eight trials, most of them cases involving insufficient provisions. In six other cases, one or more of the group who had come to register a complaint went home with a sound lashing.

The St. Kitts record demonstrates that Leeward Island slaves utilized formal judicial procedures to protest the behavior of masters. They knew their rights and they were ready to argue for them. The data also reveals two interesting differences in the ways that slaves, as opposed to free colonists, used the courts.

First, most of the cases were brought by slaves in groups, rather than by single complainants.[37] Perhaps they sought safety in numbers, but in any case the decision to prosecute a master was often an act of consensus, not an isolated decision by a disgruntled person. Slaves were not full legal individuals but they were in law a class and in this sense they acted as legally constituted.[38] The slave court cases were like slave rebellions in that they were instances of collective resistance.

Second, a large percentage of these slave complaints were voiced by women. This was not peculiar to St. Kitts because records from other Caribbean colonies reveal the same pattern. One governor of Trinidad, for example, complained bitterly about the litigious nature of slave women—they were "the most prone to give offense." Trinidad's court records from 1824 to 1826 support the governor's observation: almost twice as many women as men appeared before magistrates (Ferguson 1987:xi). Slave women played only a slightly less active role in Jamaican courts. There, they accounted for almost half of the cases

brought between 1819 and 1835 (ibid.). The Protector of Slaves in British Guiana complained to the Secretary of State for the Colonies in 1826: "There is no question as far as has come within my reach of observation as to the difficulty of managing the women and they are irritating and insolent to a degree (often instigated by the men), take advantage of the exemption from stripes and in town do little or nothing" (in Williams 1952:76; also cited in Lazarus-Black 1994).[39]

Several anthropologists have argued that people who are relatively powerless in their relationships with others find courts to be powerful allies (see, e.g., Nader and Todd 1978; Yngvesson 1985; Merry 1990; Hirsch 1990).[40] I believe powerlessness was sometimes a dimension of slave women's use of courts, but in taking their cases to magistrates they also opposed white gender stereotypes which held women did not belong in politically charged arenas such as legislatures or courts. In making a complaint, slave women resisted the idea that women should be reticent, docile, subservient to men, and attentive to the conventions of class. They spoke out in their own interests and on behalf of their male and female friends and kin. Sometimes, too, they used courts to testify to brutality and crime within the slave quarters (Higman 1984a:64–69). As was true in the United States (Fox-Genovese 1988), slave women in the West Indies sometimes took advantage of the fact that over time white men were less inclined to beat, dismember, or murder slave women than slave men.[41] They found in courts a significant way to oppose injustice. Hence gender hierarchy influenced the forms and sites of slaves' strategies of resistance.

To summarize, at least three alternative juridical forums existed simultaneously in the Leeward Islands and in Jamaica in the period between 1736 and 1834. Slaves created their own courts, used those of their masters, and sometimes made use of colonial tribunals. These forums differed in composition, in their definitions of crime and punishment, in their ability to compel social order, and in their conceptions of justice. I have argued that in the islands, as in mainland America, colonial courts operated not just as instruments of punishment, or even as arenas for negotiating and resisting slavery, but as the loci and agents of a system of hegemony that united master and slave. I have also shown that class and gender mediated the process of litigation in these courts.

CONCLUSION

In the English-speaking West Indies, law made slavery possible and yet provided a way out of that condition. Bondage was legal everywhere

in the British islands by 1688; it became illegal in 1834. Between those two points in time, millions of enslaved people openly defied or quietly resisted the statutes that gave their lives to others.

Caribbean historians have missed the significance of the point that issues of law and justice were as crucial to slaves as they were to masters. They have assumed that law and legal cases remained within the lawmaker's province and had little impact upon the daily lives of the slaves. To the contrary, slaves made a variety of courts integral to their lives.

We should not assume that slaves, any less than contemporary litigants, went to court only for ameliorating verdicts. Indeed, cynical Jamaican planters would assert that slaves went to court to get out of work. And they were probably right some of the time. The point reminds us that investigating the process and the practice of going to court is as critical as examining the logic of judicial reasoning or counting verdicts of "guilty." Neither legal doctrine nor judicial behavior reveals fully the impact of law upon the commonsense understanding of oppressed peoples.

However limited West Indian slaves' access to formal law, it was a part of their world almost from the first days of slavery. My research demonstrates that slaves found in courts another arena in which to right grievances and to challenge the institution of slavery itself. Slaves found in law both an ideology that became "part of a struggle over control" and "the language in which this struggle takes place and in which relative power is contested" (Merry 1990:8). Moreover, as Yngvesson points out, access to official courts was critical because "it is here that the transformation of ephemeral relations into continuing ones receives collective affirmation" (1985:635). By making use of colonial courts, West Indian slaves extended the boundaries of their own communities to incorporate the magistrate, the planter-adjudicator, and the system of social control these colonists represented. Slave women in particular found they could sometimes use formal courts to gain protection from men, slave or free. As a consequence of going to court, of course, slaves would find themselves dependent upon the state and legal actors, and legal rhetoric would reshape the terms of their discourse (see, e.g., Genovese 1974; Grossberg 1985; Merry 1990). What role West Indian lawyers played in these processes remains unknown.

At other times, however, Caribbean slaves kept masters and magistrates at bay. In their own courts, slaves embraced other forms of power and knowledge, other means to determine guilt and innocence,

and other conceptions of crime and justice. Participation in these trials exemplifies a claim to law and order rooted in a particular class experience and exclusive of state law. Herein lie both a source of the hegemony of law and the potential to generate contradiction and resistance.

Notes

Versions of this paper were presented at the joint meetings of the Law and Society Association and the Research Committee on the Sociology of Law of the International Sociology Association held in Amsterdam, the Netherlands, June 26–29, 1991, and at the American Anthropological Association convention in Chicago, November 20–24, 1991. My thanks to Bill Black, Don Brenneis, John Comaroff, Jon Glassman, Susan Hirsch, Michael Musheno, Richard Small, and fellow panelists at these sessions.

1. The most comprehensive analysis of the Antiguan conspiracy can be found in Gaspar (1985). Other accounts appear in Craton (1980, 1982) and Lazarus-Black (1994).

2. In the eighteenth century, the British Leeward Islands included Antigua, Barbuda, Montserrat, Nevis, Anguilla, St. Christopher, and the British Virgin Islands. They shared a Governor-in-Chief and participated intermittently in the Leeward Islands General Assembly. Britain separated Antigua, Montserrat, and Barbuda from the other islands in 1816. They were reunited in 1832 and Dominica was included in the group. However, the islands' General Assembly did not meet between 1799 and 1871 (Goveia 1965:51, 58–59).

3. Jamaican sources are more readily available in the United States than are records from the smaller islands. Slaves in Barbados, Trinidad, and Guyana also used the legal tactics I describe here for the Leewards and Jamaica.

4. Merry defines legal consciousness as "the way people understand and use law. . . . Legal consciousness is expressed by the act of going to court as well as by talk about rights and entitlements" (1990:5). The "courts" to which I refer in this paper were not all "legitimated" by the state. Nevertheless, they were vital in the evolution of legal consciousness in the Caribbean because they were specifically concerned with problems of rights and entitlements, order and disorder, and crime and punishment.

5. By "resistance" I mean an individual or group action—linguistic, bodily, or pragmatic—toward the expression or empowerment of self or a collectivity, and against words or actions interpreted as "domination." "Domination," following Weber, implies a situation in which the will of the actor or actors is meant to influence the conduct of one or more others and actually does influence it (cf. Weber 1978:2:946). I intentionally define both terms broadly to allow "resistance" and "domination" to take culturally and historically specific forms and meanings. "Resistance" may make use of legal relationships and formal legal channels, as when slaves reported masters to magistrates for failure to provide adequate subsistence. It may also take the form of illegal relationships and proceed through illegal channels, as in slaves' participation in obeah (Lazarus-Black 1994).

6. Over time West Indian slaves, like those in the American mainland colonies, also turned to a fourth arena to resolve disputes; namely, courts

held by Christian ministers. South Carolina clergymen, for example, regularly listened to slave conflicts (Jones 1990:144–46). Wedenoja finds that in Jamaica: "Native Baptist cults . . . contributed to the socialization of slave communities by establishing church courts to enforce their codes of behavior and settle disputes without having to turn to the law and authorities of white society" (Wedenoja 1988:100). During fieldwork in Antigua (1985–87), I learned ministers were frequently called on to mediate conflicts. Moreover, today at least one fundamentalist Baptist sect occasionally holds courts presided over by senior members of its congregation. In Trinidad and Guyana, countries receiving large numbers of East Indians who worked as indentured servants after the slaves were emancipated, people's legal consciousness was also partially shaped by the presence of a fifth legal arena, the Indian panchayat. Panchayats functioned until the late nineteenth century in Trinidad (Trotman 1986:233) and until the 1950s in Guyana (Dodd 1979:279).

7. See Hirsch and Lazarus-Black (this volume) for a review of how Gramsci and later scholars have used the concept "hegemony" and for its special relevance to law.

8. Genovese understood that in slave societies law would function as "a principal vehicle for the hegemony of the ruling class," but that because law is "an active, partially autonomous force," it "mediated among the several classes and compelled the rulers to bend to the demands of the ruled. . ." (1974:26). (The point has also been made by Thompson [1975], Hay [1975], and more recently by Critical Legal Scholars.) In contrast to Caribbeanists, Genovese saw the importance of the fact that slaves discovered they could use law to effect important objectives: "The slaves grasped the significance of their victory with deeper insight than they have usually been given credit for. They saw that they had few rights at law and that those could easily be violated by the whites. But even one right, imperfectly defended, was enough to tell them that the pretensions of the master class could be resisted. Before long, law or no law, they were adding a great many 'customary rights' of their own and learning how to get them respected" (ibid.:30).

9. A number of historians of American slavery have taken Genovese to task over his paternalism hypothesis. Anderson, for one, accuses Genovese of failing to distinguish between "paternalism as an ideology and as a way of life" (cited in Jones 1990:28).

10. Comparing slavery on the U.S. mainland and in the West Indies, Mullin (1977) points out that Caribbean slaves had greater autonomy from masters, manifested less evidence of paternalism, and sometimes participated in separate legal arenas. My separate interest is in understanding how these different juridical forums functioned and evolved, interacted, and contributed to the development of local legal consciousness and hegemony.

11. Following Schwarz (1988:xii), slave crime is defined as actions by slaves which violated the criminal codes of the colonies. Such behaviors usually resulted in public prosecution and punishment, including whipping, branding, mutilation, deportation, and execution. Schwarz analyzed more than four thousand slave trials for criminal offenses in Virginia between 1705 and 1865. He interprets slave crime as resistance to bondage. As Friedman notes, however, historians must be wary of lumping together "under a single rubric stealing a chicken, poisoning, arson, striking an overseer, running away, assault on another slave—and slave insurrection" (1990:616). Moreover, according to

Friedman, Schwarz's work fails to "grapple with the problem of motivation" (ibid.:619).

12. In 1815, however, St. Vincent passed a statute directing courts to appoint counsel for slave defendants (cited in Edwards 1966:5:190). Patterson (1967:230–31) reports some Jamaican slaves functioned as "amateur lawyers" who pleaded for their fellow slaves.

13. A comprehensive analysis of the development of legal consciousness and hegemony in the Caribbean would, of course, also investigate how other groups used law and courts. There is evidence from Antigua, for example, that free blacks used colonial courts during the slave period (Lazarus-Black 1994). Grant's law report for Jamaica (1794), covering the period 1774–1787, includes cases of free black men suing whites, and Edwards's *History of the British West Indies*, first published in 1819, indicates that in eighteenth-century Jamaica the colonists tried to draw the independent Maroons into their legal system by drafting special legislation applying only to them (1966:1:531, 534–35; see also Dallas 1968:1:63–64). Bilby and Steady report Moore Town, which was founded by Jamaican Maroons, still retains "the traditional Maroon jural institution called the 'committee'—a village council, headed by an elected community leader called the 'Colonel' " (1981:460). For a discussion of the legal rights of slaves in comparison with those of indentured servants in Barbados see Beckles 1989.

14. The source of Catterall's accounts is John Grant's *Notes of Cases Adjudged in Jamaica* (1794), which I discuss in greater detail elsewhere (Lazarus-Black 1992b, forthcoming). Anyone who has conducted historical research in the smaller West Indian islands can attest to the poor quality and general unavailability of local records. There are few published historical sources on Antigua and almost no secondary material regarding its legal history.

15. Masters brought slaves to the authorities for a variety of offenses. In Jamaica, these included attempted and fatal poisoning of masters and other slaves, assault, stealing livestock, property damage, obeah, and arson (Brathwaite 1971:157–58; Higman 1984a:64–69). Stealing was the most common offense committed by slaves in Virginia (Schwarz 1988:64). In cities of the American South, slaves were brought before magistrates for infractions of municipal ordinances such as being out after dark, traveling without a pass, buying liquor, or striking a white man. Wade describes these "hearings" in which slaves were taken to court, charges announced, and verdicts rendered quickly (1964:102–3). He emphasizes that in the cities municipal courts gained "the final power of discipline over bondsmen outside the master's premises. . . . This meant that authority, so clearly focused on the master in the country, would be at least shared if not dominated by a public tribunal" (ibid.:105). However, the consequences of the pervasiveness of the experience of participating in this system of "justice" for the development of hegemony remain unanalyzed in both Schwarz's and Wade's studies. After all, the hearings were not held in courts accidentally.

16. Further discussion of the merits and shortcomings of using legal records can be found in Jordan (1968:587–88) and Higginbotham (1978:7–9).

17. In a similar vein, Jordan reminds us that while the slave codes "seem at first sight to have been intended to discipline Negroes, to deny them freedoms available to other Americans, a very slight shift in perspective shows the codes in a different light: they aimed, paradoxically, at disciplining white men.

Principally, the law told the white man, not the Negro, what he must do; the codes were for the eyes and ears of slaveowners" (1968:108).

18. Tyler (1988) and Lind et al. (1990) report there is no evidence that different types of people in the same society think differently about the meaning of "fairness." Of course, they are reporting survey results of Americans questioned in the 1980s, and not members of slave societies. Even so, it would be interesting to test these findings further and by different methods. During my research in Antigua I found men and women defined "fair" parental behavior differently and women used courts to buttress their own conceptions of "just" relationships (Lazarus-Black 1991, 1994).

19. In asking historians to pay attention to the different concerns people express when they become involved in litigation, I do not mean to divert attention from the critical issues of substantive and distributive justice. My thanks to Michael Musheno for reminding me that American ideology emphasizes justice as fairness, while downplaying people's concerns about the maldistribution of material benefits and burdens (memorandum to Lazarus-Black, November 1, 1991). As I demonstrate later in this paper, slaves sometimes took masters to court for very pragmatic reasons—like obtaining adequate nourishment.

20. Antigua was very unusual in allowing free persons of color with the necessary property qualifications to vote in elections (Goveia 1965:82). In most of the Leewards and Jamaica, free colored persons could not vote, find employment in the professions, run for office, serve on juries, or gain commissions in the militia. There were other restrictions as well. For example, Jamaican historian Edward Long distinguished three classes of freed persons: (1) those manumitted by their owner or by will who "were allowed no other mode of trial than the common slaves"; (2) free-born persons, accorded jury trials in which they could give evidence against one another or in civil cases against whites; and (3) those few persons granted most of the rights of whites by private acts of assembly (1970:2:320). Until 1813, free persons of color could not testify against whites or inherit more than two thousand pounds currency or its equivalent in property. Brathwaite suggests the ameliorating changes in the 1813 laws may have been the result of protests from the free colored population of Kingston: "There had been a petition for an extension of privileges, especially to be allowed to give evidence in court, from 2,400 coloured signatories in 1813 while the Act was being considered in the House" (1971:195).

21. Town slaves experienced more diversity in their daily lives. Men worked on the docks, as fishermen, seamen, messengers, transporters, carpenters, tavern sweeps, and "assistants" to whites. Slave women labored as maids, laundresses, and petty traders in the towns. For accounts of slave life in the English-speaking Caribbean see Goveia 1965; Patterson 1967; Brathwaite 1971; Mintz 1974; Mintz and Price 1976; Craton 1978; Higman 1984b; Beckles 1984, 1989; Gaspar 1985; Smith 1987; Morrissey 1989; and Bush 1990. Wade (1964) provides a comprehensive look at slavery as an urban phenomenon in the American South from 1820 to 1860.

22. It was common practice for Caribbean planters to deliberately buy Africans from different regions to prevent them from communicating. Beckles argues persuasively that slaves rapidly overcame this obstacle (1984:28–30).

23. Goveia doubts that humanitarian motives lay behind the Antiguan

assembly's decision to change the 1784 trial of criminal slaves law because lawmakers cited they suffered "inconveniences" without juries to determine the facts in cases and because slaves were still tried with half of the number of jurymen allowed free persons (1965:169).

24. There were few laws specifically designed to protect slaves in the Leeward Islands until the end of the eighteenth century, when pressure from the antislavery movement in England forced local initiative to improve conditions. Caribbean lawmakers penned some protective codes in 1798, in part to avoid being forced to contend with ameliorating legislation from the Colonial Office in England (Goveia 1965:189–91).

25. Slave-protection laws limited the number of hours per day that slaves could work, stipulated minimum food and clothing allotments, ended punishment for more than three months at the workhouse without trial, ordered slave families to be sold together, awarded monetary sums to women with six living children, protected elderly slaves, outlawed excessive whipping, iron collars, and heavy chains, sent coroners to investigate sudden deaths, and set aside Sundays and holidays for the slaves (Brathwaite 1971:292–93).

26. The literature is remarkably consistent over time. A few examples illustrate the point. First, Goveia argues the protective clauses of the West Indian slave laws "carried very little weight" and that their "small number indicates that they were exceptional" (1970:28; see also Goveia 1965:188, 197). Bush cites Goveia to support the point that slaves' legal entitlements had little importance in their daily lives (1990:30). The position is ironic since Bush also calls breaking slave laws a form of resistance, mentions that slaves "formulated legal and moral codes administered by their own headmen," and claims that a "dual moral code existed in the slave community" (ibid.:31). However, she never develops these claims. According to Lewis, "Every piece of circumstantial evidence (the Parliamentary returns, the reports of island correspondents, the dispatches of island governors, the reports of the Berbice Fiscal, or adjudicator) shows conclusively that every suggested reform of the ameliorative literature . . . was frustrated by the fact that the administrative machinery of slave society was monopolized by the very class that stood to lose by their implementation" (1983:119). Morrissey suggests that "the results of amelioration programs were disappointing throughout the region, in part because their application was haphazard . . ." (1989:127). Like Bush, Morrissey understands that "slaves' culture and struggles were always impeded and framed by symbolic and legal orders" (ibid.:13), but she too fails to pursue the implications of that assertion.

27. I argue that it is misleading to reduce obeah to "magic," "sorcery," or "religion," as is common in scholars' historical and contemporary accounts of obeah (Lazarus-Black 1992b, 1994). It comprises a body of knowledge and a set of rites which utilize forms of power that were mostly incomprehensible to the early colonists. Obeah offered to slaves an important means to defy masters, to promote order, and sometimes to create disorder within their own quarters. As Brathwaite observes, "the slaves poisoned each other more often than they poisoned their masters" (1971:15).

28. Another trial by ordeal involved marking a page of the Bible by pressing a door key upon the eighteenth and nineteenth verses of the fiftieth psalm. During the trial, the accused and the accuser balanced the book at the point of the keyhole. The key turned when the accused was guilty (Flannagan

1967:2:56). Rubenstein (1976) describes mock trials and effigy hangings used to punish sexual deviance in St. Vincent. However, he does not explore the historical derivation of those trials.

29. Investigating the role of law and its administration as factors contributing to the 1865 Morant Bay Rebellion in Jamaica, Chutkan found a charge that some of the peasants implicated in the riots against the authorities "had established their own courts with their own judges, police, and clerks. Documents relating to this said to be found among Bogle's papers were introduced into evidence before the Royal Commission. These described Mock Courts of Justice which included summonses for jury duty as well as for alleged crimes. They were written in imitation of official summonses in a mixture of dialect and English. [Governor] Eyre also referred to an article published in the *Jamaica Tribune* which described these peasant judicial courts as being organized in several localities, held in 'sham court houses—roughly put together but arranged internally upon the same plan as parish court houses have been erected; there are a sham chief justice, sham assistant judges, sham magistrates, sham clerks of the courts, sham clerks of the police, sham lawyers, sham policeman, sham indictments and sham convictions' " (1975:85). Chutkan recognizes these courts "are an indication that not only were the peasantry aware of the defects and injustices of the judicial system, but they were trying to do something about it" (ibid.). What is fascinating and relevant to our investigation of the making of hegemony is that over time these extralegal courts seem to have appropriated many of the procedures, offices, and symbols of the formal courts.

30. American slave masters also sometimes set up courts to contend with conflicts on their estates. Genovese cites a few interesting examples, but concludes only that "the slaves were asserting their wish to settle matters among themselves and that many masters were seeking some kind of compromise" (1974:635). Jones gives us an example from South Carolina in which compromise was clearly not a feature of the slave owner's court: "Fine day. Had a trial of Divorce and Adultery cases. Flogged Joe Goodwyne and ordered him to go back to his wife. . . . Separated Moses and Anny finally—And flogged Tom Kollock. He had never been flogged before. Gave him 39 with my own hand interferring [*sic*] with Muggy Campbell, Sullivan's wife—Did not break him of his Drivership" (1990:145).

31. Phillippo's interpretation was widespread. Stewart noted it in Jamaica (cited in Bush 1990:31) and Genovese recounts similar tales about slaves' definitions of theft in the United States: "they stole from each other but merely took from their masters" (1974:602). Slaves sometimes stole from masters because they were hungry, but at other times they used theft as a form of harassment. Occasionally they claimed to be following the example of whites— who had stolen them from Africa! (ibid.:603–7). Jones reports theft was the most common crime committed by slaves in South Carolina: "It was a way of getting back at masters for stealing their labor, energies, and freedom" (1990:17). Schwarz suggests this interpretation of theft developed over time: "I have found no direct evidence that eighteenth-century Afro-Virginia slaves shared the belief then prevalent in slave communities such as those in Jamaica that one could 'take' property from white people but one could 'steal' only from other slaves." By the next century, however, Virginian slaves also made this distinction (1988:119, 214). Lichtenstein (1988) argues persuasively that

theft by slaves in the American mainland colonies was part of slaves' indepen-
dent moral economy and a mode of resistance to planter hegemony.

32. In Guyana, some of these plantation courts persisted into the twentieth
century (Jayawardena 1963; Shahabuddeen 1973; Dodd 1979; Rodney 1981).
Jayawardena explains: "Most managers were Justices of the Peace, but the
manager's court did not administer the law of the colony; rather it enforced
the rules of management and in inter-personal disputes dispensed, to use a
term employed by Weber, a kind of 'kadi-justice,' i.e. 'judgments rendered in
terms of concrete ethical or other practical valuations.'. . . The manager had
powerful sanctions at his command. He could shift a man's residence . . . or
expel him. . . . With these powers he settled marital disputes, quarrels between
labourers, complaints about assault, nuisance, defamation, and larceny"
(1963:18). Like the extralegal courts described by Chutkan (1975) for post-
emancipation Jamaica, these manager's courts appropriated characteristics of
formal tribunals. They met regularly, included a court orderly, allowed litigants
and witnesses to present testimony, and gave the manager power to render a
verdict, levy fines and other punishments, or direct that the case be sent to
another court.

33. Legal protection and compassion for slaves who reacted illegally to
barbarous treatment by whites became more common in Virginia over time,
particularly after the American Revolution (Schwarz 1988:24). Schwarz men-
tions only in passing early trials in which slaves successfully challenged whites
(Ibid.:68–69).

34. Douglas Hay's sagacious analysis of the criminal law's capacity to
govern eighteenth-century England without police or a large standing army
is an exception. As he explains, "Majesty," "Justice," and "Mercy," three
critical ideological components of eighteenth-century criminal law, sustained
the hegemony of the English ruling class (1975). My analysis of the consequence
for slaves of judicial discretion in the colonies is analogous to Hay's interpreta-
tion of how and why English magistrates used "pardons" (1975:42–49).
Both practices were critical to maintaining social order and convincing the
disadvantaged masses of the essential justice and legitimacy of law.

35. Wade's report is particularly interesting because South Carolina had
one of the most repressive slave codes in the United States. After an act passed
in 1740, no blacks, Indians, mulattos, or mestizos could bring an action on
their own behalf. South Carolina slaves were denied legal capacity, but even
there the courts sometimes ruled in their favor (Higginbotham 1978:194,
210). Analyzing slave court records from Georgia, Higginbotham concludes:
"Fortunately, despite the number of offenses that theoretically warranted the
death penalty, the evidence available suggests that the Georgia courts seldom
imposed that extreme sentence" (ibid.:256–57).

36. Another indication of the bench's efforts to render verdicts according
to law is the fact that judges convicted slaves and free men in Virginia at
about the same rates. For example, Spotsylvania justices convicted 62.3 percent
of slave defendants between 1786 and 1859. In the same period, "they con-
victed or sent to a higher court 66.7 percent of free white defendants whom
they examined or tried for offenses of which both slaves and free whites could
be accused" (Schwarz 1988:49). Interestingly, Trotman's (1986) study of the
disposition of cases in Trinidad's magistrate's courts (1870–1899) and superior
courts (1871–1900) shows conviction rates between 43 percent and 64 percent.

Thus, former slaves and their descendants on that island also experienced considerable variability in the outcomes of their cases. Instead of being convicted of charges, defendants might be acquitted or declared insane, or find their cases dismissed, sent to a superior court, or judged "nolle prosequi" (ibid.:281).

37. Schwarz also found that in Virginia pairs or groups of slaves regularly stole property, set fires, poisoned masters and committed other crimes against masters (1988:75, 105, 123). On the other hand, crimes committed against other slaves were rarely group efforts (ibid.:154, 247).

38. My thanks to John Comaroff for clarifying this point.

39. Gender probably played a role in determining the number and types of crimes that West Indian slaves committed, as it did in colonial Virginia. Slave men in Virginia were much more likely than women to be charged with criminal activity. Men were most likely to be found guilty of major stealing. When they were accused of crime, slave women were likely to be charged with arson and poisoning, less often with insurrection and assault (Schwarz 1988:116, 212, 217, 283).

40. Yngvesson explains that in western Massachusetts women use courts to punish husbands or lovers and to contend with rebellious children: "There is no evidence that complainants in these domestic abuse cases use the legal system in order to terminate a relationship. They use it rather to restructure and continue the relationship" (1985:641, 642). Merry argues that working-class women in the United States are "more likely to take their neighbors, husbands, lovers, and children to court than are men because they are relatively powerless in these relationships" (1990:4).

41. My findings accord with those of Fox-Genovese (1988), who examines gender conventions upheld by American slaveholding women and their female slaves in relation to the constructs of masculinity held by the men who dominated both of their lives. She gives examples of how American gender conventions protected slave women. In the early 1770s, for instance, a slave woman named Mariana received one hundred lashes and lost her two ears for participating in a revolt, "a substantially lighter punishment, notwithstanding its cruelty, than that meted out to her male coconspirators" (1988:303). In addition, in Savannah in 1774, a slave uprising resulted in the death of all male slaves who participated, but two slave "wenches" were "returned to the plantation" (ibid.:306). As Fox-Genovese points out, the law treated men and women similarly, but some judges did not (ibid.:303). For another example of the differential treatment of slave men and women in Charleston, South Carolina, see Wade 1964:189. Bush (1990) is inconsistent about how Caribbean masters treated female as opposed to male slaves. She first states: "Women slaves were no less immune to physical punishment than male slaves. . . . Under the overseer's whip neither age nor sex found any favour" (1990:42). Plantation records from some estates, however, suggest that masters complied with ameliorating legislation which prescribed time in the stocks or solitary confinement for women, as opposed to the lashings that men received (ibid.:58).

References

Abel, Richard L., ed. 1982. *The Politics of Informal Justice.* Vol. 1. New York: Academic Press.

Antigua. 1818. *The Laws of the Island of Antigua: Consisting of the Acts Passed by the Captain-General, Council, and Assembly, from 26th May, 1804, to 13th June, 1817, with an Analytical Table of the Acts; and a Copious Digested Index.* Vol. III. 1804–1818. Prepared by the Legislature of Antigua and printed by their order under the revision of Anthony Brown, Esq., Colonial Agent in London, by Samuel Bagster, Paternoster-Row, London.

Beckles, Hilary. 1984. *Black Rebellion in Barbados: The Struggle Against Slavery, 1627–1838.* Bridgetown, Barbados: Antillo Press.

———. 1989. *White Servitude and Black Slavery in Barbados, 1627–1715.* Knoxville: University of Tennessee Press.

Bilby, Kennedy, and Filomina Chioma Steady. 1981. "Black Women and Survival: A Maroon Case." In *The Black Woman Cross-Culturally.* Filomina Chioma Steady, ed. Rochester, Vt.: Schenkman Books. 451–467.

Brathwaite, Edward. 1971. *The Development of Creole Society in Jamaica, 1770–1820.* Oxford: Clarendon Press.

Bush, Barbara. 1990. *Slave Women in Caribbean Society, 1650–1838.* Bloomington: Indiana University Press.

Cain, Maureen. 1983. "Gramsci, the State, and the Place of Law." In *Legality, Ideology, and the State.* David Sugarman, ed. New York: Academic Press. 95–117.

Catterall, Helen Tunnicliff, ed. 1968. [1926] *Judicial Cases concerning American Slavery and the Negro. Vol. 5 Cases from the Courts of States North of the Ohio and West of the Mississippi Rivers, Canada, and Jamaica.* New York: Negro Universities Press.

Chutkan, Noelle. 1975. "The Administration of Justice in Jamaica As a Contributing Factor in the Morant Bay Rebellion of 1865." *Savacou* 11/12:78–85, 112–13.

Comaroff, Jean, and John Comaroff. 1991. *Of Revelation and Revolution: Christianity, Colonialism, and Consciousness in South Africa.* Vol. 1. Chicago: University of Chicago Press.

Conley, John M., and William M. O'Barr. 1990. *Rules versus Relationships: The Ethnography of Legal Discourse.* Chicago: University of Chicago Press.

Craton, Michael. 1978. *Searching for the Invisible Man: Slaves and Plantation Life in Jamaica.* Cambridge: Harvard University Press.

———. 1980. "The Passion to Exist: Slave Rebellions in the British West Indies, 1650–1832." *Journal of Caribbean History* 13:1–20.

———. 1982. *Testing the Chains: Resistance to Slavery in the British West Indies.* Ithaca: Cornell University Press.

Dallas, R.C. 1968. [1803] *The History of the Maroons.* 2 vols. London: Frank Cass and Co.

Dodd, David J. 1979. "The Role of Law in Plantation Society: Reflections on the Development of a Caribbean Legal System." *International Journal of the Sociology of Law* 7:275–96.

Dunn, Richard S. 1972. *Sugar and Slaves.* New York: W. W. Norton and Company.

Edwards, Bryan. 1966. [1819] *The History, Civil and Commercial, of the British West Indies.* 5 vols. 5th ed. New York: AMS Press.

Femia, Joseph V. 1981. *Gramsci's Political Thought: Hegemony Consciousness, and the Revolutionary Process.* Oxford: Clarendon Press.

Ferguson, Moira, ed. 1987. *The History of Mary Prince, a West Indian Slave, Related by Herself.* London: Pandora.

Flannagan, Mrs. 1967. [1844] *Antigua and the Antiguans: A Full Account of the Caribs to the Present Day, Interspersed with Anecdotes and Legends. Also, an Impartial View of Slavery and the Free Labour Systems, the Statistics of the Island, and Biographical Notices of Principal Families.* 2 vols. London: Spottiswoode, Ballantyne and Comp.

Forgacs, David, ed. 1988. *An Antonio Gramsci Reader: Selected Writings, 1916–1935.* New York: Schocken Books.

Forsythe, Dennis. 1975. "Race, Colour, and Class in the British West Indies." In *The Commonwealth Caribbean into the Seventies.* A. W. Singham, ed. Montreal: McGill University Centre for Developing Area Studies. 16–42.

Fox-Genovese, Elizabeth. 1988. *Within the Plantation Household: Black and White Women of the Old South.* Chapel Hill: University of North Carolina Press.

Friedman, Lawrence M. 1990. "Turning the Tables: Slaves and the Criminal Law." *Law and Social Inquiry* 15(3): 611–23.

Gaspar, David Barry. 1985. *Bondmen and Rebels: A Study of Master-Slave Relations in Antigua.* Baltimore: Johns Hopkins University Press.

Genovese, Eugene D. 1974. *Roll, Jordan, Roll: The World the Slaves Made.* New York: Pantheon Books.

Goveia, Elsa V. 1965. *Slave Society in the British Leeward Islands at the End of the Eighteenth Century.* Westport: Greenwood Press.

———. 1970. "The West Indian Slave Laws of the 18th Century." *Chapters in Caribbean History 2.* Douglas Hall, Elsa Goveia, and Roy Augier, eds. Aylesbury, U.K.: Ginn and Company. 9–53.

Grant, John. 1794. *Notes of Cases Adjudged in Jamaica from May 1774 to December 1787.* Edinburgh: Adam Neill and Co.

Great Britain. 1826. *The Report of the Commissioners of Inquiry into the Administration of Civil and Criminal Justice in the West Indies.* Ordered by the House of Commons, to be printed, 11 December 1826. 3 vols.

Grossberg, Michael. 1985. *Governing the Hearth: Law and the Family in Nineteenth-Century America.* Chapel Hill: University of North Carolina Press.

Hall, Stuart. 1981. "Notes on Deconstructing 'the Popular.' " In *People's History and Socialist Theory.* Raphael Samuel, ed. London: Routledge and Kegan Paul. 227–240.

Hay, Douglas. 1975. "Property, Authority, and the Criminal Law." In *Albion's Fatal Tree: Crime and Society in Eighteenth-Century England.* Douglas Hay et al., eds. New York: Pantheon Books: 17–63.

Higginbotham, A. Leon, Jr. 1978. *In the Matter of Color: Race and the American Legal Process.* New York: Oxford University Press.

Higman, B. W. 1984a. "Terms for Kin in the British West Indian Slave Community: Differing Perceptions of Masters and Slaves." In *Kinship Ideology and Practice in Latin America.* Raymond T. Smith, ed. Chapel Hill: University of North Carolina Press: 59–81.

———. 1984b. *Slave Populations of the British Caribbean, 1807–1834*. Baltimore: Johns Hopkins University Press.

Hirsch, Susan. 1990. *Gender and Disputing: Insurgent Voices in Coastal Kenyan Muslim Courts*. Ph.D. dissertation, Duke University.

Jayawardena, Chandra. 1963. *Conflict and Solidarity in a Guianese Plantation*. London: Athlone Press.

Jones, Norrece T., Jr. 1990. *Born a Child of Freedom, yet a Slave: Mechanisms of Control and Strategies of Resistance in Antebellum South Carolina*. Hanover: University Press of New England.

Jordan, Winthrop D. 1968. *White over Black: American Attitudes toward the Negro, 1550–1812*. Baltimore: Penguin Books.

Lazarus-Black, Mindie. 1990. "Marriage and Power: The Legacy of Law and Other Structures of Domination and Resistance." Paper presented at the American Anthropological Association, November 30.

———. 1991. "Why Women Take Men to Magistrate's Court: Caribbean Kinship Ideology and Law." *Ethnology* 30(2): 119–33.

———. 1992a. "Bastardy, Gender Hierarchy, and the State: The Politics of Family Law Reform in Antigua and Barbuda." *Law and Society Review* 26(4): 863–99.

———. 1992b. "Witchcraft, Crafty Science, and the Rule of Law: A Historical Account of Hegemony and Resistance in Eighteenth-Century Jamaica." Paper presented at the Law and Society Association Meetings, May 28.

———. 1994. *Legitimate Acts and Illegal Encounters: Law and Society in Antigua and Barbuda*. Washington, D.C.: Smithsonian Institution Press.

———. forthcoming. "John Grant's Jamaica: Notes Towards a Reassessment of Courts in the Slave Era." *Journal of Caribbean History*. 27(2).

Lewis, Gordon K. 1983. *Main Currents in Caribbean Thought*. Baltimore: Johns Hopkins University Press.

Lewis, M. G. 1929 [1815–1817]. *Journal of a West Indian Proprietor*. Mona Wilson, ed. London: George Routledge and Sons.

Lichtenstein, Alex. 1988. " 'That Disposition to Theft, with Which They Have Been Branded': Moral Economy, Slave Management, and the Law." *Journal of Social History* Spring:413–40.

Lind, E. Allan, et al. 1990. "In the Eye of the Beholder: Tort Litigants' Evaluations of Their Experiences in the Civil Justice System." *Law and Society Review* 24(4): 953–96.

Long, Edward. 1970 (1774). *The History of Jamaica, or General Survey of the Antient and Modern State of That Island: With Reflections on its Situations, Settlements, Inhabitants, Climate, Products, Commerce, Laws and Government*. 3 vols. London: Frank Cass & Co.

Merry, Sally Engle. 1986. "Everyday Understandings of the Law in Working-Class America." *American Ethnologist* 13:253–270.

———. 1990. *Getting Justice and Getting Even: Legal Consciousness Among Working-Class Americans*. Chicago: University of Chicago Press.

Mintz, Sidney W. 1971. "The Caribbean as a Socio-Cultural Area." In *Peoples and Cultures of the Caribbean*. Michael M. Horowitz, ed. New York: Natural History Press: 17–46.

———. 1974. *Caribbean Transformations*. Baltimore: Johns Hopkins University Press.

Mintz, Sidney M., and Richard Price. 1976. "An Anthropological Approach to the Afro-American Past: A Caribbean Perspective." Philadelphia: Institute for the Study of Human Issues.

Morrissey, Marietta. 1989. *Slave Women in the New World: Gender Stratification in the Caribbean*. Lawrence: University Press of Kansas.

Mullin, Michael. 1977. "Slave Obeahmen and Slaveowning Patriarchs In an Era of War and Revolution (1776–1807)." In *New World Plantation Societies: Comparative Perspectives on Slavery*. Vera Rubin and A. Tuden, eds. New York: New York Academy of Sciences: 481–490.

Nader, Laura, and Harry F. Todd, Jr., eds. 1978. *The Disputing Process: Law in Ten Societies*. New York: Columbia University Press.

O'Barr, W. M., and J. M. Conley. 1988. "Lay Expectations of the Civil Justice System." *Law and Society Review* 22:137–52.

Patterson, Orlando. 1967. *The Sociology of Slavery*. Rutherford: Fairleigh Dickenson University Press.

———. 1970. "Slavery and Slave Revolts: A Socio-Historical Analysis of the First Maroon War, 1655–1740." *Social and Economic Studies* 19(3): 289–25.

Price, Richard, ed. 1973. *Maroon Societies*. New York: Anchor Books.

Rodney, Walter. 1981. *A History of the Guyanese Working People, 1881–1905*. Baltimore: Johns Hopkins University Press.

Rubenstein, Hymie. 1976. "Incest, Effigy Hanging, and Biculturation in a West Indian Village." *American Ethnologist* 3:765–81.

Schwarz, Philip J. 1988. *Twice Condemned: Slaves and the Criminal Laws of Virginia*. Louisiana: Louisiana State University Press.

Scott, James C. 1985. *Weapons of the Weak: Everyday Forms of Peasant Resistance*. New Haven: Yale University Press.

Shahabuddeen, M. 1973. *The Legal System of Guyana*. Georgetown: Guyana Printers.

Smith, M. G. 1965. "Some Aspects of Social Structure in the British Caribbean about 1820." In *The Plural Society in the British West Indies*. Berkeley: University of California Press: 92–115.

Smith, Raymond T. 1987. "Hierarchy and the Dual Marriage System in West Indian Society." In *Gender and Kinship: Essays Toward a Unified Analysis*. Jane Fishburne Collier and Sylvia Junko Yanagisako, eds. Stanford: Stanford University Press: 163–196.

Stalans, Loretta J. 1991. "Citizens' Procedural Expectations for an Upcoming Tax Audit: Their Nature and Formation." Paper presented to the Law and Society Conference, June.

Starr, June, and Jane F. Collier, eds. 1989. *History and Power in the Study of Law: New Directions in Legal Anthropology*. Ithaca: Cornell University Press.

Thompson, E. P. 1975. *Whigs and Hunters: The Origin of the Black Act*. New York: Pantheon Books.

Trotman, David Vincent. 1986. *Crime in Trinidad: Conflict and Control in a Plantation Society 1838–1900*. Knoxville: University of Tennessee Press.

Tushnet, Mark. 1975. "The American Law of Slavery, 1810–1860: A Study in the Persistence of Legal Autonomy." *Law and Society Review* 10(1): 119–84.

Tyler, T. R. 1988. "What Is Procedural Justice? Criteria Used by Citizens to Assess the Fairness of Legal Procedures." *Law and Society Review* 22(1): 103–35.

Wade, Richard C. 1964. *Slavery in the Cities: The South, 1820–1860*. New York: Oxford University Press.

Weber, Max. 1978. *Economy and Society*. Guenther Roth and Clause Wittich, eds. 2 vols. Berkeley: University of California Press.

Wedenoja, William. 1988. "The Origins of Revival, a Creole Religion in Jamaica." In *Culture and Christianity*. George Saunders, ed. New York: Greenwood Press. 91–116.

Williams, Eric, ed. 1952. *Documents on British West Indian History, 1807–1833*. Port-of-Spain, Trinidad: Trinidad Publishing Company.

Williams, Patricia J. 1991. *The Alchemy of Race and Rights*. Cambridge: Harvard University Press.

Yngvesson, Barbara. 1985. "Re-Examining Continuing Relations and the Law." *Wisconsin Law Review* 1985(3): 623–46.

ENACTING LAW THROUGH SOCIAL PRACTICE: SANCTUARY AS A FORM OF RESISTANCE

Susan Bibler Coutin

One Sunday afternoon in April 1987, representatives of twenty-six congregations that had declared themselves sanctuaries for Central American refugees gathered in a Protestant church in Berkeley, California, for their monthly steering committee meeting.[1] Among the agenda items was an announcement about an upcoming event: a "Journey to Central America." Instead of its regular business meeting in May, the Northern California Sanctuary Covenant—a group of eighty sanctuary congregations, to which the twenty-six that were meeting in Berkeley belonged—would hold "a smorgasbord of events" designed to renew participants' enthusiasm for sanctuary work. According to a flyer that was distributed to representatives, the Journey would have "something for everyone! . . . New people may hear their first testimonies, and ask those first difficult questions. Experienced workers may be refreshed in a workshop on Christian base communities, or get the latest information on Human Rights violations." The journey took place, and, at the June steering committee meeting, a local minister declared that it had been a success. There had been delicious Salvadoran food, informative updates on the situation in Central America, and "some people there heard their first testimonies!"

The testimonies featured during the journey to Central America were among the oppositional legal practices created by members of the Sanctuary movement: a grass-roots religious-based network that formed in the early 1980s to aid undocumented Salvadoran and Guatemalan refugees.[2] The Central Americans assisted by the movement

were in a *contested state of being*. Because these immigrants had entered the country without the knowledge or authorization of the U.S. government, the U.S. legal system defined them as illegal aliens. Religious workers who encountered these immigrants and heard their stories of persecution concluded that they met the legal definition of "refugee" and therefore deserved asylum in the United States. After attempts to secure asylum for these immigrants proved futile, volunteers resorted to granting Central Americans the refuge to which they felt they were entitled. Drawing on their knowledge of U.S. immigration law, volunteers began screening Central Americans who were still south of the border, bringing those deemed refugees into the United States, sheltering Central Americans in volunteers' homes and religious institutions, and publicizing these immigrants "testimonies"—their accounts of flight and persecution. Paradoxically, these practices, which derived from law, also *redefined* law by authorizing private citizens to determine immigrants' legal statuses.

The fact that a dissident movement used the law to challenge the deportation of torture victims would appear to settle a much-debated question: Does law legitimize or limit repression?[3] To Sanctuary workers, U.S. and international refugee law seemed an indictment of authorities' treatment of Central American immigrants. Participants' knowledge of the law fueled their shared sense of injustice, became a basis for movement practices, and enabled volunteers to construct persuasive public arguments. By grounding their actions in law, Sanctuary workers made the community, rather than the government, the ultimate legal authority, and thus created a form of popular justice. However, the political implications of movement practices were more complex than this analysis suggests. By assuming the authority to interpret law, Sanctuary workers created hierarchies between themselves and Central Americans. For example, although the testimonies performed during the journey to Central America drew listeners into the discourse of the movement, these tales of torture subjected Central Americans to the scrutiny of Sanctuary workers who would define these immigrants' legal identities and use this knowledge to fuel volunteers' own activism. The Sanctuary movement's oppositional legal practices thus demonstrate the difficulty of drawing on the law's potential for resistance without simultaneously invoking its capacity to oppress (see, e.g., Foucault 1980; Abu-Lughod 1990; see also Hirsch and Lazarus-Black this volume). Fully understanding how the movement's use of law was simultaneously hegemonic and resistant requires a deeper exploration of the ways that Sanctuary practices both shaped and were shaped by U.S. immigration law.

U.S. IMMIGRATION LAW

U.S. immigration law consists not only of legal codes, juridical procedures, and institutional structures, but also of meanings and practices that pervade everyday social relations. These meanings and practices form a discourse that both derives from and produces written law. The assumptions that make it possible to divide the U.S. populace into citizens, legal residents, illegal aliens, and so forth have become so culturally ingrained that these categories shape individuals' perceptions of social reality. Moreover, just as police surveillance and court hearings judge individuals' legal statuses, daily activities, such as going to the bank or applying for a job, continually objectify, identify, and classify individuals within legal categories. These classifications *materially constitute* individuals as legal beings, making people's privileges, rights, and actions dependant on their juridical statuses. As law creates social reality, social reality reproduces the law. When individuals are defined within particular legal categories, these categories are reauthorized and recreated on an ongoing basis. The fact that law shapes and is reconstructed through social life makes everyday social practices an arena in which juridical notions (and ultimately, the formal legal statutes) can be contested and reshaped. It was this dialectic between legal notions and social action that enabled religious volunteers to create the Sanctuary movement.

The legal category that most deeply affected the social reality that Sanctuary workers sought to change was "illegal alien." In the United States, this category derives from forms of juridical identity that emerged with constitutional government and that distinguish sharply between citizens and aliens. Citizenship, which replaced the monarch-subject relationship when the American colonies became a nation, is an abstract linkage between an individual and the law. The legal nature of citizenship is demonstrated by the fact that, to become U.S. citizens, individuals swear allegiance to the Constitution, and even those who are citizens by birth are assumed to have accepted the law's authority (Foucault 1979). Their relationship to the law grants citizens a *jural* existence in addition to their *physical* existence—a form of legal personhood that is attested to through birth certificates, death certificates, and the like. The creation of citizenship also produced this category's antithesis: alienage. All those who are not party to the law of a given nation are aliens. Unlike citizens, aliens do not intrinsically possess a jural existence.

If citizens remained within their country's borders and aliens remained without, then physical and juridical reality would coincide.

However, individuals do cross international boundaries, therefore states have assumed the authority to grant partial or temporary legal statuses (such as "resident alien") to aliens whose presences are authorized, and to define those whose presences are *not* authorized as *illegal* aliens: beings who, paradoxically, are physically present but legally nonexistent. In the United States, the days of open immigration, when "aliens simply arrived on our shores, found lodging and jobs, and were assimilated by degrees into the society" (Harwood 1986:2), ended in 1882 with the Chinese Exclusion Act. Over the years, the United States established quotas to regulate the immigration of different nationalities and criteria to exclude such people as homosexuals, communists, and criminals. By 1986, the federal prosecutor who tried eleven Sanctuary workers on alien-smuggling charges could proclaim, "Every nation has the absolute power to control its borders, to determine who comes in their country, when they come in, where they come in, how long they are going to be here, what they are going to do, how they are going to support themselves and when they are going to leave" (Official Trial Transcripts 1986:14191). When being present in the United States without governmental permission became a crime, actions such as overstaying one's visa or clandestinely crossing the border became *states of being* (see, e.g., Asad 1983)—though, these might be better termed states of *non*being, since illegal aliens are in, but not of, society.

The jural notions out of which the construct "illegal alien" was formed authorize and derive from institutional structures that situate individuals within this and other legal categories. These structures include law enforcement authorities who scrutinize the population, extracting knowledge that can be used to categorize individuals. Along the U.S.-Mexico border, over four thousand border patrol agents use motion detectors, surveillance cameras, helicopters, and spotter aircraft to identify unauthorized border crossers. In the interior, Immigration officials observe bus and train stations, check the highways for suspicious-looking travelers, raid workplaces, and inspect employee records (Harwood 1986). Immigration discourse is institutionalized not only in the form of law enforcement officials but also in detention centers that hold apprehended illegal aliens pending deportation or a redefinition of their legal statuses. By separating "illegal aliens" from the rest of the population, detention centers restore the alignment between physical and juridical reality. Finally, immigration discourse is embodied in Immigration courts and Immigration judges; institutions that further scrutinize immigrants by eliciting statements and documents that are then measured against legal categories in order

to properly classify individuals. Those judged to be illegal aliens are returned to their sites of legal existance, not as a punishment, but rather as a means of restoring order.

The structures that locate individuals within particular immigration categories—and thus reproduce these categories—are not limited to the formal legal apparatus. U.S. immigration law and policy hold individuals accountable for the legal statuses of those whom they harbor, transport, and hire. As a result, private individuals as well as government officials scrutinize the populace and judge immigration statuses. Identity documents, social security numbers, and proofs of citizenship are sometimes required by hospitals, college admissions officers, landlords, employers, social service agencies, religious charities, banks, and granting agencies, usually by individuals with no connection to the U.S. Immigration and Naturalization Service (INS). To give but a few examples, one community college denied admission to an otherwise qualified undocumented Salvadoran immigrant, social workers screened Arizona welfare applicants by tapping into INS computers (Fischer 1986), and, as of 1988, the Tucson Salvation Army not only required proof of legal status from aid recipients, but also detained undocumented women and children arrested by the border patrol (personal communication). Because those who are defined as illegal immigrants are usually denied services, daily social life separates the undocumented and the documented as surely as the bars of detention centers. Thus, the classifications performed by private citizens, like the judgments rendered by Immigration officials, recreate the legal discourse that defines individuals as juridical (or nonjuridical) beings.

The mutually influencing relationship between immigration law and daily social life creates a potential for resistance that Sanctuary workers exploited. By acting according to *their own* rather than the state's, interpretation of U.S. immigration and refugee law, movement members sought to produce a different legal and social reality than is usually created by interaction between the documented and the undocumented.

DEVISING OPPOSITIONAL LEGAL PRACTICES

It was in the early 1980s, when they encountered undocumented Central American immigrants, that the religious volunteers who eventually would become Sanctuary workers first realized that their actions were being defined by U.S. immigration law. Until then, most of these middle-class, white, more often than not middle-aged members of mainline congregations had had little contact with the legal system, and even less with immigration law. Soon, however, they found themselves

preparing asylum applications, attending deportation hearings, raising bail bond for detained Central Americans, and serving as legal guardians for Salvadoran and Guatemalan minors apprehended by the INS. These experiences gave volunteers the legal expertise—what Merry (1990) terms the "legal consciousness"—that enabled them to formulate their own interpretations of U.S. refugee and immigration law. Volunteers discovered that it could be illegal to act on these interpretations by aiding Central Americans who had not been detained by Immigration officials and who therefore lacked even a temporary legal status. Volunteers also realized that if they did *not* aid undocumented Central Americans, they would be allowing their own actions to define Central Americans as illegal aliens who could be detained and deported. This awareness led volunteers to devise practices that would prevent deportations, define Central Americans as refugees rather than as illegal aliens, and promote their own understanding of U.S. immigration law.

The first contact between undocumented Central Americans and religious volunteers in Tucson, Arizona, and the San Francisco East Bay in California—the two communities where I did fieldwork—occurred during the summer of 1980, when a group of Salvadorans was found in an Arizona desert where they had been abandoned by their *coyote*, an individual who, for a fee, smuggles undocumented people into the United States. Half had perished. Several church groups in Arizona set out to aid the survivors, only to find the INS preparing to deport them to El Salvador. This shocked church workers who had resettled Cuban, Southeast Asian, Indonesian, and Chilean refugees with the *support* of the U.S. government. One volunteer reported that such governmental actions taught her "the difference between a 'refugee' and a 'refugee.' Before, I'd thought of a refugee as someone who is seeking shelter, but after working with the Central Americans, I became aware that it's a legal status." Shortly after the Salvadorans were abandoned in the desert, the Manzo Area Council, a local community organization, informed Tucson church groups that undocumented Salvadorans had begun requesting legal assistance. Outraged over the INS's treatment of the abandoned Salvadorans and galvanized by the growing publicity about human rights abuses in Central America, the churches readily agreed to help. Manzo, Tucson church groups, and the INS developed the following arrangement: Manzo prepared and submitted asylum applications for Central Americans, churches agreed to meet asylum applicants' material needs, and the INS accepted applications without detaining applicants.

Church groups' outrage over INS treatment of Central Americans

deepened when INS policy changed and religious volunteers learned that, all along, the INS had been detaining Salvadoran and Guatemalan immigrants who were not associated with church groups. In the spring of 1981, shortly after former president Ronald Reagan's inauguration, a Manzo client who had voluntarily entered an INS office to apply for political asylum was taken into custody rather than released. A Manzo representative traced the client to the El Centro detention center only to discover some two hundred Central Americans imprisoned in deplorable conditions. Reportedly, it was common for the INS to expose prisoners to the Arizona sun in order to coerce them into signing deportation papers. Inmates lacked medical attention, attorneys, and the ability to receive phone calls. Members of Manzo and the Tucson Ecumenical Council of churches met to address this situation. A minister present at the meeting related: "[We] decided to mount an enormous effort to bond out the people who were in detention. Within a short period of time, we had raised something like $30,000 for bond money, and folks put up their homes for the bonds. . . . I think that we bonded out fourteen people in one day. . . . We found that we were responsible for a legal aid project, for raising bonds, and for social services for people who were bonded out."

As they prepared asylum applications and raised money for bail bond, Tucson church workers became convinced that Salvadorans and Guatemalans were entitled to refugee status, but that the political asylum process was stacked against them. Tucson volunteers reported that the INS pressured detained Salvadorans and Guatemalans to sign deportation papers by separating families and telling each member that the others had already signed. Government officials raised bond fees from $500 to $1,000 to $5,000, draining volunteers' sources of bond money. The immigrants that were bailed out by Tucson church groups were almost immediately replaced by newly detained Central Americans. The asylum applications prepared with congregation members' assistance were consistently denied. Tucson volunteers soon discovered that their experiences were not unique. At a fall 1981 meeting, church and legal groups from Tucson, Los Angeles, San Francisco, Texas, and elsewhere compared notes and concluded that INS harassment of Central American asylum applicants and their advocates was widespread and systematic. A minister who attended this meeting commented, "We thought at first that what we were experiencing was a strange, isolated situation of some rednecked administrator, but we discovered that everyone had had the same experiences."

As they began to conclude that helping Central Americans apply

for political asylum was futile, religious workers in Tucson resorted to what they then considered illegal actions. Volunteers continued to submit asylum applications for detainees, since this was the only way to secure their release. However, rather than bringing undetained Central Americans to the attention of INS officials by way of an asylum application, volunteers began helping unapprehended Salvadorans and Guatemalans evade detection. The pastor of one of the churches involved in this effort explained that his congregation had refused to let immigration law determine its response to the persecuted: "We decided that we had always helped people before on the basis of human need, and that we'd never asked anyone for their IDs, or green cards." When the INS warned participating church groups that they would be indicted if they continued to aid undocumented Central Americans, Tucson religious workers decided to seek public support. On March 24, 1982, Southside Presbyterian Church in Tucson, five East Bay congregations, and a handful of churches around the United States publicly declared themselves sanctuaries for Central American refugees. At the time, participants believed that the declarations broke the law. A March 23, 1982, letter from Southside's pastor to the U.S. attorney general stated, "We are writing to inform you that Southside United Presbyterian Church will publicly violate the Immigration and Nationality Act, Section 274(A)" (Corbett 1986:36). The letter justified the church's actions by noting that the U.S. government was violating both international law and the 1980 Refugee Act by detaining Central Americans and deporting them to places of persecution.

As, during the coming months and years, the original Sanctuary congregations were joined by others, members of what was fast becoming a movement redefined the legal significance of their actions. After consulting their attorneys and further studying U.S. and international refugee law, church groups concluded that, far from breaking the law, offering sanctuary to undocumented Salvadorans and Guatemalans *obeyed* U.S. and international laws guaranteeing refuge to victims of persecution. As early as sixteen months after the original declarations, attorneys began to advise Sanctuary workers that their actions could be considered legal under the very laws they accused the government of breaking. For example, in July 1983, Ira Gollobin, the immigration law consultant for Church World Service, informed Sanctuary workers that the United Nations protocol on refugees, which was made part of U.S. law in 1968, prohibited returning individuals with a well-founded fear of persecution to their countries of origin, even if they had entered another country illegally. Gollobin concluded, "In granting

sanctuary to the Salvadoreans seeking asylum here, the Churches act in conformity with the letter, as well as the spirit, of constitutional rights and statutory law" (Corbett 1986:64).

Sanctuary workers had an opportunity to test their claim that sanctuary was legal (and to develop additional legal expertise) when, in January 1985, a Tucson grand jury indicted fourteen movement members on felony charges of conspiracy and alien smuggling. These were not the first charges filed against Sanctuary workers, since, during the previous year, four volunteers had been arrested in Arizona and Texas in separate incidents. However, the extent of the indictments and the discovery that the government had resorted to infiltrating the movement led many Sanctuary workers to regard this legal contest as the deciding battle in their struggle on behalf of Central Americans. Sanctuary communities around the United States contributed to the defense effort, while, in Tucson, the indicted and their attorneys further elaborated their legal arguments in preparation for the courtroom confrontation. However, Sanctuary workers' initial enthusiasm for having their day in court faded when, at the trial's outset, the judge ruled most of their legal arguments inadmissible. When the trial ended with convictions for eight of the eleven defendants who actually stood trial, movement members renewed their determination to continue sanctuary work.

When I began doing fieldwork in Tucson and East Bay Sanctuary communities some six months after the trial's conclusion, I learned how Sanctuary workers' interpretations of the law had shaped movement practices. In Tucson, Sanctuary activists sought to define Central Americans as refugees through a legal philosophy and praxis that participants called "civil initiative." Civil initiative is grounded in the notion that communities have a sense of law that is more fundamental than the formal legal codes.[4] According to the Sanctuary workers who devised civil initiative, this fundamental sense of law concerns basic human rights which, because they are universally valid, are codified in international and religious law. Tucson Sanctuary workers argued that in the case of U.S. immigration law, the problem was not that U.S. legal codes conflicted with basic human rights, but rather that the U.S. government had *interpreted* its immigration statutes in ways that violated the community's consensus that the persecuted should not be deported to face further persecution. To correct this misinterpretation, Sanctuary workers decided to act as they felt the government ought to have been doing. They reasoned that this would force the U.S. government to comply with community legal norms in one of two ways. Either the government would fail to prosecute Sanctuary

workers, thus tacitly legitimizing their claims, or authorities would issue indictments, thus giving Sanctuary workers the opportunity to state their position before a jury of peers who, presumably, would share their interpretation of the law. (Movement members did not consider the Tucson Sanctuary trial a true test of this theory, since defendants had not been permitted to present their legal arguments.) Participants called their legal strategy civil *initiative* rather than civil *disobedience* because they believed that it enforced, rather than violated, federal and international law.

Although sharing Tucson volunteers' belief in the legality of their work, East Bay Sanctuary activists' use of the law was not as complex as that of their Tucson counterparts. East Bay Sanctuary workers did not differentiate between communities' understanding of the law and the formal legal codes, but rather argued simply that sanctuary was legally justified on the basis of federal and international law. Legal arguments were less important to East Bay Sanctuary workers than to Tucsonans for several reasons. East Bay Sanctuary workers devoted a greater portion of their time to stopping U.S. military aid to El Salvador, while their Tucson colleagues focused more on establishing refugee rights. Due to their distance from the U.S.-Mexico border, East Bay activists were not involved in the legally risky work of border crossings, nor had any East Bay Sanctuary worker been arrested for participating in the movement. However, there were parallels between Tucson and East Bay activists' legal philosophies. Both groups declared that their work was legal, that Salvadorans and Guatemalans were refugees rather than economic immigrants, and that the U.S. government's refugee policy violated U.S. and international law. Both also incorporated immigration law into movement practices in order to establish the validity of these contentions. The political implications of the movement's use of law can be assessed by examining movement practices that both derived from and sought to influence U.S. immigration law. There were three such practices: screening potential immigrants; giving sanctuary to undocumented Central Americans within the United States; and publicizing refugees' testimonies.

SCREENING

One of the ways that Tucson Sanctuary workers invoked and sought to redefine U.S. immigration law was by screening the Central Americans who asked for the movement's help crossing the U.S.-Mexico border. (East Bay Sanctuary workers did not use these particular screening methods, since they were not involved in border crossings.)

Drawing on their earlier experiences preparing asylum applications and observing courtroom hearings, Tucson Sanctuary workers devised practices that they believed accurately differentiated legitimate refugees from economic immigrants. This distinction was important to Tucson activists because they had accused the INS of treating all Central Americans like economic immigrants. If the movement aided all Central Americans, Sanctuary workers reasoned, then it would be guilty of a similar error. Volunteers also believed that their ability to successfully defend themselves in the event of future indictments depended on being able to demonstrate that the Central Americans whom they brought into the country were legally entitled to asylum. One Sanctuary worker urged any colleague involved in border crossings to know "who they are helping, why they believe they are refugees under the Refugee Act of 1980, and whether the means of assistance are [sic] the only and necessary option available." As this participant explained, a successful defense would not only enable Sanctuary workers to avoid legal sanctions, but also could establish "that citizens must act to see that refugee rights are respected," and thus set a precedent that would apply to other refugee groups in addition to Central Americans.

To separate political from economic refugees, Tucson Sanctuary workers examined potential immigrants in a manner reminiscent of political asylum hearings.[5] Before and during political asylum hearings, applicants are repeatedly questioned about their reasons for emigrating, any instances of persecution, and their prospects if they were to return to their countries. From their responses, attorneys construct a narrative which is then presented in court and measured against the legal definition of a refugee. Similarly, when movement members learned through Mexican or Central American colleagues of individuals who wished to be taken across the border by Sanctuary workers, a counselor was sent to the border to discover why these individuals had left their countries, whether or not they had experienced persecution, and what they feared would happen if they returned home. Just as the written word substantiates truth during asylum proceedings, Sanctuary counselors asked to see any documents, such as letters, death threats, or newspaper clippings, that corroborated the circumstances described. After counselors completed their investigation, Tucson border workers then met to decide by consensus whether those requesting assistance met the definition of a political refugee, and thus whether or not these individuals had the right to safe haven in the United Sates. To make this determination, movement members used the definitions of "refugee" contained in the 1980 Refugee Act, the United Nations Protocol on Refugees, and the Geneva Conventions—in short, the

same federal and international laws that form the basis of U.S. refugee law.[6] Those individuals who were deemed refugees were brought into the United States, while those who were not were left alone or given another form of assistance.

Tucson Sanctuary workers' screening procedures took advantage of the potential for resistance created by statutes that held individuals legally liable for the immigration statuses of those whom they transported across the U.S.-Mexico border. Movement participants *did* make themselves accountable for Central Americans' legal statuses, arguing that since they had examined these immigrants and determined that they had valid asylum claims, it *was* legal to bring them into the United States. As they exploited the law's potential for resistance, Sanctuary workers *redefined* the law itself. Unlike U.S. Immigration authorities, Sanctuary workers did not regard "refugee" as a status to be granted or denied at the discretion of government officials. Rather, they insisted that an individual's refugee status was conferred by having been persecuted, that valid stories of persecution could be recognized by private citizens as well as federal authorities, and that persecution inherently entitled an individual to asylum. Movement screening practices declared that undocumented Central Americans not only merited, but *actually possessed* legal status. When one Arizona Sanctuary worker told me, "I knew they [Central Americans] were refugees because I had heard so many of their stories," he was asserting a truth that bypassed the official immigration process. By arguing that groups of ordinary citizens had the power to recognize asylum claims and grant safe passage to certain immigrants, Tucson Sanctuary workers made immigration a matter of community as well as state control. Like the countless other social contexts in which individuals check their fellows' identity documents, Sanctuary screening procedures empowered citizens to interpret and enforce law.

At the same time, the very laws that created this potential for resistance imbued screening procedures with power-laden overtones. Just as immigration law and policy subject the U.S. populace to the scrutiny of employers, social workers, college officials, and Immigration officials, the Sanctuary screening process compelled undocumented Central Americans to reveal painful experiences to inquisitive, albeit sympathetic, strangers. By assuming the authority to judge these accounts, Sanctuary workers created an asymmetry between themselves and Central Americans that paralleled the hierarchy between Immigration officials and asylum applicants. As one Tucson participant whom I interviewed noted with pride, "We are better at separating political refugees from economic refugees than the INS is!" Though

such statements did empower citizens, asserting that political refugees had legal rights that were not shared by economic immigrants implied that political refugees' life experiences granted them a jural existence wherever they physically existed, but that economic immigrants' physical presence did not automatically grant them a jural existence within U.S. borders. When Sanctuary workers acted on this assertion by denying assistance to "economic" refugees, they reinforced the distinction between legal and illegal immigration that defined some Salvadorans and Guatemalans as illegal aliens. In sum, screening procedures illustrated that the law's potential for resistance is unavoidably connected to its potential for repression.

The political ambiguity of screening procedures also characterized the practice from which the movement derived its name: giving sanctuary to undocumented Central Americans.

GIVING SANCTUARY

Like the movement's screening procedures, giving sanctuary to undocumented Central Americans enacted Sanctuary workers' contention that individuals who had entered the country without the permission of the U.S. government and who had not presented themselves to U.S. officials could nevertheless possess legal status. The prototypical Sanctuary arrangement consisted of a congregation declaring itself a sanctuary for Salvadoran and Guatemalan refugees, holding a press conference to announce the declaration, and then openly sheltering a refugee family in a church building, a synagogue, or a member's home.[7] Sanctuary workers were aware that they could be indicted for such actions. A Tucson border worker who defined sanctuary as "protective community with the violated" noted, "To the extent that the violated are viewed as 'illegals,' the community itself becomes 'illegal'—in quotes." However, though they realized that the U.S. government did not agree with their interpretation of the law, congregants refused to consider their actions crimes, contending that, since undocumented Central Americans were refugees, it was legal to shelter these individuals. To make this argument, Sanctuary workers manipulated legal notions. Declaring that it was legal to shelter undocumented Salvadorans and Guatemalans suggested that individuals become legal refugees by being persecuted, not by being declared refugees by government officials, and that private citizens can differentiate between refugees and other immigrants. By *openly* sheltering undocumented individuals, Sanctuary workers implied that these individuals were *not* illegal aliens. Rather than separating citizens and illegal aliens, as do the many

requests for identity documents that are made on a daily basis in the United States, giving sanctuary brought the documented and the undocumented into intimate contact. Giving sanctuary thus not only challenged the U.S. government's assessment of human rights violations in El Salvador and Guatemala, but also resisted that discourse that defined Central American immigrants as illegal aliens.

Despite the oppositionality of sheltering undocumented Central Americans, this practice, like screening potential immigrants, recreated power relations that were intrinsic to the legal notions that it manipulated and resisted. By protecting undocumented Central Americans from the deporting gaze of the INS, participants subjected them to the gazes of Sanctuary congregations. A Tucson border worker who had been involved in the first bail-bonding efforts explained that this was one of the original goals of the public Sanctuary declarations. He recalled, "When we had had firsthand experience with real live refugees, our own lives and our understandings had changed. Since that's how we'd been converted, we thought that it might work for others as well." As in the process of screening immigrants, giving sanctuary required that Central Americans recount their experiences of persecution. In fact, some congregations limited their offers of sanctuary to refugees who agreed to tell their stories to congregation members, journalists, and other audiences, arguing that such public (and, as will be discussed below, subversive) accounts, along with legal risks, distinguished sanctuary from "charity" and made this practice oppositional.[8] For example, a West Coast Sanctuary congregation's announcement of a vacancy for a refugee family stated: "While the Church works to meet the physical needs of a small Salvadoran or Guatemalan family, the refugees teach us about their faith, their story, their struggles and their culture." The notice went on to specify that the church wanted to learn "why they had to flee their homeland and why they are here"—the same information that attorneys elicit when constructing asylum claims.

Within the Sanctuary movement, the definitional scrutiny that U.S. immigration law bequeathed to sanctuary living arrangements was intensified by a religious discourse that imbued the persecuted with a quasi-sacred, life-giving power. José Martin, a Salvadoran community organizer, explained how Sanctuary workers' faith had led them to seek knowledge of refugees: "The Sanctuary movement is . . . an exodus for the [North American] people who act within it. It brings them persecution and sacrifice, and it causes them to renounce the luxuries that they have. Sanctuary is moving in the exodus, even though physically people aren't moving. Rather, Sanctuary is transforming North

295

Americans as they come to identify with *our* exodus." By knowing Central Americans, Sanctuary workers could be redeemed. A San Francisco activist explained, "I think it's the classic situation, where they get money from us, and we get life from them." To Sanctuary workers, Central Americans' transformative power stemmed from their ability to acquaint the privileged and the comfortable with suffering and faith. The power of direct contact with persecuted Salvadorans and Guatemalans was heightened by the fact that, since they were undocumented, Central American refugees were still subject to detention and deportation. Moreover, as Sanctuary workers risked arrest by sheltering undocumented refugees, this form of contact with Central Americans could bring Sanctuary workers into the ranks of the persecuted, thus, in participants' eyes, enabling movement members to make the sacrifices required by their faith. As one Tucson border worker exclaimed, "I believe that the refugees can save our American souls!"

Whatever refugees' transformative potential, Central Americans' own reactions to being the objects of Sanctuary workers' gazes revealed that being imbued with life-giving power was not the same thing as empowerment. Some Central Americans resented what they characterized as being put on display by members of the Sanctuary movement. For example, while I was talking with a minister and a Salvadoran man who had once been given sanctuary, the minister asked the Salvadoran, "Remember when you were being a refugee?" The man answered, "Oh, yeah, I used to go around and they would look at me, the exotic refugee, and say, 'Wow! You have two legs just like white people and you walk just like white people!'" Central Americans also resented the objectification and distancing that resulted from being categorized. One Salvadoran student being sheltered in a Bay Area seminary found that being continually defined as a refugee constricted his relationships. He explained, "I would prefer to live freely, and to free myself from the word 'refugee' . . . I mean, I left my country due to the violence and due to the fear and danger of disappearing, *not* in order to become a refugee. To me, the word 'refugee' implies inferiority and superiority." The student added tellingly that he preferred relationships that were "person to person instead of person to refugee." A Salvadoran active in the Bay Area refugee community spoke eloquently about the paternalism that sometimes occurred when congregations or individuals sheltered Central Americans:

> A refugee can feel like a bird in a cage. And while the cage may be beautiful, it's still a cage. A person can feel very overprotected. And being overprotected isn't the same as being a refugee and yet being free. . . .

Like, they say that you shouldn't work, because it could be danger-
ous. Or they tell you to forget your country, and to learn English.
They try to tell you how to raise your children, explaining how they
raised their children. They tell you to cook a certain way, and to eat
a certain way, and to view your own community a certain way. For
example, maybe they think that it's important for you to go to
church every Sunday at 11:00. And maybe you would rather go to
a community event on Sunday.

Clearly, as they attempted to redefine legal reality by giving sanctuary
to undocumented Central Americans, Sanctuary workers assumed the
authority that derives from the ability to define.

A deeper understanding of the subversive yet power-laden nature
of Sanctuary workers' quest for knowledge of refugees is granted by
a closer examination of the practice that made such knowledge possi-
ble. This practice was known as refugee testimonies.

TESTIMONIES

To substantiate their claim that undocumented Salvadorans and Guate-
malans were refugees, Sanctuary workers took advantage of the way
that legal performances produce cultural meanings, constitute material
reality, and define social norms (see Merry this volume). During court-
room examinations of asylum applicants, the border patrol's interroga-
tions of suspected illegal aliens, and private citizens' informal but
nonetheless constitutive scrutiny of their peers, individuals are com-
pelled to produce knowledge that situates them within immigration
categories. The Sanctuary movement replicated such performances by
encouraging Central Americans to publicly recount the narratives that
defined them as refugees.[9] When asylum applicants recount such narra-
tives in court, their words define them as either illegal aliens or political
asylees. Similarly, within the Sanctuary movement, each repetition of
a Central American's account of persecution reconstituted the speaker
as a refugee, rather than as an illegal alien. By calling these perfor-
mances "testimonies," Sanctuary workers and Central Americans in-
voked legal notions of truth, and thus sought to convince audiences
that speakers were indeed legitimate refugees entitled to asylum in the
United States.

Although listening to testimonies, unlike bringing immigrants across
U.S. borders and giving sanctuary to the undocumented, did not risk
legal sanctions, the Sanctuary workers who heard Central Americans'
testimonies often experienced these words as forbidden knowledge.
Refugee testimonies publicized the voices of "illegal aliens" who lived

"in the shadows," émigrés from lands where fear, torture, and death had silenced many. Listeners were aware that, by advertising their presence, undocumented speakers risked being captured and deported. Sanctuary workers also believed the U.S. government would have preferred to silence the victims of wars that it had helped finance. Refugee testimonies' revelatory quality was further deepened by speakers' notions of *testimonio*, a Latin American tradition in which common people educate others about oppression by publicly describing their personal experiences. Drawing on this tradition, one Salvadoran activist said of himself and his exiled compatriots, "We have become like an open book, and [a] radio which switched from silence to sound, the throats of thousands, and like the biblical reference [to] the voice in the desert." In this metaphor, refugees could be read, they were known, they were the subjects of their own speaking. As "the throats of thousands" they spoke not only for themselves, but for their people. Like John the Baptist ("the voice in the desert"), they heralded the coming of change.

The forbidden, revelatory quality of refugee testimonies gave these speeches a transformative power. According to Foucault (1980), knowledge that must be extracted is deemed more reliable than knowledge easily given. The testimonies publicized by the Sanctuary movement exemplify the confessional discourse that Foucault contends has become the authoritative method of producing truth in the West. Foucault (1980:62) describes a confession as "a ritual that [requires] the presence . . . of a partner who is not simply the interlocutor but the authority who requires the confession, . . . a ritual in which the truth is corroborated by the obstacles and resistances it has had to surmount in order to be formulated; and finally, a ritual in which the expression alone, independently of its external consequences, produces intrinsic modifications in the person who articulates it." Like confessions, testimonies were elicited by audiences, had to overcome obstacles, and transformed speakers by defining their legal statuses. However, because refugees' words were thought to reveal a truth about U.S. policy that would otherwise have been hidden from listeners, these narratives altered not only speakers but also their audiences, turning uninvolved listeners into committed Sanctuary workers. One movement member related, "Once I went to a testimony where a woman passed around a picture of her son and then described how he'd been captured, tortured, and finally killed. You could hear the shock in the room! That's when people are won over in an instant. . . . After walking away from that, when a person hears the news, he'll think, 'Now who am I going to believe? That trash that's printed in

the newspaper, or this woman who came to my church last week and told me about her husband and two kids?'" A measure of Sanctuary workers' belief in the authoritativeness of refugee testimonies is that participants sometimes called testimonies "witnessing:" an evangelical practice in which Christians seek through their life and words to communicate their faith to others (Greenhouse 1986:83–86). At one Bay Area sanctuary gathering, a minister told her audience, "We came to see the face of Jesus in the Central Americans. . . . God is speaking to us through the Central Americans."

Despite the fact that testimonies were a form of knowledge that challenged the status quo and transformed listeners, there was still a power relationship—analogous to that between a listening judge and a testifying asylum applicant—between the Sanctuary workers who knew and the refugees who were known. Refugee testimonies conveyed knowledge primarily from refugees to Sanctuary workers rather than vice versa. For example, during an interview, a Tucson Sanctuary minister criticized a church that had misconceptions about the refugee family it was sponsoring. He then exclaimed, "Some churches don't get to know their refugees at all!" Yet, during my fieldwork, I never encountered concern about whether or not a refugee family got to know "its" congregation. Imbuing refugees with the power to speak truth was also a power-laden process of knowing an oppressed and foreign other. Though insurrectional, the Sanctuary movement's quest for transformative knowledge of refugees' lives in some ways derived its authority from foreign governments' searches for dissidents, the INS's search for illegal aliens, and the political asylum process's search for discourse and documentation. The two-edged process of imbuing power while extracting knowledge, begun during screening procedures, continued through giving sanctuary and, celebrated during public testimonies, was proof that the Sanctuary movement's use of U.S. immigration law was simultaneously oppositional and power-laden.

CONCLUSION

U.S. immigration law creates interconnected potentials for power and for resistance. For example, holding individuals accountable for the immigration statuses of their peers makes private citizens agents of surveillance but also implies that individuals are capable of interpreting and enforcing the law. When Sanctuary workers used their knowledge of the immigration system to devise practices that would promote their own legal notions, they inevitably both resisted and furthered repression. On the one hand, screening, sheltering, and publicizing

the stories of undocumented Salvadoran and Guatemalan immigrants challenged U.S. Central American and refugee policy, contested the exclusivity of the state's control of international travel, declared that individuals could be legal refugees without having been so designated by government officials, made the community, rather than the state, the ultimate legal authority, and overcame some of the divisions between the documented and the undocumented. On the other hand, these practices reinforced distinctions between legal and illegal immigration, criminalized the presence of the immigrants denied movement assistance, subjected Central Americans to the scrutiny of movement members, objectified Central Americans by measuring their lives against legal definitions, and created a hierarchy between the Sanctuary workers who defined and the refugees who were defined. The movement's effort to define Central Americans as refugees in some ways reinforced the system that constituted these immigrants as illegal aliens.

By pointing out the contradictions within Sanctuary practices, I do not mean to imply that there is a purer form of resistance in which the movement could have engaged. The individuals who devised Sanctuary practices chose between strategic options, each of which would have engendered its own political contradictions. Nor do I wish to suggest that the Sanctuary movement's oppositionality was limited simply by the fact that participants manipulated *legal* discourse. Had they forsworn legal arguments, movement members would not have reproduced the above power relations in the same way, but they would have abandoned a powerful source of legitimacy and allowed authorities to define the movement's legal significance. Rather, my goal in examining how power and resistance are intertwined within Sanctuary practices has been to shed light on the complexity and political ambiguity of U.S. immigration law. Because of this ambiguity, authorities' attempts to use immigration law to repress dissidents and immigrants are as contradictory as activists' efforts to secure legal justice (Coutin 1993).

The political complexity of Sanctuary practices suggests that, because immigration law and social life shape one another, other forms of interaction between the documented and the undocumented are equally contradictory. In creating movement practices, Sanctuary workers did not intend to reinforce the subjugation of undocumented people or to create hierarchical relations between themselves and Central Americans. Rather, movement members sought only to compel government officials to recognize Salvadorans' and Guatemalans' status as political refugees. However, the political implications of social practices derive not only from their ultimate goals, but also from the practices themselves. When Tucson Sanctuary workers concluded that

a Salvadoran met the legal definition of "refugee" and deserved to be brought into the United States, these activists asserted that citizens were empowered to interpret and apply U.S. immigration law. This assertion challenged the U.S. government's claim to be the sole legitimate arbiter of immigration status, but placed Sanctuary workers in positions of authority vis-à-vis the Salvadoran in question. Similarly, when a Sanctuary congregation invited an undocumented Guatemalan refugee to give her testimony during Sunday morning services, the congregation publicized the voice of one whose very presence was forbidden but also subjected the Guatemalan to an invasive if well-meaning examination by congregation members. If such legally inspired social actions could deconstruct and reinforce power relations, so too can a nurse's decision to treat an undocumented patient, or an employer's refusal to hire a day laborer who lacks papers. The power and resistance that inhere in Sanctuary practices are intrinsic to the relationship between law and social life.

Notes

1. Earlier versions of this essay were presented in November 1991 at the 90th Annual Meeting of the American Anthropological Association in Chicago, Illinois, during the panel entitled "Hegemonic Processes and Oppositional Practices: Law and Bureaucracies as Arenas of Transformation," and in June 1991 at the joint meetings of the Law and Society Association and the Research Committee on the Sociology of Law of the International Sociological Association in Amsterdam, the Netherlands, during the panel entitled "Hegemonic Processes and Oppositional Practices: The State and Varieties of Transformation II." I would like to thank Michael Musheno, Susan Hirsch, Mindie Lazurus-Black, Jane Collier, and fellow panelists and audience members for their comments.

2. My analysis of the Sanctuary movement is based on fieldwork conducted between January 1987 and March 1988 with sanctuary groups in Berkeley, California, and Tucson, Arizona. Among other things, I volunteered with the movement, attended communitywide Sanctuary-related meetings, gatherings, and worship services, observed the activities of three Sanctuary congregations (two Protestant churches and one synagogue), and interviewed approximately one hundred participants. This research was supported by an American Fellowship for dissertation research from the American Association of University Women.

3. For discussions of this debate, see Althusser 1971; Thompson 1975; Nader and Todd 1978; McBarnet 1984; Henry 1985; and Hunt 1985.

4. Tucson Sanctuary workers' distinction between what one participant called "common" or "customary" law and "statutory" law is a version of the distinction between natural and official law that is part of American culture. See Greenhouse 1989 for an explication of these concepts.

5. It is important to note that other forms of assistance, such as food,

housing, and job referrals, were granted to "unscreened" refugees, who out-numbered the "screened" refugees.

6. According to handouts distributed by the Tucson refugee support group—a Tucson Sanctuary group—the UN Refugee Protocol "defines a refugee as anyone who is outside the country of his or her nationality and who cannot return because of 'well-founded fear of being persecuted for reasons of race, religion, nationality, membership in a particular social group, or political opinions.'" Handouts also explained that the Geneva Conventions forbade the forcible deportation of civilians to areas of armed conflict.

7. Actual arrangements often differed from this prototype. A number of Sanctuary congregations in both the East Bay and Tucson never housed a Central American, but instead donated money for bail bond, sent volunteers to provide social services through Sanctuary or Task Force offices, wrote letters to Congress urging changes in U.S. foreign policy, funded delegates to Central America, organized communitywide events relating to Central American issues, and performed countless other tasks. In Tucson, many Sanctuary workers quietly housed Central Americans who arrived on the underground railroad for days, weeks, months, or years, neither publicizing their actions nor requiring presentations from the immigrants they aided.

8. For example, the December 1983 steering committee minutes explained: "'prepared for sanctuary' means 'refugees who have no legal status and thus are in need of the protection of a congregation, who are mentally stable in spite of the persecution and dislocation they had suffered, and who are willing to speak to North American congregations about the reasons for their flight here.' Whether or not to make willingness to speak publicly a prerequisite for living in sanctuary was a point of contention between different segments of the movement (see Bau 1985 and Lorentzen 1991). In Tucson, many Sanctuary congregations prided themselves on aiding all refugees, regardless of their politics or their willingness to give testimonies. One Tucson border worker told me, "To even suggest that people be moved around on the basis of political efficacy is an obscenity." Another commented, "I believe in helping people, not causes."

9. Typically, a Sanctuary worker would introduce the refugee and give some background about Central America, Sanctuary, and U.S. policy. Then the refugee, speaking through an interpreter, would give a narrative that moved from his or her personal experience to statements about stopping the violence in El Salvador or Guatemala. The testimony was often followed by a question-and-answer period and usually was accompanied by fund-raising appeals or announcements about how to get involved. Activists sometimes attempted to match the refugee speaker to the audience. For example, a catechist might speak to a religious group, and a former student might speak to a high school history class.

References

Abu-Lughod, Lila. 1990. "The Romance of Resistance: Tracing Transformations of Power through Bedouin Women." *American Ethnologist* 17(1): 41–55.

Althusser, Louis. 1971. "Ideology and Ideological State Apparatuses." In *Lenin and Philosophy*. New York: Monthly Review Press. 127–86.

Asad, Talal. 1983. "Notes on Body Pain and Truth in Medieval Christian Ritual." *Economy and Society* 12:287–327.

Bau, Ignatius. 1985. *This Ground Is Holy: Church Sanctuary and Central American Refugees*. New York: Paulist Press.

Corbett, Jim. 1986. *Borders and Crossings. Vol. I: Some Sanctuary Papers, 1981–86*. April ed. Tucson: Tucson Refugee Support Group.

Coutin, Susan. 1993. *The Culture of Protest: Religious Activism and the U.S. Sanctuary Movement*. Denver: Westview Press.

Fischer, Howard. 1986. "Panel OKs INS Trace for Welfare." *Arizona Daily Republic*, 2 April:1C.

Foucault, Michel. 1979. *Discipline and Punish: The Birth of the Prison*. Alan Sheridan, trans. New York: Vintage Books.

———. 1980. *The History of Sexuality, Volume I: An Introduction*. Robert Hurley, trans. New York: Vintage Books.

Greenhouse, Carol J. 1986. *Praying for Justice: Faith, Order, and Community in an American Town*. Ithaca: Cornell University Press.

———. 1989. "Interpreting American Litigiousness." In *History and Power in the Study of Law: New Directions in Legal Anthropology*. June Starr and Jane F. Collier, eds. Ithaca: Cornell University Press. 252–76.

Harwood, Edwin. 1986. *In Liberty's Shadow: Illegal Aliens and Immigration Law Enforcement*. Stanford: Stanford University Press.

Henry, Stuart. 1985. "Community Justice, Capitalist Society, and Human Agency: The Dialectics of Collective Law in the Cooperative." *Law and Society Review* 19(2): 303–27.

Hunt, Alan. 1985. "The Ideology of Law: Advances and Problems in Recent Applications of the Concept of Ideology to the Analysis of Law." *Law and Society Review* 19(1): 11–37.

Lorentzen, Robin. 1991. *Women in the Sanctuary Movement*. Philadelphia: Temple University Press.

McBarnet, Doreen. 1984. "Law and Capital: The Role of Legal Form and Legal Actors." *International Journal of the Sociology of Law* 12:231–38.

Merry, Sally. 1990. *Getting Justice and Getting Even: Legal Consciousness among Working-Class Americans*. Chicago: University of Chicago Press.

Nader, Laura, and Harry F. Todd, Jr. 1978. "Introduction." In *The Disputing Process: Law in Ten Societies*. Laura Nader and Harry F. Todd, Jr., eds. New York: Columbia University Press. 1–40.

Official Trial Transcripts. 1986. *U.S. v. Aguilar*. No. CR–85–008–PHX–EHC (D. Ariz.).

Thompson, E. P. 1975. *Whigs and Hunters: The Origins of the Black Act*. London: Allen Lane, Penguin Books.

INDEX

Abrahamson, Shirley, 180n.66
Abu-Lughod, Lila, 9, 142, 147, 148, 149n.10, 149n.12, 209
adultery: women and legal system in sixteenth-century Turkey, 199, 204n.4
Africa: European colonization and educative function of local courts, 41. *See also* specific countries
agriculture: agricultural exhibition and colonial hegemony in early modern Uganda, 124–32; and Meo women in rural north India, 96; state control of land and production and international trade in nineteenth-century Turkey, 233, 242–47, 249n.14; and women in sixteenth-century Turkey, 194, 202
Althusser, Louis, 61, 64
Amish: cultural defense cases and history of resistance, 11
Anderson, J. N. D., 226–27n.17
anorexia nervosa: power and gender in contemporary Western society, 3
anthropology: recent scholarship on law and power, 4–5. *See also* historical anthropology; legal anthropology
Antigua: marriage laws and social class, 42; slave conditions, 257; slave laws, 258–59; slave resistance through legal channels, 260–67. *See also* Leeward Islands
Antoun, Richard, 225n.3
Arnold, Thurman, 38–39
Arthur, H. W., 132
Asad, Talal, 122
Ashoka (Hindu emperor), 112n.15
audiences: court performances and, 36–37

banking: in eighteenth- and nineteenth-century Ottoman Empire, 241–42. *See also* loans
Bannerman, A. D., 96
Bano, Shah: divorce and Indian Supreme Court, 107–109
Beckles, Hilary, 272n.22
Belenky, Mary F., 92
Bilby, Kennedy, 271n.13
Black Sea: international trade in Ottoman Empire, 248n.4
Bordo, Susan, 3
Bourdieu, Pierre, 120, 139, 142
Brathwaite, Edward, 258, 272n.20, 273n.27
Brenneis, Donald, 112n.9
British Guiana: slave women and courts, 267
Buci-Glucksmann, Christine, 121
Busbecq, Ogier Ghislein de, 187–89
Bush, Barbara, 273n.26, 276n.41

Cain, Maureen, 22n.9
The Campaign (Fuentes), xi-xii
capitalism: international trade and agriculture in Ottoman Empire, 246–47
Caribbean studies: hegemony and resistance in legal practices, 19, 254–55. *See also* West Indies
caste: village society in rural north India, 98, 111–12n.8
Catterall, Helen Tunnicliff, 255, 271n.14
Central America: refugees and sanctuary movement in U.S., 20, 282–301
Certeau, Michel de, 146, 149n.7
Chanock, Martin, 55n.4, 122

CONTRIBUTORS

John Comaroff is Professor of Anthropology at the University of Chicago and Senior Research Fellow at the American Bar Foundation. He has written extensively about southern and central Africa, investigating culture and consciousness, politics, law, and sociocultural transformation. His most recent books include *Of Revelation and Revolution: Christianity, Colonialism, and Consciousness in South Africa, Volume One* (University of Chicago, 1991) and *Ethnography and the Historical Imagination* (Westview Press, 1992), both co-authored with Jean Comaroff. In 1993, he published *Modernity and its Malcontents: Ritual and Power in Postcolonial Africa* (University of Chicago Press), co-edited with Jean Comaroff.

Susan Bibler Coutin is Assistant Professor of Anthropology at North Adams State College. She received her Ph.D. in Anthropology from Stanford University. She has done research on state terrorism, human rights and the mothers of the disappeared in Argentina, and the U.S. Sanctuary movement, a grass-roots religious-based network that assists and advocates for undocumented Salvadoran and Guatemalan refugees. Her volume *The Culture of Protest: Religious Activism and the U.S. Sanctuary Movement* is published by Westview Press. She is currently an Executive Board member of the Association of Political and Legal Anthropology of the American Anthropological Association.

Michael Grossberg is Associate Professor of History and Law at Case Western Reserve University. He received a Ph.D. in the History of American Civilization from Brandeis University. His research concentrates on the social history of American law. His major publications include *Governing the Hearth: Law and the Family in Nineteenth-Century America* (University of North Carolina, 1985), which won the Littleton-Griswold prize of the American Historical Association, and several articles on the legal history of the family and gender relations as well as on methodological issues in legal history.

Susan F. Hirsch is Assistant Professor of Anthropology at Wesleyan University in Middletown, Connecticut. She received her Ph.D. in Anthropology from Duke University. She has written about Kenyan Islamic courts, with particular attention to gender differences in the language of disputes involving family law. She received a National Science Foundation grant to study the relation between legal consciousness and social movement (e.g., feminism and religious fundamentalism) in postcolonial East Africa. Her primary research interests include feminist theory, the anthropology of law, and discourse analysis. She is a Trustee of the Law and Society Association (Class of 94).

Mindie Lazarus-Black received her Ph.D. in Anthropology from the University of Chicago. She is Assistant Professor of Criminal Justice and Affiliate Assistant Professor of Anthropology at the University of Illinois at Chicago. Her scholarship focuses on the history and ethnography of class, kinship, gender, and the law in the English-speaking Caribbean. She is the author of *Legitimate Acts and Illegal Encounters* (Smithsonian Institution Press, 1994) and recipient of a National Endowment for the Humanities Fellowship for College Teachers that enabled her to develop a longitudinal study of the consequences of radically altering a nation's kinship codes. She is a member of the Board of Trustees for the Law and Society Association (Class of 1996).

Sally Engle Merry is Professor of Anthropology at Wellesley College. She received her Ph.D. in Anthropology from Brandeis University. She is the author of *Urban Danger: Life in a Neighborhood of Strangers* (Temple, 1981), *Getting Justice and Getting Even: Legal Consciousness among Working-Class Americans* (Chicago, 1990), and co-editor of a book entitled *The Possibility of Popular Justice: A Case Study on American Community Mediation* (Michigan, 1993), with Neal Milner. She has worked primarily on sociolegal relations and urban social life in the United States and has published numerous articles and review essays on legal ideology, mediation, urban ethnic relations, and legal pluralism. She has been elected President of the Law and Society Association for 1993–1995. She is currently working on a project on the meanings of law in the American colonization of Hawaii.

Erin P. Moore is Visiting Professor of Anthropology at the University of Southern California. She received her Ph.D. in Anthropology from the University of California-Berkeley. Her publications include *Conflict and Compromise: Justice in an Indian Village* (University Press of

America, 1985), which examines dispute processing in an Indian village. Her areas of scholarly research include South Asian studies, legal anthropology, and gender.

Susan U. Philips is Professor of Anthropology at the University of Arizona. She received her Ph.D. from the University of Pennsylvania. As a specialist in linguistic anthropology, she examines the relation between linguistic structure and language use. Her research includes work on language and gender, the dynamics of language use in legal contexts, and the ethnography of Polynesia. Her publications include *The Invisible Culture* (Longman, 1983, Waveland, 1993) and *Language, Gender, and Sex in Comparative Perspective* (Cambridge, 1987), a coedited volume. In addition, she has published articles on the role of language in legal processes in journals and edited collections.

Yvonne J. Seng is Visiting Lecturer in Islamic History at the Wesley Theological Seminary in Washington, DC. She received her Ph.D. from the University of Chicago. She received the Malcolm Kerr Award (second place) from the Middle Eastern Studies Association of North America for outstanding dissertation of 1991. Her research interests center on everyday life in the Ottoman Empire with special focus on legal strategies of both the community-at-large and of women and non-Muslim minorities.

June Starr is Associate Professor of Law at Indiana University Law School, Indianapolis. She received her Ph.D. in Anthropology from UC-Berkeley and her J.D. degree from Stanford Law School in June of 1992. Her primary research interests include cultural anthropology, politics and law, and social history, and she has conducted research in these areas in Turkey. Her publications include *Law as Metaphor: From Islamic Courts to the Palace of Justice* (SUNY Press, 1992), *History and Power in the Study of Law: New Directions in Legal Anthropology* (ed. with Jane Collier) (Cornell, 1989), *Dispute and Settlement in Rural Turkey: An Ethnography of Law* (E. J. Brill, 1978), and numerous theoretical articles on dispute settlement and/or gender relations in rural Turkey. Dr. Starr has been a Trustee of the Law and Society Association and a past member of the executive board of the Association of Political and Legal Anthropology of the American Anthropological Association.

Joan Vincent is Professor of Anthropology at Barnard College, Columbia University. She received her Ph.D. in Anthropology from Columbia

University. Her areas of research interest include law, political anthropology, and the anthropology of colonialism. Her volume *Anthropology and Politics* (University of Arizona Press) was published in 1990. She has pursued research in Northern Ireland, and in Uganda on Brehon law, agrarian law, and colonialism. She is currently President of the Association of Political and Legal Anthropology of the American Anthropological Association.

Barbara Yngvesson is Professor of Anthropology at Hampshire College in Amherst, Massachusetts. She is the author of numerous articles on disputing and the constitution of order, the interplay of state power and the ideology of community, and on agency and theories of the subject. She is also the author of *Virtuous Citizens, Disruptive Subjects: Order and Complaint in a New England Court*. She has been a Trustee of the Law and Society Association and Book Review Editor of the *Law and Society Review*.